PAUL
KLEE

1. PAUL KLEE
 Photograph, about 1925.

by

PHILIPPE COMTE

Translated by
Carol Marshall

MALLARD PRESS

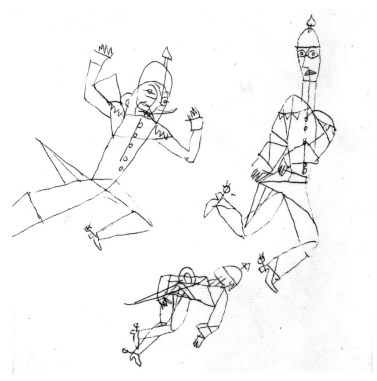

2. FLEEING POLICEMEN
(DIE FLIEHENDEN POLIZISTEN)
1913/55 (A) – Pen and India ink on Ingres paper, 19.6 × 15.5 cm
Paul Klee Foundation, Kunstmuseum, Bern.

MALLARD PRESS
An imprint of BDD Promotional Book Company, Inc.
666 Fifth Avenue
New York, N.Y. 10103

Mallard Press and its accompanying design and logo
are trademarks of BDD Promotional Book Company, Inc.

ISBN: 0-7924-5772-2

Printed in Hong Kong

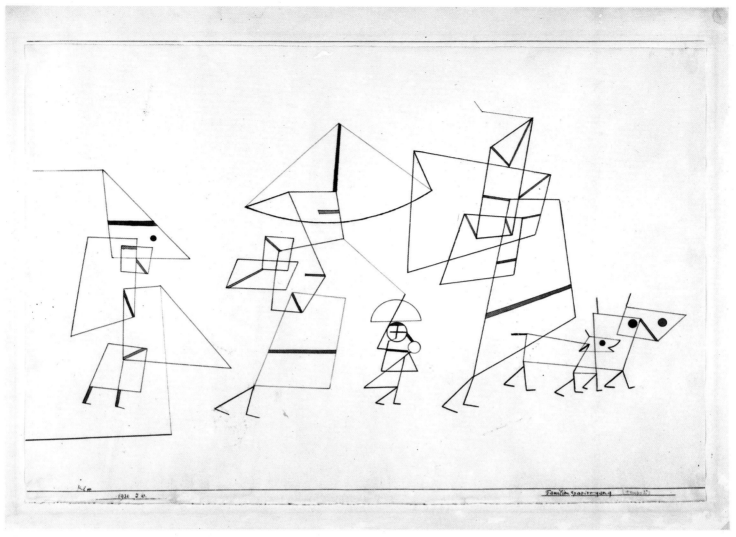

3. FAMILY WALK, TEMPO II
(FAMILIENSPAZIERGANG, TEMPO II)
1930/260 (J 10) – India ink on paper mounted on cardboard 39.7 × 57.5 cm
Paul Klee Foundation, Kunstmuseum, Bern.

PAUL KLEE

WHEN Klee was born in 1879, in Münchenbuschee, near Bern, three good, appropriately Germanic fairies, were bending over his cradle: The spirits of painting, poetry, and music, the three arts that head Hegel's romantic classification. His mother Ida, a Franco-Swiss inhabitant of Basel, had studied piano and singing at the Stuttgart conservatory, and his father Hans, of German descent, was teaching music at Hofwil college at the time of his birth. Three years later, a girl, Mathilde, was born. Both his parents had dreamed of having singing careers, and Paul was given violin lessons from the age of three. He had real talent, so much so, that at the age of eleven, despite his youth, he was appointed as an understudy to the municipal orchestra in Bern where his parents had moved in 1880.

He adored his sarcastic father and charming calm mother, and his childhood unfolded in a climate of affection and encouragement. His grandmother, a skilled dress designer and embroiderer, looked after him during the day, and revealed to him the world of color, drawing, and cutout, giving him magazines and calendars as sources of inspiration. Also, she initiated him into the imagination of the plastic arts through the dreamlike drawings accompanying the text of *The Youngest Roussel*, a childhood book of hers from which she had learned to read French.

She died when he was five years old, and he was overcome with grief. It was his first encounter with the shock of death and the despair that follows the loss of loved ones. At nineteen, his deep indecisiveness, which his parents could not understand, was due to a reawakening of this anguish.

In 1980, when he was eleven, Paul entered the

5

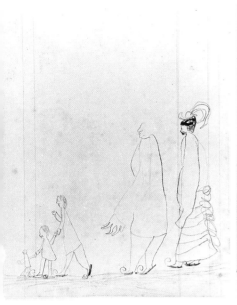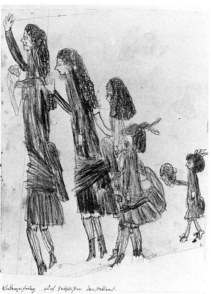

4. FAMILY WALK
(FAMILIENSPAZIERGANG)
1883 – Pencil on paper, 28.2 × 18.4 cm
Private collection, Switzerland.

5. FIVE SISTERS
(FÜNF GESCHWISTER)
About 1885 – Pencil drawing, 15.6 × 14 cm
Private collection, Switzerland.

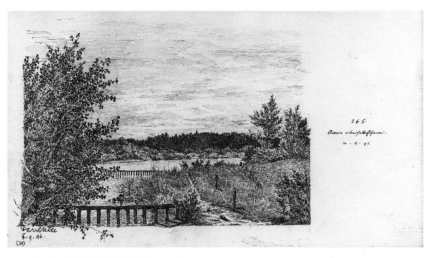

6. L'AAR, ELFENAU COAST
(AARE OBERHALB ELFENAU)
1896/29 IX – Drawing Book VIII, 13.2 × 20.3 cm
Paul Klee Foundation, Kunstmuseum, Bern.

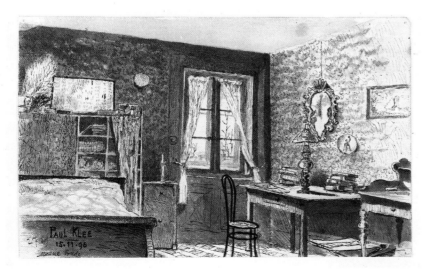

7. MY ROOM
(MEINE BUDE)
1896/15 XI – Pen and India ink on cardboard, 12.1 × 19.2 cm
Paul Klee Foundation, Kunstmuseum, Bern.

Progymnasium. Apart from botany and Greek, his enthusiasm for his studies was lukewarm, but his quick mind enabled him to pass his final exam in 1898 and graduate. Pleased with his success, the artistic, somewhat dreamy, adolescent returned with his exercise books filled with drawings of flowers, birds, and landscapes to his family home, accompanied no doubt by the cats of the quarter, the old companions of his wanderings.

Klee then found himself at a crossroads, in the grip of a profound dilemma. Twenty years later he wrote in his Diary: "Frequenting poets was not without charm, but poetry was not the profession for me. Nor was a career in musical composition tempting on the present descending scale. And from the moment I saw that my teacher was not a satisfied artist, I did not want to be a violinist either." The decision to devote himself to painting matured slowly. However, it was more the possibility of being able to form himself than his desire to paint that attracted him to a big art center. In Bern he could not hope to realize this ambition.

1898–1920 — The Developing Years

In October 1898, Klee applied for a place at the Munich School of Fine Arts; on the advice of the director, he enrolled in the independent Knirr School of Art, which developed beginners. Despite the presence of his childhood friend Herman Haller, who went on to become an excellent sculptor, he was lonely in the foreign town as well as being discouraged by the art teaching of the period with its emphasis on drawing from the model. Separated from his beloved parents, he wandered round the Bavarian town, experiencing vague yearnings of the soul and the awakening of an adolescent sensuality that would not be satisfied by banal adventures. He was disappointed with what he produced and questioned his true vocation and place in society. It was during this period of doubt, anxiety, and moral crisis — quite natural to adolescence — that he met the woman of his life, Lily Stumpf, a sensitive and cultured pianist. They had so much in common, and the two young people, with their passion for music, poured out their hearts to each other and soon established a keen friendship. Lily encouraged him to persevere with his art, and in October 1900, he was admitted to the Academy of Fine Arts at the same time as a thirty-four-year-old Russian who had just given up a lucrative legal career in order to devote himself to painting. But the difference in their ages and the time that Paul spent with Lily in his free hours meant that the two men crossed paths without getting to know each other. Eleven years later they met again, and an indestructible friendship was

forged. Neither the "madman of painting" that was Kandinsky nor the young Klee, who was searching for himself, fared well in Franz von Stuck's studio. Von Stuck was a mediocre artist and a pompous teacher — yet another disappointment for Klee.

Klee then saw himself branching off into cartoon, which was well suited to his caustic mind, but the magazine *Jugend* to which he applied did not even bother to send him a reply. He disliked Stuck's teaching so much that in March 1901 he left the Academy. This rupture was not his only daring act; the other was his decision to become engaged to Lily Strumpf. Despite the precariousness of their financial situation, she accepted, but they were both agreed that Paul must finish his artistic education with a trip to Italy. She would wait for him.

In June 1901, he and Hermann Haller left Munich. At the time, a trip to Italy was considered an educational journey and fundamental preparation for an artistic career. Indeed, Klee was to receive some great shocks: in Milan the Tintorettos of Bera; in Genoa the exciting discovery of the hitherto unknown sea, an arresting image that unsettled and delighted him. Going from surprise to surprise, he arrived in Rome on October 27. Naturally, he had read Burckhardt's *Cicerone*, which was the bedside table reading of all young intellectuals, but he had not expected the emotion with which he was overwhelmed before Raphael's *Stanze*, the ceilings of the Sistine Chapel, and above all, Latran's Byzantine mosaics. He was filled with joy. At last he had found great art; he would devote the rest of his life to understanding its secrets.

In today's world ease of travel and media's omnipresent images, make it difficult for us to understand the importance of that which is inaccessible or has taken a long time to get to, or to realize that this initiation was necessary in order to crystallize sensibility and rouse creative emulation. For Klee the journey was the point at which he started to believe. "Here I am," he wrote, "at a pinnacle from which I can view together all the great culture produced by antiquity and the Renaissance." After this he devoured Aristophanes, Tacitus, Tolstoy, and Zola and started to study the nude again, this time with enthusiasm, for he had seen with his own eyes examples of great successes in this field.

He continued his descent toward the sun to Naples, where he arrived in March and where he attentively scrutinized the Pompeian paintings that seemed to him to have been exhumed specially for him. One day on going into the aquarium, he suddenly experienced the most overwhelming feelings in the "atmosphere of magical isolation," where in the center of the iridescence, in the blue-green light of the peaceful

8. PORTRAIT OF WOMAN AND STUDY OF LEGS
 (FRAUENBILDNIS UND BEINSTUDIEN)

9. ACCORDING TO NEW COMPOSITION RULES
 (NACH NEUEN KOMPOSITIONSREGELN)
 1899 – Extract from a sketchbook done at Knirr's, 32.5 × 20.7 cm
 Paul Klee Foundation, Kunstmuseum, Bern.

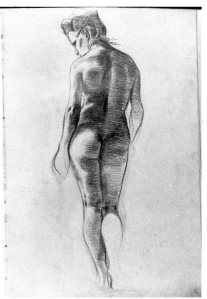

10. A NOTORIOUS HERMAPHRODITE
 (EIN BERÜCHTIGES MANNWEIB)

11. NUDE WOMAN SEEN FROM THE BACK
 (WEIBLICHER RÜCKENAKT)
 1899 – Extract from a sketchbook done at Knirr's, 32.5 × 20.7 cm
 Paul Klee Foundation, Kunstmuseum, Bern.

12. NEAR THE CIDER PRODUCER
 (BEIM MOSTBAUER)
 1899 – Pencil on paper, 32.5 × 20.7 cm
 Extract from a sketchbook done at Knirr's.
 Paul Klee Foundation, Kunstmuseum, Bern.

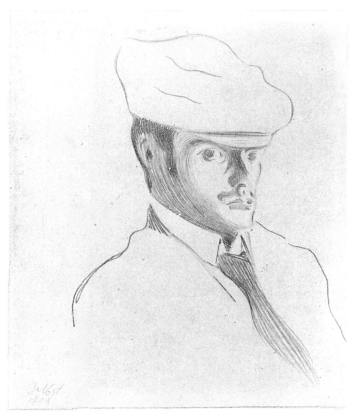

13. SELF-PORTRAIT WITH A WHITE HAT
(SELBSTBILDNIS MIT DER WEISSEN SPORTMÜTZE)
1899/1 (B) – Pencil on paper, 13.7 × 12.9 cm
Private collection, Switzerland.

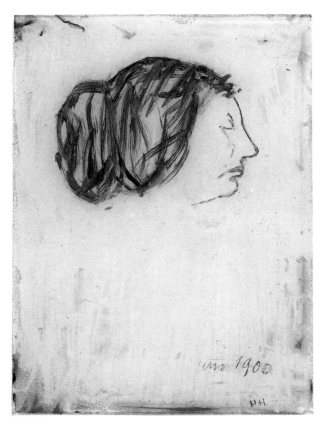
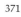

14. SMALL PORTRAIT SOUVENIR OF LILY
(KLEINES ERINNERUNGSBILDNIS LILY, EINE ZEICHNUNG VON
1900) 1905/21 (A, B) – Watercolor on glass, 17.8 × 12.9 cm
Paul Klee Foundation, Kunstmuseum, Bern.

depths, polyps, starfish, and shells develop their strange forms with sublime slowness. The light, color, and living geometry were registered by him and later transfigured in his work.

But even in the middle of his enchantment, his humor did not desert him: "The polyps look like they could be art dealers; in particular one of them who winked at me knowingly in an insinuating way, as if I was a new Bocklin and he himself a second Gurlitt. Niente affare! A tiny gelatinous and angelic beast (of psychic transparency) swam on its back with a continuous movement, making a small, endless swirl of color. The spirit of a foundered liner."

In Genoa, Rome, Naples, and Florence "a piece of history was resuscitated," and yet he had to painfully acknowledge that "the notion of the ideal in the domain of the fine arts is completely out-of-date." He was extremely perplexed, but he tried to combat his puzzlement with satire and caricature. After his return to Switzerland, the young, still puzzled painter, did a series of etchings between 1903 and 1905 entitled *Inventions*. Independent of any immediate natural model, they were inventions in the real sense of the word.

A dazzled Klee came back to Bern in May of 1902, happy to be back with his family and full of gratitude

that so many great works of art existed. He decided to "start again from the beginning" and eventually perfected the method by which he could give "birth to a painting."

Up until then he had shown excellent but limited aptitude. The landscapes that he drew so carefully did not have "deep meaning," even allusively, according to his own words. The *Portrait of His Mother* (1893) is a beautifully constructed piece, and some views of the old towns of Bern and Geneva and of the chateau at Chillon have a nervous subtle style, but it is safe to say that his mastery of the violin was certainly comparable to his expertise in art. During the same period, Picasso, who was the same age as Klee and who had just arrived in Paris, was already sure of his talent. Klee's intelligence, however, was very keen; in 1900 he wrote: "I was sketching a testament. I was demanding that I destroy all that remained of my artistic attempts. I knew without doubt to what point they were miserable and worthless in comparison with the possibilities that are now casting their shadow before me. Sometimes, because of my modesty, I denigrated myself entirely and was ready to do illustrations for humorous magazines. Later, I would not be less able to illustrate my own thoughts. What ought to have come out of such modesty were more or less refined technico-graphic experiments."

It was not brilliant virtuosity that led Klee to

371

realize his vocation, but rather his refined sensibility, his sharp intelligence, his faculty for analysis, his pleasure in introspection, his real gift for metaphysics that enabled him to perceive the subtle links between things, and a methodical mind that he no doubt got from his study of the great musical works, which have to be patiently deciphered in order to interpret them.

He no longer tried to complete works; instead, he tried to assemble the conditions for the work, as a scientist in a laboratory applies himself to creating the conditions for an experiment. An admirable resolution, it led him to question the different forms of expression. Klee realized from this time on that a plastic artist had to be a poet as well as a naturalist and philosopher.

He then adopted a most rigorous program. Every morning he went to the anatomy room at the medical school where he immersed himself for two hours in an analytical study of the human body taken from life. Once a week he went to Professor Strasser's course given specially for artists, and lastly, he attended Kornhaus' classes three times a week to work from the nude model. His trip to Italy had shown him the Renaissance artists' fantastic knowl-edge of anatomy, and he was hypnotized by their example.

Faced with the resolve of this eternal student, Lily Stumpf's parents, of whom the father was a doctor, remained unsure of their daughter's relationship with Klee. Worriedly, they opposed the marriage. But the young people continued to see each other clandestinely and corresponded as well. Klee's detailed letters to Lily tell us about his projects, his work, and his prodigious reading (the Bible, the Greek tragedies, Aristophes, Cervantes, Calderon, Voltaire's *Candide*, Hoffmann, Gogol, Dostoevsky, Strindberg, Wedekind, Goethe's "Elective Affinities.") The two met in Basel, took a trip to Beatenberg and a journey to Geneva, where Paul, though very much in love, still managed to discover the coral in the Rath museum and a nude as well, "which is what is the most beautiful in modern painting."

As a result of the studies he imposed on himself, Klee learned how to etch onto zinc, and from 1903 to 1905 he made about fifteen satirical prints that could fairly be considered his first inventions. He had a good sense of the grotesque and knew perfectly how to show intent by an expressive deformation. This caricatural symbolism shows the influence of Aubrey

15. TWO MEN MEET: EACH SUPPOSING THE OTHER TO BE OF HIGHER RANK
(ZWEI MÄNNER EINANDER IN HÖHERER STELLUNG VERMUTEND BEGEGNEN SICH)
1903/5 – Etching, 12 × 22.6 cm
Paul Klee Foundation, Kunstmuseum, Bern.

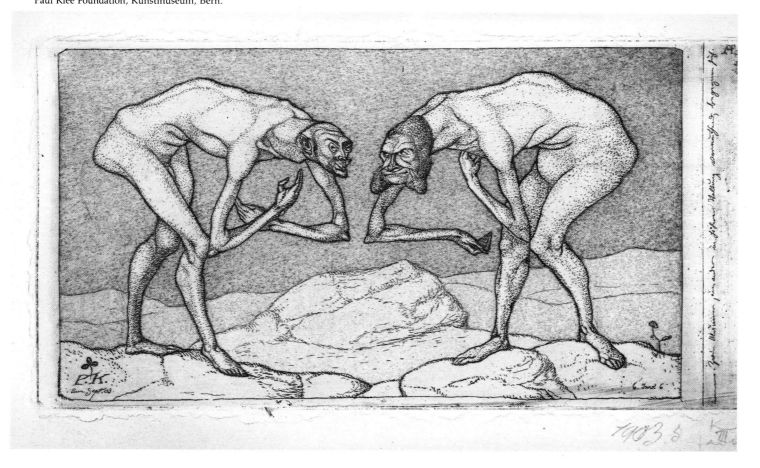

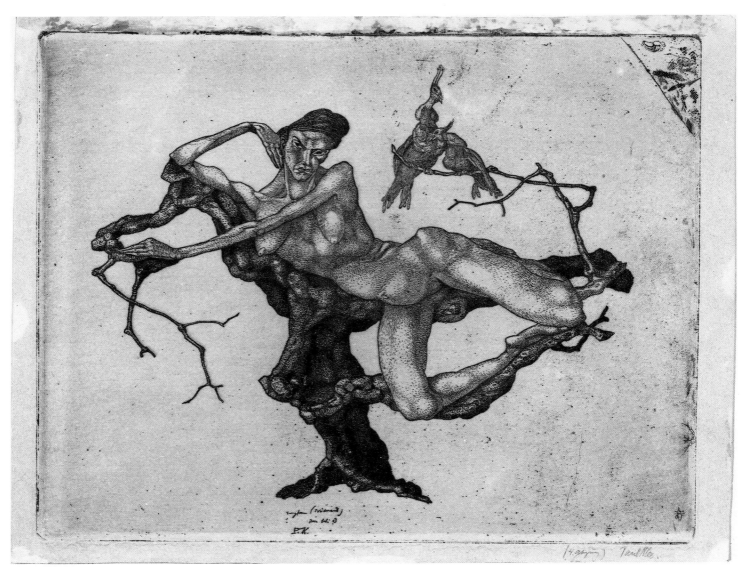

16. VIRGIN IN A TREE
(JUNGFRAU IM BAUM)
1903/2 (A) – Etching, 23.7 × 29.7 cm
Paul Klee Foundation, Kunstmuseum, Bern.

Beardsley and James Ensor: *Menacing Head* (1905) evokes a Beardsley woodcut, *The Cat* (1895). With regard to the *Virgin in a Tree* etching, which is reminiscent of Pisanello's allegory *Lust*, Klee wrote to Lily on July 18, 1903: "What can one infer from it? A truth at least of forced but sacred virginity, which is of no use at all. A criticism of bourgeois society." His corrosive humor burst out in *Two Men Meet: Each Supposing the Other to be of Higher Rank* (1903), and the masks of *Komiker* (1904), "arose from reading Aristophanes." He gave his own commentary to the *Winged Hero*: "This person, born with one wing of an angel contrary to divine nature, tirelessly forces himself to take wing. In doing this he breaks his arms and legs but does not persevere less in his ambition." "My work is nothing but satire," he attested during his stay in Italy.

And in effect, the art he made between his first etchings of 1903–1905 and his illustrations for *Can-dide* in 1911–1912, is mainly satirical and illustrative, influenced in particular by Ensor, whose work he had been introduced to by his friend Sonderegger in 1907.

However, in June 1902, he remarked in his *Journal*: "Satire must not come from an excess of bad temper in memory of what is superior. Ridiculous humans, divine God. Rather it must express the hatred for the average mire of human baseness that comes to mind when one thinks of the possible peaks humans can attain." He added in July 1902: "There are in actuality only three things: Greco-Roman Antiquity (Physics) with its architectonic gravitation and objective conception directed toward what is on earth and Christianity (Psyche) with its musical gravitation and subjective conception directed toward the beyond. The third thing consists of being a modest and ignorant, self-taught human being, a miniscule I." Dissatisfied with the academic teaching

10

17. WOMAN AND ANIMAL
(WEIB UND TIER I)
1904/13 (A) – Etching, 20 × 22.8 cm
Paul Klee Foundation, Kunstmuseum, Bern.

in Munich, he hoped to feed himself directly from the spring by direct contact with Antiquity and the Renaissance. His *Journal*, giving us a different glimpse, shows that this was a moment of painful sudden awareness for him. Despite his admiration for Antiquity, he had realized that the classical ideal was obsolete and that there was no sense in trying to emulate it. Forced to go back to his family in Bern because of his financial situation, the young Klee saw that he would have to climb alone the steps of a career in which he believed despite everything. As Auguste Detoeuf had said: "God created heaven and earth but the self-taught one did better: he created himself."

Innocence, the fecund purity of mind, was lost early. Then Klee discovered the tragic. He was certainly not Goya, but he almost could have been. After all, to whom did he owe his first aesthetic awakenings? To three great names, the masters of tragic expression in the history of art: Goya, Ensor,

and Van Gogh. You have only to see his etchings from 1903–1905 or the *Road with Cart* of 1907, to discover to what point the universe Klee took in was pessimistically seen. He was fully aware of this and noted in the spring of 1901: "I often say to myself that I serve beauty by drawing her enemies (caricature and satire). But everything is not made for all that. I need, moreover, to represent beauty directly and with the full strength of conviction. That is my distant, sublime goal. Only half awake, I am embarking on a path that is already full of risk. A path that will perhaps be longer than my life. Henceforth, I must tread it in an awake state. "

In December 1903, writing again in his *Journal*, he pens these sentences, which give the key to his tragedy and, given his concerns, come from a most unexpected source, unexpected because he worked so hard to detach himself from it, to vanquish it, and therefore to make us forget it: "There are two

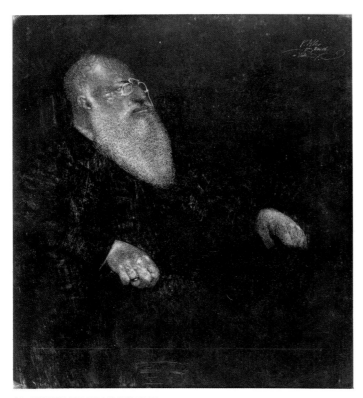

18. PORTRAIT OF MY FATHER
(BILDNIS MEINES VATERS)
1906/23 – Drawing in India ink on glass, 32 × 29 cm
Private collection, Switzerland.

mountains, the mountain of beasts and the mountain of Gods, on which light and clarity reign. But between the mountains stretches the twilight valley of humankind. And when one of them, knowing that he does not know, raises his eyes, he experiences with foreboding an insatiable nostalgia for those beings who do not know that they do not know and those who know they know."

This "valley of the shadow" from David's psalms is the point of departure of Klee's road. It is the friction inherent in the impossible human condition, where man is tugged between original innocence forever lost and the ultimate omniscience that would be innocence regained but that is impossible to attain here on earth. It is the fate of human nature to be in a condition of being torn apart, and tragedy is nothing other than the bitter and constant awareness of this untenable situation. Nevertheless, Klee did not despair. He decided to confront the tragedy directly, reconquer innocence, and walk with a determined step toward the summit of light.

As we grow up and leave childhood behind, the world progressively concretizes, and our childish innocence cannot be regained by simple return. Which significantly complicates things. Braque remarked that we can turn a river from its path, but that we can't make it go back to its source. What has been done is done; it is not in anyone's power to become a child again. Except perhaps for genius,

which is nothing more than "childhood regained," as Baudelaire so admirably put it. But in general it is not possible to go backwards.

The inescapable fact of the tragic is something Paul Klee grappled with and, had he not been a musician, would probably have stayed with. It is not possible to listen to Bach or Mozart, and even less play them, without suspecting that man still has some power over the tragic. Bach's Concerto in E Major, for example, would be sufficient to teach us that man can surpass himself, therefore surpass his tragic condition and regain a certain innocence. If the illuminated and fertile terrain of simplicity cannot be reconquered by regression, it can be done by progression. Nostalgia for our origins should not call for a return, a retreat (which, if it were possible, would be cowardliness), but on the contrary for a most determined march forward.

We can thus imagine that, while playing Bach on his violin, Klee discovered that if a little bit of science quickly distances cherished innocence, a lot of science can bring it back again. He might have said to himself: The world we live in no longer surprises us, no longer makes us marvel. Condemned to daily banality, we have grown weary of this reality, and even the greatest of our discoverers longs for the return of wonderment. All right, that might be so! But is it the power to marvel at the world that we desire or merely the power to marvel? Simply to marvel, of course, and once we realize this that power can be ours again. We have to create other worlds, other realities that surprise us and plunge us again into the happy amazement of our wide-eyed childhood — that will be enough.

But the work still remained to be done. These new worlds had to be created, and this could not be done in a haphazard fashion. Paul Klee knew that he was going to have to discover the laws according to which universes can be created. Contrary to what the lay person and even some artists believe, the creation of an aesthetic universe is not purely an affair of capricious imagination, unbridled inspiration, and unlimited daring. These elements are often necessary, but they by themselves can never be enough. And he who is satisfied with them risks ending up with uninhabitable worlds and impossible monsters. These may enjoy a brief and superficial success because of their curiosity value, but, in every other way, they are insubstantial and therefore unworthy of being called works of art. Klee was perfectly aware of this. He knew that creativity did not come easily and that the artist's work of transformation and translation was far from being vain or capricious. The artist can never be wholly creator, for when he starts to construct his worlds, he does not start with nothingness, but rather with an already formed universe. He can change the appearance of this real

world, which is what the Impressionists attempted, or he can profoundly transform it by creating other worlds that start with himself. This is Klee's way. An endeavor that, thanks to the parable of the tree, he explains very well in his 1924 "Jena Lecture."

The artist is the trunk who gathers what comes up from the bottom and places it, transformed into leaves, flowers and fruits, higher up in the branches. "It doesn't enter anyone's mind to demand of a tree that it form its branches from the model of its roots. (. . .) And yet we wish to forbid the artist to distance himself from his model when plastic necessity has already obliged him to. (. . .) He is neither submissive servant nor absolute master; he is simply an intermediary. The artist's place is therefore a very modest one. He does not claim the beauty of the boughs as his own; he has merely been the medium."

It is only in 1905 that we can see the beginning of a ray of hope for Klee due to the discovery of new possibilities that the technique of glass painting offered. Up until 1913, Klee kept strictly to technical experiments conducted in a systematic fashion. Evidence of these experiments can be found in his *Journal* entries of July 1905: "In an absolutely straightforward way, I put down a layer of asphalt paint on a sheet of zinc. Then I drew on it with a point according to my whim, without the least scruple, and I even worked on the light surfaces with a knife. In order to atone for this technical crime, I spread a film of aquatint (either in liquid or sprayed form according to what I felt like) over all of it. There it was, something that would prevent corrosion as well as giving depth to the light surfaces."

Despite struggling with a difficult argument that proclaimed itself simultaneously on two levels, that of content and that of "pure elaboration of the means," the work progressed successfully from the graphic to the pictorial. The direction the research took leaned more naturally toward the formation of a dynamic that was integral to the work.

18
21–
24
58 &
59

Between 1905 and 1908 Klee completed several fixed works on glass (26 according to Grohmann), the juxtaposition of the popular characteristics with the nature of the material interesting him particularly. He would coat a sheet of glass with dark or black color then engrave on it with an etching point. The indirect and disconcerting character of this technique pleased him. Six years later in Munich, when the "Blaue Reiter" appeared, collectors were looking for paintings on glass of the 18th and 19th centuries. Klee then proposed to them a succession of delightful works like *Garden*, *Animal Feeding Its Young*, and *Portrait of a Woman Full of Feeling*.

In June 1905, he decided with two friends, Louis Moilliet and Hans Bloesch, to go to Paris. They stayed for only thirteen days, and strangely, it was

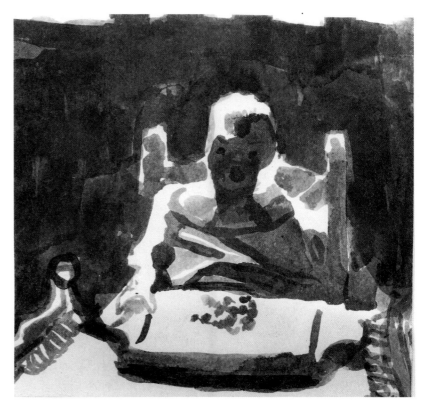

19. CHILD IN A FOLDING CHAIR II
(KIND IM KLAPPSTUHL II)
1908/57 – Black watercolor drawing on paper, 15.3 × 15.3 cm
Private collection, Switzerland.

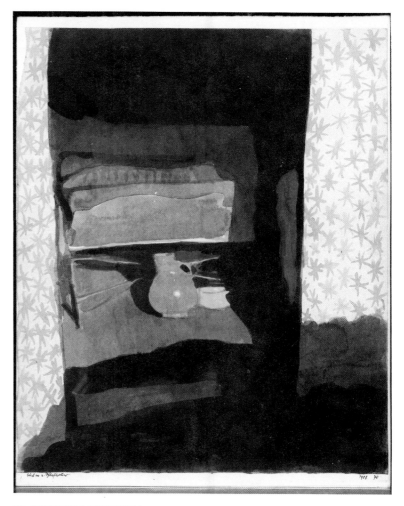

20. VIEW OF A BEDROOM
(BLICK IN EINE SCHLAFKAMMER)
1908/70 (B) – Watercolor on paper, 30 × 23.9 cm
Kupferstichkabinett, Kunstmuseum, Basel.

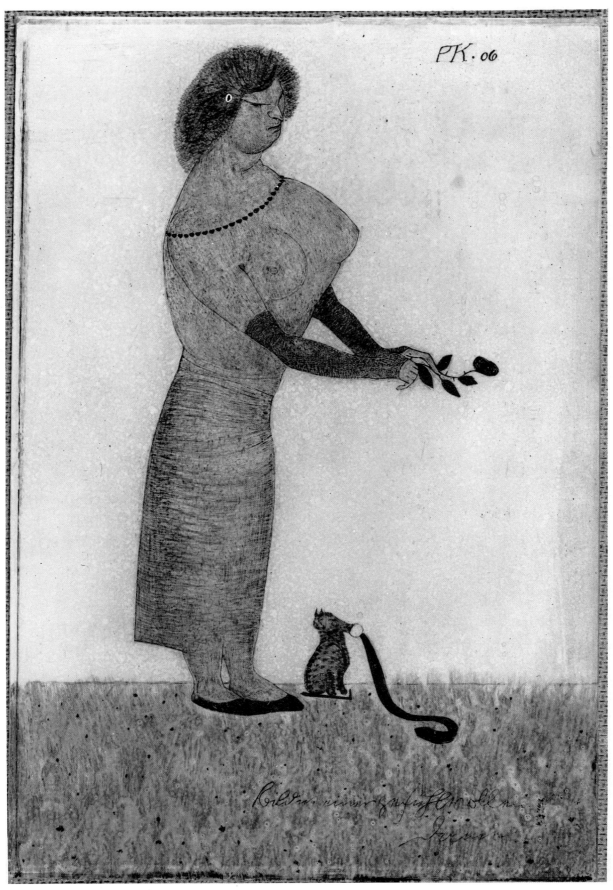

21. PORTRAIT OF A WOMAN FULL OF FEELING
 (BILDNIS EINER GEFÜHLVOLLEN DAME)
 1906/16 (A) – Painting on glass, 24 × 15.8 cm
 Paul Klee Foundation, Kunstmuseum, Bern.

the art of the past that interested him the most, as his diligent visits to the Louvre show. His inspection stopped with the Impressionists, whom he judged without any particular sympathy. He found Monet "impulsive" and Renoir "slight," preferring Eugene Carriere's monochrome paintings to theirs. On his return, feeling more sure of himself, he prepared ten etchings for the 1906 Munich "Secession," but they did not meet with any success. On September 16, 1906, after a six-year engagement and against the wish of her father, he married Lily Stumpf. The couple set up house in Schwabing, the artist's quarter in Munich, where they remained until 1920. The following year Felix, their only child, was born. It was Paul who looked after the baby while Lily, the breadwinner of the household, gave piano lessons.

His marriage with Lily Stumpf saw his victory over satire (henceforth referred to by Klee as, "the convulsive me with big blinkers on my eyes") and marked in the following years patient research of the elementary plastic means of line, surface, and value of color.

"When the child, a boy, was born," Klee notes in his private *Journal*, "I was even more astonished to see that everything did not become duly disorganized, but that on the contrary, a new center was formed. And I experienced from then on, profoundly and continuously, what this center was. We were a real little family." Still on the subject of Klee's family, Felix noted in his turn, with regard to his grandfather: "Hans Klee was a genial potterer and a good translator of certain parts of the Bible. Grandfather was always extremely critical about the artistic evolution of his son Paul."

Klee's bad luck continued: The review *Simplicissimus* refused his humorous drawings; the Seccession Show, his etchings and paintings on glass, and the Drawing Artist's Union, his membership. As a crowning misfortune, Lily became seriously ill.

The love Lily and Paul Klee shared made their relationship one of the most powerful to be found among famous artists. Because of it, the many hardships of their life meant little to them, and nothing was allowed to diminish their resolve and enthusiasm. They spent their evenings alone or with friends, playing Handel, Bach, and Mozart. Paul was able to go to the opera and concerts in Munich as well as an exhibition of the Impressionists.

"My memory of Paul Klee is today still very clear," says his son Felix in the 1985 catalogue of the Pierr Gianadda Foundation in Martigny. "Klee was until 1916 to be the person in charge of the Munich household, including the education — not always easy — of his son Felix. My mother had to support the whole family with her piano lessons. It was, therefore, not at all possible for her to fulfill any of her traditional functions in the house. Klee replaced her in numerous tasks with accomplished know-how.

"I was very often sick. Pneumonia, angina, chills, and jaundice were the order of the day, and Klee took care of me with touching patience and devotion. He made semolina for me, seasoned with cinnamon and sugar or raspberry syrup, and sometimes used a clean brush to stir the dishes instead of a spoon. Later, he oversaw my homework as well as my drawing and painting attempts."

His will to create became an intransigent passion. In the middle of winter, half frozen, he tracked motifs in the snow or left, armed with binoculars, "to hunt images" over the Bavarian meadows. "In this way," he would shout, "we surprise our models best. They don't suspect anything and therefore do not lose the naturalness of their posture and physiognomy either."

"A work of art that surpasses naturalism," he continued in his *Journal*, "is one in which line appears as an autonomous pictoral element, just as in Van Gogh's drawings and paintings or Ensor's graphics. The juxtaposition of lines in the latter is remarkable in its graphic formations. In a general manner, it is here that the proper domain for my line lies.

"Newly fortified by my naturalist studies, I have been permitted to come back again to the original terrain of psychic improvisation correct for me. In this place, where I am only linked in a very indirect fashion to an impression of nature, I can dare again to represent the thing that obsesses my soul.

"There, held for a long time in reserve, is to be found a new creative possibility before which, previously, only the anxiety of isolation made me retreat. Now, the pure personality will be able to be shown and therefore liberated."

This psychic improvisation that he talks about constitutes the essential of his original steps. Henceforth, all his efforts would be toward disengaging himself from the Expressionism reigning in Munich, the town of five thousand painters. He affirmed his will: "Reduction! We want to say more than nature, and we therefore commit the unjustifiable mistake of investing it with more means than it has, instead of restraining it. Light and rational forms are in opposition; light starts the ball rolling by curving the straight lines, making ovals of the parallels, and tracing circles in the spaces, thereby activating these spaces. From this comes its inexhaustible variety."

Here he states his resolve and determines the genesis of his work:

1) draw rigorously according to nature, eventually with the means of a telescope
2) turn the drawing upside down and make the principal lines come out at will
3) place the sheet in its original position and harmonize 1 = nature with 2 = painting.

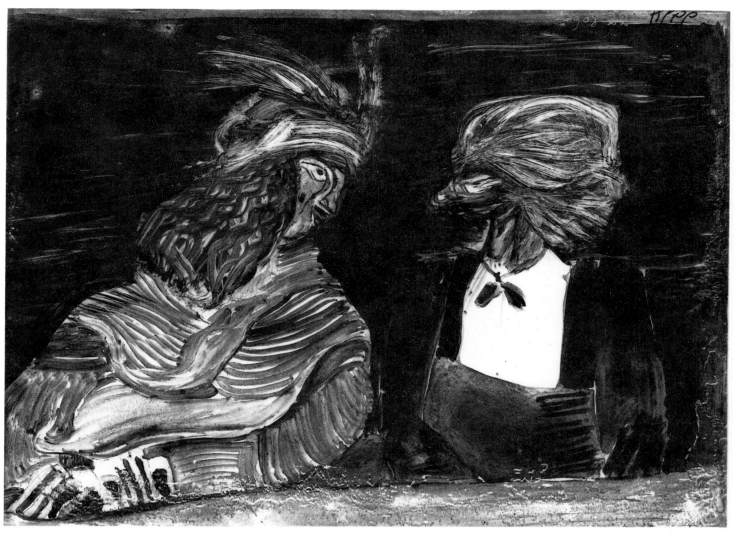

22. COUPLE IN THE BOX SEATS
(HERR UND DAME IN DER LOGE)
1908/22 (A) – Painting on glass, 12.9 × 17.8 cm
Paul Klee Foundation, Kunstmuseum, Bern.

"My lines," he wrote, "of 1906 to 1907, were what I originally had. But I had to stop using them for the slightest convulsion, perhaps even a decorative one, threatened them. In short, I was scared, and I stopped doing them because I still deeply felt them to be beyond me. It was not possible to 'make them come out.' Impossible also to discern them around me; the coincidence of the interior and the exterior was too difficult to establish. Then the reversal occurred in a brutal way during the summer of 1907, I devoted myself entirely to nature and, on the basis of my studies, constructed some black and white landscapes on glass during 1907–1908. But I had barely mastered this stage when nature again bored me. Perspective made me yawn. Would it be necessary henceforth to distort them (which I attempted to do mechanically)? How could a bridge most freely be spanned from interior to exterior?"

Through this fundamental question, we can see that Paul Klee already possessed the force that was to grow and succeed in its endeavor. But at that moment he was still only talking about it; it was only a thread,

not yet the "spanned bridge" that he wanted. The distinction between the "not taken from nature" (A) works and the "naturalistic" (B) works that he used as headings in his catalogue until the end of 1913, clearly shows his position vis-a-vis nature.

From 1901 to 1904, "not taken from" inventions appeared exclusively, and it was only from 1905 that the "naturalistic" works started to crop up. During 1908 to 1910 the proportion of these augmented, and from 1911 a certain balance was established between the two. In 1908, through his search for a new graphic plateau and arising out of his studies painted from nature, he was attracted to the field of illustration. Balzac's *Droll Tales* illustrated by Gustave Dore, which Lily gave him for Christmas in 1907, reinforced his convictions. At the same time Ernst Sonderegger introduced him to Daumier's caricatures and James Ensor's work. The influence of the latter is obvious in the drawings that he did for his childhood friend, Hans Bloesch's satirical epic poem entitled *Musterburger*.

A 1908 drawing, *Women and Children in the*

Country, shows a high degree of spontaneous abstraction. The simplification of contours and the staggering of forms with regard to the central figure, resulting directly from the arbitrariness of spontaneous drawing, are reminiscent of some of Picasso's cubist compositions done at the same time.

The interior form of the figures and the play of light on the body will become more and more important to him, and under the influence of Ensor and Van Gogh, the firm contours will dissolve into little hachure marks. The "impressionist" language of forms, as Klee saw it, constituted a first graphic decomposition according to the phenomenon of pale and somber, light and dark, in short, of tonality. The technique of vacillating hachures was no longer enough for the demands of a pictorial conception of light. Klee perfected a technique of "black watercolor" in his paintings on glass, and in his *Journal* he explained their method: "By means of a first layer I sparingly put down the principal places of light in white. This distinctly light gray layer has on its own a perfectly reasonable effect because it appears very somber against the white. Then, as soon as I sparingly put down a second layer on the first dry one, making again the slightest marks, I considerably enrich the painting and establish once again a rational development. Naturally, the earlier sparingly put down marks remain intact during the course of the elaboration. I progress in this way, keeping this 'chronographic' dosage as fundamental to the tonality."

The 1909 drawings of "grainy marks," like *A Sick Girl Visited by some Friends*, constituted a development of this technique of black watercolor. Klee noted in his *Journal* in 1909 some thoughts concerning the discipline that the artist has to impose on himself in the face of "nature's prolixity" if he is to arrive at an economy of expression, which however, for Klee himself was only completely successful in his works of the last years. "While nature can be extravagant in all things, the artist has to be economical in the smallest of things. Nature is eloquent to a point

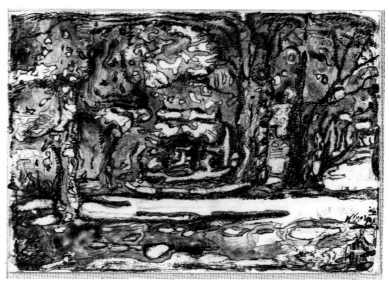

24. WALDEGG FOREST PATH
(GEPFLEGTER, WALDWEG, WALDEGG BEI BERN)
1909/16 (B) – Black and white India ink watercolor on glass,
12.9 × 17.8 cm
Paul Klee Foundation, Kunstmuseum, Bern.

of verbosity; let the artist be discreetly wise. Besides, it is essential as a preliminary to not elaborate a definitive pictorial impression, but to devote oneself totally to the part that gradually becomes a larger piece to paint. The impression of the whole bases itself on an evaluation of economy, which consists of setting out again the effect of the whole on a restricted gradation.

"Everything depends on will and discipline. From discipline comes the whole work, from will the parts of the work. Will and ability are one, knowing neither power nor desire. The work is done then by starting with its parts, aiming by virtue of discipline for the whole."

His first one-person exhibition, with fifty-six works, was shown in April 1910 at the Bern Museum, in October at the Zurich Museum of Art, and at the Winterthur Show and the Basel Museum of Art in January 1911.

That year Hans Arp, Walter Helbing, and Oskar Luthy founded the "Moderne Bund" and organized two shows with Klee, one in December 1911 in Lucerne and the other in 1912 in Zurich.

On November 1, 1910, the organizers of the Winterthur show wrote to Klee: "Your works have been on show here since October 15, and we feel compelled to state that during that time the majority of the public have delivered a highly unfavorable critique of them. Various well known and highly placed people want us to take them down. We would like you to be kind enough to tell us what you want done; perhaps you could send us some explanations to go with the show for visitors to the exhibition. While waiting for your kind reply . . ."

Klee replied: "Very honored sir, your embarrassment is without doubt regrettable in itself. But in

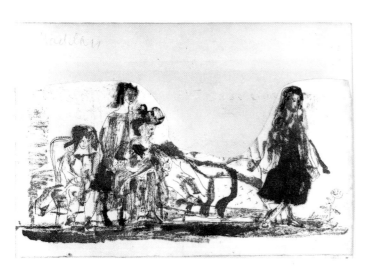

23. A SICK GIRL VISITED BY SOME FRIENDS. FIVE FIGURES
(EIN KRANKES MÄDCHEN EMPFÄNGT DEN BESUCH EINIGER FREUNDINNEN.
FÜNF FIGUREN) 1909/11 (A) – Brush and pen and India ink, 16.9 × 31.5 cm
Paul Klee Foundation, Kunstmuseum, Bern.

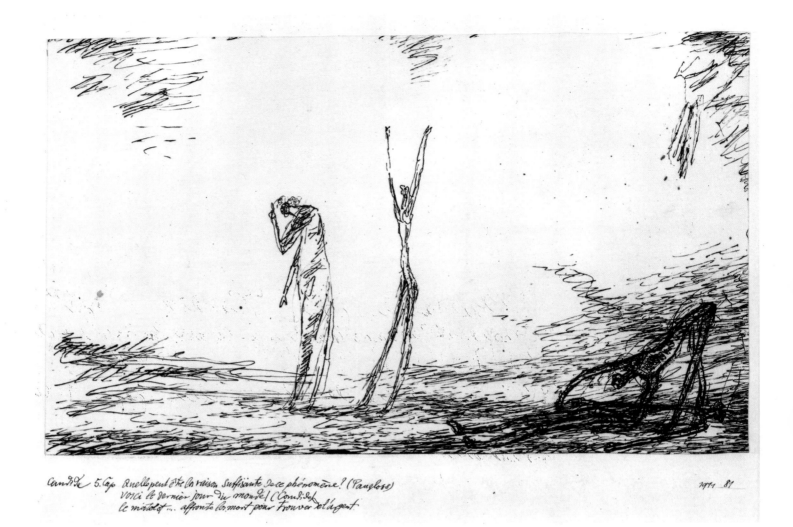

Candide 5. Cap Quelle peut être la raison suffisante de ce phénomène? (Pangloss)
voici le dernier jour du monde/ (Candide)
le matelot... affronte la mort pour trouver de l'agent

1911 81

your capacity of expert you cannot ignore the fact that, from time to time, good artists do happen to find themselves in conflict with the public. Without wanting to compare myself to whomsoever, I allow myself only to cite the well-known Hodler, who right now is doing very well despite the hostility that was directed against him. An artist who, independent to the production of his works, would furnish explanations of them, would in my view give proof of extremely mediocre confidence. Explanations are the role of the critic, and I enclose for your perusal a review by Trog, which appeared in the *Zurich Gazette* on October 30, 1910."

In general, the works shown by Klee and his friends were disapproved of by the majority of viewers, and their artistic renewal was seen as that which upset religious, moral, and national values. In defense, the artists put forward the right to subjective feeling, victory over materialism, and pure and irrational construction.

25 & 26 In January 1906, Klee mentions *Candide* for the first time in his *Journal*, but the twenty-six pen and Chinese ink drawings that will illustrate it will not be done until 1911–1912. These are then the result of long reflection on drawing and the illustrator's pro-

fession. On October 7, 1909, he wrote to Lily: "I have perfected my technique as an illustrator." His friend Sonderegger had offered him Sterne's *Sentimental Journey*, but Klee had preferred Voltaire's stories: "There is a superior element in *Candide* that seduces me; Voltaire's language is characterized by a preciously economic use of just the right words." The spiritual arabesques of the story's characters and their intertwined adventures are brought to life in these sinuous figures by a knowledgeable twisting of their features. As in the story, the slim puppet characters are practically reduced to signs. Saturated with "repugnant models," Klee found in them a skeleton that was rich and supple enough to permit all possible variations. Admired by his friends and proposed to various publishers, these illustrations of *Candide* were not published until 1920 by Wolff.

Illustration makes the painter a mediator of poetic content, which is renewed by its plastic representation. But it also elicits his personal interpretation of the poetic universe proposed and gives rise to a secret relationship between poetry and the plastic arts. In this sense, illustrating *Candide* was a challenging enterprise for Klee and it took several years for him to complete. The text became so familiar to him that

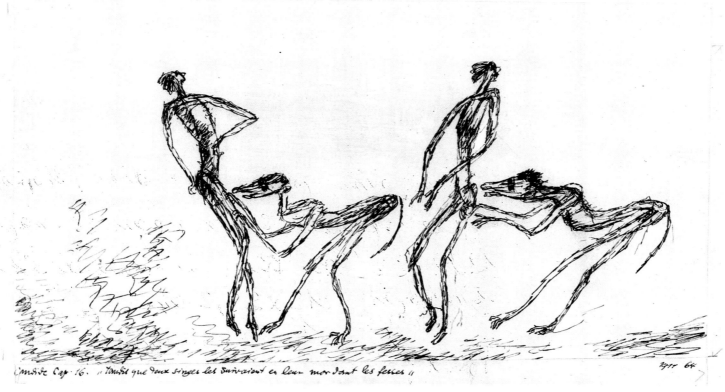

Candide Cap. 16. "Tandis que deux singes les suivaient en leur mordant les fesses"

2711 64

25. ILLUSTRATION FOR *CANDIDE*, CHAPTER 5
"WHAT COULD BE THE CAUSE OF THIS PHENOMENON? . . ."
1911/81 (A) – Pen and India ink on paper, 13.7 × 22.2 cm

26. ILLUSTRATION FOR *CANDIDE*, CHAPTER 16
"WHILE TWO MONKEYS FOLLOWED THEM BITING AT THEIR BACKSIDES"
1911/64 (A) – Pen and India ink on paper, 12.7 × 23.6 cm
Paul Klee Foundation, Kunstmuseum, Bern.

he remarked in his *Journal*: "I am discovering myself again." Beyond the art of the illusionist, as much figurative as spatial, the principal role fell to the line, the most abstract and spiritually expressive graphics medium, which seemed to him the essential way to visually transmit in a stenographic way the black humor and the acerbic Voltairian wit.

The year 1911 was a promising year: Klee met up with Kandinsky again and became aquainted with Macke, Marc, Jawlensky, Arp, Kubin, Campendonk, and Gabrele Munter. He saw the Blaue Reiter exhibition, which showed forty-three paintings. Among the artists were Henri Rousseau (Le Douanier) and Robert Delaunay to whom he was particularly attracted; he participated in the second Blaue Reiter drawing exhibition, which was held at the Goltz gallery in 1912.

In the autumn of 1911, Klee noted in his *Journal*: "This Kandinsky wants to gather together a new community of artists. On meeting him personally, I am much taken by him. He is definitely someone, has an exceptionally beautiful head, and is lucid. We first met at the café where Amiet and his wife are often to be found. Then we agreed on the tram to meet more often. During the course of the winter, I

associated myself with his group, the 'Blue Horseman.'"

In January 1909, in fact, Kandinsky and Marc had founded the New Association of Munich Artists (Neue Kunstlervereinigung) around a German core (Kubin, Kanoldt, Hofer, Gabriele, and Munter), with some French like Le Fauconnier, and some Russians like Denissoff and the Burliuk brothers. In December 1909, they organized the group's first exhibition at the Thanhauser gallery. Klee participated in the second show in February 1912, showing his "poetic watercolors" next to the graphic works of Arp, Braque, Gontcharova, Larionov, Malevitch, Nolde, Pechstein, Picasso, Kubin, Kandinsky, Marc, and Munterm, as well as popular Russian woodcuts. At the same time the Blaue Reiter's *Almanac*, which became the reference catalogue for a collective sensibility from which many 20th-century art sources originate, was produced. "Traditions are fine things," wrote Franz Marc, "but what is beautiful is to create a tradition and not to live by one." No aesthetic rule was formulated; there was only their hatred of academics, their renunciation of exterior nature, and their faith in what Kandinsky called the "interior necessity."

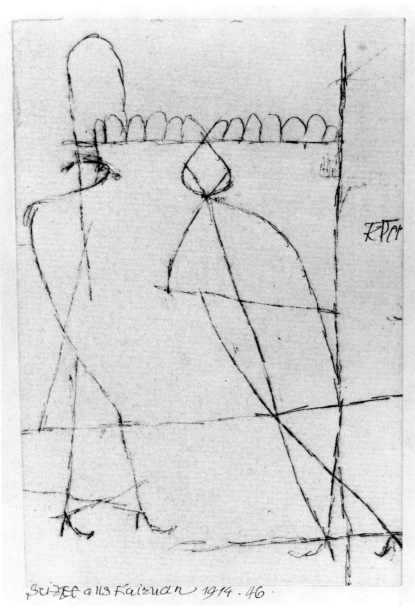

Suzec aus Kairuan 1914.46.

27. SKETCH OF KAIROUAN
(SKIZZE AUS KAIROUAN)
1914/46 – Pen and India ink on paper mounted on cardboard, 15.8 × 10.5 cm
Paul Klee Foundation, Kunstmuseum, Bern.

In Klee's career, 1911 marked a turning point, for, working until then in relative isolation, he at last met the artists who were showing in Munich. His friend Alfred Kubin greatly encouraged him, and his childhood friend, Louis Moilliet, introduced him to Auguste Macke, Kandinsky, and Franz Marc just before the famous December Blaue Reiter show. Felix Klee writes on this subject: "At this time the artistic atmosphere in Munich was extraordinary. The history of art justly gives it prominence today. The "Blue Horseman" after long wandering, is erected in a bronze monument facing the world. The two great columns that support it are Franz Marc and Wassily Kandinsky. The two painters were part of a very restricted little circle who were friends of my parents. (. . .) Uncle Kandinsky fascinated me particularly,

and when I was too noisy in our little house, I was sent to number 36 (Ainmiller road) where I played at painting with Wassily."

When Klee became associated with the Blaue Reiter, his apprenticeship as a painter came to an end. In Kandinsky's and Macke's work, he found clear confirmation of his own artistic ideal, which depended on a strong inner life. Klee considered the elder Kandinsky as much friend as teacher, and his friendship with Franz Marc was one of the most important he ever had. Thanks to the Blaue Reiter, Munich became a place where the French, Italian, and Russian avantgarde could be seen.

Klee did not interpret the poetic enthusiasm of the Blaue Reiter through abstraction. Lessing's critical observations of *Laocoön* introduced the idea of figuration specifically stating that the gestalt had to be formed according to concepts fundamentally different from those of Kandinsky's "interior necessity." It is possible that Klee's historic meeting with the Blaue Reiter was also the occasion for his break with Expressionism. In 1916 he confessed: "My ardor is more like that of the dead or the unborn. My art is probably wanting because I do not have a kind of passionate humanity. I do not love all animals and humans by and large. I do not descend to them, nor do I raise them to myself. I tend rather to dissolve into the whole of creation and then find myself on a fraternal level in relation to everything terrestrial. The earthly then gives way to the heavenly. My love is distant and religious.

"I have no Faustian tendencies. I put myself at a remote starting point of creation from which I presuppose the formulas for mankind, animals, vegetables, minerals, and the elements, and for all the cyclical forces in general. Thousands of questions cease, as if they had been resolved. Neither doctrine nor heresy exist there. The possibilities are infinite, and faith in them lives creatively in me."

A comparison of these two passages from his Diary shows clearly the dialectic with which Klee linked his position vis-à-vis Expressionism and the Blaue Reiter.

From April 2 to 18 in 1912, Klee made a second trip to Paris, where he really discovered modern art. Wilhelm Uhde, Henri Rousseau, Braque, and Picasso; Derain and Vlaminck at Kahnweiler's gallery, and Matisse at the younger Bernheim's. But his most important encounter was with Robert Delaunay. The critic, San Lazzaro, had this to say of the event: "These three hours multiplied many times for him in that they freed him from his doubts and gained years in time for him." His admiration for Delaunay was so great that he translated his work on light and published it the following year in the *Sturm*.

From then on it seemed as if Klee had suddenly received a new sensibility. The crystallization of his remarkable creative intuition as a painter had com-

menced, wherein incidences, flukes, and events came together, pushing him toward more clarity, mystery, and truth, and always more magic. A most formidable combination of contrasts for anyone to have taken upon themselves.

27 The first of these decisive elements was, without any doubt, his trip to Tunis in April 1914 with Auguste Macke and Louis Moilliet who already knew the country. They were met at the port by Moilliet's friend, Doctor Jaggi. For Klee, it was a revelation: He was overcome by intense excitement and began im-
69– mediately to paint in watercolor. The doctor took
80 them first to the sea and then to his property in the Saint-Germain suburb at Sidi Bou Said, then to Carthage, Hammamet, and, most particularly, to Kairwan, the town with hundreds of mosques. On the day following his arrival, Klee noted in his Diary: "My head is full of impressions from last night. Art — nature — self. Getting immediately to work I painted in watercolor in the Arab quarter. I synthesized urban architecture with pictorial architecture. Not yet pure, but an effort full of charm in which the atmosphere and my euphoria mingled. Later, I will no doubt become more objective when my excitement wears off a bit."

On April 16, at Kairwan: "This morning, painted facing the town in a gently diffused light, clear but soft at the same time. (. . .) A happy moment. Louis pointed out to me several beautifully colored delicacies, and left them for me to capture. I have stopped working now. The atmosphere penetrates me with so much sweetness that without having to make any effort I am becoming more and more confident. I am possessed by the color here. There is no need to pursue it. I will always be possessed by it, I know. That is what the meaning of this happy moment is: Color and I are one. I am a painter." There was no more need for pomposity; Paul Klee had finally found his road to Damascus.

He later considered this short Tunisian sojourn as the most important stage in his career. He discovered there that really strong light can give volume to a surface and transform the ground into line. He stored away a host of memories and images and allowed them to germinate. He thought deeply about color and its function. At first, he gave it the role of
73 defining the form (*Hammamet Motif*), but then, in the house in Saint-Germain, he prefigured in his geometrical groupings his later magical squares. He understood very quickly the value of each element of the work making up his plastic grammar, elements that he later called the formal givens of the varying extensions of lines and the tonalities of light, shade, and color.

Nearing 1914, it was not the idea of romanticism that was a decidedly new element in his style, but rather the revelation that the pathos of our fundamental disposition to the tragic must be made sublime by using a coded way of working. The apparition of the tragic must remain remote; the hero in ruin, becomes by means of abstraction, a symbol, a puppet, a shadow, or a sign that is nonfigurative but full of meaning.

The war, which started on August 1, 1914, took his friends away from him. On September 26, August Macke fell in Champagne, and on March 4, 1916, Franz Marc was killed at Verdun. Kandinsky and Jawlensky, who were Russian, left Germany. A brief happy interlude during these dark years was a visit from the poet Rainer Maria Rilke in 1915. Klee showed him his Tunisian watercolors, of which Rilke said later: "They attracted and intrigued me a lot, but most particularly in the way that one could still see in them the Kairwan that I knew. During the war years I often had this impression of seeing objects disappear . . . shattered beings are perhaps best represented by fragments, debris."

Klee returned the visit to Rilke and his girlfriend Lou Albert-Lasard who said of it: "A completely different note was brought into the house by the painter Klee. Sweet, calm, and introspective, he sometimes played the violin for us on our terrace under the moon. This delighted us as much as the beautiful watercolors that he left for us to contemplate during the succeeding months. It is perhaps because of his long contact with these works that Rilke began to understand modern art; although I don't know whether it was the purely lyrical and romantic side of Klee that he responded to more than the subtle musical sense, which is as present in his painting as in his playing."

Being past the age of active service, Klee was only drafted to the German land forces in March 1916. In 1915, he painted in oil on different surfaces little used for this purpose — jute, linen, and muslin —that he primed himself with plaster or chalk. The medium for his watercolors, temperas, or drawings, was cardboard and paper of different coarse grains, that he also sometimes prepared. He noted apropos these works: "The cold romanticism of this style without pathos is unknown. The more terrible this world, the more abstract our art; whereas a happy world produces an art focused on the here and now."

The term "abstract" necessitates being more specific. It is not a question here of the dissolution of the subject like in Kandinsky's or Mondrian's work. Klee is not looking for the nonfigurative, but rather for the process of the effect of alienation from the real to the abstract. In his world, abstraction signified a position in opposition to humor. He placed himself in a way above things, looking into the distance and not, like in the satires, toward this side of something.

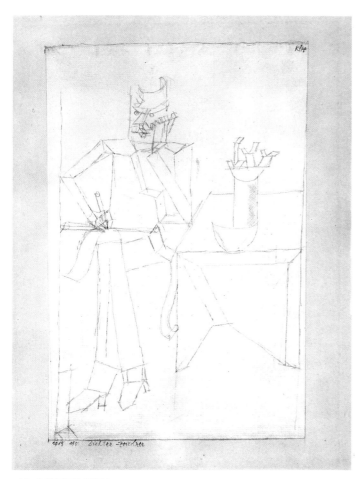

28. POET-DRAWER
(DICHTER-ZEICHNER)
1915/195 – Pencil on Ingres paper glued on cardboard, 24 × 15.4 cm
Paul Klee Foundation, Kunstmuseum, Bern.

"The further away I am, the more saintly I become. Part of joy reigns always on this side. These are the hues in the work."

In response to the "terrible world" of the war years, more abstract forms emerged in his work. During this uncertain period, he stopped the constant questioning of his creations; they were good enough to stand for themselves.

28 In a 1915 drawing, Klee described himself, using Cubist terminology, as a "poet-drawer" (Dichter-Zeichner). Writing verse and drawing, the artist is seated near a table. He does not look at the exterior objects — the still life on the table — but looks rather, inside himself, as if he wants to transcribe his mental images directly onto the drawing.

Felix Klee writes: "My earliest memory of him goes back to 1912. That year we spent our holidays at Beatenberg, on the Thoune lake, at the Beau-Sejour hotel, which belonged to my great-aunt Louise. When it was time to go back to Bern, the whole family walked along the road that went to the main railway station. On the way a snake crossed the dusty path. Holding our breath, we all stopped to admire the undulating traces. The animal disappeared into a thicket on the side of the road. When we continued on our way, I saw Klee turn back several times in a very considered way. I asked him why. 'There are snakes,' my father answered, 'who bite their tails so that, rolling along like a child's hoop, they can follow people. I turned round a few times to see if that snake was going to follow us.'

"At the beginning of 1916, Klee began to make me puppets. In all, up until 1925, he created fifty puppets for my 'theater,' and thirty of them still exist to this day. Klee watched carefully over my drawing and painting efforts. He kept everything I produced then 'mounted' my works with the same care as his own and wrote the title I told him on them.

"I often watched Klee as he worked in the kitchen, preparing his etchings, stirring the pots, painting or drawing, and in the evening I listened to him play his violin with great expertise. The apartment at Ainmillerstrasse 32, on the second floor of the building at the back, had three little rooms: the 'living room,' the bedroom for us three, and the music room, which was a little bigger. Lily gave her piano lessons there, and almost every evening my parents would play sonatas there. Was it modern music? Oh no! Only Bach, Handel, Haydn, Mozart, Beethoven and Schumann. The apartment was only heated by a stove and had gas lighting. To go to the bathroom, which contained a good selection of books and a bath heated by wood, there was a long dark corridor and then a passage as long again; there was also a maid's room that was used as a guest room, a big kitchen where my father worked, and a big balcony that doubled as a refrigerator in winter.

"Twice a year there was a fair in Munich. There were merry-go-rounds and shooting galleries, and, best of all, a puppet theater where my father would leave me with lots of money in my pocket so that he peacefully could go to the flea market where he bought old frames with paintings or photographs in them for two marks each. After two hours of a wonderfully Bavarian performance with Kasperl, Death and the Devil, Klee would, alas, arrive to fetch me. On the way back home I would help him carry the frames.

"Klee would also often stop his work and sit himself down with the cat Fripouille and his pipe in front of my puppet theater. He was the only spectator, and he took great delight in the vigorous popular scenes that I performed for him. Besides the puppets, Klee also built me sets, for example, a flourishing village that was a kind of collage and was dominated by a bell tower. Today, I often say to myself that more than an echo of these relaxing hours can be found in his marvelous works.

"Sometimes I had to accompany him on his peregrinations and help him carry his painting equipment. We went to the cemetery in the North, to Aumeister, or

to the Wurm canal at Milbertshofen. Klee made me boats that I could put on the water; I also remember very well the superb station with rooms, signs, windows, and shuntings that he assembled for me out of bits of cardboard. When I was older, my mother often told me about my tricks and discoveries. There was a drawing that I entitled 'Uncle Fritz.' But there was only an empty room on the paper. 'Where then,' asked Klee, 'is Uncle Fritz?' My reply was: 'Well, he must have left the room.' Another time, he saw me on Friedrichstrasse. I was a train going full steam ahead to meet him. He opened his arms wide to stop me, but my reaction was: 'Don't touch me I'm burning hot.'"

The excitement over Dadaism seemed a priori, foreign to Klee's harmonious world. However, from March 1917, Zurich's leading lights of the Voltaire tavern, including Kandinsky and de Chirico, claimed Klee as one of their, in Hans Richter's words, "spiritual ancestors." "Klee's work seemed in effect," declared Hans Richter, "to show the way to the Elysian fields that we could only see in the distance." Hugo Ball, notably, revered his work and showed it when the Dada gallery opened in Zurich in March 1917. On March 31, the art historian Waldemar Jollos gave a lecture there on Klee, and an exhibition that he had there in May was considered by Marcel Janco as, "the big event of the Dada Gallery." Janco also said: "We saw in his beautiful work the reflection of all our efforts to interpret the soul of primitive mankind, the plunging into the unconscious and the forces of spontaneous creation in order to discover the immediate and pure sources of the child's creativity."

Klee's materials and techniques correspond more closely to those of a folk artist rather than an academic. From 1914, he combined colors, collages, and mixtures, which, despite the explanations given in his own catalogue, still offer much to analyze. The oil and watercolors are applied on bases of plaster/gypsum, chalk, and encaustic. Besides the paper and linen canvas that he bought, he also used as surfaces wrapping paper, cotton remainders and — during war time — aeroplane canvas. Klee never used collage as a means in itself like the glued Cubist papers. However, he often worked with sheets or strips of glued paper that determined the size and structure of his compositions, and he used scissors to reduce or modify them.

His capacity to produce magical effects with the most ordinary materials set the tone of his exhibition at the Dada gallery. At the same time as it, there was an exhibition called "Graphics. Embroidery. Relief.," which showed works by Africans and children, side by side with Klee and the Dadaists works, illustrating the Dadaists' scorn for the traditional Western infat-

uation for high art. Sophie Taeuber's colored threads were there, as well as Marcel Janco's montages and Arp's reliefs. The latter developed his colleagues' primitive thought by taking nature for his model.

In Klee's own aesthetic, nature played a fundamental role. His close relationship with nature is present not only in the theme of his work but in his conception of the creative process as well. In 1923, Klee put down his principles in "Wege des Naturstudiums" ("Ways of Studying Nature"): "The dialogue with nature remains for the artist a sine qua non condition. The artist is a human; he is nature itself, a piece of nature in nature's space." In his Diary of 1917, Hugo Ball demonstrates how well he grasped Klee's microcosmic vision of the universe: "In this period of the colossal, he falls in love with a green leaf, a little star, the wing of a butterfly, and as the sky and infinity are reflected in them, he paints them in harmony."

Until his demobilization in 1919, Klee continued to paint with unbelievable and marvelous diversity.

29. CASTLE IN THE AIR
(LUFTSCHLOSS)
1922/42 – Oil and gypsum on cardboard, 62.6 × 40.7 cm
Herman and Margrit Rupf Collection, Kunstmuseum, Bern.

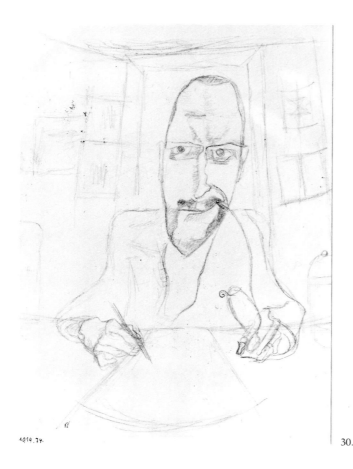

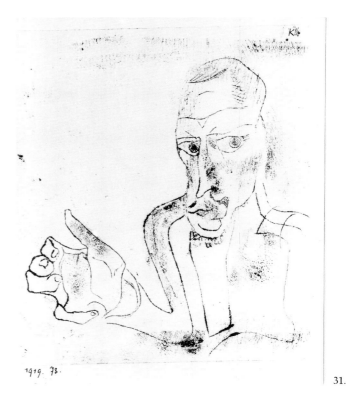

30. ARTIST AT WORK, SELF-PORTRAIT
 (FORMENDER KÜNSTLER, SELBSTBILDNIS)
 1919/74 – Pencil on writing paper, 27.1 × 19.5 cm
 Private collection, Switzerland.

31. ARTIST DELIBERATING (SELF-PORTRAIT)
 (ABWÄGENDER KÜNSTLER)
 1919/73 – Original on tracing paper, 25.6 × 18 cm
 Private collection, Switzerland.

32. MEDITATION – SELF-PORTRAIT
 (VERSUNKENHEIT SELBSTBILDNIS EINES EXPRESSIONISTEN)
 1919/113 – Lithograph, 25.6 × 18 cm
 Private collection, Switzerland.

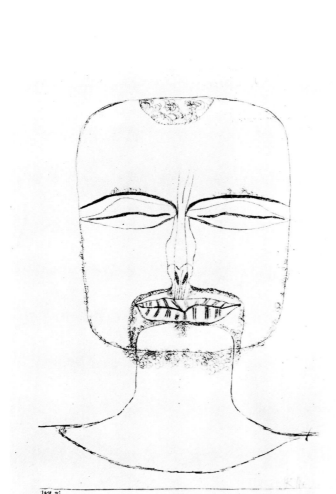

The King of Bavaria, a worthy descendant of Louis II and a protector of artists, spared him from the trenches, and Klee was sent successively to Landshut and Schleissheim, where he painted the fuselages of planes, then to Gersthofen. All the themes/ideas that were later expanded, appeared in the works of this period. Color in particular has multiple uses in his drawings. The colored whites seem to vibrate, almost as if the color is the expression of an internal force.

There were numerous themes: ideograms, interlacing of angular lines, the symbolism of the open circle, the disproportionate eye, and the arrangement in tiers or sustentation of the figures in space . . . He was not merely looking for some new techniques, but rather, new forms that would enable us to more forcefully participate in a world in a state of perpetual becoming.

From the time of the armistice in 1918 till the beginning of 1919, Klee did six illustrations for Curt Corrinth's *Postdamer Platz oder die Nachte des Neuen Messias.* He translated the ecstatic visions of the expressionist author into a bizarre fabric of animated lines that expressed the frenetic tension of the Prussian town, the excess of cynicism and the

erotic banter of the novel. In his introduction to the illustrated edition of 1922, Eckart van Sydow went as far as to say that Klee's drawings "illuminated the reality of a burning eroticism."

30–
32

The year 1919 was crucial for him, and through deep introspection, he decided to do a number of self-portraits, nine in total, which was unusual for him. However, he did not call them self-portraits, even though all bore his features or clearly referred to his person. He was affected by a number of external events in this year of regained peace, but only peripherally. All the self-portraits clearly show his thought process and express an interior necessity. In nearly all of them, Klee defines himself creatively and details his conception of art as the result of certain conceptual processes. In several works he used sexual metaphors, carrying them through to numerous subsequent works, to explain his philosophy of creation.

"In 1919," says Felix, "Klee had his studio in the little baroque Werneck castle. His neighbors there were Lahusen, the composer, and Hans Reichel, the painter, who hid Ernst Toller in an outhouse after the 'Raterepublik.'"

In 1920 Klee saw a turning point in his career: He signed a contract for three years with Goltz and showed 362 works in his Munich gallery; Casimir Edschmid published his "Creative Confession" in his Berlin review and Kurt Wolff, the Munich publisher, at last published *Candide* with the illustrations he'd done in 1911; Hans von Wedderkop and Leopold Zahn each did a monograph on him, and most importantly, he was invited, on November 25, by Gropius, unanimously backed by the Bauhaus teachers, to Weimar.

1921–1930 — The Bauhaus teaching experiment

Brought into existence by a republican majority and ended by the Nazis, Bauhaus coincided with the beginning and end of the first German Republic of Weimar. Paradoxically, this most modern institution was situated in two old princely houses.

The Bauhaus aim was to reestablish harmony between all the different art-related activities, creating solidarity between artisanal and artistic disciplines through a new conception of building. The inaugural manifesto states: "We want to create a new corporate body of artisans without the high barrier of class that presently exists between artisans and artists. We have to want, imagine, and design together the new building of the future, which will harmoniously unite architecture, sculpture, and painting; this building, built by the hands of thousands of workers, will rise into the sky, a crystalline emblem of new faith in the future. (. . .) Our final aim, though it is

still distant, is the unitary work of art, the Great Work, where there will not be any distinction between monumental and decorative art."

Bauhaus was meant to be both an academy of fine arts and a school at university level; a complete and largely spiritually oriented teaching center of artistic culture. The open form given to Bauhaus by Gropius arose naturally from his own openness of mind. Provided that it was realizable, all creative initiative was immediately adopted, and the program accordingly changed. The atmosphere of creative freedom was experienced by both teachers and students.

If Gropius had yielded to the opinion of the art critics, he would have had Expressionist painters like Nolde or Kokoschka at the Bauhaus, as well as the Brucke painters who were very well known at the time. But Gropius employed painters like Klee and Kandinsky, whose names and work were only known within a small circle of admirers, and whose reputations, even though today incontestable, had at that time barely crossed the German border.

We often talk about the Bauhaus painters, but they were not a group with a definite program. All the Bauhaus teachers were equally independent as artists and as men. The teachers taught only their own style to their pupils, and in the teaching, the same weight was given to the "objective existence of the elements of form and color," as to the laws that govern them.

Painting was only important at Bauhaus in liaison with architecture. However, pure painting always had its partisans among the students, who were given the chance to exhibit, and Kandinsky, Klee, and Feininger were always ready to advise and help them. The teaching of form thus took on a very particular reality, simply because (parallel with painting) it came from the same geometric forms that Kandinsky and Klee used in lyrical, romantic, or ironic ways in their work. "Point, Line, Plan" (*Punkt und Linie zu Flache*) and "Thoughts on Painting" (*Das Bildnerische Denken*) were a synthesis of their Bauhaus teaching and writings about the underlying principles of art.

In fourteen years the Teutonic knights of functionalism invented the style of the 20th century. It is all there: environment, accumulation, op art, kinetic art, action abstraction, assemblage, light machines . . . Thanks to Lily Klee, the essays and manuscripts dating from this period have been published in two volumes entitled respectively *Thoughts on Creativity* and *Infinite Natural History*. Klee, his classes an obligatory part of the curriculum in the second semester, taught at the Bauhaus from 1920 to 1931. His aims were to get his pupils to look inward and to help them realize their creative potential. "We must be content to fulfill our destiny . . . I want to portray controllable realities; therefore, I listen to my inner voice."

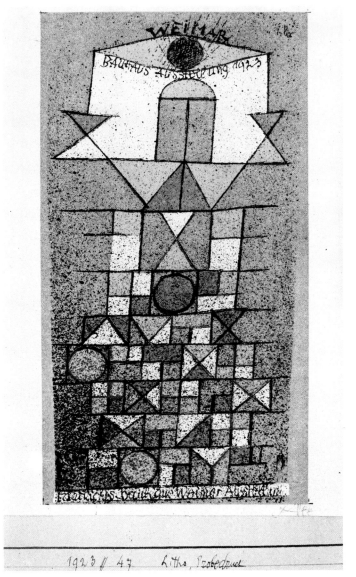

33. THE SERIOUS SIDE (WEIMAR BAUHAUS)
(DIE ERHABENE SEITE)
1923/47 – Lithograph, 16.7 × 7.5 cm
Private collection, Switzerland.

His teaching of seven to eight hours a week was divided between various two-hour theory lessons and practical work done in the afternoon. "His course had nothing scholarly about it in the narrow sense of the term," one of his students remarked. "What he did was to disclose to his students the immense world of his ideas and personal experiences." The main goal of his teaching was to locate the living element in a composition and to depict it with a sketch that retained the main fundamental lines of the figure's order.

"Education," emphasized Klee, "is a difficult subject, the most difficult of all subjects, specially when it is a question of an artist's education. Even if we present it as an applied method, if one supposes a priori the existence of a great number of educators worthy of this name, it is nevertheless true that most

of them would hold to the visible domain because they don't need anything more. Rare are those who get to the bottom of the problem and who begin truly to create. We hang onto theories because life frightens us, because we dread insecurity."

What did he teach? That art cannot be taught and that it is necessary to give up running after it with regard to either matter, codified methods, or preestablished vision. Scorning all prescriptions, Klee confesses in the "Creative Credo" of his Jena conference, that he wants to put himself at the origin of things, at the source of creation, "there where I can find," he says, "the formulas that represent, at one and the same time, man, beast, plant and mineral . . . and all the other whirling forces of the world." For what is the world to the artist? A huge natural opera wherein everything — twigs, birds, human beings, and planets — have the same value. The verve, inventiveness and richness of such an enchanted, humorous, and mystical universe, has to be rediscovered by rivaling of nature and fostering in a work of art all possible interferences, from the microscopic to the sidereal, and from things in transformation to those in suspension.

The painter remained a poet, and the profession of faith engraved on his tomb transports the romantic Germans back to Pantheism. It goes back to Hoffmannsthal, Novalis, Nerval — to the cosmic supernatural lyricism equally present in the works of Ernst Junger, who, before becoming "flower, animal, stone, star," wanted to combine botany with imagination, savagery with intellectualism, bizarreness with mathematics, and mystery with the meticulousness of a "good Bavarian housekeeper."

The interplay of the forces that have created the world should be imitated, says Klee, "as the child in his games imitates adults"; becoming one, therefore, with the impulse that is at the origin of life and the springing forth of creation; that equals finding again "the organizing/organized laws of painting from which it develops automatically into new types/designs . . . and attaining, beyond form, the very mystery of being."

In order to arrive there the artist has two processes of autonomous expression, two productive forces of form that function, so to speak, by themselves, and it is enough to let oneself be carried along by them. The one is called line, the other color.

What is line? "A living independent force that feels its way, determines, and defines itself by its movement in space. Line is the very principal of organic life. It has to be followed and seized in all the material structures that Nature presents: 'human tissue, bony substances, muscle cords,' and incorporated with its action, its progression, and its three dimensional work of constitution when it becomes surface and volume."

In his book on The Fold, Gilles Deluze begins the chapter entitled "Folds in the Soul," in this way: "The ideal genetic element of the variable curve, or fold, is inflection; inflection is the true atom, the point of elasticity. Inflection is what Klee defines as the genetic element of the active spontaneous line, showing thus his affinity with the Baroque and Leibniz and his opposition to Cartesian Kandinsky for whom angles and points are hard, brought into movement by an exterior force. But for Klee the point as a 'nonconceptual concept of noncontradiction,' goes through an inflection. It is the point of inflection itself, the place where the tangent crosses the curve. It is the folded point. Klee begins with three succeeding forms. The first draws the inflection. The second shows that the form, as Leibniz said, is not exact or pure, 'there is nothing straight that does not have curves intermingled through it,' but there is also no 'curve of a particular finite nature that does not have something else mixed in as well, in its smallest as well as largest parts,' so that one 'could never give any body a certain and precise surface in the way one would be able to if it were atoms.' The third shades the convex side, highlighting the concavity at its curve's center and changing from one side to the other at the point of inflection."

All Klee's exegetes concur with this theory of line, considered the deus ex machina of the discovery and plastic creation of such a revolutionary nature. We have to remember though, that the Bauhaus was a school of applied arts where Klee taught theory, glass painting, and tapestry. As a teacher of decorative art, he expressed himself very simply to his students, anxious to teach them the most original linear combinations.

But perhaps before Klee, no one had ever let a "line dream" as Michaux puts it. The beginning of the decided upon line establishes a particular plane or linear style, a certain way for the line to be and make itself a line, "to become a line." With regard to it, all inflection that follows will have a diacritical value, a connection to the line itself, it will create an adventure, a story, and a sense of the line, according with which it will deviate a lot or a little, quickly or slowly, and more or less subtly. As it continues on its way along its length, gnawing meanwhile at prosaic space, it develops a way of actively extending itself that underlies the spatiality of a thing, be it an apple tree or a human. Put simply, to give a man a generating axis, the painter "would need a network of lines so tangled that the question of a truly elementary representation would no longer apply," says Klee. Alberto Giacometti's paintings are a good illustration of this. Whether he decides like Klee, to hold firmly to the principal of the genesis of the visible, to fundamental and indirect, or absolute painting, as Klee called it — giving the title the task of designating the constructed being so as to let the painting function more purely as painting — or decides, on the contrary, that like Matisse in his drawings, he can put in a single line and prosaically draw attention to the being and the dull process that denotes softness or inertia and the force that constitutes a nude, a face or flower, does not mean they are so different. There are two holly leaves that Klee painted in a totally figurative way, which at first are completely indecipherable and which always appear unbelievable and phantasmal because of their exactitude. And Matisse's women, which were so criticized by his contemporaries, were not instantly visible: Matisse taught us to see their features, not optically, but as nervure, the axes of a system of active and passive sensuality. Figurative or not, the line in all cases is no longer an imitation of things or a thing. It is a kind of imbalance worked into the inertness of the paper.

Then Klee discovered the value of color. "The meaning of symbolic forces have to be found again," he writes, "that is, the reciprocal integration of mountain, air, and water." How to do this? By trusting the dynamic efficacy of color. With this sentence Klee defined, before the event, his real genius as the most inventive and refined colorist of his generation. Klee thought, like Cezanne, that Nature "is not exterior but interior," and that the colors on the painting's surface have to be the expression of that internal force.

34. EXTRACT FROM "THOUGHTS ON CREATIVITY" p. 105
 THE ACTIVE LINE

Dynamic movement. The point in a dynamic visual angle, considered as the agent.

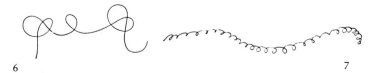

1

Simple linear movement founded/lying on itself. Freely drawn line a-b [1].

Free line a-b, accompanying line a-b. (The figure 1 melody is accompanying) [2, 3, 4, 5].

2 3

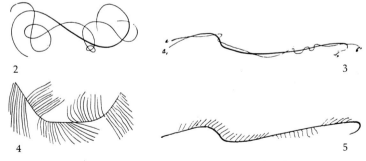

4 5

Freely drawn line based on a construction of meanders and angles [6, 7, 8, 9].

6 7

It was up to Klee, in his teachings at the Bauhaus and then at the Dusseldorf Academy, to prove the merits of a vitalist and transformist doctrine in which true plastic creation was defined as the fruit of a kind of spontaneous generation, or parthenogenesis, brought about by the artist's intervention. He put forward, as a symbol of artistic creation, the image of a tree that, rooted in the soil, grows, branches out, and flowers as a result of celestial yearning.

What is the artist's role?

He compared the artist to the trunk of a tree that "welcomes the sap from below," transmitting it from low to high, as an intermediary who is neither master nor servant, but who, contrary to the Surrealist doctrine, remains aware of his function and has to give proof of certain technical mastery.

Does this fortuitous genesis, inherited from the great German current of romanticism that later turned into symbolism, explain in the least degree the phenomenon of the creation of a work of art?

Klee used it as a metaphor to link the process of natural creation to that of artistic creation, with which it really has nothing in common, since artistic creation uses real physical and chemical forces that are subordinate to an affective determinism and to concrete creative ends, and is not a series of spiritual disciplines obeying an interest-free order of creation essentially playful and sensual.

We can now understand why the Surrealists, who at first adopted Klee because of the strangeness of his work, soon disowned him, not allowing that artistic creation has its origin in the magical intervention of a deified nature rather than in the totally human mechanisms of hallucination and automatic writing.

Felix Klee says about this period at the Bauhaus: "In October 1921, I arrived at Weimar. At thirteen and three-quarter years old I became the youngest pupil of Johannes Itten at the Bauhaus where Paul Klee had been teaching for a year. It is with the greatest joy that I remember this marvelous period of my 'golden youth.' In 1915, when I had obtained the title of 'companion,' my father asked me: 'And now what do you want to do? I tell you, if I have any advice to give you, it is, don't become a painter, your life will be too difficult. Paint as much as you want, but don't make it your main profession.' So I said: 'I would like to work in the theater.' And Klee said: 'Good, then that's what you'll do.' (. . .)

"At the Bauhaus they had nicknamed him 'God Almighty,' which did have a touch of malice in it; it is not difficult to picture his reserve there. But it was a wall of protection that, being such a modest and reflective man, he needed."

His *Pedagogical Sketchbook*, a summary of the grammar of form that is treated at length in his posthumous manuscripts, was published in 1925 in a collection of books from the Bauhaus. It constitutes the structure and the conducting wire. Out of two thousand five hundred posthumous pages (notes, course outlines, projects, drawings, sketches, drafts) the following chapter headings emerged: "An Enlargement of the Idea of Perspective"; "A Subjective Theory of Space"; "Displacement of Vision in Relation to a Point"; "Theory of Structure"; "Rhythm and the Structure of Rhythm"; "Synthesis of the Static and the Dynamic". His pedagogy is characterized by the modification of the notion of form that operates progressively, revealing itself in successive portions. For Klee, theoretical explanation and creative activity remained narrowly linked.

Stimulated by the creative atmosphere at the Bauhaus, the painter became more creative. He achieved amazing brilliance, particularly with regard to his research into material/matter and color: stencilling, scratching, rubber stamping, transparencies . . . He described a landscape with a few curved or parallel lines. *Castle to Build in the Forest* (1926) is practically a semi-divisionism of evanescent lightness. *Barbarian Captain* (1932) consists of a face of three lines perfectly balanced in the flat/smooth/unfolded space, a truly transparent perspective. There were so many different styles, one of which would have made any other painter happy enough! He had reached the height of his technical prowess where he could use matter/ material and color to put down imaginings, observations, and sensations exactly as he wanted; every new idea produced another fascinating invention.

194
237

Through the Bauhaus texts, we can appreciate just how profound and meticulous his investigations in the field of pure plastic methods, were. His numerous writings on art are as much complete analyses of his own work as theoretical discourses. He makes us see and understand the mechanisms, internal workings, and most hidden movements; he gives us a window onto the creative process: from point to line, from line to drawing, from drawing to space, from construction to composition, taking us "across things, to beyond both real and imaginary."

On the science of form and color Klee seems to have said it all. To better understand all his plastic inventions, the amateur should read his writings directly. By doing so he would really be able to see the precision of Klee's analyses of the genesis of form, the activity of living forces, constructive procedures, the structure of the pictorial ensemble, the interior study of nature, the emergent form of object and content, dynamic equilibrium, chromatic movements, and the spiritual and beautiful in art: in fact, how pertinent his analyses are on anything connected to the work.

Surrounded by his paintings, Klee presented his research and experiments in the form of synthesis to his pupils at the Bauhaus. Faced with the apparent spontaneity of certain works, it is easy to forget that behind the poet and philosopher lay an exacting builder

35. ANALYSIS OF VARIOUS PERVERSITIES
 (ANALYSE VERSCHIEDENER PERVERSITÄTEN)
 1922/170 – Pen and watercolor, 31 × 24 cm
 National Museum of Modern Art, Georges-Pompidou Center.
 Gift of Heinz Berggruen.

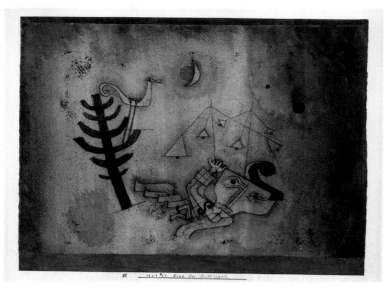

36. SONG OF THE MOCKING BIRD
(LIED DES SPOTTVOGELS)
1924/66 – Watercolor on paper mounted on cardboard, 29.9 × 39.2 cm
Paul Klee Foundation, Kunstmuseum, Bern.

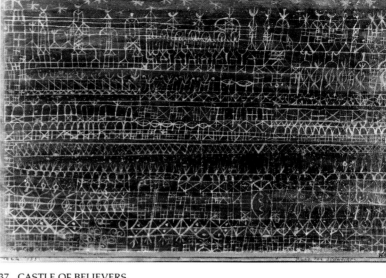

37. CASTLE OF BELIEVERS
(BURG DER GLÄUBIGEN)
1924/133 – Watercolor, 23.3 × 39.2 cm
Rosengart Collection, Lucerne.

constantly worrying about getting the different elements of his compositions into strict order. In 1902, he noted in his Diary: "Henceforth my goal, which is both close and remote, will consist of harmonizing architectonic painting with poetic inspiration." Six years later he wrote, "Form is in the foreground of the visual element. It is what we are striving for. It is what makes the work really worthy." But there is form and form: "Formalism is form without function."

This assertion became the driving force of his creations: "Genesis as a formal movement constitutes the essential of the work . . . Form as movement, therefore, is good, as is form in action. What is bad, is dull and inert form, terminally stopped form. Form is the end. Formation is its creation." He never loses sight of the creative range: "It is good to fit the various sections of the itinerary together so that they become cohesive; in other words, so that we can take them in with a glance, as if they were a single organism."

Exacting builder, insatiable seeker, and scrupulous analyst, Klee never subscribed to a single aesthetic law: "The knowledge of laws is precious, as long as we don't simplify to such an extent that we confuse pure law with living reality. Such mistakes lead to construction for construction's sake and the haunting memory of fearful asthmatics who give us rules instead of works . . . We construct continuously, but intuition is a good thing. When intuition unites with exact research, it accelerates the latter's progress in an astonishing way."

"Genius," Klee said to his students, "is the error in the system." At a time when conceptual art's only rival is poor art, we should think about this reflection made to his Bauhaus students in the context of a "general retrospective," the subject of the sixth exercise on July 3, 1922: "The artistic image does not possess particular qualities. Its only purpose is to make us happy." A

similar statement to Matisse's in 1929: "Without sensuality there is nothing."

For a painter to be able to teach, he has to have an awareness of the implicit and nonverbal usually articulated only in the actual work. Artists' writings, therefore, take on new importance, as emphasized by Theo van Doesburg in 1917: "Theory came into existence as an indispensable consequence of creative activity. Artists do not write about their art; their writings are an extension of their creative activity." (*Die nieuwe beweging inder schielderkunst.*)

It took time for Klee's work, unique in the world as far as its poetic inspiration, to make its mark. It was, in fact, only from 1925 that it was recognized by a handful of Parisian writers, poets, and art dealers, and it was the Surrealists who first brought it to the public's attention. And we must not forget the Zurich art critic who, with a friend, was directing the Vavin-Raspail gallery in Paris. It was in this gallery, belonging to Max Berger (Eichenberger was his real name), that thirty-nine of Klee's works, curated by Louis Aragon and Paul Eluard, were shown from October 21st to November 14th. "It is not possible to speak of the great Weimar painter," wrote Eluard, "without citing the lightness, grace, spirit, charm, and finesse that belong particularly to him. One does not know what to like better, the delicacy of his watercolors or the ceaseless renewed invention of his drawings. Both of these would no doubt appear to our Bissiere and Loitiron amateurs as the works of children or mad people. For this grace, with its profound imagination, usually belongs to poets and in our day is labeled puerile or insane, according to the advocate who judges and removes with one slice what is most precious and subtle."

Just before this, Klee had said to Lothar Schreier, a

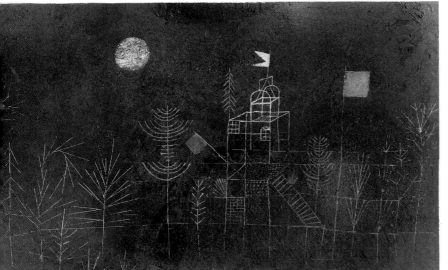

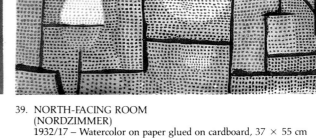

38. PAVILION WITH FLAG
(BEFLÄGGTER PAVILLON)
1927/15 – Oil
Sprengel Museum, Hannover.

39. NORTH-FACING ROOM
(NORDZIMMER)
1932/17 – Watercolor on paper glued on cardboard, 37 × 55 cm
Paul Klee Foundation, Kunstmuseum, Bern.

colleague at the Bauhaus: "The critics often say that my pictures resemble the daubs and scribbles of children! If only it were true! What my son Felix paints is worth more than all my paintings, for too often mine have been filtered, drop by drop, through my brain . . . But that is not all. The doctors, are of the opinion that my paintings are the work of a very sick person."

And so Klee set to writing a eulogy of Prinzhorn's famous *Plastic Activity of the Mentally Ill*, which had just been published: "Truly sublime art, a wholly spiritual vision. Does it indicate more than anything else that I am on the road to the asylum? Without realizing, of course, that the whole world is an asylum of mad people." Twenty years later his work would be condemned by the Nazis as "degenerate."

Klee was a painter, poet, musician, philosopher, and naturalist, but he was also interested in history, geology, and engineering. "Algebra, geometry, and engineering exercises (balance and movement) educate and take us to the essential," he said, "to the function and not to the exterior impression. We learn to see behind the façade, to grasp something of the root. We learn to take apart and to analyze." His mind was always open to knowledge and his work is a veritable "plastic cosmos."

For the exhibition at the Vavin-Raspail gallery, Paul Eluard composed the following poem:

On the fatal slope, the voyager profits
From the day's favors, icy and stone free,
And love's blue eyes discover their season
Which puts rings of big stars on all fingers.
The sea has left its ears on the beach
And a fine crime has hollowed the sand.
Torture is harder for the torturers than the victims,
Knives are signs and bullets tears.

On the last day of this show (Klee's first in Paris), the Surrealists' first show, in which Klee was given as much space as Miro and Masson, opened at the Pierre gallery. The Surrealists knew Klee well. In his, Letter from Berlin, which appeared in the review *Literature* in 1922, Louis Aragon wrote: "A plant that looked like a wizard's tooth blossomed at Weimar. No one here has realized yet that Paul Klee is going to be preferred by the future generation to his predecessors." Paul Klee's art was a revelation to the painters that came together under Breton's leadership at the beginning of the 1920s. He was cited in the first installment of the *Surrealist Revolution*, and in the third, Antonin Artaud reproduced four of his watercolors, one of which was the *Castle of Believers* (1924), which Breton so admired. "The secret of Klee's art," wrote Philippe Soupault in 1929, "must remain for a long time our secret." The Surrealists did not attempt to analyze Klee's work but tried instead, through metaphor and association, to reveal the poetry of his compositions. It was Crevel who came closest to the work in his little 1930 monograph that appeared in the N. R. F: "Paul Klee, we can only call miraculous your journey into the most secret seas from which you returned with a treasure of mica, comets and crystals in the palm of your hand, a harvest of haunting seaweed and the reflection of engulfed towns.

"As transparent as serrated fish, everything you brought back from the depths is worthy of attention. The crabs, yes, even the crabs have wings.

"A painter opened his fist and an amazing assortment of caged birds escaped from in between his talented fingers to obediently and happily inhabit his magical paintings.

"Klee's work is a complete museum of dreams."

The Surrealists always admired the miniature scale of Klee's work. As poets, they deeply understood the economy of his art and the advantage of using limited means to render infinity. Unconsciously, Klee was the harbinger of this poetic vision, and Eluard and Tzara made direct contact with him. In April 1928, Eluard sent him some poems begging him to illustrate them, and in 1931, Tzara, inspired by the 1929 drawing *Eye and Ear* got an etching from him for "Approximate Man" that harmonized beautifully with this exceptionally musical poem: "I think of the heat that weaves the word around this kernel, the dream we call ourselves."

125 But André Breton, who saw the *Perspective of a Room with Inmates*, as a spiritual interior, found Klee more graceful than violent (Philippe Soupault wrote in 1929: "Klee could never shock."), his marvels more refined than explosive or liberating. The Surrealists held Klee in high esteem, but he was not really one of them. And for him, already famous beyond the Rhine, there was never a question of belonging to their group, or to any group. Even though he joined the Blaue Reiter, it was as observer rather than participant. Besides, Klee and the Surrealists were incompatible on many issues. Firstly, his conception of the artist was different to theirs; as a teacher at the Bauhaus, he was not only aware of his means and aims but made them clear to his students too. The notion that art should be fortuitous, spontaneous, and mediumistic would probably have scandalized him. Then, the revolutionary and humanistic aspect of the Surrealists' breaking of taboos was completely foreign to him. Even though he painted what Michaux (whose titles suit his work so well: "Distant Interior," "Stirring Night," "Life in the Folds") called so authoritatively "The Inner Space," he comes to it through totally different ways than those recommended by Breton. When he was at the Bauhaus, Klee made several journeys: Sicily (1924), from the island of Elba to Ravenna (1926), Porquerolles and Corsica (1927), and Brittany (1928). But the most important in his work's development was the trip to Egypt from December 1928 to January 1929. This long tour from Alexandria to Aswān over the period of a month was almost as important for the fifty-year-old Klee, as the brief trip to Tunisia in April 1914 had been. Confronted with the grandiose vestiges of a five-thousand-year-old civilization, he experienced an inkling of the oneness of life and eternity reminiscent of Goethe's declaration: "The ephemeral is the symbol of the eternal." Uncertain of his place in this world as many references in his Diary show, he finally discovered the intermediate state, which is neither completely life nor completely death, but which, existing beyond the phenomenon of birth, is just another aspect of neutrality. We can

see an echo of this in his epitaph. It was through this realization that he attained the simplicity and final grandeur of his hieroglyphic style.

He did not like everything he saw in Egypt though: "I went first to the Egyptian museum. We have certainly been satiated in our own museums with everything they have there, except for the Tutankhamen excavations, which I had never seen and which looked as if they had been made yesterday. They are definitely hyper-cultured, but so very beautiful! In addition to them, I saw marvelous ornaments and somewhere a little musical instrument that charmed me a lot. I was only partially attracted to the rest. The collection of caskets borders on the operatic. If we put all our coffin lids together, it would be similar, though European." It was in Tunisia that he had really been transported: "I took other impressions away from Tunis, and I am convinced that Tunis is the richer place. The Kairouan mosques themselves indicate that Tunis was almost always richer. Nearly all of the Cairo mosques are kitsch, even those with two stars. However, the grandeur of the jumble of Europe — the East — and Africa is simply stunning here."

He was very taken by the Nile valley, and in December 1928, he wrote to Lily: "The countryside and the agrarian economy are uniquely arranged in Egypt. The river is the the main artery for everything. Downstream of Cairo it runs through a huge magically green expanse of forage, vegetables, and fruit trees, and corresponding with this are the various herds of camels and gray buffalo standing below mules, goats, and sheep. As none of them are enclosed in this region yet remain in one place, and everything around has not been devoured, it makes a very strong impression."

During this time, the Bauhaus was in a crisis. Following Gropius' departure in 1928, Hannes Meyer became the director, but the dedicated Marxist had some problems with the Dessau townspeople and was replaced by Mies van der Rohe in 1930. Klee, for his part, was finding it increasingly difficult to reconcile his teaching load with his work as an artist. He started some informal negotiations with the Düsseldorf Academy and in 1930 received the following letter from Walker Kaesbach: "As we are going through a process of revision at the moment, we have to recognize that three of our drawing teachers have not had any pupils for a long time. Which is why you have become such an important element. I think that the more free and comfortable you feel, the better it will be for the institution with which you choose to work." During the summer of 1930, he obtained the drawing professorship at Düsseldorf, and on April 1, 1931, he broke his contract with the Bauhaus. After his departure, Kandinsky paid tribute to him in the Bauhaus review: "The singular example of his words

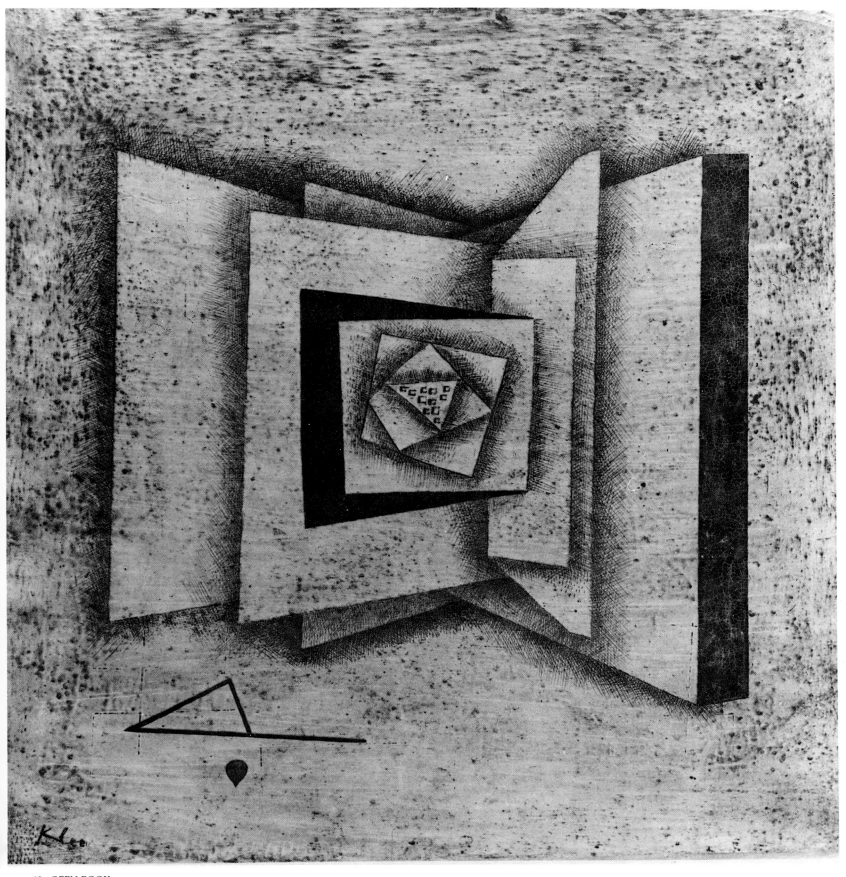

40. OPEN BOOK
 (OFFENES BUCH)
 1930/206 (E 6) – Watercolor on canvas, 45 × 42 cm
 Solomon R. Guggenheim Museum, New York.

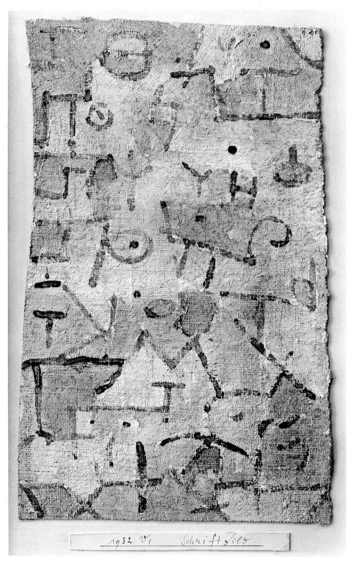

41. SCRIPT-PICTURE
(SCHRIFTBILD)
1932 – Watercolor on sacking, 27 × 15.5 cm
Kunstmuseum, Basel.

and his work contributed, in a large measure, to the positive and profound development of the students' qualities. Klee gave us an example, with a wealth of instruction, of someone totally dedicated to his work. He certainly taught us a lesson."

As a professor at the Düsseldorf Academy from 1931 to 1933, Klee stuck mainly to the correction of his drawing classes' work. Groups working together were freely formed in his studio, and there were frequent critiques and discussions of the students' work as well as his own. These two years in the "little Paris" of the Rhineland must have been very pleasant, as he was able to satisfy both his desire to be surrounded by youth and his need for independence with regard to his own work. In Düsseldorf he did little pointillist paintings according to a system of punctuation that he had already used in certain drawings from 1925 onward. He continued to read the Greek tragedies, took on *Parsifal* in the original,

and read the epic *Mahabharata* and the teachings of the Buddha as well. Klee was, therefore, no longer at the Bauhaus when it was closed by the Nazis in October 1932, but the insults and official attacks labeling modern art, his own in particular, "degenerate" became more and more virulent. Branded a Jew and a foreigner, he lost his job at the Düsseldorf Academy on April 21, 1933, just as he would have if he had remained at Dessau.

In the autumn of 1933, he made a last journey by himself to Provence. From Saint Raphael he wrote to Lily on October 10: "There is something so agreeable about being in a country where everything is neither prejudged nor restrained. Perhaps this country will soon be the only one that resists infiltration. Something important for souls in opposition."

And from Port-Cros on October 15: "At present I am in a paradise where there are no roads, only foot and mule paths, no cars, only the occasional mule, a place where there is nothing pernicious, not even electric light, instead beautiful warm parrafin lamps in all the corners of the house. There isn't even a hotel, but a hostelry where everything is provincial, like formerly at Auray, but not in exactly the same way; here everything is totally of the same style, tables, chairs, plates, and napkins. And something really capital, the sea is deep. I have reforged my old relationships. Helios set magnificently, and as I adored it, Venus consoled me for the disappearance of the day's splendor."

On December 22, 1933, Paul Klee wrote to his son Felix: "Everything has now been moved out. Tomorrow evening I will in all likelihood leave this place. Then the beautiful Christmas days when bells chime in every foolish head will come. I have aged a little during these last weeks. But I won't vent gall, or I'll do it with humor anyway. Which is easy for men to do. In similar circumstances women usually cry."

The time had come for the painter to go into exile in Bern, the town in Switzerland where he spent his childhood.

1933–1940, Bern — The last years

"Without doubt it was a psychic shock," declared his son Felix, "even though he went to Switzerland where he was able to start again." "I have started painting again, as if I was a tiny little orchestra," Klee wrote to Grohmann. "After the big Bauhaus and Düsseldorf studios, he was again living in a kind of cell," says Felix, "but it is precisely in this room that his last great works were accomplished. He had enough to live on, and that was extremely important to him, for his big success, which was mainly in America where many European art dealers had immigrated, only came after the Second World War."

In Bern, Klee was reunited with his father and sister Mathilde, who still lived in the little house at number 6 Obstbergweg. He found a small apartment of three rooms for himself at 6 Kistlerweg. The biggest was the studio; another was taken up by the grand piano and the violin, and the kitchen was used for everything else. The space that Klee lived in became his life space: a continent for pictorial experimentation, an island for music, and an intercommunicating door between them. His vital space shrank and condensed to become what was purely essential. After observing the world from behind these closed doors, he then dissected it in his studio. This tiny laboratory-apartment becomes the place that Georges Bataille describes in *Inner Experience*: "That state of nakedness, of never replied-to entreaty, in which I nevertheless catch a glimpse of the fact that he clings to the evasive notion of that which is false receding."

Klee's biographer, Will Grohmann, was one of the few people he saw in his last years, and this friendship was as important to him on the human level as on the artistic. Lily, moreover, wrote to Grohmann on October 24, 1936, saying that their relationship is an exception "given that he is very isolated here (this just between us), as much on the moral plane as on the artistic. I sometimes think he must feel it too. And on top of the isolation of this last year, he has had to suffer ill health as well." During the summer of 1935, the first symptoms of the scleroderma (thickening of tissue fibers) that would kill him five years later, had become manifest.

Also in 1935, both the Bern and Basel art museums had big Klee retrospectives confirming the importance of his work. Despite his illness, Klee worked as hard as ever right until the end, except for 1936, when the number of works he did, which usually came to several hundred, fell to fifty-five. His first outing in 1937 was to the Kandinsky show, which took place during February and March at the Bern Art Museum. In the same year, he was visited by both Braque and Picasso; the latter admired his "miniatures" and replied later to a friend's questioning him on the impression the painter from Bern had left on him: "Pascal-Napoleon." In 1937 as well, the Degenerate Art Show in Munich had on display seventeen of Klee's works, and the Nazis confiscated two hundred others in German public collections.

Starting in 1933, two faces that could be interpreted as self-portraits, recall for us the political tensions of the day and the painter's exile: *Martyr's Head*, a broken-toothed and empty-eyed death mask, and *Struck off the Roll*, where a thick black cross ruthlessly bars and darkens the face thrown into the background. A third portrait, the *Clandestine Judge*, is a black mask illuminated by two spiraling red eyes that says everything there is to say about violence and menace. The titles of the works also forsook their

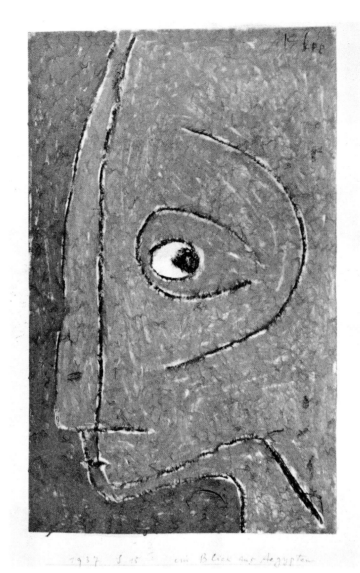

42. A GLANCE FROM EGYPT
(EIN BLICK AUS ÄGYPTEN)
1937/175 (S 15) – Pastel on paper, 27.6 × 16.3 cm
Paul Klee Foundation, Kunstmuseum, Bern.

former poetry for an anxiety sometimes bordering on anguish. Their themes are ships and voyages, but the way has become perilous, the destination lugubrious: *Place of Sighs, Infernal Park, Boat Accident, Sinister Place, Sick Person in a Boat, He Rows Despairingly* . . . There are also the angels, backward glances heavy with memories. These drawings all were part of a series done over many years. *Angels*, whose precursor in 1920 was *Angelus Novus*, belongs with 295–305 *Forgetful Angel, Doubting Angel, Prudent Old Angel, Failed Angel, Ugly Angel*, and finally in 1940, *Angel of Death*. They are not masked or veiled works; on the contrary, they are direct and tender, full of feeling and sensation. Few contemporary works have attempted to render interior states in such a pure way. Their ingenious beauty and purity of soul, unaltered by the struggle for life and the affirmation of self, are what make the angelic beings so profound.

There was also the series of *Urchs*, vaguely drawn 46

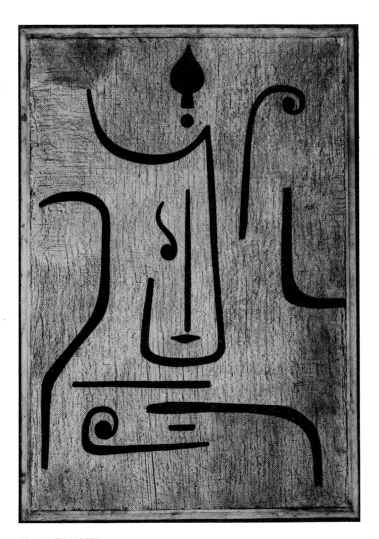

43. ARCHANGEL
(ERZENGEL)
1938 – Oil on canvas, 100 × 65 cm
Stadtische Gallery, Munich.

his slightly anxious but always attentive wait for his meeting with the Angel.

Klee's work of the last years has not yet succeeded in gaining unanimous recognition, even among his admirers. This last period began in 1933, following the advent of Nazism, when the artist understood that the age when he had been teaching at Weimar, Dessau, and Düsseldorf was irrevocably over. The time, long deferred, had come for him to do some big paintings, which, according to him, were the only ones that could resist time. In 1924, he had declared at Jena: "I dream often of a work on great scale that would embrace the whole field of the elements of art, subjectmatter, content, and style. This will certainly remain a dream We must not force anything; we must leave it to ripen We have already discovered its parts but not the totality."

These "conceived in the spirit" works became even more difficult to make when those in charge, who were calling forth human beings' basest instincts, began to condemn this genre of art and Klee's in particular. It was during Christmas 1933, in his old childhood home in Bern, that he painted *Woman in Mourning*. The depth of his despair was evident in the movement of the curve folding into three circles above/around her. But this big image of mute mourning was not understood.

In *Untamed Waters*, a 1934 watercolor, Klee was endeavoring to find life again. He rediscovered the sinuous gushing line in the twists of the Meandre river, which hurls itself into the sea not far from Ephese. He brings the profile of Heraclite, born on the banks of the river, to life in his waves. The "panta rhei" of Greek philosophy became for the painter a phrase embodying hope. But no one recognized the richness and crystalline purity of this work.

In 1935 and 1936, Klee's scleroderma got worse. With a presentiment of death, he sought once again to have a dialogue with the vital elements — earth, water, air, and fire. In *The Gray Man and the Coast*, 283 a big composition that united earth and water, the new mingled with a reminder of the old. Klee used the gray man in the corner of *Fisherman with Net* (1922) again, as well as a more in-depth form of the abstract composition of *Heroic Fiddling*. By drawing 282 from the 1922 painting, which was still very narrative, he managed to create the strong tension between earth and water.

In 1937, his lines, which were usually so thin, underwent a strange thickening; the linear motif, the line that continuously closed itself and was so fundamental to his art, became sticklike. It seemed that by reinforcing the rhythmically measured lines, Klee was trying to create a balance of greater tension between them and the melodic colored ground. During 1938 and 1939, it became clear that he was

45
312–315

animals from the beginning of time, and the *Eidola* series, which must not be translated, as we usually do, as "archetypes" (more Jungian than Platonic) but rather in its original Greek sense of images, simulacrum, portraits, idols, and phantoms. All these series (despite their humor, touches of irony and unusual seriousness) show the wounds inflicted by the anxiety and waiting of the last years and remind us of it through the sometimes comical distortion of their forms that Klee often uses to depict the tragic.

The results of a lifetime's research on the symbolism and expressive quality of line and color, and on the problems in constructing a work that integrates movement, are apparent most particularly in the less anguished works of 1933 to 1937 — *Open* (1933), *Invention* (1934), *Abstract Ballet* (1937) — and again in the 1935 series of animated threadlike personages. The pursuit of a pictorial ethic, which had always dominated the painter's career, doubled in these last years with his acceptance of approaching death and

making a biological phenomenon — the slow erosion of the power of growth and the disintegration of the whole order of creation — artistically evident. There were more and more titles, such as *Broken Key,* *Destroyed Labyrinth, Infernal Figure, Death and Fire, Funerary Urn* . . .

41 &
318

The combination of his illness and the weight of the historical events taking place was most certainly a decisive factor in the evolution and expression of the last works. But to try in these works to detail the way in which Paul Klee reacted to contemporary events is a difficult task. Direct and unambiguous allusions to Nazism are infrequent, and the suffering, like his depiction of physical suffering, only finds its expression in a changed form. As Max Pulver says: "The war, the new war, was already in the air. But nobody mentioned it. One spoke of art and artists, but secretly everyone was thinking of death."

318

In works like *Drummer, Alea Jacta* and *Death and Fire,* Klee tries to convey his thoughts on death. Are meditations on destiny not, after all, the objective of artistic thought? To think one's destiny is to cause its advent. And Paul Klee defied his death the way Goya defied the king.

His hastily drawn black bars — ramparts holding back the terror — are the cortex of his anguish. Klee's art became an art of exorcism, and the terrifying forms that he painted were his ultimate cries for deliverance from fear. Strangled, mute cries without echo.

From 1937 on, his output, particularly drawings, was astonishingly huge. As Lily Klee said: "He had one of his creative periods again. One of drawing as well. He stayed up at night till eleven, and the drawings fell onto the floor one after another." Like the hastily skimmed-through pages of a tear-off calendar — for there wasn't much time — or the pages of an intimate diary written daily in a cursive urgent hand, the works of his last years have to be seen as a feverish whole.

44. DESTROYED LABYRINTH
(ZERSTÖRTES LABYRINTH)
1939/346 (Y 6) – Oil and watercolor on paper pasted on jute, 54 × 70 cm
Paul Klee Foundation, Kunstmuseum, Bern.

45. EIDOLA FORMER EATER
(EIDOLA: WEILAND ESSERIN)
1940/87 (V7) – Black greasepaint drawing, 29.8 × 21 cm
Paul Klee Foundation, Kunstmuseum, Bern.

46. URCH FROM HEROIC TIMES
(URCHS AUS DEM HEROISCHEN ZEITALTER)
1939/1058 (EF 18) – Black greasepaint on paper
mounted on cardboard, 42 × 29.6 cm
Paul Klee Foundation, Kunstmuseum, Bern.

Signs and ideograms and hieroglyphics or cursive writing abound in these works, either expressing a transition from the real or, on the contrary, signifying a concept integrating time and memory into the pictorial language. Klee manages to convey an intimate reality, a reality that exists only as an inner necessity. The communion with nature — in the sense of nature becoming nature, that is, genesis and growth in time and space — was always for him the sine qua non condition of creation; at that time Klee was listening to nature from inside himself so that he could transcribe its most minute quivers. The concepts of movement, fluidity, progression, and belief were translated in the form of lines, abstract signs, and arrows, which orient one's look and reading of the picture. The symbolism of the colors and the subtly arranged zones of light are the result of this inner listening, this search for meaning in the signs emitted by an encoded universe.

The key word here is receptivity. In order to be authentic, one has to always be aware and listening. As the titles indicate, it is important to find characteristics that are "once again childlike" and to remain, like the Urchs, "attentive." The rejection of an imposed culture that could not be surpassed by the lived experience, plus the search for an expression

that took memory into account, led Klee to utilize a pictorial language close to hieroglyphics, as, for example, in *The Gray Man and the Coast* (1938), where the personage on the other side of the watery border that separates him from the symbols of life turns to look at the things he will be distanced from forever. Like in all alphabets, the meaning of each sign is in its relationship to the other signs. Thick black signs of joined curves and straight lines cover the canvasses like ideograms that sometimes become recognizable forms: a boat, a stylized personage, a tree; their abstract interlacings sometimes cover the whole surface. They become symbols of unknown distances to be crossed as in *Boat Composition* (1940), when a ship starts sailing over them; he also constructed the pictorial space by separating the planes of air and earth, as in *Pond in a Park* (1938), the lines acting like lead in a stained-glass window.

The titles of the works (calligraphies in a meticulous hand at the bottom of the drawing or painting, sometimes underlined with a fine straight line) often contrast with the expressive violence of the composition and what it is done on. We know how important technique and materials were to Klee, and it appears that in these last works he rejected fine canvasses and quality paper in favor of machine-made paper, crude

jute, cardboard, and newspaper that he transformed with color.

Meanwhile, as Lily's letters show, his illness had become a permanent companion. "He is quite well, God be praised," she writes from Bern on May 15, 1937. "He gathers strength every day, and for some time already he has been able to go on short walks. He has put on weight and is only a little anemic. Best of all is that he is having an excellent working period. He experimented with numerous new things, which have been brought to term, and he is in good form and full of ideas. (. . .) His work is the most important thing, and because he has still not got all his strength back, we still live a very retiring life." There was, therefore, by force of circumstances an enigmatic relationship between Klee's artistic production and his omnipresent illness.

"As life faded away from him," wrote Henri Hoppenot in 1948, "I would see him every day at Elfenau, taking a slow walk with his memories under the shady trees alongside the river." Did he feel the end approaching; did he accept that harmony was going to be disturbed, its reflection absorbed into the light? He, who had written twenty-five years earlier in his diary: "I was thinking of death, war and death. But how can I die, I who am crystal?"

In the spring of 1940 his health deteriorated, and he was taken to a clinic in Locarno where he died fifty days later on June 29th. Klee had said that he would prefer to die than to live through a second world war, and he kept his word. His famous epitaph is engraved on his tomb in the little Schlosshalden cemetery near to Bern: "I am not well understood in this world, for I am as much at home with the dead as with those yet to be born, a little closer to the heart of creation than is usual, yet far from being near enough."

Such was his epitaph, but his poem followed: "Does heat emanate from me? Does cold? On the other side, passion can no longer be debated. The farther away I am, the more pious. In this world I am sometimes maliciously happy at the evil of others . . . Shades, all of it, of one and the same thing. But the priests are not pious enough to see it. And because of it, the Doctors of Law harbor just a little resentment." This was Paul Klee's last sarcastic glance at this world.

Epilogue

When René Crevel says to us that "Klee's work is a museum full of dreams," he understandably forgets that this museum is also a center for research without which the dreams would not be possible. For Klee's brilliance is precisely to make us forget the other side of the whimsical world that he unleashed onto our so ordered universe. The unseen side conceals a complex mechanism, a necessary condition for this comet of fantasy whose trajectory cannot be calculated by any known law. All we see, when faced with Klee's work, is his spontaneous and quasi-childish freedom, and we rarely question how he got this freedom and spontaneous dash, which in fact entailed so much calculation, experimentation, and research. If one has not read his theoretical writings, the misinterpretation is inevitable.

The plastic work is also, similarly to that of his friend Kandinsky, a theoretical work. Klee's *Pedagogical Sketchbook* consists of extracts from his lectures at the Bauhaus. His ambition? "To organize the laws of painting . . . from which it then will automatically develop into new types . . . and succeed in reaching beyond form, the very mystery of life."

Paul Klee's *On Modern Art*, was published posthumously in Bern in 1945. In it the author tried to explain why (in painting) element, object, meaning, and style have to be separated. Marcel Brion tries to account for this recital of facts with the idea of the

47. STERN VISAGE
(ERNSTE MIENE)
1939/857 (UU 17) – Watercolor and gouache on paper
mounted on cardboard, 32.9 × 20.9 cm
Paul Klee Foundation, Kunstmuseum, Bern.

48. WAVES
(FLUTEN)
1929/287 (UE 7) – Pen drawing on Ingres paper, 12 × 30 cm
Private collection, Switzerland.

mobility and complete liberty that the artist pursues in order to reach an act that is purely creative. In his, *Abstract Art*, Brion writes that one has to understand that Paul Klee wanted to introduce the painter "into the world of primordial essences held out as connections with an almost religious range"; an idea left over, he adds, from the German romantic philosophy and a concept of nature in which the artist is a rival and not a tributary.

In his preface to the English translation of the same book, Herbert Read tries in his turn to give a global explanation of Klee's work. "It is a metaphysical art. It presupposes a philosophy of appearance and reality. It does not believe that normal perception would be sufficient to inform us of the real, for the eye's vision, directed outwards, is arbitrary and limited." Inside is the marvelous world that has to be explored. It is sufficient for the artist to contemplate his pencil, "for his pencil, to dream."

"A Klee drawing," concludes Marcel Brion, "is like a new being that has been liberated from himself and been given autonomous life. This is where we can see his magical power, his gift of incantation, and sometimes, his dramatic vehemence and hallucinatory violence, even when the form is a childish drawing; for he is commanded by the most secret currents of the unconscious. Klee's merit is that he brought the mysteries of this subterranean and underwater world to the surface as evidence."

It's the old platonic theory that the Surrealists had of Ideas and automatic writing, improved upon by the intervention of the Freudian pencil, which dreams and draws by itself. Does this inner world truly remain uncontaminated from anything real? Or are we not quite simply dealing with residual elements more or less refracted in pure consciousness and then deliberately transposed by fantasy and graphic skill?

Klee acknowledges it himself when he refers to "abstract matter," which feeds on the "rubble lying in the great mine of forms"; meaning, Chinese, Byzantium, Persian, and Pre-Columbian memories . . . as has been observed by Jean Cassou.

Is Klee's originality not made up of particular and long thought about groupings that he alters to show a new emotion by "additions, renunciations and omissions," thereby reducing the universe to diagrams?

The critics talk about "the unfolding of a fairylike and secret universe on the canvas," of "undulating rhythms that unlock the mysterious for us." Klee, who did not demand as much, indicated that he intended quite simply to rid himself of Nature's yoke when it became too oppressive. So he prunes, schematizes, distorts, ironizes, and amuses himself. His great adventure is graphic and optical, not metaphysical.

Nor does it belong to geology, as Michel Seuphor would have us believe in his *Dictionary of Abstract Painting*. "Klee," he writes, "is the key to the

spiritual fields, to the free spirit that spiritualizes everything. Which is to say that everything is a continuous creation happening at the end of a pen or brush; it is not an ignored inner appeal, nor an entreaty so strange or preposterous that it will not be obeyed. All of Klee is so improbable, yet true."

His work is not like nature, it is natural. His art is as natural as the "growth of a flower, the winding of a river, the hooting of a screech owl." It is not the result of an "intelligence that dominates and exploits, contemplates and then explains, but rather of a sensibility that has integrated the internal laws of creation."

Do we really need to cite so many hypothetical, grandiose, and obscurantist powers, in order to define the sources of Paul Klee's art? Most often they are simply a matter of a decorative graphic plastic technique, wielded by a practitioner full of fantasy, invention, and verve who had decided to collaborate with chance.

Paul Klee, notes Will Grohmann, the most careful of his interpreters, takes his point of departure from a little scheme that he calls a, "pretext of formal development" (Formotiv), which he lets proliferate by chance, like crystals, more or less geometrically, in ramifications, articulations, and unexpected constructions that even astonish the artist. Then, when the work ends up resembling some object, when it has a more or less identifiable "subject," he gives it a name.

In this way a bevy of colored points becomes an aerodrome at night; a figure four, a sailboat; a yellow circle, a moonlike face; a blue circle, the sign that evokes the sea. Is this a posteriori symbolism, equally childlike and full of poetic finds as the essence of Bernese facetiousness, really the expression of this "interior and marvelous world," of these "magical sources of being" that the artist's historiographers and critics exalt?

The collectors who assured Paul Klee's success did not concern themselves with the fetishes of fashion or the critics' clichés. What they appreciated in the work of the Bernese artist were his artistic qualities that could be understood by everyone; the delicacy of his graphic screen woven with such transparence and gossamerlike rigor; his art of subtle shading from one tone to another, which had no rival; the way he inlays his ground with lozenges of color; his fluid and refined monochrome superimpositions of delicate bands of color, resonating dully or singing, as if infallibly reconciled in the interior of a geometric, leaded-glass window.

Through his resourceful imagination and graphic organization and the certainty and confidence in his chromatic register that he diversified and unified at leisure, Paul Klee was able to acquire the mastery of his forms that André Lhote (another theoretical painter) terms as scriptural and musical.

A calligrapher who enjoyed having writing effects predominate in his pictures, Paul Klee was fully aware of the different writing styles in Chinese and Arab works, Japanese engravings, and Irish or Persian miniatures, but he also bore in mind the constructivist demonstrations from the Bauhaus, as can be seen in *Perspective with Open Door* (1923) and the *Acrobat* (1930), made from a red ball and a choreography of matches. He transposes with humor, going as far as using Seurat's pointillism (*Portrait of Doctor G.*, 1923), stylizing Grosz's unkind character sketches (*Old Man Calculating*, 1929), miniaturizing the technique of Oriental carpets (*Mural*, 1924), and making scratchings and incisions with the handle of a paint brush (*Florentine Villas*, 1926), stamping the painting with an embroidered lacy effect.

He experimented with Signac's and Cross' multicolored confetti, condensing it into tight miniscule patchwork squares (*Ad Parnassum*); in a more systematic way, he used Picasso's caricaturism (*Dame Demon*, 1935), Henri Rousseau's lyrical green plants, Mondrian's clean-cut tiled combinations, the infantilism of Pueblo art, and childish writing done with his left hand to accentuate the awkward effect of naïveté.

So many of the works were really successful, both technically and imaginatively: for instance, the legibility and tautness of the graphic weft woven with the spiderlike finesse of the Chinese in *Picture of Fish* (1925), or the possessed spirit of the very Japanese in *The Creator* (1934); the inflections suggesting features and the rhythmic interlacing and meaningful colored areas of the *Madman in a Trance* (1929); the refined colorist who knows how to choose and place the most difficult tones — the ochred pinks, burnt

49. ANCHORED SAILING BOATS
(SEGLER IN RUHE)
1939/1203 (No 3) – Black chalk on Japanese simili mounted on cardboard, 20.7 × 29.6 cm
Paul Klee Foundation, Kunstmuseum, Bern.

50. PERSPECTIVE WITH OPEN DOOR
(PERSPEKTIVE MIT OFFENER TÜRE)
1923/143 – Watercolor and pen on paper mounted on cardboard, 26.2 × 26.8 cm
Rosengart Collection, Lucerne.

51. MURAL
(WANDBILD)
1924/128 – Watercolor brush drawing on paper on muslin, 25.4 × 55.1 cm
Paul Klee Foundation, Kunstmuseum, Bern.

umber, faded lilac, vermilion shot with orange, golden browns, succulent beiges and browns of *Hanging Fruits* (1921). Throughout his unfailingly pertinent use of techniques like sowing and trellising, or the deployment of lozenges of color and monochrome painting, the painter remained a musician enamored of harmonies, and even when using the harshest tones, he never became strident, inopportune, or affected.

His poetic system is determined by a vision of the world that is neither magical nor affective but is rather a scrupulous form of observation in which technical alchemy plays a big part. Klee's aesthetic, which in the history of contemporary art stands out as so singularly his, owes less to his predecessors (even though his writing style, the refinement of his material, and his taste for the little format and delicate "Closet" work is reminiscent of the great Germans of the 16th century) than to the musical and, above all, literary culture of German Romanticism. Grohmann cites Novalis in connection with this, and in *The Star Over the Town* (1969–1970), Hans-Ulrich Schlumpf suggests numerous parallels of Klee's work with the texts of Goethe, Jean-Paul, Tieck, Eichendorff, and Heine.

Neither his "Creative Confession" nor his Jena Lecture can be fully understood without having read something of his great predecessors. Even though he declares in his Diary in 1916: "I have no Faustian inclinations," the following phrase immediately contradicts this assertion: "I place myself at a faraway point, at the origin of things, at the level of creation where I can find the formulas for humankind, animal, vegetable, mineral, the elements and all the cyclical forces." This sentence corresponds with one of Faust's monologues: "You have brought the long chain of living beings before me; you have taught me to recognize my brothers in the tranquil bush, the air, and the water."

When he wrote in Tunis: "I myself am the rising moon in the South," this is similar to Novalis' desire to, "become flower, animal, stone, star." And when he wrote in 1912 to a Swiss correspondent: "Children are not less talented, and there is also wisdom at the source of their talents!" this is again like Novalis: "Where there are children, there is the golden age," and Tieck's saying to a painter in 1828: "I could do voluntarily without action, passion, composition, and all the rest if you could open for me with rose-pink keys the country wherein dwell the mysterious thoughts of children."

When in a 1915 entry in his Diary, Klee defines his style as, "cold romanticism," he is certainly not only referring to the romantic motifs of his pictures. He is placing them, as do all the German Romantics, in a much larger context, which starts with an individual vision of the world. The text that he uses for his epitaph clearly states his position in this world. And significantly this text appears first, not in his Diary, but in *Argrat*, a publication that came out at the time of his big 1920 exhibition at the Goltz gallery.

This statement, reproduced in a facsimile of his writing on the occasion of his first one-person show is quite plain. The artist, who had decided to follow the workings of his own mind in a time agitated by war, revolution, and inflation, and who because he was so individualistic would not participate in any collective events, still took the real facts and what they would mean to his career into careful consideration.

In order to frame a reply, we have to first ask ourselves what Klee meant exactly by, "I cannot be understood in this world." Did this attitude contrib-

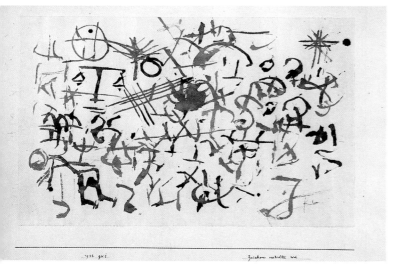

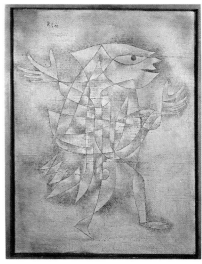

52. MORE AND MORE SIGNS
(ZEICHEN VERDICHTEN SICH)
1932/121 (qu 1) – Brush drawing, blue ink on Ingres paper,
31.4 × 48.5 cm
Paul Klee Foundation, Kunstmuseum, Bern.

53. THE INVENTOR OF THE NEST
(DIE ERFINDERIN DES NESTES)
1925/33 (M 3) – Watercolor brush drawing on a chalk base,
27.6 × 22 cm
Paul Klee Foundation, Kunstmuseum, Bern.

54. MADMAN IN A TRANCE
(NARR IN TRANCE)
1929/46 – Oil on canvas
Walraff Richartz, Cologne.

ute to the Romanticism of his work, and how was he and his work affected by it?

Strangely, Klee never mentioned Caspar David Friedrich in his numerous writings and only once cited Philipp Otto Runge, as the theoretician and inventor of the color sphere, in his course at the Bauhaus. Yet Klee's use of the figurative, even though he would not have seen any of Friedrich or Runge's work in the original, is deeply connected to German Romanticism.

His romantic temperament took various forms: He is either the solitary wanderer coming tragically up against the outer reality or the humorist trying to find equilibrium between the opposites. After contemplating reality, Klee decided on abstraction, humor, satire, and irony.

There is a startling similarity between his attitude and that of the poet Jean-Paul, a marginal and solitary figure of the Romantic period. Both looked toward infinity but kept both their feet on the ground. And both were aware of the dangers inherent in their romantic nostalgia. They distanced themselves from this world but managed to remain balanced by always having it in their sight. They were both fatalistic as regards their remoteness from this world and subtle humorists as often as they could be. Like Klee, Jean-Paul compared the humorist to the ancient bird Merops, who flies from the underworld to this world and then toward infinity, circling in the sky, its distant regard imprisoned forever by what it sees.

Humor and satire or caricature are deeply connected to the essence of romanticism and culminated in the concept of "romantic irony." Although the Romantics discussed it so passionately and thor-

oughly, and though a lot was later written about it, the concept is still illuminating and rich with meaning. Romantic irony can be defined as a form of self-awareness that presupposes a certain distancing from accepted facts, coupled with the boldness of a spiritually liberated individual. The well-known definitions of romantic irony by Schlegel, Schelling, Tieck, or Novalis read like subtle descriptions of Klee's world; it means being as far distant as possible from this world without losing touch with the real or ideal.

Oddly, in all the literature about Klee, no one, to this day, has seriously attempted a fundamental description of his humor, satire, and irony. This is particularly significant since any examination of Klee's art has to include these. In his rendering of the grotesque and comical, the failed and spiteful, Klee relativizes not only the world of appearances but also himself and his own activity.

In the plastic arts, caricature is a good way to reflect aspects of reality. It is crucial to Klee's art. He uses all his intellectual and plastic talent to set up caricature as a particular compositional style. Klee combines the visual and linguistic elements of image and title in an extraordinary way. If one would see the extreme nonacademic quality of caricature, let him look at caricatures done by Hogarth, Goya, Daumier, and the "Simplicissimus" illustrations, all of which are highly original. Klee makes caricature into gallery art by liberating it from the restrictiveness of always having an actual theme and by developing different possibilities of plastic expression at will. Not only his drawings but a number of his paintings as well can be interpreted as subtle caricatures.

The *Revolution of the Viaduct* (1937) doubtless caricatures a procession of headless revolutionaries in

55

the guise of geometric moving arches. Because of its pathos, Klee's comment avoids becoming mere playful expression. What is marvelous with Klee is that the image has several possibilities of interpretation. Is this toy revolution a caricature of the Nationalist-Socialist revolution of the Germany of the thirties or rather, as some have supposed, of the cultural revolution of the avant-garde?

In *Very Shortly Afterward!* (1940), soon before Klee's death, as in the *Revolution of the Viaduct*, he again caricatured the individual threatened by external elements. The troops, trotting on their little legs, chase the figure that has taken refuge on the right edge of the image and is trying to protect himself against the aggression by a sign of distress. In such works, Klee's caricaturization, which he had worked on throughout his life, reached the highest point of this style.

While still a student, a long time before his etched inventions, he had filled the margins of his exercise books and other books with grotesque faces and spiritual commentaries. Seen beside the drawings he did as a child, his caricatures recall these first important artistic inclinations.

Let us return to the image of the humorist as the strange bird Merops, wheeling above things, but with a gaze inverted by 180 degrees. Once the direction has changed, the limited world disappears and the artist is to look at boundless infinity. This elevated view of the world corresponded for Klee with the concept of abstraction. Gazing at the otherworld, Klee's abstraction is expressed, among other things, by the signs and the colored layers or quadrilaterals that appear in *Evening Fire* (1929). By comparison, when he looks at this world his plastic language remains figurative. The fact that all of Klee's figures from 1912 and 1913 become silhouettes, dolls and mannequins, is absolutely only a formal aesthetic jest. All of the puppet beings conceal Klee's fatalistic conviction that, in our "human powerlessness" (the title of a 1913 sketch), we unconditionally obey the laws of a superior cosmic power.

Even when he uses formal means of expression, Klee goes in two different directions. When he paints he leans toward the otherworld and abstraction, but drawing remains the medium in which he analyzes anecdotally the more worldly human contingencies. "Man in my work does not represent the species," he wrote in his Diary in 1916, "but a cosmic point. I look too far into the distance and almost always over the most beautiful things."

Holiness without evil joy, nostalgia for the beyond or romantic irony, abstraction and color, or figurative calculations and drawings — the only distinction Klee makes between the opposite poles depends on whether he is looking at the otherworld or this world. Figures like, *More Feminine Angel* (1939), with one eye glancing up and one down, look from their elevated positions, just like Klee, in two different directions.

This bipolarity defines Klee's conception as well as his plastic vision of the world. Since his youth it was evident to him, in the domain of art as well as life, that forms were determined according to these contrary poles. A short while after his return from Rome in June 1902, he entered a schema in his Diary that remained more or less unchanged until his death: "As of now, there are actually only three things: a Greco-Roman antiquity (*Physis*) with an objective attitude, worldly orientation, and architectonic center of gravity; and a Christianity (*Psyche*) with a subjective attitude, otherworldly orientation, and musical center of gravity. The third thing is the state of the modest, ignorant, self-taught man, a miniscule ego."

Later, other concepts were added to these opposing pairs, the static corresponding with the worldly and the dynamic, with the otherworldly. To a certain extent the stylistic concepts of Classicism and Romanticism can be included in this system as much as a pole of determination as an artistic point of view. "Thus the dynamic and static parts of the mechanism of form coincide very accurately with the distinction between Classical and Romantic," he stated in his Jena Lecture in 1924.

Klee's definition of his style as "cold romanticism," that is, nonpathetic romanticism that is always aware of reality, is basically nothing more than his attempt to find a balance between the two opposite poles because the subjective romantic attitude, oriented musically and spiritually toward the otherworld, was only possible for him if it simultaneously included both of the opposing dimensions.

Klee's "Romanticism" cannot be defined as being in favor of one and against the other pole; it is, rather, a concept of contraries, embracing the entire Universe, in which out of their action one upon the other all creativity arises. Consequently, he does not accord any moral value to the concepts of Good and Evil but defines them instead as equivalents, "forces collaborating to produce a totality." A direct connection can be seen here with the ideas of the Romantics for whom "God is life and not only being" and therefore "the God/Life essence must be present in Good as well as Evil," as Schelling wrote in 1809, in his book *The Essence of Human Liberty*. It goes without saying that the relationship that existed between opposite poles was not something that had been discovered by the Romantics. It can be found in the Taoist principles of Yin and Yang in which the opposites of heaven and earth, light and dark, sun and moon, man and woman, strong and weak, good and bad, and so on were seen not as dualism, but as duality in which the implicit unity was always apparent.

As we know, Klee believed that artistic formation

obeyed the same internal laws as every natural form; art, he said, is "equivalent to creation." He therefore tried to analyze the laws of plastic creation, not only as he had in his theoretical research but also according to their inner relationship with nature's apparent forms. For example, according to Klee, the static and dynamic create through their reciprocal action the substructure of every compound responsible for becoming and decaying in nature, as well as all plastic form. In this sense, "art renders visible" the creative legitimacy that the exterior forms conceal. In addition, Klee uses the definition of polarity as the most important code to unlocking the inner relationship between what is living and the artistic image formed in its imitation.

The extreme individuality of Klee's work indicates the extent of his attempt to show the similarity between the creation of a work of art and that of life, and to give the spectator the shock that directs vision from the individual to the universal and from the symbolic to the prototype. Although allusions and feelings belonging to the inconceivable otherworld are an essential part of his art, he always remembers the facts of this world and never wholly gives himself up to the spiritual. Even his angels are living beings who have taken their identity from their earthly antecedents.

Klee was part of a generation that, in the face of the rise of Nazism, developed a pessimistic fascination for destiny. This fascination, coupled with his illness, gave some of his works an extremely dramatic aspect. But in order to interpret them correctly we must not forget a very important stimulus to his creative activity: irony, as defined by Tieck, Schlegel, and Novalis. Being armed with irony in times of adversity makes a certain detachment from events possible. Irony, this deeply romantic attitude, ensured that right until the end he was able to work from within and establish some kind of relationship with death. All his work bears out this phrase in the "Creative Confession": "Art unconsciously plays a game with the unknown ultimate realities, and despite all, it succeeds!"

Klee freed himself from the imitation of Classical drawings; he did not copy the model or object but instead formed a mental image that he then transformed by using a precise problem of form or content that was resolved at the moment of drawing or painting. Whatever is problematic can then arise empirically as the work progresses. In 1908 he wrote in his Diary: "Similarly to a human being, a picture also has a skeleton, muscles, and a skin. We can speak of the specific anatomy of a picture. A picture of 'a naked person' must not be created according to the laws of human anatomy, but only according to those of compositional anatomy. We begin by constructing a framework on which the picture will be built. How

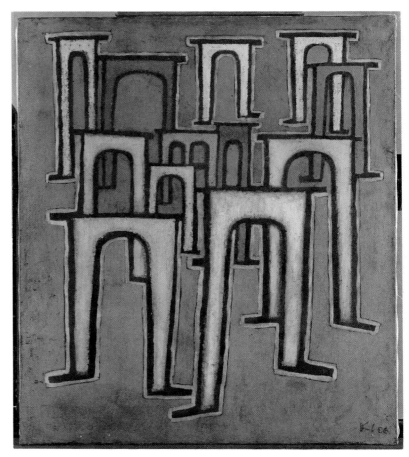

55. REVOLUTION OF THE VIADUCT
(REVOLUTION DES VIADUKTES)
1937 – Oil on canvas, 60 × 50 cm
Hamburger Kunsthalle, Hamburg.

far one goes beyond this framework is a matter of choice." In other words, the extrinsic structure of the object must not be confused with the intrinsic structure of the picture.

However, Klee did not resolve the relationship between form and content in the same way as Picasso, Braque, or Matisse. In 1905, Klee was introduced to Ernst Mach's research on the interpenetration of the interior and exterior world of the subject. The relationship that they have with Nature gives meaning to Klee's refusal to merely copy it. The form-content relationship is unified in his work through the intermediary of the "Stimmung," which refers to Novalis' notion of the "magic self."

Subtle elective affinities exist between Novalis and Klee, so much so that he could rank among those famous "Sais Disciples" of the poet's first work. However, one has to take the word "disciple" in its ancient meaning, as the one who has just been, or who is on the point of being, initiated, that is, introduced to the beginnings, if not of knowing, at least of religious respect for the mystery of the soul. A passage from the 1924 Jena Lecture is very clear on this subject. Recalling the emerging romanticism Klee affirmed: "And if I at last let the adverse forces

of the terrestrial world spread themselves as far as the cosmos, I then give up the impetuous aspirations of the pathetic style in favor of the other romanticism, the romanticism of fusion in the Great Totality."

Is this latter romanticism not precisely that of Friedrich von Hardenberg, called Novalis, born on May 2, 1772, the day of a solar eclipse? For the utmost proof, nothing more is needed than to read this actual quotation from the beginning of *The Disciples at Sais*: "Humans walk many paths. Those who follow and compare will see that there are people born who appear to be part of the vast encoded writing that one catches sight of everywhere: on wings, eggshells, clouds, snow, in crystals and in rock formations, on frozen water, inside and outside mountains, plants, animals, and human beings, in the stars, on the pieces of glass and lumps of resin that we have touched and rubbed, in the sparks around the lover, and in the singular contingencies of chance. One has a presentiment that there is a key to this marvelous new writing, even to its grammar." These "singular contingencies of chance" are the same that Hans Arp, Klee's friend, extolls in his *Configurations* and *Constellations*. There is a definite relationship between them that has not yet been sufficiently emphasized. Similarly to Arp, Paul Klee constantly cultivated this ambiguity between the abstract and the figurative that gives the savor to most of his works. Following behind Novalis, Klee and Arp both crossed this thin line between the two domains that 20th-century art had begun exploring. Another passage from the Jena Lecture, despite the modernity of the terms, captures completely the spirit of Novalis' romanticism: "Go from the Model to the Matrix!" Klee said. "Impostors, those artists who will not deviate from their path! Elected, those who take the deep plunge toward original law and to some proximity to the secret source by which all evolution is nourished. This place where the central organ of all movement in space and time — that we call the heart and brain of creation — always animates all functions; which artist would not like to reside there? In nature's bosom, in the primordial depths of creation where the key to all creation lies buried?"

Almost at the same moment, the philosopher Henri Bergson, was making the same discovery in Paris which he set down in his work *The Creative Evolution*. This "Creative Evolution" had just been revealed to Klee. He knew now that Nature was not simply a form that art had to faithfully copy, but a force to which the artist could and had to add his own force, in order to cooperate with it in the realization of all possible new forms and new worlds. From this moment, Klee's art no longer copied or tried to rival nature but instead collaborated with it. He took up Spinoza's distinction between nature in becoming and nature realized, the latter being nothing more

than the momentary fruit of the former, which alone is interesting because it is alive.

Another paragraph from the Jena Lecture is explicit on this subject: "First of all, the artist does not accord the same constraining importance to nature's apparent forms as do his numerous realist detractors. He does not feel subjugated, and for him the static forms do not stand for the essence of the creative process in nature. Nature in becoming gives him more than nature realized."

What purpose does it serve to reproduce nature already formed, a possibility that has already been realized? How much more interesting it is to dive into the source, to get to the heart of all transformation through this force that can perhaps impart life to everything that is not yet living! In 1906, Klee wrote this dream in his Diary: " . . . I was there where Creation begins: at the side of my adored Madam original cell who assured fertility." Paul Klee thus became a collaborator with Nature in the creation of all possible forms.

It is because of this collaboration that Klee was able to represent for us what we could never have imagined: new plants like the 1926 *Spiral of Flowers*, a totally believable bestiary from which came *Scorned Animal* and *Animal-Monument*, never before seen physiognomies, imaginary or utopian architecture, and machines that had not yet been invented. "Paul Klee only had to look through the keyhole, to discover in two centimeters square, a world of stars that we had thought lost."

Klee saw a work of art as an autonomous organism. An organism that develops according to a precise genesis and has a function and specific laws pertaining to it. It would be dangerous to ignore or transgress these laws, for the organism would then cease to be viable, likely, or possible and would consequently return to nothingness. These laws, necessary though they are, are however not sufficient. The organism still has to receive life from what both Klee and Kandinsky term the *spiritual*.

Klee invites us to understand "that if one tries to see the laws separately when confronting the works, it is in order to see how they move apart from nature without straying beyond its bounds." He wants us to understand that, "the laws are only the evident substructure of nature and art." This (annotated) phrase is enough in itself to show the Surrealists' gigantic blunder when they claimed Klee as one of them. For they rejected all the laws as they did Nature, and their monsters can hardly be considered viable. Klee has no affinity with this kind of thinking. He was a scrupulous constructor; he never raved, and like Leonardo de Vinci whom he admired, he thought that the artist must not concern himself with the impossible.

His world is the "in-between world," the world of

"those not yet born," the intervening world between the impossible and the real, a world that can become real, that must become real: it waits only for the artist or nature's impetus.

Paul Klee created this in-between world for us to explore. And these pictures are very powerful, without the smallest detail being gratuitous or superfluous. Everything is in its correct place, and they are perfectly balanced. These fantasies with their internal logic are much more subtle than any of our syllogistic reasoning. Look, for instance, at some crystals of potassium chlorate under the polarized light of a microscope. And remember that the fairyland of forms and colors being looked at is a kingdom of order and constraint. There is not a single atom that is not exactly where it should be. There is no fantasy in this enchanted world. And the dream that it offers us has only implacable necessity as its source. It is the same as Klee's works. "If the picture ultimately has the aspect of a configuration of cut crystals or polished stones, this is not a game but the logical result of a meditation on form." A meditation that Klee will push to the extreme in his courses at the Bauhaus. All forms are studied, as well as the possibilities of their combinations, in order to show what the result would be of putting a particular line at a particular point in the picture.

"For the artist," remarks Sartre in *What Is Literature?*, "a bouquet and the tinkling of a spoon on the saucer are things in the supreme degree; he insists on the quality of sound or form, comes back to it without cease, and bewitches himself with it; it is this color-object that he transports onto the canvas, its only modification being its transformation into an imaginary object. He is therefore very far removed from considering colors and sounds as language."

Sartre notes here that: "Klee's attempt to make a painting that is both sign and object at the same time shows both his greatness and his error."

The problems of language most certainly lie beyond pure painting, which makes Klee still one of the most vital artists of our day. The delicacy of his plastic mastery is inseparable from the poetry of his soul; together, they were able to capture the deepest forces hidden from ordinary mortals. "My love is distant and religious," he said. "I am in a remote place from where I choose as hypotheses, formulas applicable to man, animal, or vegetable, the stars and the earth, fire, water, and air and at the same time to all moving forces."

The dialectical structure of Sartre's observation reveals a fundamental paradox: It brings the symbol to life in the object and transforms the object into symbol where the connotative function of the symbol is almost reduced to nothing but still, at the same time, has the ability that we could describe, using a neocritical expression, as myth creation, as if the

linguistic cosmos had come back to original chaos, where there is no relative horizon and where consciousness has to be created. The paradox is in the dissolution of the gnoseological distance between consciousness, which names, and the object, which is named: a kind of community between the representation and its content: the stumbling block that overturns the notion of the autonomous form of recognition and the alienated linearity of its deployment. Sartre said something very profound about Klee's painting, but he did not reflect enough on Klee's intentions. Klee's irony, which is an inherent and fundamental part of the process, escapes Sartre, and even though he understands the gnoseological property of Klee's experience, Sartre does not realize that Klee's reflection is a metacriticism of the gnoseology. Kandinsky had already observed in, "The Spiritual in Art" that the work of art is its own subject, and all the consequences of the Cubist revolution are only a radicalization of the theoretical premise that postulates painting in so far as object. It is here, without doubt, that the basis for the criteria for the identification of modern art is to be found. But it is exactly this disposition that is the destructive aspect of Klee's theoretical and plastic work. His painting, which is sign and object at the same time, reveals the problem of form that no longer comes

56. PASSION DETAILED, ALSO THE MOTHER OF DÜRER (DETAILLIERTE PASSION. AUCH DÜRERS MUTTER 1940/178 (R 18) – Black grease pencil on Japanese simili, 29.5 × 21 cm Paul Klee Foundation, Kunstmuseum, Bern.

47

from the self and indicates the limits of this degradation/reduction of language. Contrary to modern art, which directs the attention to subjective and formal conditions of "making" and resides to a certain extent in the theoretical premises of gnoseology, as well as tending to exhaust the dialectic of the subject, Klee grasps the question in its totality, reestablishing an analogous relationship and crossing over the limits of transcendental knowledge to its very root. Conceivably, Sartre's observation of the principle of "grandeur" and "error" in Klee's work was just. But this error, which is a conscious alienation, must be treated with the greatest prudence, for Paul Klee's true face is hidden in this secret dialectic.

Modern painting has consisted not so much of choosing between line and color or even between figuration and the creation of signs, as in the multiplication of systems of equivalents. For example, there has been a prosaic conception of the line as a positive attribute belonging to the object in itself. It is the outline of the apple or the edge of the plowed field. This latter line is disputed by all of modern painting. Now the challenging of the prosaic line by no means excludes all line in painting, as the Impressionists perhaps believed. It is a matter of freeing it, of bringing its constituent power to life again, and we see it reappear and triumph without any contradiction in painters like Matisse or Klee, who believed more than anyone in color. For according to Klee, the

author of the "Creative Confession": "Art does not reproduce the visible, it renders it visible." We tend to forget that Eugene Fromentin said exactly the same thing: "The art of painting is only the art of expressing the invisible by the visible." There is only a difference in appearance, for Paul Klee was certainly not an abstract painter.

According to Deleuze and Guattari, the "bird in becoming" can only happen insofar as the bird itself is in the process of becoming something else, pure line and color, which is exactly Klee's case. In his last pictures of 1940, Klee used a simple and direct graphic expression (*Death and Fire; Drummer*), even though he abandoned it for his final *Still Life*. Fundamentally, Klee remained faithful to the end to a conscious use of theme, symbolism (Death, Fire), and even traditional subjects.

According to Apollinaire, there are phrases in a poem that seem to have formed rather than been created. And according to Henri Michaux, Klee's colors sometimes appear to emanate from primordial depths, slowly coming to life on the canvas, "breathed onto the right place" as a patina or mould. Art is not construction, artifice, or industrial relationship to space and the world outside. It is truly the "soundless cry," the voice of light that Hermes Trismegistus talks about. And once accomplished, it awakens in ordinary vision the latent power that is the mystery of preexistence.

1939 HI 19 ein Antlitz auch des Leibes

57. FACE AND BODY EQUALLY
 (EIN ANTLITZ AUCH DES LEIBES)
 1939/1119 (HI 19) – Oil paint and glue on paper, 31 × 23.6 cm
 Private collection, Switzerland.

The sous-verre paintings

Between 1905 and 1908, Klee's interest was caught for a while by the popular feel and the delicate material of sous-verres and he did a number himself. Heinrich Campendonk, one of the founders of the Blaue Reiter, was the first to discover these fixed paintings made by Bavarian peasants as votive offerings. He tried to recreate their naïveté and expressive strength in his work, living for several years on farms in the neighborhood of Sindelsdorf and Seeshaupt and acquiring exceptional mastery over the sous-verre painting technique.

When Klee attempted them, he covered a plate of glass with black or color and used a needle to engrave on it; the indirect and surprising characteristics of this technique pleased him a lot. "Drawing and painting 'sous-verres' gives me a lot of pleasure," he wrote in his Diary in 1906. "I have already completed a sentimental woman with a a hypertrophic bosom accompanied by a tiny dog."

In February 1906, he did *Young Girl Writing*, stepping, all white, out of a fish, after a drawing from nature.

And in February, he also described this "ingenious glass-pane technique" in his Diary:

"1) Cover the plate completely with white tempera and, if needed, by spraying on a diluted mixture.
"2) When it is dry, scratch the drawing onto it with a needle.
"3) Fix it.
"4) Cover the back with black or colored areas.
"The trained hand is often much more knowledgeable than the head. The compositional harmony gains character by dissonant values (roughness imperfections), which are balanced by means of counterweights."

Also in 1906, he produced *Sentimental Virgin with a Daisy*, in which caricature and "Jugendstil" mannerism are used in a much more effective way than in the zinc etchings of 1903 to 1905 (*Virgin in a Tree*, *Two Men Meet Each Supposing the Other to Be of Higher Rank*, *Comedian*, *Menacing Head. . .*)

Another black gouache sous-verre, the *Sleeping Herd* of 1908, shows, on a predominantly naturalist subject like a landscape, his desire to transfigure the realist vision. "This work comes together easily," he wrote in his Diary in 1908. "Contrarily, the primary effect of the black begins where nature ends. Like the sun on dark valleys, which it penetrates by degrees as it rises."

58. PAUL AND FRITZ
(PAUL UND FRITZ)
1905/19 (A) – Sous-verre, 12.9 × 17.7 cm
Paul Klee Foundation, Kunstmuseum, Bern.

59.

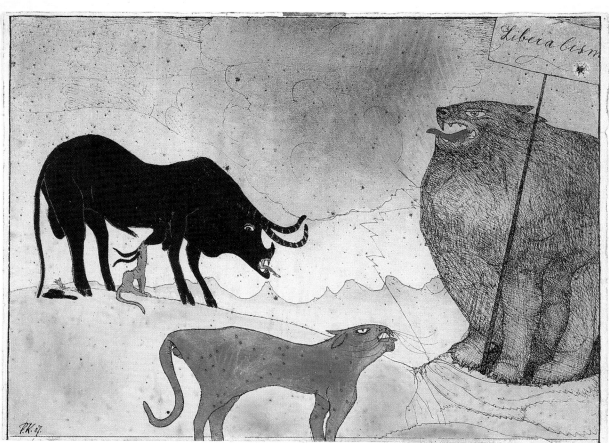

60.

59. GARDEN SCENE WITH WATERING CAN
(GARTENSZENE GIESSKANNE, EINE KATZE, EIN ROTER STUHL)
1905/24 (R) – Sous-verre, 14 × 18.5 cm
Private collection, Switzerland.

60. THE PARTY CONCERT
(DAS KONZERT DER PARTEIEN)
1907/14 (A) – Watercolor, pen and India ink
on paper, 24.2 × 33 cm
Paul Klee Foundation, Kunstmuseum, Bern.

61. CACTUS
(KAKTEEN)
About 1913 – Oil on cardboard, 52 × 41.5 cm
Lenbachhaus Städtische Gallery, Munich.

63. NUDE WOMAN (JUST AS FAR AS THE KNEES)
(WEIBLICHER AKT [BIS ZU DEN KNIEN])
1910/124 (B) – Oil on canvas remounted on cardboard, 38.9 × 25 cm
Paul Klee Foundation, Kunstmuseum, Bern.

62. BUCKET AND WATERING CAN
(EIMER UND GIESSKANNE)
1910/44 (B) – Watercolor on paper mounted on cardboard, 9.8 × 11.9 cm
Paul Klee Foundation, Kunstmuseum, Bern.

Girl with Jugs, 1910 64

In the years preceding this picture, Klee perfected the first of the principles that would govern his painting. Under the title, "Genesis of a Work," he wrote in his Diary in 1908: "Another oil painting.

"1) Putting down patches of color in various complexes, freely produced from my feelings, as the ineradicable essential principle of the work.

"2) Objectively take in this 'nothing' (the marble tables in my uncle's restaurant), make it figurative, clarifying it by means of light and shadows. A given ground tone was first laid down, which shows through here and there over the surface."

The following year he added: "The total impression is based on an economic evaluation that consists of deriving the effect of the whole from a few steps." This is the procedure followed in this painting.

It was also in that year that he first saw Cézanne's work at the Secession exhibition. It was an important discovery. "For me, he is the master teacher," he wrote, "much more qualified to instruct me than Van Gogh." His influence, which is evident in *Girl with Jugs*, came at the critical time of Klee's rupture with Expressionism. This influence can also be seen in a watercolor of the same year, *Bucket and Watering* 62 *Can*. In *Girl with Jugs*, the jugs are pressed down onto the table whose planes are also registered on the young girl's face. The composition is marked by a violent chromatism in which red and blue dominate; a red close to madder-red ("the basic determining tone") bursts over her cheeks, the three jugs, and the vase of flowers. Cezanne's influence on Klee was much greater than that of Matisse, whose exhibition at the Thannhauser gallery in Munich he had just seen.

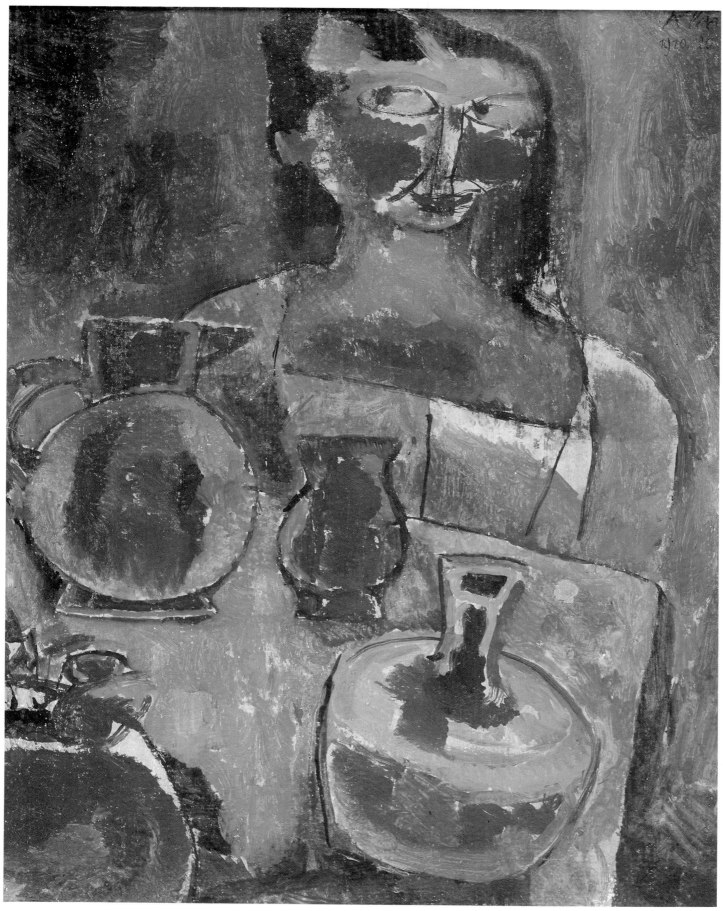

64. GIRL WITH JUGS
(MÄDCHEN MIT KRÜGEN)
1910/120 – Oil on cardboard, 35 × 28 cm
Private collection, Switzerland.

66. MILBERSTHOFEN NEAR MUNICH (AFTER NATURE)
VORSTADT MILBERSTHOFEN-MÜNCHEN (NACH NATUR)
1913/44 – Watercolor, 10 × 22.5 cm
Private collection, Switzerland.

67. MUNICH, MAIN STATION II
(MÜNCHEN HAUPTBAHNHOF II)
1911/25 (B) – Pen and India ink on paper mounted on cardboard, 9.1 × 19.6 cm
Paul Klee Foundation, Kunstmuseum, Bern.

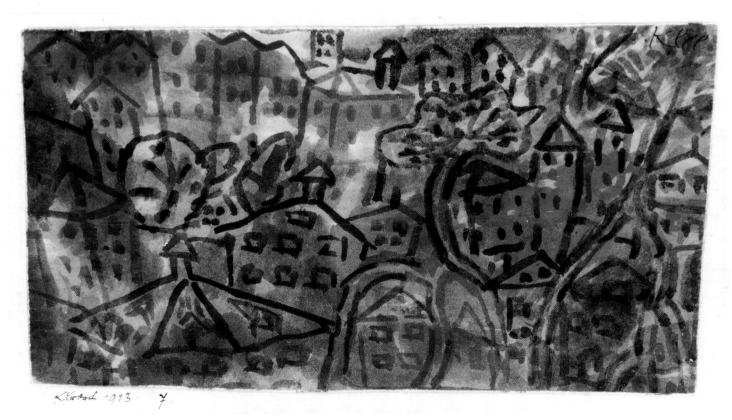

68. SPA
(KURORT)
1913/7 – Watercolor, 9.5 × 17.5 cm
Old Collection, Saidenberg Gallery, New York.

55

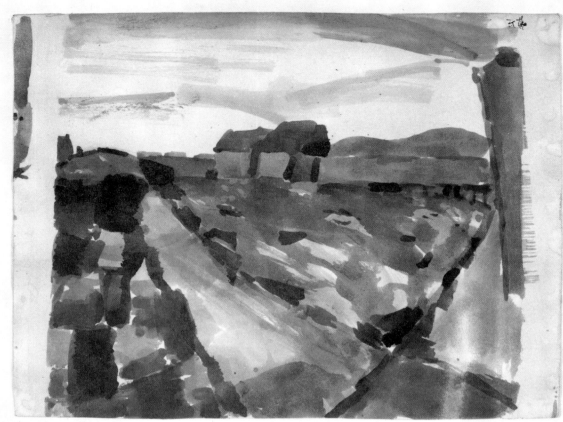

1914/214 Landhäuser am Strand

69. HOUSES ON THE BEACH
(LANDHÄUSER AM STRAND)
1914/214 – Watercolor, 21.9 × 28.6 cm
Paul Klee Foundation, Kunstmuseum, Bern.

60–80 The Tunisian Watercolors, 1914

In Tunis, Klee noted in his Diary:
"Arrived at Hammamet, there is still a bit of a journey by road before we get to the town. What a day! There were birds singing in all the hedges. (. . .) The town is magnificent, right by the sea — it is all bends and sharp corners. From time to time from the top of the surrounding walls someone will toss you a glance! We see many more women in the streets than in Tunis. The little girls are unveiled just like at home. Then too, one is allowed to go into the cemetries here. One of these stretches splendidly along the sea. Some cattle are grazing in it. I try to paint. The reeds and bushes form a beautiful rhythm of patches."

70 Saint-Germain near Tunis Inland, 1914

On April 11, 1914, Klee noted in his Diary: "Saint-Germain (Tunis). Several watercolors on the beach and from the balcony. The watercolor of the beach still a touch too European. Could just as well have been painted in Marseilles. In the watercolor from the balcony, I encountered Africa for the first time." This "watercolor from the balcony," was done almost at the same time as *Villas on the Shore*, which was "still too European."

Here Klee divides the paper with horizontal and vertical axes and fills each of the squares with its respective color. So as to restrict some isolated elements, marks are put on in sweeping flourishes; the composition becomes concentrated and an unexpected gradation of the atmospheric content occurs at the same time. In comparing it with contemporary works, we can see what Klee, in this important phrase, meant by "abstraction" and the "disengagement from relationships that are purely plastic." Klee renounced the exaggerated drawing of perspective; only a part of the image seemed to be on the exterior. The colors are harmonious, pure, and dense, meaning that each is a definite field that can be perceived as an isolated tone within the whole. "Purity," Klee later said, "is an abstract domain. Purity is an elementary analysis at the heart of the plastic limitations of the image." The forms and colors of the natural model are henceforth no longer restrained in the way they are rendered. There is, therefore, no limit to the process of abstraction, as long as the plastic laws are obeyed. The picture's effectiveness no longer depends on a faithful copy of nature, but on its own intrinsic laws. In the Tunisian watercolors, the landscape motifs are only used insofar as they comply with the plastic laws of composition.

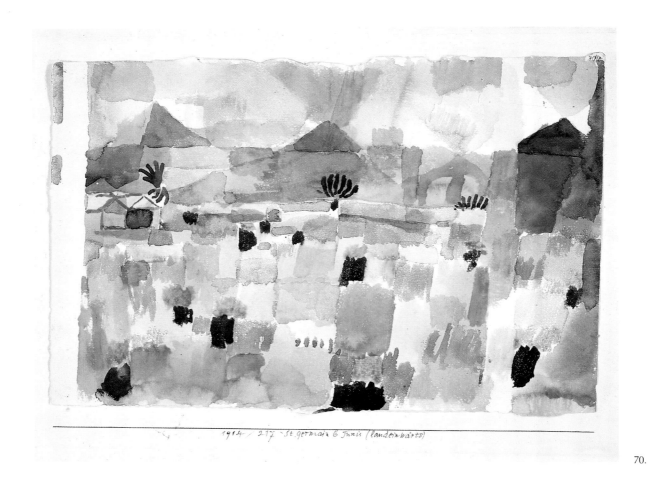

1914 / 217 St.germain 6 Juni (landeinwärts)

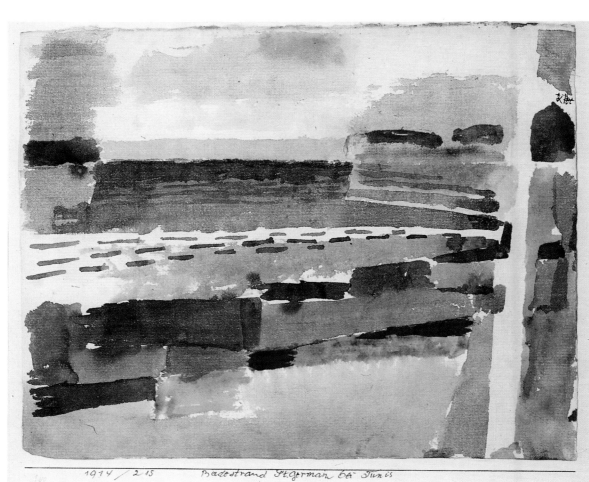

1914 / 215 Badestrand St.german bei Tunis

70. SAINT-GERMAIN NEAR TUNIS, INLAND
(SAINT-GERMAIN BEI TUNIS, LANDEINWÄRTS)
1914/317 – Watercolor on paper, 21.8 × 31.5 cm
Georges-Pompidou Center, Paris
Gift of Nina Kandinsky.

71. BEACH AT SAINT-GERMAIN NEAR TUNIS
(BADESTRAND, SAINT-GERMAIN BEI TUNIS)
1914/215 – Watercolor on paper mounted on
cardboard, 21.7 × 27 cm
Museum der Stadt, Ulm.

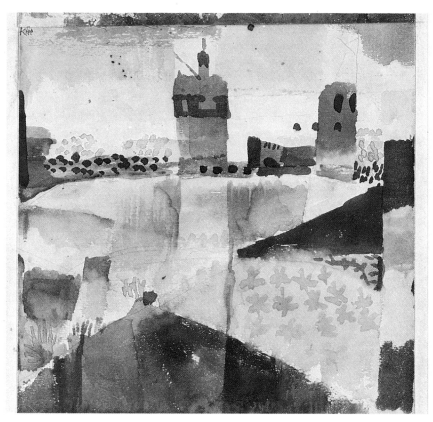

72. HAMMAMET WITH MOSQUE
(HAMMAMET MIT DER MOSCHEE)
1914/99 – Watercolor on paper mounted on cardboard, 20.5 × 19 cm
Heinz Berggruen Collection, Metropolitan Museum, New York.

73 **Motif from Hammamet, 1914**

This watercolor, one of the first done on his famous trip with Macke and Moilliet, puts itself, on the contrary, on the indecisive frontier between the visible and the readable that Klee so delighted in. The composition, based on little juxtaposed squares, is the forerunner of the later "magic squares" and architectural series. His mastery of color is remarkable and bears out his statement of April 16: "That is the meaning of this happy hour: color and I are one. I am a painter!" Less quoted and shedding more light on this work is this passage in spring 1914, after the voyage: "Drawing as the expressive movement of the hand holding the registering pencil, which is essentially how I practice it, is so fundamentally different from the usage one makes of tone and color that one could very well use this technique in the dark, even in the blackest night. On the other hand, tone (movements from light to dark) presupposes a bit of light, and color presupposes a great deal."

This movement from light to dark can be clearly seen going from the lower right corner to the upper left corner, as pale yellow becomes midnight blue as it passes through the warmest colors at the center. This rhythm of pure form and color reappeared in *Hammamet with Mosque*, the first of the works 72 painted from memory after the Tunisian voyage. The mosque's minarets clearly rise into a blue sky that has been obliterated by a mass of green and red points. There is still vegetation here and there on parts of the surface, but the light seems to upset the line, and the color, modulated from carmine to mauve and from yellow to green, searches for itself in this chaos, according to Delaunay. As he often did, Klee brought in two lateral bands to prop up his composition, the one on the right, adding a blue missing from the chromatic scale, and the other at the top, forming an echo of the big red triangle at the bottom.

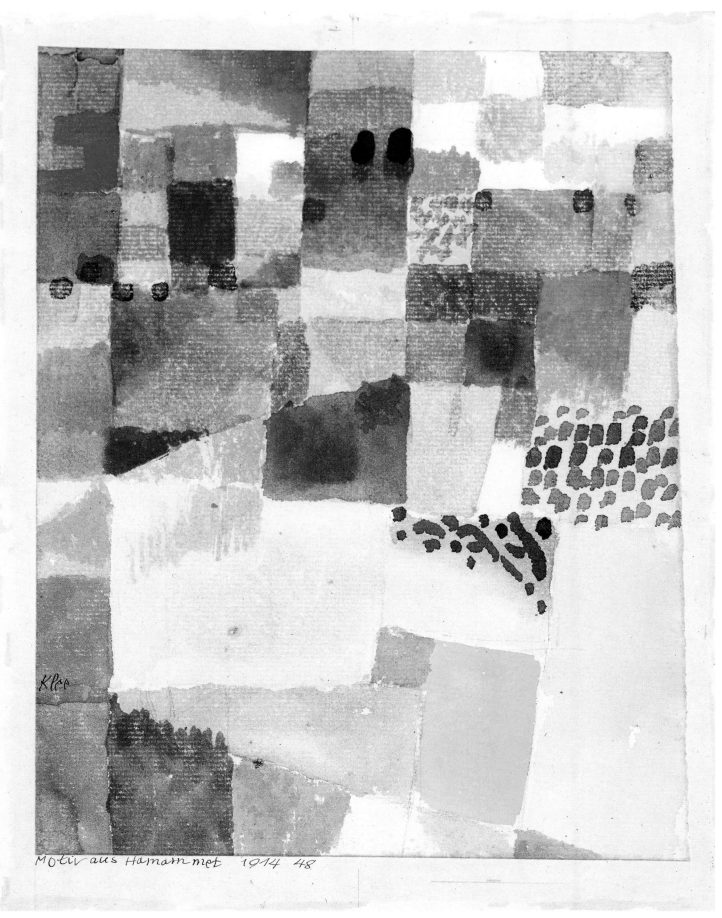

73. MOTIF FROM HAMMAMET
(MOTIF AUS HAMMAMET)
1914/48 – Watercolor on Ingres paper, 20.2 × 15.7 cm
Kupferstichkabinett, Kunstmuseum, Basel.

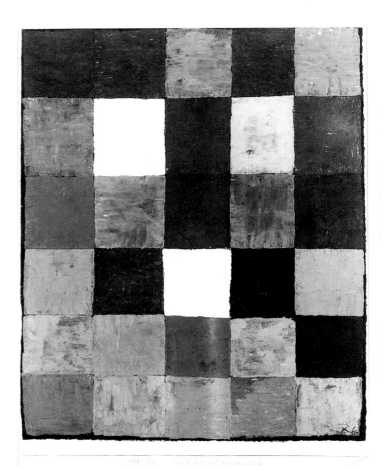

74. ON A MOTIF FROM HAMMAMET
(ÜBER EIN MOTIF AUS HAMMAMET)
1914/57 – Oil on cardboard, 27 × 22.5 cm
Kupferstichkabinett, Kunstmuseum, Basel.

75. TABLE OF COLOR (IN GRAY MAJOR)
(FARBTAFEL [AUF MAIOREM GRAU])
1930/83 (R 3) – Pastel on black Ingres paper, 37.7 × 30.4 cm
Paul Klee Foundation, Kunstmuseum, Bern.

76 **Red and White Domes, 1914**

The way the colored surfaces are put down in *Red and White Cupolas*, is reminiscent of Delaunay whom Klee had met two years earlier in Paris. Delaunay tells us what he is after in talking about his *Saint-Severin* series: "The search for another aesthetic due to the uncertainty of the old; the disintegration of traditional perspective; light in the old construction as a means of disturbing the line; color searching for itself in this chaos, but not yet being able to organize itself, makes the elements used discordant; the depth obtained is through the colors themselves rather than through any real relationship with each other."

Where his travelling companion, August Macke, used a composition in vertical bands (*Kairouan III*, 1914), Klee used a checkered composition that comes 75 up again in the *Magic Squares* series. It is possible to see the painting of the series of white and red cupolas (thrown into disarray by the light) as abstract. As is often the case with Klee, we are once again on the thin line between abstract and figurative that he likes

so much. He explains this in his "Creative Confession" as: "A simultaneous combination of forms, movement, and counter-movement, or, more naïvely put, contrasting objects. (Chromatically: the use of complementary hues of pure color, as in Delaunay). Every force needs its complementary power in order to attain a state of equilibrium." Color, spilling over the checkerboard composition, adds to the oriental impression of chaos. This impression of incompleteness gives free rein to the viewer's imagination, instead of leaving him outside the work without any possibility of collaboration. The work becomes a "crossing": the object is begun by the painter then continued by the viewer, who unable to complete it throws it back to the painter, establishing a kind of shuttle. This kind of collaboration is impossible with, for example, someone like Raphael, where everything is safely locked inside. This necessity (or right) of the viewer to participate in the work, which is then called "open," can never be emphasized enough for a great part of 20th-century art.

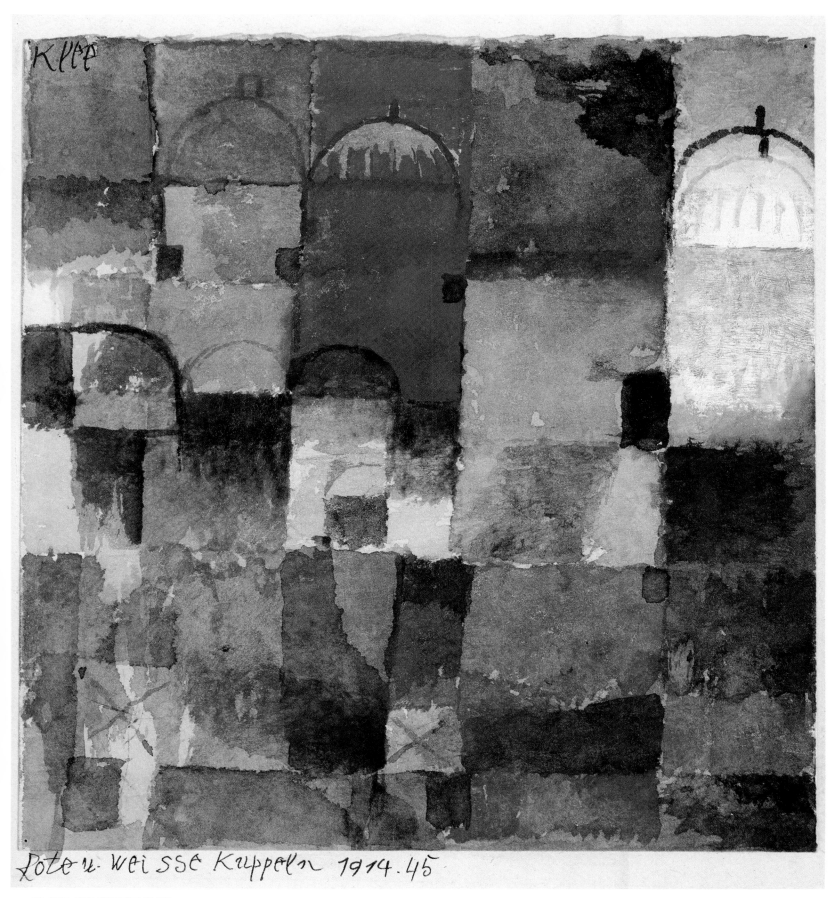

76. RED AND WHITE DOMES
(ROTE UND WEISSE KUPPELN)
1914/45 – Watercolor and gouache on paper, 14.6 × 13.7 cm
Kunstsammlung Nordrhein Westfalen, Düsseldorf.

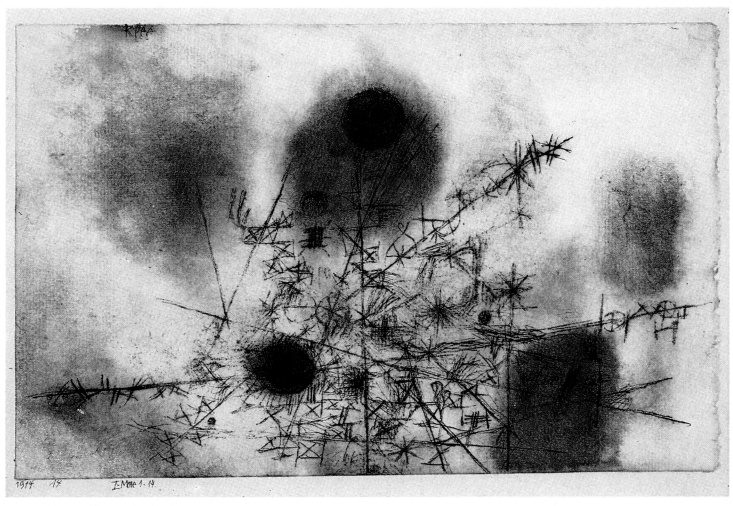

77. GENESIS OF CONSTELLATIONS
(GENESIS DER GESTIRNE [1 MOSE 1. 14])
1914/14 – Pen and watercolor on Ingres paper mounted on cardboard, 16.2 × 24.2 cm
Private collection, Munich.

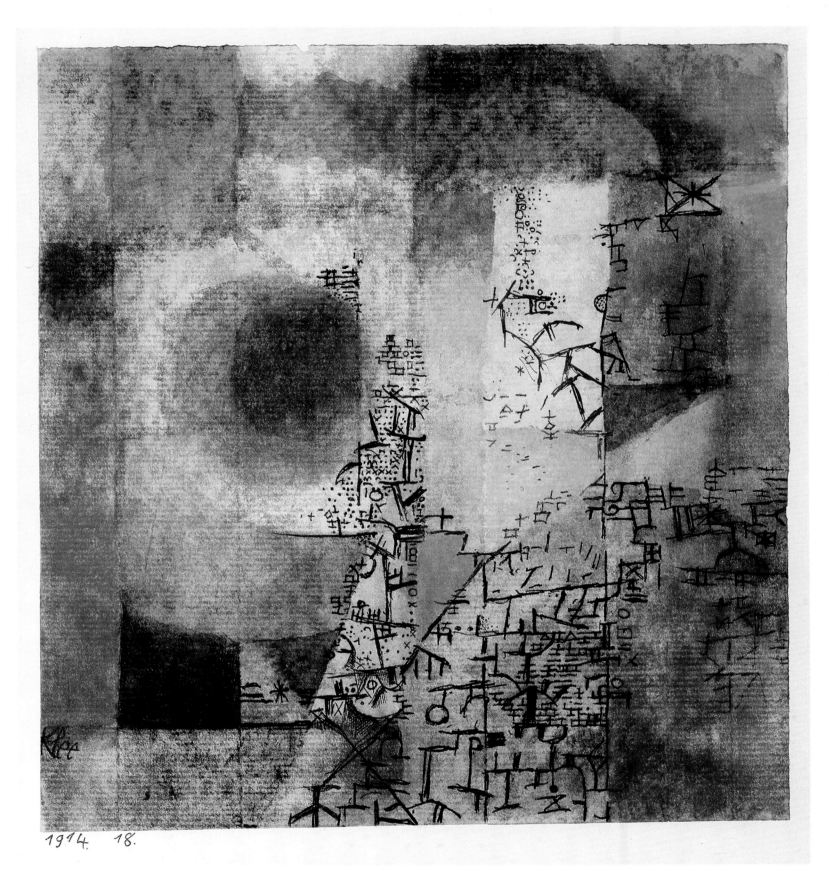

1914. 18.

78. UNTITLED
(OHNE TITEL)
1914/18 – Watercolor and pen on Ingres paper, 17 × 15.8 cm
Kupferstichkabinett, Kunstmuseum, Basel.

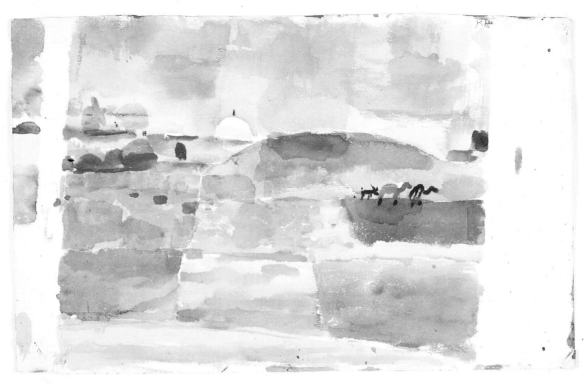

79. BEFORE THE GATES OF KAIROUAN
 (VOR DEN TOREN VON KAIROUAN)
 1914/216 – Watercolor on paper, 20.7 × 31.5 cm
 Paul Klee Foundation, Kunstmuseum, Bern.

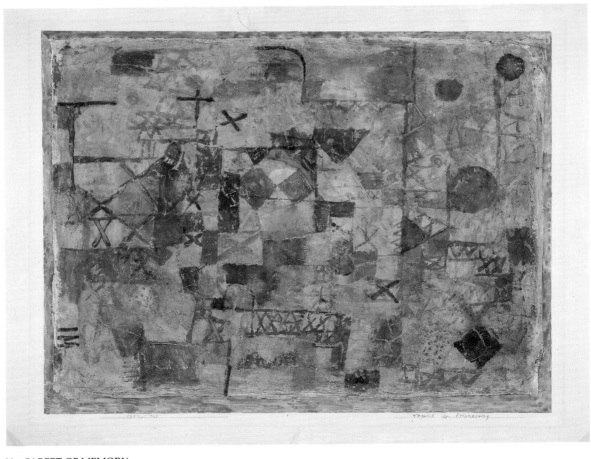

80. CARPET OF MEMORY
 (TEPPICH DER ERINNERUNG)
 1914/193 – Oil and chalk on cardboard, 40.2 × 51.8 cm
 Paul Klee Foundation, Kunstmuseum, Bern.

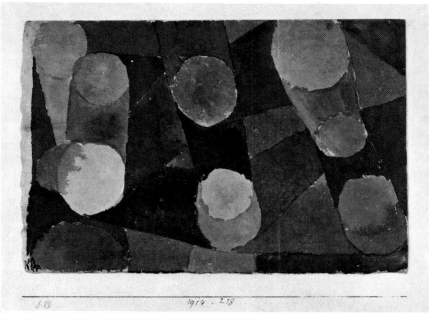

81. ABSTRACTION: COLORED CIRCLES WITH COLORED BANDS
(ABSTRAKT, FARBIGE KREISE, DURCH FARBBÄNDER VERBUNDEN)
1914/218 – Watercolor on paper mounted on cardboard, 11.7 × 17.2 cm
Paul Klee Foundation, Kunstmuseum, Bern.

80 Carpet of Memory, 1914

Klee and Kandinsky both had a strong influence on the Zurich Dadaists regarding the development of a formal abstract language, which leaned more toward symbolic expression than material representation. The painter, refusing to be dictated to by strict resemblance, is the same thing as the poet trying to get away from syntax bound to literal meaning. In the seemingly absurd Dadaist poetry, the way the poets were trying to express this renaissance of letters and sounds was very much like what Klee and Kandinsky were trying to do with line and color. Hugo Ball formulates it in this way in "Flight Outside of Time": "Painters, advocates of the Vita comtemplativa: harbingers of the supernatural language of signs. Repercussions on the imagery of poets. The symbolic aspect of things is a consequence of their long use of images. Is sign language not the true language of paradise?"

This remark, which harks back to the Blaue Reiter, was proof of Ball's admiration for Klee's recent works. *Carpet of Memory* (1914), is an ideal example to explain this phenomenon. This is one of the first works in which Klee refrains from a simple description of visible reality and puts down instead the world that is in his head. This work was done shortly after his journey to Tunis in April 1914. This trip was very important for him, for it was at this time that his formal abilities, which he knew conditioned the development of a personal expression, crystallized. The watercolor landscapes done after nature in Tunisia, provide the plastic base of *Carpet of Memory*, which is a graphic erection of the kind of scaffolding apparent in analytical Cubism. Colors and lines soar and thrust in a deep amorphous space formed by a thick base of muslin covered with yellow plaster.

The image can no longer be read as a naturalist landscape. Nor is it the representation of a carpet. The rich irregular structure of the material certainly brings the flora of an antique carpet to mind, and the muslin edge is very like the fringes and knots from weaving. But the title means much more. Like a worn carpet talking about the life it shared with humans, the work manifests its creator's fantasies. This work does not have the villagelike nostalgia of a Chagall, but Klee also renders the spirit of the place and a remembered moment. When in 1915, he describes himself in his Diary as "abstract with memories," he says something very important about his art and time. For Klee's work shows us that the act of "seeing" not only consists of optical perceptions but also includes associations of feelings, things, and events that have been in our memories for a long time.

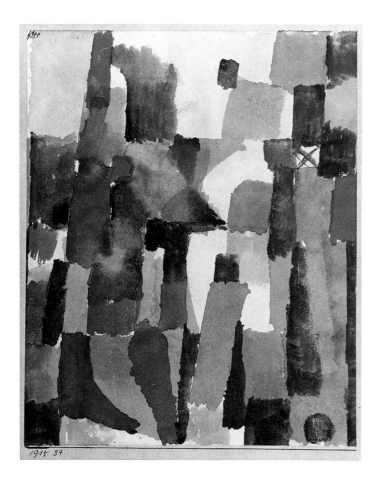

In a prismatic space animated by gyratory movement, blades of complementary color are arranged around a center in which are some pieces of a fir tree. There is a real "struggle for the space" or a treatment of the interior and exterior space by means of simultaneous penetration. Klee explains it like this: "The movement of the boundary-opposition is highlighted in different ways, by a treatment of the interior, focusing on the boundary-opposition or by a treatment of the exterior. Sometimes the center itself of the interior space is particularly accentuated. This situation brings about a conflict between the exterior and interior space. The final result could almost be described as a meshing of forms."

82. QUARRY AT OSTERMUNDIGER — TWO CRANES
(IM OSTERMUNDIGER/STEINBRUCH — ZWEI KRANE)
1907/23 (B) – Charcoal, India ink, and watercolor on Ingres paper mounted on cardboard, 63.1 × 48.6 cm
Paul Klee Foundation, Kunstmuseum, Bern.

83. VISION OF A RISING CITY
(HOCHSTREBENDE STADT-VISION)
1915/54 – Watercolor on paper, 20.5 × 15 cm
National Museum of Modern Art, Georges-Pompidou Center, Paris.

84. SKETCHES FOR "ANATOMY OF APHRODITE"
(FLÜGELSTÜCKE ZU "ANATOMIE D'APHRODITE")
1915/48 – Two watercolors on chalk-coated ground on Ingres paper, 23 × 19.5 cm
Private collection, Switzerland.

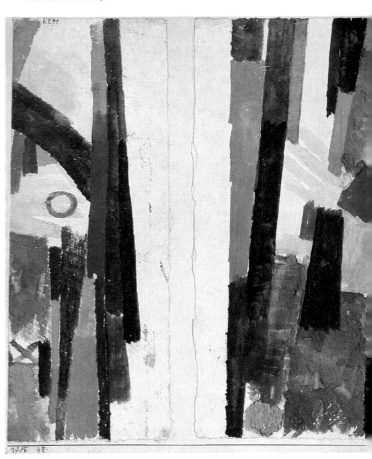

85. THE IDEA OF A FIR TREE
(DIE IDEE DER TANNEN)
1917/49 – Watercolor on paper, 24 × 16 cm
Solomon R. Guggenheim Museum, New York
Gift of Eve Clendenin.

86. QUARRY AT OSTERMUNDIGER
(STEINBRUCH OSTERMUNDIGER)
1915/213 – Watercolor on paper mounted on cardboard, 20.2 × 24.6 cm
Paul Klee Foundation, Kunstmuseum, Bern.

87. ARCHITECTURE WITH RED FLAG
(ARCHITEKTUR MIT DER ROTEN FAHNE)
1915/248 - Watercolor and oil, 31.5 × 26.3 cm
Private collection, Switzerland.

88. ON THE SUMMIT
(ÜBER BERGESHÖHE)
1917/75 – Watercolor on Ingres paper, 31 × 24.1 cm
Private collection, Holland.

89 **Breezes in Marc's Garden, 1915**

Some brief moments spent in the garden of Franz Marc — his great friend from the Blaue Reiter days who was to fall one year later at Verdun — with the warm wind from the south blowing, were an interlude, a short respite from the absurd and murderous war. As if to reinforce the antagonism existing between himself and the alpine nature, Klee transformed everything into a precise arrangement of overlapping checkered or losangelike shapes. Using analytical Cubism to break the subject up into stereometric elements allows Klee to develop an associative optical language that accords with that of dream and memory.

This is far removed from the prismatic fairyland brought out by Franz Marc in 1913 in a picture like

Stables at the Guggenheim Museum. Klee was no doubt aware of this, for in 1915 he wrote in his Diary: "Today is a transition from yesterday. In the great ocean of forms lie the ruins to some of which we still cling. They provide abstraction with its material. A junkyard of inauthentic elements for the creation of impure crystals." The impression of impure crystals is, in fact, what one registers in front of these pines spread around a red roof, pines that find their echo in the blue, violet, and white conical peaks. In the foreground, to the right, the mauve and green resemble the shingled roof of a chalet. They are the only reassuring and intimate note (this is also where Klee wrote) in this solitary and desolate landscape, in this garden where no flowers grow.

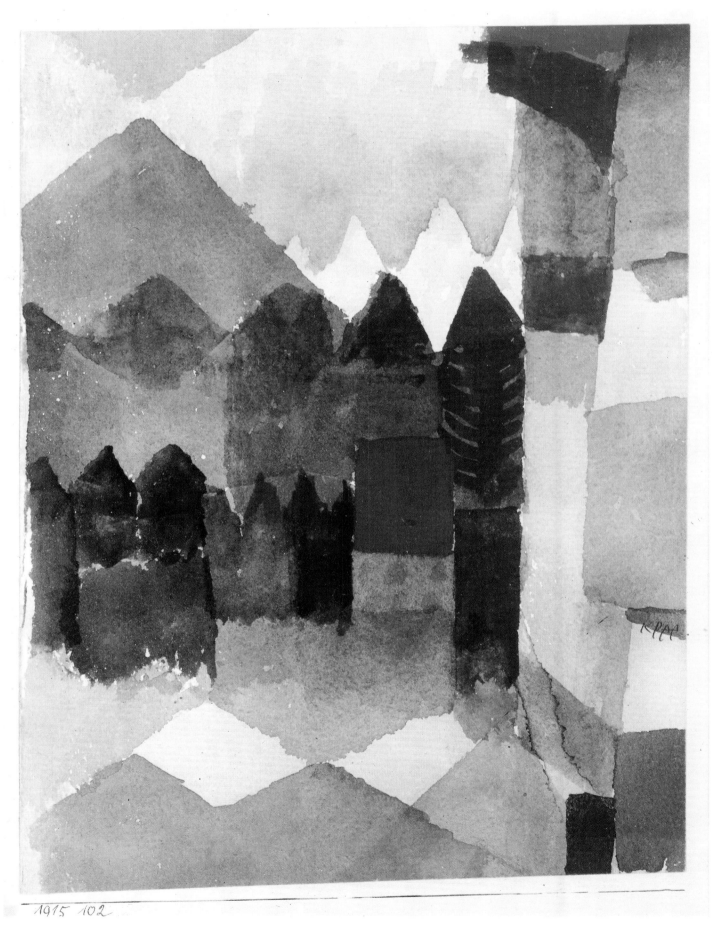

1915 102

89. BREEZES IN MARC'S GARDEN
(FÖHN IM MARC'S SCHEN GARTEN)
1915/102 – Watercolor on Ingres paper mounted on cardboard, 20 × 15 cm
Städtische Gallery in Lenbachhaus, Munich.

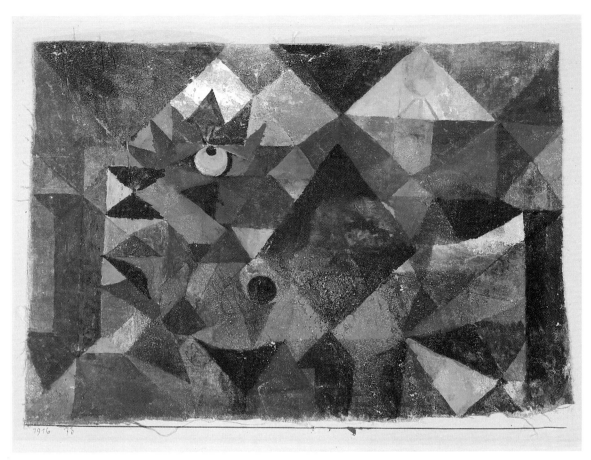

90. KAKENDAEMONISCH
 (KAKENDÄMONISCH)
 1916/73 – Watercolor on cardboard, 18.5 × 25.5 cm
 Paul Klee Foundation, Kunstmuseum, Bern.

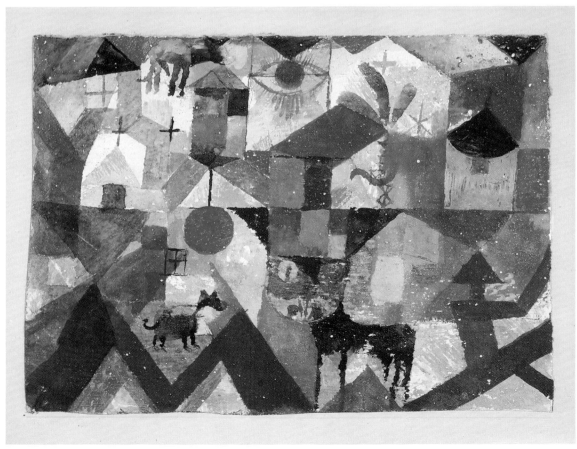

91. ZOO
 (TIERGARTEN)
 1918/42 – Watercolor on cardboard, 17.1 × 23.1 cm
 Paul Klee Foundation, Kunstmuseum, Bern.

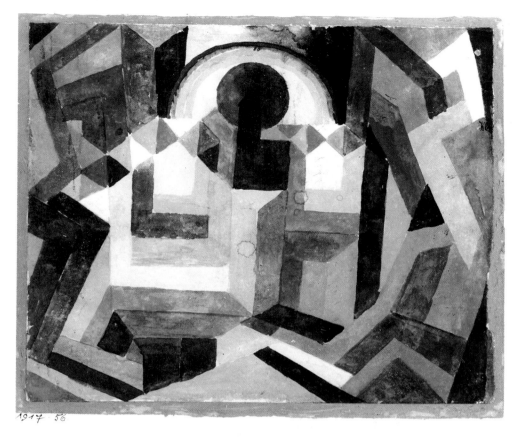

1917 56

92. WITH RAINBOW
 (MIT DEM REGENBOGEN)
 1917/56 – Watercolor on chalk, 18.6 × 22 cm
 Private collection, Switzerland.

93. AB OVO
 1917/130 – Watercolor set on gauze backed with paper, 14.9 × 26.6 cm
 Paul Klee Foundation, Kunstmuseum, Bern.

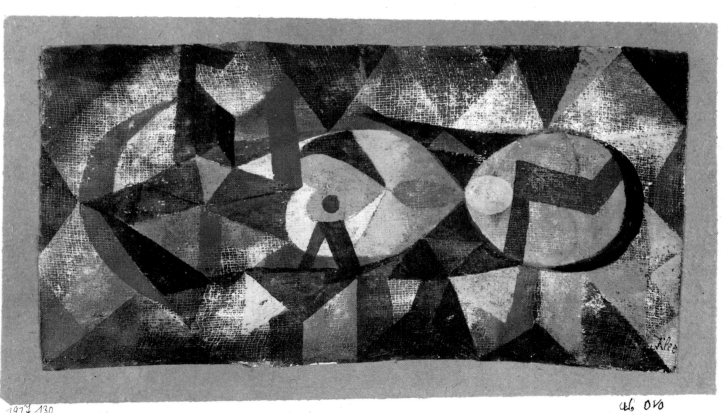

1977 130.

1917 / 152 Zeichnung zum Unstern der Schiffe

94. DRAWING FOR "SHIP'S WARNING"
(ZEICHNUNG ZUM UNSTERN DER SCHIFFE)
1917/152 – Pen and India ink on paper mounted on cardboard, 21.5 × 27.4 cm
Paul Klee Foundation, Kunstmuseum, Bern.

95 Ship's Warning, 1917

The year 1916, when Klee entered the army, was a period of reduced productivity, but the following year saw a series of drawings linked to watercolors. For the first time, watercolor becomes more important than drawing. In a letter to Lily on September 9, 1917, he is astonished at how prolific he is despite the difficult circumstances and observes that after each watercolor he feels as rested as if he had just had a leave of absence.

One of these series of drawings takes the ship and its symbolic significance as its theme. The threatened ship, a symbol of the uncertainty of life at that time, is acknowledged as one of the archetypes of Western iconography. The title of this watercolor has been incorrectly translated as *Ships' Sirens*, for Klee clearly wrote at the bottom of the pink sheet "Warnung" and not "Warner." All the same, we can pick out

some siren in these strange aquatic birds, either painted in gray or simply indicated with a stroke of the pen, that occupy the center of the composition. The most prominent has a blue half moon hanging over it and is flanked by a black star and two pink exclamation marks. A series of steam or sail ships, which look like humorous toys, drift in a fashion around these swan-sirens.

We find the black star with six branches again in a superb drawing of the same year, slightly later than this one. The "Bad Star" hangs over a muddle of ships, either in difficulty or shipwrecked, that seem to have paid no attention to the sirens. But it is all depicted with such humor that one forgets the dramatic and conventional stress of this kind of allegory.

95. SHIP'S WARNING
(WARNUNG DER SCHIFFE)
1917/108 – Pen and watercolor on paper mounted on cardboard, 14.2 × 15.6 cm
Graphische Sammlung, Staatsgalerie, Stuttgart.

96. TEARS OF BLOOD
(BLUTIGE TRÄNEN)
1923/237 – Gouache on a gauze base glued to cardboard, 19.3 × 33.8 cm
Paul Klee Foundation, Kunstmuseum, Bern.

97 Flowers of Sorrow, 1917

While standing guard in front of the munitions depot in Frottmaning in 1917, Klee saw that "a fabulous flora made things dazzlingly colorful." But the flowers in *Flowers of Sorrow*, scattered over the ground and histologically cut with the slanting scalpel on the right, seem more dead than alive. Twisted and deformed and showing in elaborate detail the tiniest rootlets, petals, pistils, and stamens, they no longer even have the appearance of life that a 1916 drawing, *Cruciform and Thoughtful Flowers* (Basel, Kunstmuseum), still does. The microscope has been added to the fantastic in death; the vegetation's globular shape is the first thing we see, the "Gestalt," foisting on us its abundant and useless details. Issuing from proliferating rhizomes, they are all going toward the bottom of the composition, where an eye with a tear sac, a heart pierced with an arrow, and the scalpel wait for them. In "Ways of Studying Nature," Klee formulates his intention: "Through our knowledge of its internal reality, the object becomes more than the framework of simple appearance. We know also that there is more to it than the exterior surface leads us to believe.

"The object is dissected and its interior revealed by the cuts made. Its character is organized according to the number and manner of the cuts that it was necessary to make. This operation brings forth the visible interiorization; whether it is done by means of a simple sharp knife or with the aid of more precise instruments, the material structure or the function of the object will be clearly revealed."

74

97. FLOWERS OF SORROW
(TRAUERBLUMEN)
1917/132 – Watercolor and pen, 23 × 14.6 cm
Bayerische Staatgemäldesammlungen, Munich.

98. SECOND PART OF A POEM BY WANG SENG YU
(II. TEIL DES GEDICHTES WANG SENG YU)
1916/22 – Pen drawing with watercolor mounted on cardboard, 7 × 24 cm
Paul Klee Foundation, Kunstmuseum, Bern.

99 Once Emerged from the Gray of Night . . ., 1918

This picture-poem ("Einst dem Grau der nacht entaucht . . .") effects a fusion of plastic and poetic. The origin of the poem is still unknown; this verse is not to be found either in "Psalms," or in the Chinese poems. Klee could very well have composed it himself for its content is close to his thought.

It translates as:

Once emerged from the gray of night
Heavier and dearer and stronger
Than the fire of the night
Drunk with God and doubled over.
At present ethereal
Surrounded by blue
Soaring over the glaciers
Toward the wise constellations.

The structure of the poem determines the composition. The weft of the image is a wall of colored squares of more or less the same size. The black lines of the Arabic capitals determine other chromatic partitions like the stones of a mosaic. The two parts of the composition, separated by a band of silver paper, correspond with the two stanzas of the poem. Even the chromatic schema is impressed by the text: From the beginning to the end of the poem a luminous blue emerges, little by little, from the initial gray.

Klee's first attempt to mix painting and poetry was in 1916, with a series of six watercolors conceived from Chinese poems. In this work, where the image is preceded exceptionally — but also necessarily —by the title-text, it should definitely be noted that the original order of the colored squares is imposed by the logos, even though the letters lose their linguistic function. This is no doubt what the wide gray band in the center of the surface confirms. Where the text disappears, there is only chaos, that is if we follow Klee's theory of color, which is the inorganic mix (pigmentary or subtractive) of colors that justly gives gray. "In the beginning was the verb . . ." said Klee in the "Creative Credo."

Letters and numbers were highly esteemed by Klee as a way of expressing himself in an original manner. The "Creative Confession" gives some indication of the relationship he sees between a formal sign and a lived experience. Regarding these, he raises the problem of the appearance and essence of written signs. Letters and numbers not only reveal a precise experience but also contain a certain sense of a "history of form."

Bahn

Einst dem Grau der Nacht enttaucht / Dan schwer und teuer / und stark vom Feuer /
Abends voll von Gott und gebeugt // Nun ätherlings vom Blau umschauert, / entschwebt
über Firnen / zu klingen Gestirnen.

99. ONCE EMERGED FROM THE GRAY OF NIGHT
(EINST DEM GRAU DER NACHT ENTTAUCHT)
1918/17 – Watercolor on paper, 22.6 × 15.8 cm
Paul Klee Foundation, Kunstmuseum, Bern.

1918 171 Astrale Automaten

100. ASTRAL ROBOTS
(ASTRALE AUTOMATEN)
1918/171 – Watercolor on paper, 22.5 × 20.3 cm
Beyeler Gallery, Basel.

1918 172 Fatales Fagott Solo

101. FAGOTT'S FATAL SOLO FLIGHT
(FATALES FAGOTT SOLO)
1918/172 – Pen on paper mounted on cardboard, 29 × 22 cm
Private collection, New York.

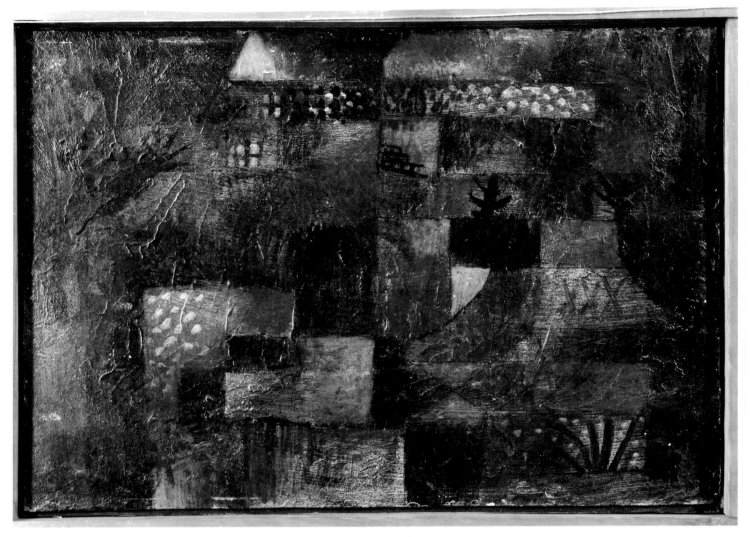

102. TERRACED GARDEN
(TERRASSIERTER GARTEN)
1920 – Oil on cardboard, 28 × 40 cm
Kunstmuseum, Basel.

103 **Hermitage, 1918**

"This watercolor takes us back to the numerous Chinese poems (known by Klee through Hans Heilmann's anthology, which appeared in 1905) that praised the life of the hermit. The hermit is the model for "wu-wei" (the non-action of Taoist thought); he lives hidden in mountain forests with the animals and birds. One of these poem's favorite themes is that of going to visit a hermit, not finding him at home, and therefore having the opportunity to meditate while contemplating nature. On the other hand, these poems often begin with the presentation of a landscape that serves to set the scene (in the theatrical sense) or act as decor for the unfolding of a psychological drama. In *Hermitage* the theatrical sense is given by the curtains framing the image. These poems ultimately describe the hermitage as a place where opposites can coexist; life and death are reconciled here. The opposing forces in Klee's image are fixed by the black sun so dear to Durer and the Romantics.

"This work is perhaps Klee's best example of his willingness to take a political position. Similarly to the Chinese poet who brought together opposing elements to enrich and widen the meaning of the image, Klee introduced a cross, the emblem of Christian redemption. This necessary complementarity of opposing elements supports Alfred Doblin's requirement, expressed in his novel *Wang-Lun's Three Leaps* (1915), of the state of inner calm that the practice of wu-wei brings. Doblin describes the latter as a state of accord with the laws of nature, proposing thus a possible way for dealing with the eternal dilemma. In associating the black sun with the cross and by placing them both in a landscape whose implications go back to Chinese poetry, Klee integrates in the same image Chinese eremitic wisdom and the belief of some Expressionists in the possibility of a new Messianic era, which doubly conveys an ideology of regeneration."

[Constance Nausert-Ribert in "Revue de l'art" no. 63, 1984, p.54]

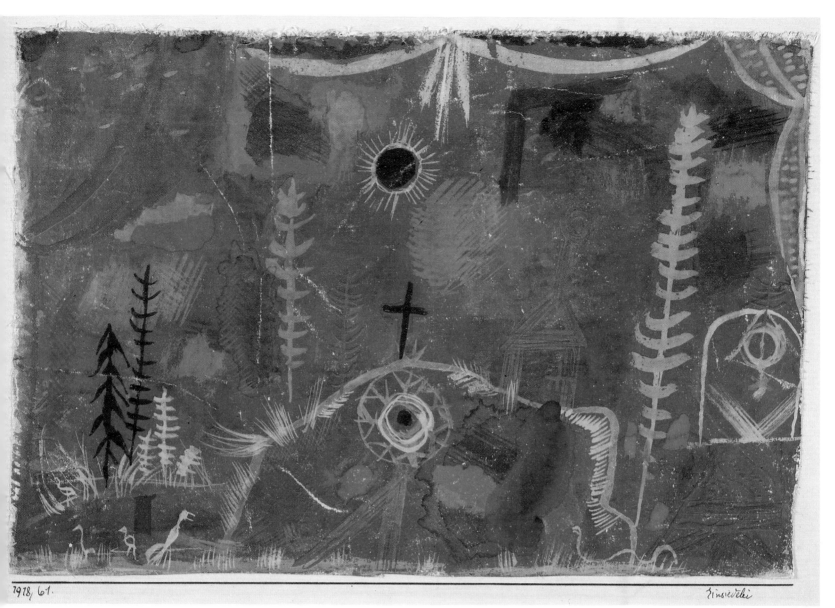

103. HERMITAGE
(EINSIEDELEI)
1918/61 – Watercolor and gouache on canvas on chalk, 18.4 × 25.9 cm
Paul Klee Foundation, Kunstmuseum, Bern.

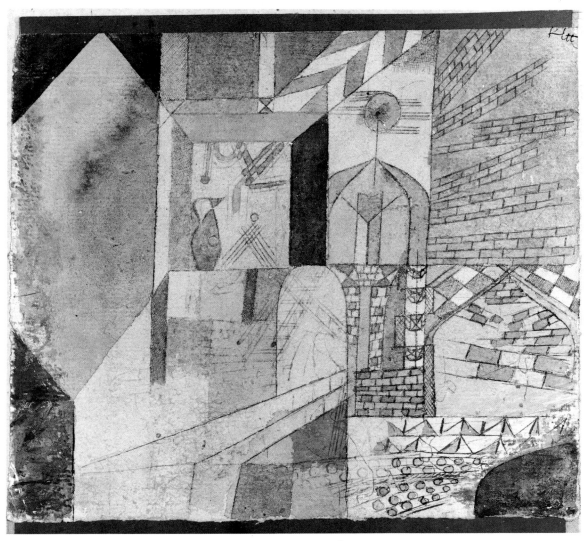

104. ARCHITECTURE WITH JUG
(ARCHITEKTUR MIT DEM KRUG)
1919/184 – Watercolor on Ingres paper, 14.5 × 15 cm
National Museum of Modern Art, Georges-Pompidou Center, Paris.
Gift of Berggruen.

105 **With the Eagle, 1918**

On September 9, Klee wrote to Lily: "In general it's all quite bearable; as one has no responsibility, one is forced into oneself. And there are compensations for every injustice. I was able to go out at midday; it was slightly overcast, just as I like the light, and I went into the Flussauen pastures, which had already comforted me at Pentecost. I took out my box of watercolors in the most isolated place, and it poured out. By evening I had five watercolors, three in particular that I liked very much. The last one I painted had all the sparkle of the marvelous surroundings."

In 1918, *Zoo*, *Hermitage* and *With the Eagle* were made in similar circumstances. The feeling of mystery in *With the Eagle* comes most of all from the image of the eye. It hovers, as in *Zoo*, but in this work it is under an arcade with an eagle, after which the composition is named, at its summit. The suggestive effect of this painting is essentially a result of the relationship of the soft miniature chromatism to fabulous motifs. A forest with a magical sparkle to it is scattered under the high and festive arcades. In the foreground are a house with a smoking chimney, a stunted stag, and two lost figurines. These details evoke a storylike atmosphere. They are not, however, important as regards the charm of the undefined romantic atmosphere emanating from the picture as a whole. What we have here is not the mystery imparted by a story but the reality of the mystery itself.

It is a simple poem from a poetic time. We can see the rule of how things in this world are read according to mimesis or anthropomorphosis. Thus the arcade is also the bird it supports and the eye it surrounds, for according to antiquity, "the eye and the sun are of the same species." Even the pines take us back to the original Germanic forest, "die Urwald," from which all things and beasts come.

82

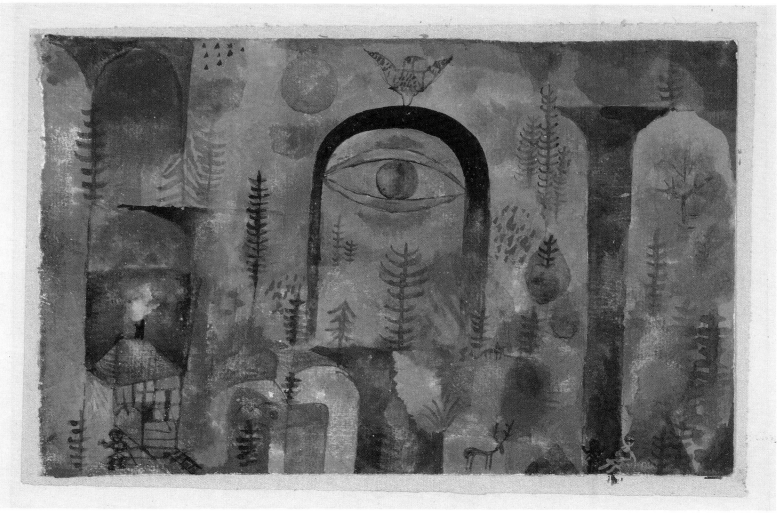

105. WITH THE EAGLE
(MIT DEM ADLER)
1918/85 – Watercolor on chalk on Ingres paper, 17.3 × 25.6 cm
Paul Klee Foundation, Kunstmuseum, Bern.

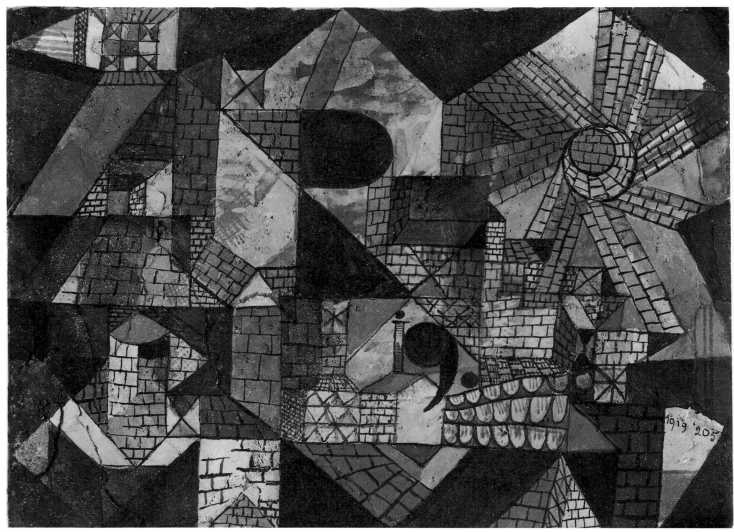

106. TOWN R
(DIE STADT R)
1919/205 – Watercolor on chalk, 16.5 × 22 cm
Städtische Gallery in Lenbachhaus, Munich.

Villa R, 1919

This work was part of the Frankfurt Kunstinstitut's collection but was sold by auction in 1937, with many other Klee works from public collections that were considered by the Germans as "degenerate art."

In the center rises an enchanted villa made of triangles and rectangles from a children's building game and painted in light and cold colors. Behind it, earth brown hills waver between a green moon and a yellow sun. On the left a mauve path narrows as it goes up toward the right. There is an occasional timid-looking plant in the middle of the foreground, while a superimposed capital R at the side of the villa is outlined against the mauve road and brown background.

Probably we all saw such a villa on our way to school. As it was inhabited only by adults, all we knew of it was its exterior; at night it was brightly lit, and we peopled it with our imagination.

Klee obviously owes his usage of printed letters in his watercolors and paintings to the Cubists (*Green X to the Left and Above*, 1915; *Miniature with the Letter E*, 1916) and (*Composition with the Letter B*, 1919), but in his work they are more symbolic than technical. The letters stand for a word or an image, as do the arrows and numbers, even if the painter does not provide the key to his ideograms. Besides what it means, the letter also becomes a poetic motif, like the medieval illuminated manuscripts or the Coptic letters that Klee had admired in Tunisia. This use of isolated letters, which appeared also in *Landscape Near E* (Bavaria) and *L Square in Construction*, gives, besides their particular plastic quality, a polysemous advantage because of their acoustic dimension. In the economy of the image, they allow ellipsis that avoids representative contingency, for according to Klee's formula in "The Philosophy of Creation,": "there is every reason for circumscribing, in the ideal sense, the domain of plastic means and giving proof of the greatest economy in their usage."

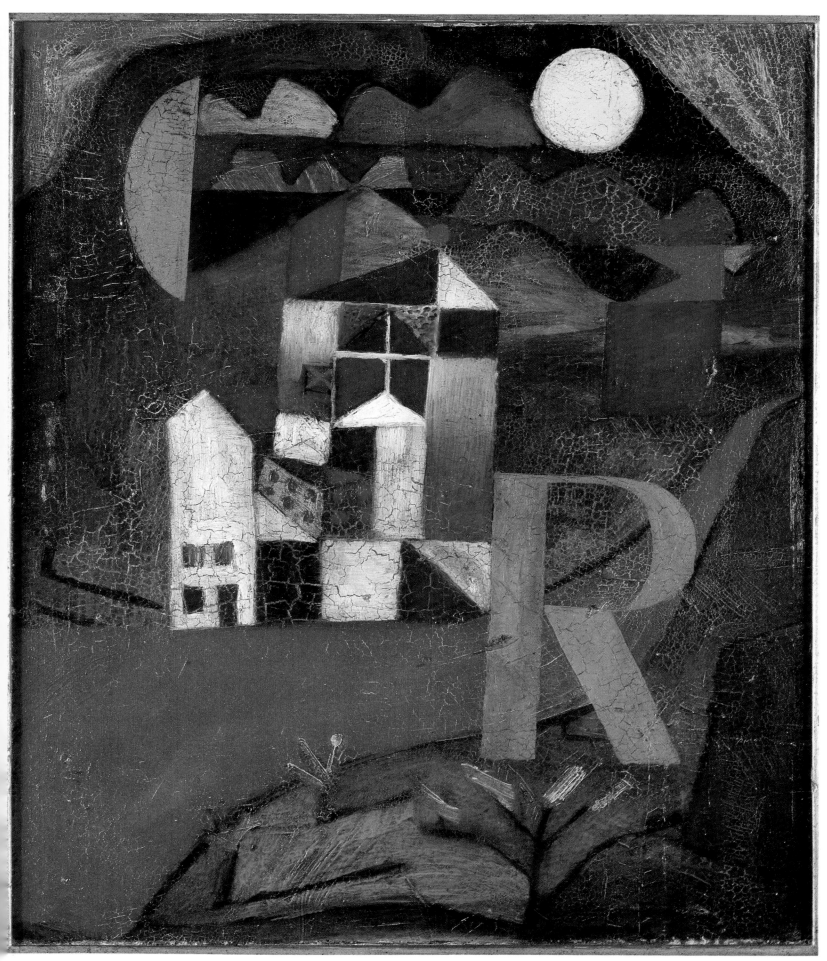

107. VILLA R
1919/153 – Oil on cardboard, 26.5 × 22 cm
Kunstmuseum, Basel.

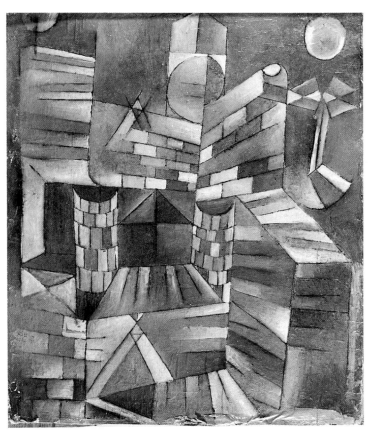

108. ARCHITECTURE WITH WINDOW
(ARCHITEKTUR MIT DEM FENSTER)
1919/157 – Oil and India ink on paper mounted
on wood panel, 50 × 41.5 cm
Paul Klee Foundation, Kunstmuseum, Bern.

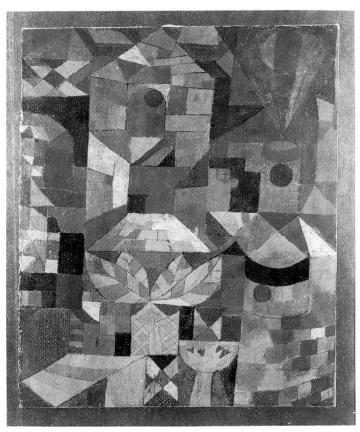

109. CASTLE GARDEN
(BURGGARTEN)
1919/188 – Gouache on paper, 21 × 17 cm
Kupferstichkabinett, Kunstmuseum, Basel.

110 Landscape near E (Bavaria), 1921

This Bavarian landscape is seen through a guillotine window, which so many chalets in this region have. The windowpanes give the picture the look of a diptych.

The naïve Cubism of childrens' building blocks, which can be found in *Cold Town* or *Town with Red and Green Accents*, is no longer present here. Klee borrows from Robert Delaunay's kaleidoscopic vision in his series of *Simultaneous Windows*, but the Klee work has a hardness that is completely Germanic and none of the luminous shading of the French. If the triangular black accents of the flat pines were not there, we would have the impression of an aerial view of roofs ringed with meadows.

Klee must have summed up this type of vision for his Bauhaus students like this: "The principal tensions are effected between pairs of opposing surfaces;

the shortest road to create volume is good enough. Even volume's interior has no form. The liaison between the center of a surface and the center of its opposing surface produces a real interior line (a dimension), and the repetition of this exchange of tensions ultimately creates the same line three times running. We establish then the creation of three dimensions of volume." Instead of being drowned in the surface by the graduation of colors like Delaunay in his *Windows* series, the edges of the prismatic surfaces keep their sharp clarity. Some black pine trees varnished like toys, as well as triangles, letters (E and K), and points, punctuate the surface of enclosed meadows from top to bottom. The chromatism is summed up in one of Apollinaire's lines: "From red to green all the yellow dies."

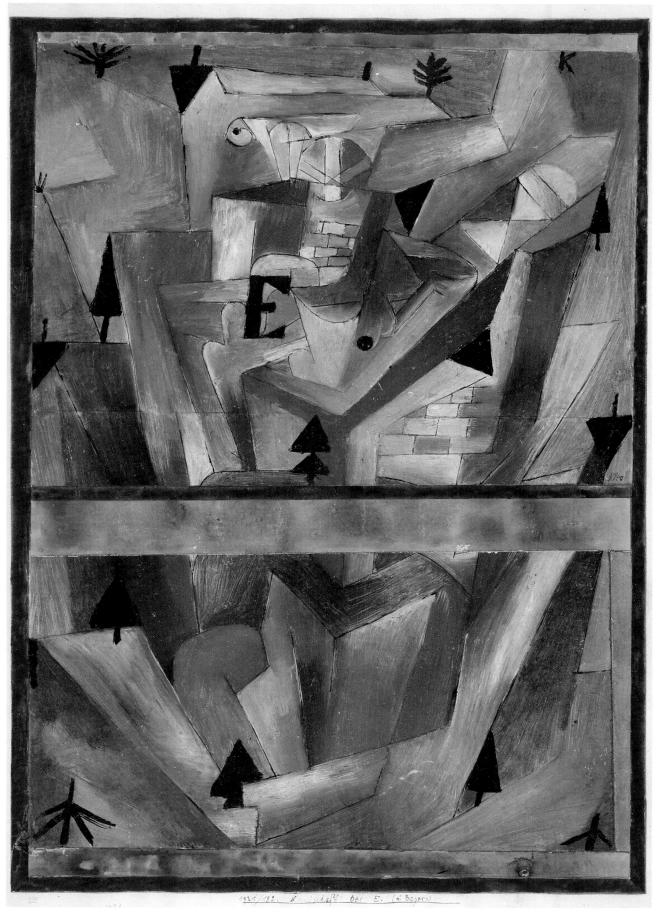

110. LANSCAPE NEAR E (BAVARIA)
 LANDSCHAFT BEI E. (IN BAYERN)
 1921/182 – Oil and India ink on paper mounted on cardboard, 49.3 × 35.2 cm
 Paul Klee Foundation, Kunstmuseum, Bern.

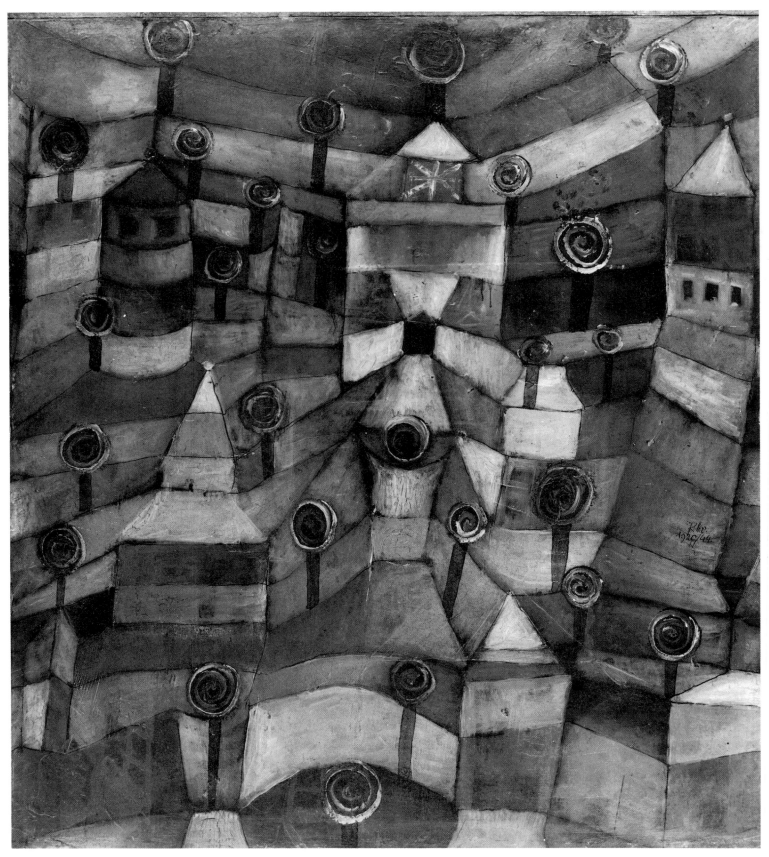

111. ROSE GARDEN
(ROSENGARTEN)
1920/44 – Oil on cardboard, 49 × 42.5 cm
Beyeler Gallery, Basel.

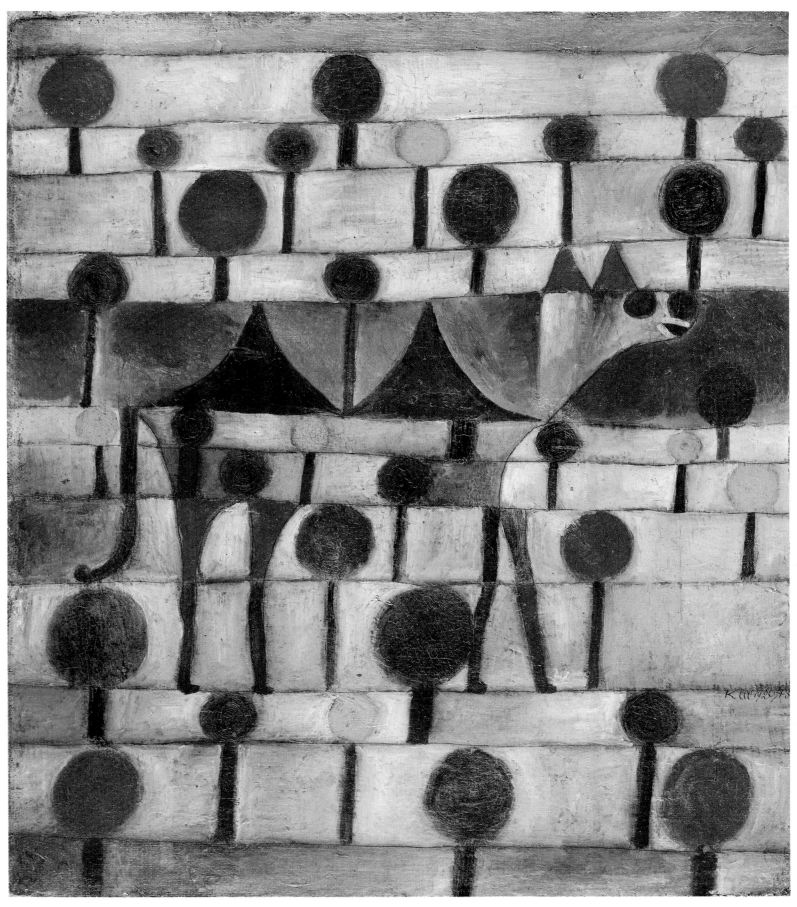

112. CAMEL IN A RHYTHMIC WOODED LANDSCAPE
(KAMEL IN RHYTHMISCHER BAUMLANDSCHAFT)
1920/43 – Oil on gauze covered with chalk, 48 × 42 cm
Kunstsammlung Nordrhein Westfalen, Düsseldorf.

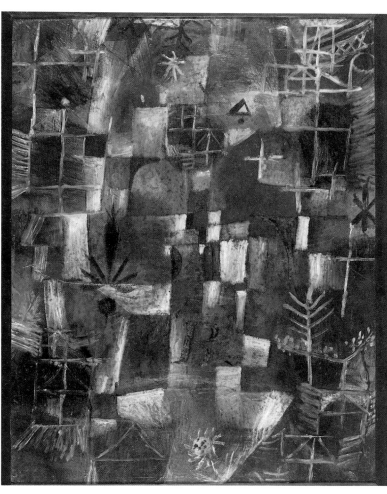

113. COMPOSITION WITH THE LETTER B
(KOMPOSITION MIT DEM B)
1919/156 – Oil and India ink on cardboard, 50.4 × 38.3 cm
Paul Klee Foundation, Kunstmuseum, Bern.

Still Life with Thistle, 1919

The work painted on the other side is a brightly colored Cubist composition, which reminds us of *Red and White Domes*, from the 1914 Tunisian period. But Jurgen Glaesmer thinks that the painting on the reverse, like the other, must have dated from 1919, for they are very similar to some watercolors that were done in 1919. The Cubist work was certainly inspired by Klee's trip to Tunis in 1914, but it might not come from this period, for Klee himself only indexed a single oil painting from this trip, and it is in the Klee Foundation in Bern.

114. THE HOUSE WITH THE ARROW
(DAS HAUS ZUM FLIEGERPFEIL)
1922/56 – Watercolor and oil on paper glued on
cardboard, 50.7 × 31.7 cm
Paul Klee Foundation, Kunstmuseum, Bern.

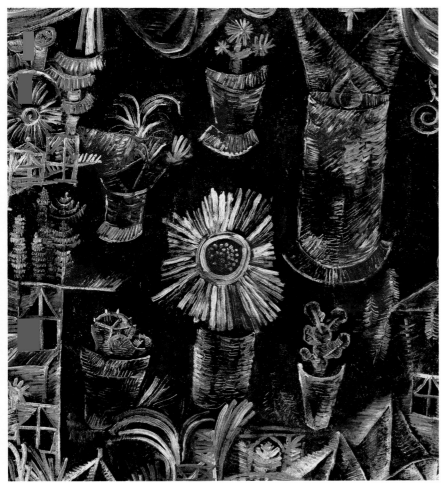

115.–116. STILL LIFE WITH THISTLE
(STILLEBEN MIT DIESTELBLÜTE)
and on the other side: CUBIST COMPOSITION IN THE STYLE
OF THE TUNISIAN WATERCOLORS
1919 – Oil on cardboard, 49 × 43.5 cm
Jan Krugier Gallery, Geneva.

117. CRYSTAL GRADATION
(KRISTALL-STUFUNG)
1921/88 – Watercolor on paper mounted on cardboard, 24.5 × 31.5 cm
Kunstmuseum, Basel.
Gift of Marguerite Arp-Hagenbach.

118 Growth, 1921

This picture from Kandinsky's collection is attached to an impression Klee noted in his Diary while on the Tunisian trip: "We walk a little. First in a park with some very peculiar plants. Green-yellow-terracotta. They resound deeply in me and will remain with me, even though I don't paint on the spot." It also evokes for us the *Magic Squares* series.

Staggered circles, segments of circles, squares, and quadrilaterals illustrate the Bauhaus teaching of the "movement of expansion and thickening of the chiaroscuro medium that is linked to the movement of measure conceived as enlargement and reduction of the surface's contents. In the chiaroscuro movement there is no absolute dependence on a given direction. (. . .) Expansion toward white signifies controlled lightening on a black polar base."

This later becomes a carefully considered act, in that all ordering of the work is a putting into order of Klee's invented signs and what they mean; it is the application of a logic belonging to a distinct language for the controlled organization of form, color, and rhythm.

118. GROWTH
(PLANZENWACHSTUM)
1921 – Oil on cardboard, 54 × 40 cm
National Museum of Modern Art, Georges-Pompidou Center, Paris.
Gift of Nina Kandinsky.

119. LANDSCAPE WITH YELLOW
CHURCH TOWER
(LANDSCHAFT MIT DEM
GLEBEN KIRCHTURM)
1920/122 – Oil on cardboard,
48.2 × 54
Bayerische
Staatsgemäldesammlungen,
Munich.

120. STATION L 112, 14 Km
1920/112 – Watercolor and India ink on paper, 12.3 × 21.8 cm
Paul Klee Foundation, Kunstmuseum, Bern.

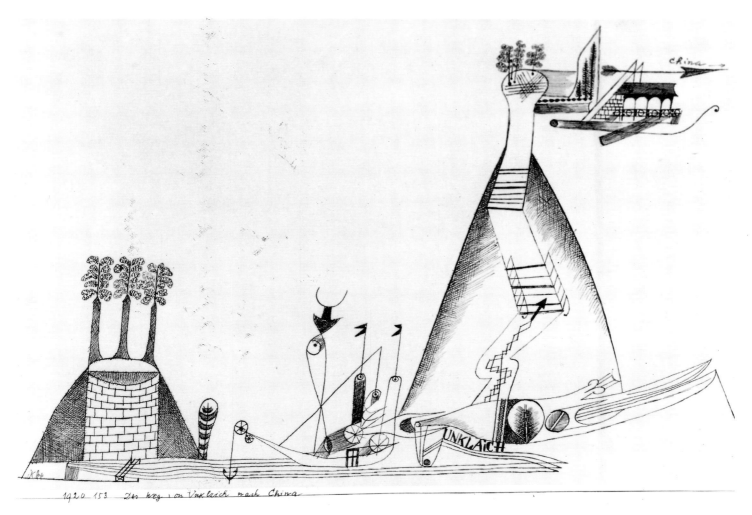

121. THE ROAD FROM UNKLAICH TO CHINA
(DER WEG VON UNKLAICH NACH CHINA)
1920/153 – Pen and India ink mounted on cardboard, 18.6 × 28.2 cm
Paul Klee Foundation, Kunstmuseum, Bern.

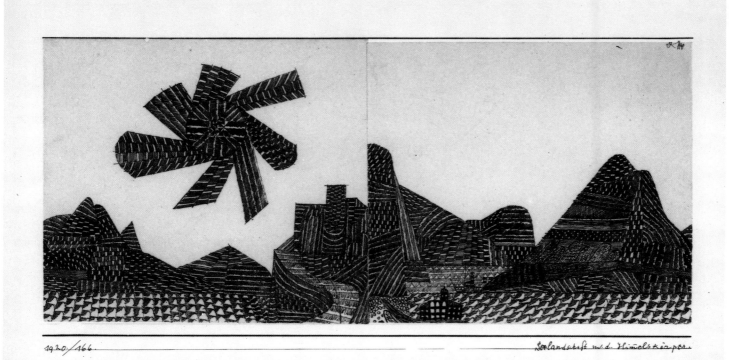

122. SEASCAPE WITH ASTRAL BODY
(SEELANDSCHAFT MIT DEM HIMMELSKÖRPER)
1920/166 – Pen and India ink on paper mounted on cardboard, 12.7 × 28 cm
Paul Klee Foundation, Kunstmuseum, Bern.

123. DRAWING FOR "PERSPECTIVE OF A ROOM WITH INMATES"
(ZEICHNUNG ZUR "ZIMMERPERSPEKTIVE MIT EINWOHNERN")
1921/168 – Pencil on paper mounted on cardboard, 33.6 × 24.7 cm
Paul Klee Foundation, Kunstmuseum, Bern.

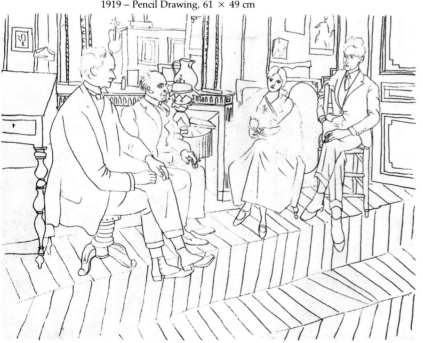

124. PICASSO: THE ARTIST'S LIVING ROOM ON BOETIE STREET
1919 – Pencil Drawing, 61 × 49 cm

Perspective of a Room with Inmates, 1921

Klee had already done a more realistic pen and ink drawing of a similar room, *Memory of Gertshofen* (Felix Klee Collection), and a sketch for this work in 1921 (Bern Museum). Its origins can be traced back to Alberti and Durer. And painters like Chirico and Carra have also dealt with perspective in a Surrealist way.

It depicts the painter's dwelling at Weimar, in which Klee, Lily, and Felix are humorously positioned in a way that is similar to Cocteau, Olga, and Satie's stiff poses in a Picasso drawing entitled *The Artist's Studio at Boetie Street* (1919). Klee introduces the invisible by disavowing the integrity of the material. The comfortable room has passed into eternity in the form of a domestic current of air; inhabitants and objects dematerialized in the flow of space and time.

It was not difficult for the theory of form, unfurling as a phenomenology of movement, to breathe new life into tired Renaissance perspective. Here it is proven in the subjection of the perspective to a typically quantitative form that was commonly thought to be obsolete. What Cassirer and Panofsky have described as an "objectification of subjectivity" becomes in Klee's hands a subjectification of objectivity. The Euclidean measures are no longer there; their place has been taken by the original vitality of a qualitative experience of life. Klee's is less preoccupied with the development of a spatial solution that coincides with modern views of pictorial space than with the elaboration of a multidimensional agreement. Here the formation of the work is again doubly significant: on the one hand, the demand for a reciprocal integration of past and present, on the other, the need to prove the analytic richness of this formation in traditional art history terms.

This watercolor is a good example of Klee's poetic approach. It is obviously a knowledgeable lesson in perspective, inspired no doubt by his first year of lectures at the Bauhaus (Chapter 18 of the *Pedagogical Sketchbook*), but one in which all the strangeness and slightly anxious naïveté come, like in Lewis Caroll, from what seems to be the most "logical." "The demoniacal is already peeking through here and there and will not be supressed," wrote Klee in his Diary on July 10, 1917. "For truth demands that all elements be present at the same time."

125. PERSPECTIVE OF A ROOM WITH INMATES
(ZIMMERPERSPEKTIVE MIT EINWOHNERN)
1921/24 – Watercolor on Ingres paper, 48.5 × 31.7 cm
Paul Klee Foundation, Kunstmuseum, Bern.

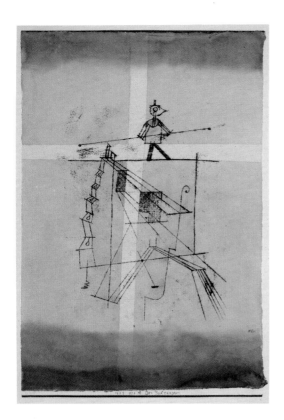

126. THE TIGHTROPE DANCER
(DER SEILTÄNZER)
1923/121 – Watercolor on Ingres paper glued on cardboard, 48.7 × 32.2 cm
Paul Klee Foundation, Kunstmuseum, Bern.

128. THE ACROBAT ABOVE THE SWAMP
(DIE EQUILIBRISTIN ÜBER DEM SUMPF)
1921/59 – India ink on paper mounted on cardboard, 29.6 × 18 cm
Kunstsammlung Nordrhein Westfalen, Düsseldorf.

127. TIGHTROPE DANCER
(SEILTÄNZER)
1923/215 – Pencil on paper, 28.1 × 22 cm
Paul Klee Foundation, Kunstmuseum, Bern.

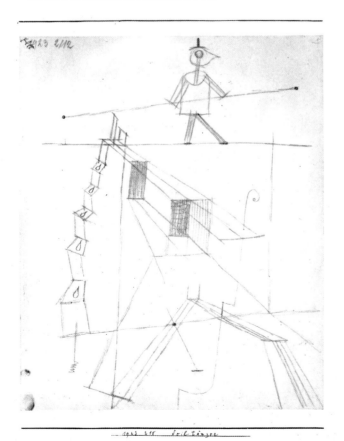

98

129. THE VASES OF APHRODITE or EROTIC RELIGIOUS CERAMIC
(DIE GEFÄSE DER APHRODITE oder KERAMISCH, EROTISCH, RELIGIOS)
1921/97 – Watercolor on Ingres paper, 46.3 × 30.1 cm
Paul Klee Foundation, Kunstmuseum, Bern.

130. CONTACT BETWEEN TWO MUSICIANS
1922 – Watercolor and oil on chalk on gauze mounted
on cardboard, 63 × 47 cm
Solomon R. Guggenheim Museum, New York.

131. THE ORDER OF HIGH C
(DER ORDER VOM HOHEN C)
1921 – Watercolor on paper, 33 × 23.5 cm
Private collection.

131 **The Order of High C, 1921**

This watercolor was sold in 1938, by Paul Eluard to Roland Penrose as *The Knight of High C*. Even though the translation was incorrect, the feeling of order, as in the order of knighthood, was still conveyed. This satirical portrait has a curious necklace at the top of the body, where the neck should be, made from a lyre (an ambiguous musical sign evoking either the ornamental bar across the pedals of a piano or the support for the music score) and a black radish, on top of which is the cross with five arms that Klee often used. The idea of a brotherhood or distinctive order is aptly conveyed by this image.

Jean-Charles Gateau, an expert on Eluard's writings on painting, says about this watercolor: "Underneath this musical fantasy is a diva." This evocation rests on an iconographic misconception. Here too, Eluard and Penrose were correct in giving a masculine rendering of the title. The five curved parallel lines placed above the C of the mouth form a moustache and also evoke a musical stave made by musicians with a special five-pointed pen.

High C is the height of the tenor's tessitura (a colaratura soprano can go higher still) whoever the character may be: Wagnerian hero-tenor, going from C to B-flat (Siegfried); high tenor, from C to C (Brighella in Strauss' *The Knight of the Rose*); spinto tenor, from C to C (Rodolfo in Puccini's *La Boheme*). Composers have, on occasion, played around with the virtuosity of these men's voices in the high notes, giving them roles that border on the ridiculous like the Captain in Alban Berg's *Wozzeck*. In the image of the distinguished high tenor of *The Order of High C*, the height the voice gets to is transcribed in the interior of the head by rising S signs which vertically suggest, either an incomplete treble clef (the part of the tenor has been written for a long time in treble clef) or a sign standing for hearing and the ear. The sound mounting in the head is a musically correct metaphor; it is what a singer experiences as he progresses to the high notes. The head in the image is surrounded by a predominantly green crystalline structure that further amplifies the impression of echo.

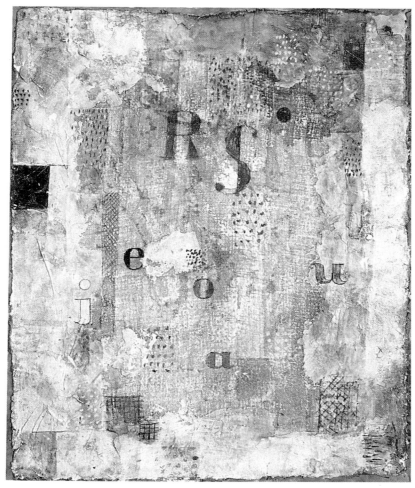

132. VOCAL FABRIC OF THE SINGER ROSA SILBER
(DAS VOKALTUCH DER KAMMERSÄNGERIN ROSA SILBER)
1922/126 – Watercolor on crayon on cardboard, 51.5 × 41.7 cm
Museum of Modern Art, New York. Gift of Mr. and Mrs. Stanley Resor.

132 Vocal Fabric of the Singer Rosa Silber, 1922

The title of this watercolor is so precise that a literal translation of it has been kept. Is it a pun on the image? The singer's initials, "R S," and the apparently haphazardly placed series of vowels are painted on muslin whose screening is still visible in places; the muslin has been worked with plaster and various pigments, making it as rough and uneven as possible, but without losing any of the wealth of detail. Thus, the essentially material aspect of the work places its autonomy in relationship to its referent, the prima donna, Rosa Silber, in question. Is this work a totem-portrait in the Dadaist style, its humorous implications only understandable if the model is known? Beginning with the play on the word *Vokaltuch* (vocal fabric), we can imagine that the singer always wore a scarf around her neck or held a handkerchief that she fiddled with while singing. Or is the work perhaps a metaphor for the thankless task of the artist whose final performance is the result of continuous rehearsal (the vowel exercises in vocalization)? Then again, is it maybe an autonomous work that the interpreter can see as concepts of archaism

and series (the series of the five vowels of the Latin alphabet representing the equivalent of a pentatonic scale) if he so wishes?

Only a study of Klee's psychological attitude in relationship to lyrical art, and in the context of contemporary music, could answer these questions. However, instead of leaving us this information, Klee chose instead to translate and transform the signs of the musical universe into paint.

133. VIOLIN AND BOW
(GEIGE UND BOGEN)
1939/311 – Pencil drawing on paper, 21 × 29.7 cm
Private collection, Switzerland.

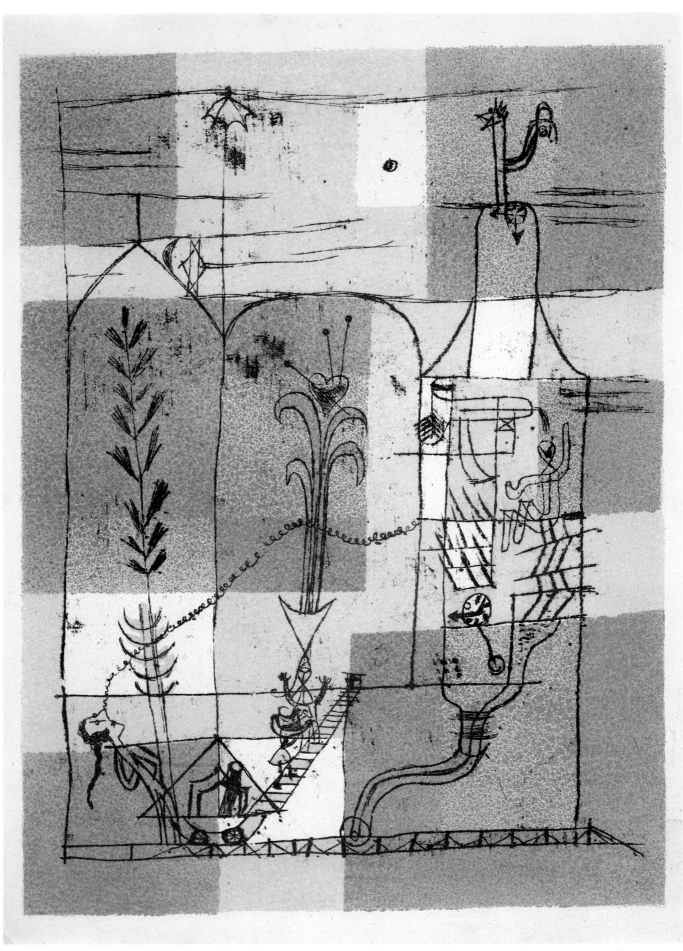

134. SCENE FROM A HOFFMANN-LIKE TALE
(HOFFMANNESKE MÄRCHENSZENE)
1921/123 – Lithograph, 31.6 × 23 cm
Paul Klee Foundation, Kunstmuseum, Bern.

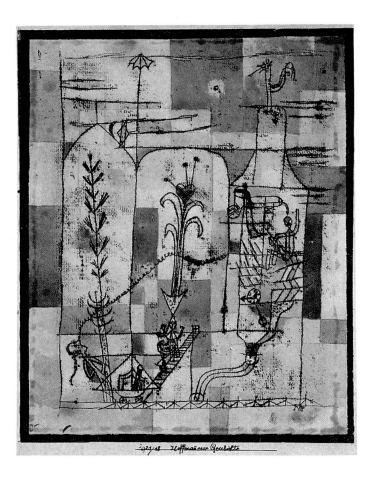

135. TALE A LA HOFFMANN
(HOFFMANNESKE GESCHICHTE)
1921/18 – Oil and watercolor on Ingres paper
mounted on cardboard, 31.1 × 24.1 cm
Berggruen Collection, Metropolitan Museum of Art, New York.

136. CAT AND BIRD SCHERZO
(KATZE UND VOGEL SCHERZO)
1920/226 – Pen and India ink and pencil on paper
mounted on cardboard, 26.2 × 14.8 cm
Paul Klee Foundation, Kunstmuseum, Bern.

Tale A La Hoffmann, 1921

Starting with his daily practice, Klee attempted to transfer his experience and knowledge of music to the plastic domain. Thus, without his having dived into the poetry, painting, and philosophy of Romanticism, his sensiblility, thought, and creativity, little by little, took on a romantic posture. A sign of this, for example, is that he discovered Ernest-Théodore-Amédée Hoffmann by way of Offenbach's operetta. This kinship also shows the indestructible force of the wonder of Hoffmann; so strong was this lightest of music that not even the heaviest of periods could stop it from being appreciated. The leap from *Coppelia* or *Ondine* to some of Klee's figures, is all due to Hoffmann.

The plastic renderings of his poetry in the watercolor and lithograph of the same year, *Scene from a Hoffmann-like Tale*, are among the rare examples of direct romantic citations in Klee's work. Just as in Hoffmann's *Tales*, one senses immediately that the facts and events are only provisional: Despite their apparent simplicity, we realize that we will later see how curious they are. As one attempts to decipher these burlesque scenes, they start to float, the personnages oscillating, as though irresistibly attracted to a mysterious lover. We have been given the signs, but not the key, to this strange picture puzzle where magic disputes with irony. What does this boat on rollers signify? These indistinct personnages climbing a ladder or an alembic? Is it a new metamorphosis of "Princess Brambilla?" According even to Hoffmann, "the inner poet will take precedence over the critical spirit and the creator of forms." With Hoffmann this turning away from society, this search for solitude, sometimes goes as far as the fear of madness, whereas Klee lightly transforms it into reflexive irony.

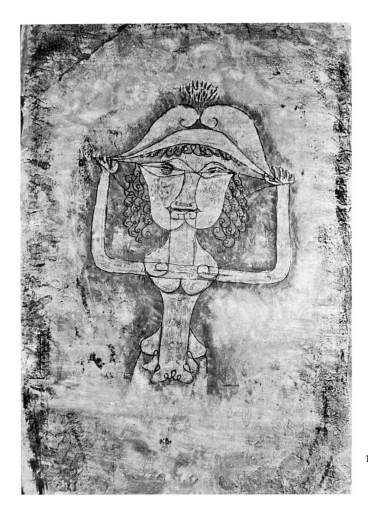

137. THE SINGER L. AS FIORDILIGI
(DIE SÄNGERIN L. ALS FIORDILIGI)
1922/39 – Oil and gouache on cardboard.
Whereabouts unknown.

137
138

The Singer L. as Fiordiligi, 1922

Klee adored Mozart and closely identified with his grace and humor. In both 1925 and 1927 he took up the theme of Fiordiligi, the heroine of *Cosi fan Tutte*. He was able to play Don Juan on his violin from beginning to end without a score, and at one time the Dresden Opera were thinking of asking him to design the decor and costumes for the opera.

The soprano singer L., whom Klee admired, also appeared twice in his work in the guise of a comic opera singer. In his Diary, Klee gives us his impressions and speaks of the magical attraction that theater and particularly opera constantly exercised on him. The specific way he used invention and composition, far removed from reality, can be seen in both of these: The singer, in line with Goethe's notion of opera, is an almost marionettelike "neutral creature."

The upper part of the body, the arms, the face, the hair, and the hat are those of a doll. The background is hardly operatic; there is no suggestion of props or scenery, only a scale of undefined tones ranging from gray-green to gray-pink. Fiordiligi rises from this like a jack-in-the-box.

However, as has been established by Christian Geelhaar, the "pose" chosen for Fiordiligi accurately corresponds with a precise place in the *Cosi fan Tutte* libretto in the twelfth scene of the second act. The frontal pose suggests a "heroic" moment that lasts only for several bars. A preparatory drawing for this oil painting is in the Rosengart Collection in Lucerne, and a version on a black base is in the Museum of Modern Art in Munich.

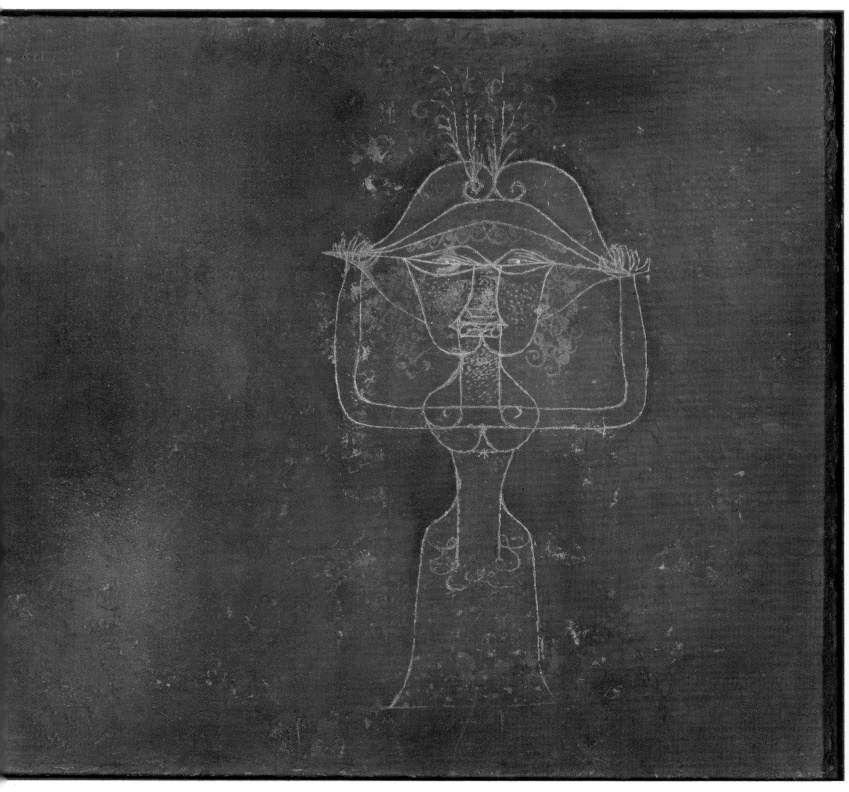

138. THE COMIC OPERA SINGER
(DIE SÄNGERIN DER KOMISCHEN OPER)
1927/10 – Tempera on cardboard, 49 × 53 cm
Staatsgalerie Moderne Kunst, Munich.

139. DYNAMIC CLASSICAL SCHERZO "217"
1923/187 – Pen and India ink on paper, 28.7 × 21.7 cm
Paul Klee Foundation, Kunstmuseum, Bern.

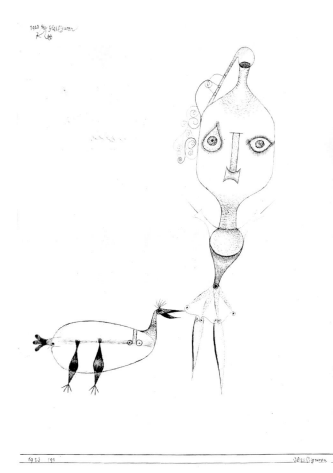

140. GLASS FIGURES (GLASFIGUREN)
1923/199 – Pen and India ink on paper, 28.8 × 22.4 cm
Kunstsammlung Nordrhein Westfalen, Düsseldorf.

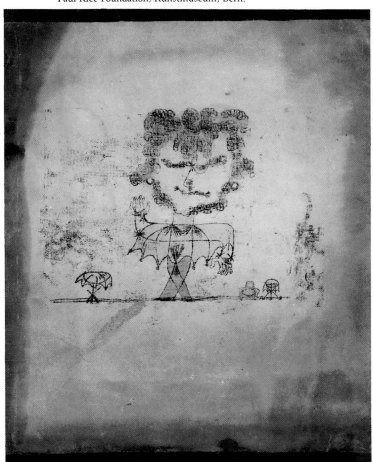

141. SGNARELLE
1922 – Watercolor on Ingres paper mounted on cardboard, 46 × 39 cm
Kunstsammlung Nordrhein Westfalen, Düsseldorf.

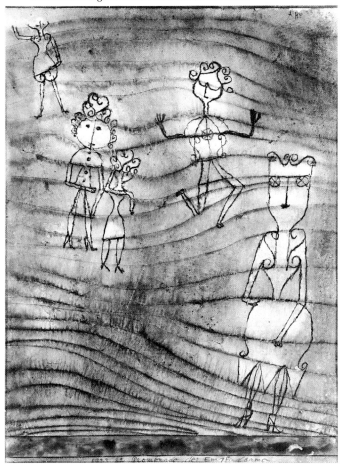

**142. THE SENTIMENTAL WALKERS
(PROMENADE DER EMPFINDSAMEN)**
1923/82 – Pen and watercolor on paper, 31.1 × 22.2 cm
Beyeler Gallery, Basel.

144 Genii (Figures from a Ballet), 1922

The initial restriction of hues in the chromatic pairs yellow-purple, red-green or blue-orange were meant by Klee to indicate "partial actions." In 1922, he extended the chromatic spectrum to include the three primary colors of the spectrum, red, yellow, and blue, so that he could command a colored totality. These experiments resulted in the watercolors *Targeted Place* and *Genii (Figures from a Ballet)*. With regard to these two works, Klee noted in his catalogue of works: "Base, yellow, action, blue and red." For the yellow base, he spread a thin yellow layer equally over the surface of the paper. The only places not covered were those that appeared in the tone of the paper or in a mixture that didn't have any yellow in it.

In *Genii*, the movement of the colors is not in one direction only but animates the whole dynamic of the figures. The circumscribed forms create an echo that becomes darker and darker, so that one has the impression that the figures have been caught in phases of distinct movement between the light foreground and the dark background. Klee was undoubtedly familiar with the work of Duchamp and the Futurists, which tried to catch simultaneously the various phases of a movement; he had also seen Marey and Muybridge's photographs. However, his attempts at simultaneous representation of movement refer more to a musical than optical impulse. What he does is to transpose the simultaneity of a polyphonic fugue to the plastic domain, as demonstrated by the title *Pink Fugue*, which he gave to a 1921 work.

In *Genii*, Klee subtly plays with gradation and the complementarity of colors (yellow-purple) so as to transport us into the enchanted atmosphere full of motion of a fairy tale adapted for the theater. We can easily see the more or less jerky movements of the dancers that are amplified in an echo of forms.

145 Puppet Show, 1923

The subject of this watercolor evokes the puppet theater that Klee made, complete with props and puppets, from 1921 to 1925, first in Munich and then in Weimar, to amuse his son Felix. Most of these puppets have, moreover, been preserved in the Bern museum. Klee loved the theater. He had acted in plays at the Bauhaus and put on puppet shows at his house. This watercolor also recalls a childhood souvenir: the puppet with a big head, frizzy hair, and an upper body in the form of a heart. The curtains are pulled aside and at the back, to the left, a unicorn, a symbol of the purity of children, ambles. The figures are set in white

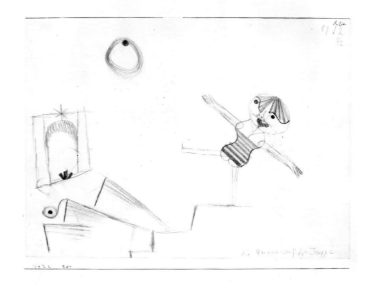

143. PUPPET ON STAIRCASE
(DIE PUPPE AUF DER TREPPE)
1922/204 – Pencil on paper mounted on cardboard, 22.2 × 29 cm
Paul Klee Foundation, Kunstmuseum, Bern.

on a black base, their appeal heightened by the use of fresh and joyful colors.

In 1912 Klee, writing to a Swiss correspondent about a Blaue Reiter exhibition at the Thannhauser gallery, said: "Restricting myself only to the idea, and not to the momentary or fortuitous nature and the merely superficial appurtenances of a number of works, I should like to reassure those disoriented people who were vainly looking here for some connection with some favorite paintings in the museum, were it even an el Greco. For these are primitive beginnings in art, such as one usually finds in ethnographic collections or at home in the childrens' room. Do not laugh reader! Children also have artistic ability, and there is wisdom in their having it! The less know-how they have, the more instructive are the examples they offer us; it is advisable to keep them from corruption from an early age."

In this painting Klee utilizes an abrupt uncontrolled line without any relief, such as children commonly use. He deliberately keeps himself at the well known stage of "intellectual realism." The optical proportions are less important than a hierarchical scale that reflects the relative importance of the different figures at play in the work, or the different parts of the body as suggested by the large-headed puppet. Klee was trying to get back to the freshness of a child's vision. In 1902 he declared: "I would like to be like a newly born, knowing absolutely nothing about Europe and ignoring poets and fashions, almost primitive." The year this watercolor was done at the Bauhaus, he said to Lothar Schreier that he was not at all dismayed when his work was compared to "the scribbles and scrawls of children."

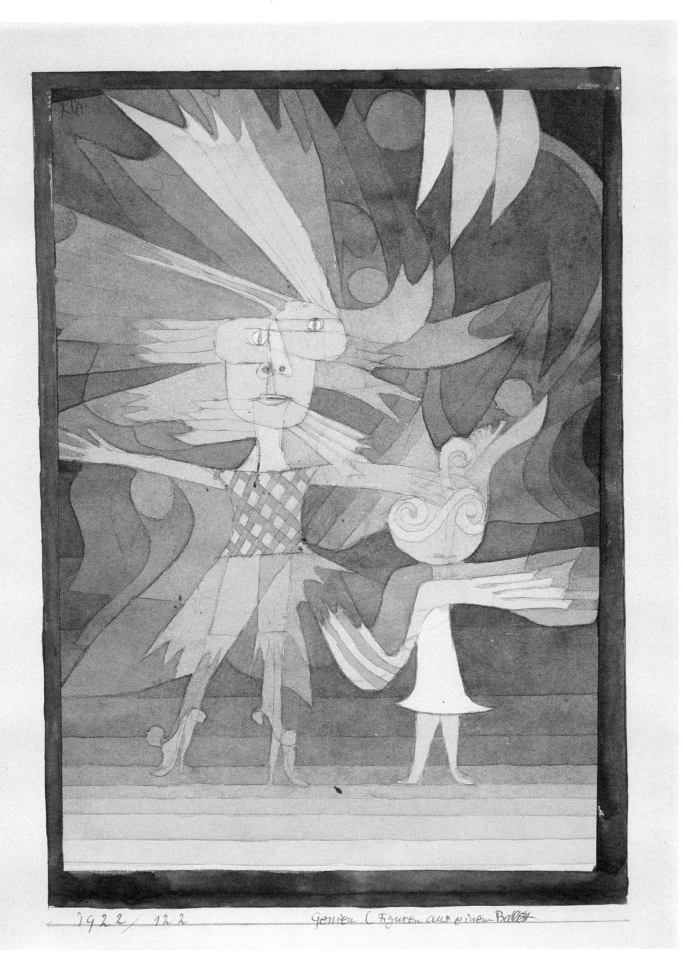

144. GENII (FIGURES FROM A BALLET)
GENIEN (FIGUREN AUS EINEM BALLET)
1922/122 – Watercolor on Ingres paper glued on cardboard, st 25.7 × 17.4 cm
Paul Klee Foundation, Kunstmuseum, Bern.

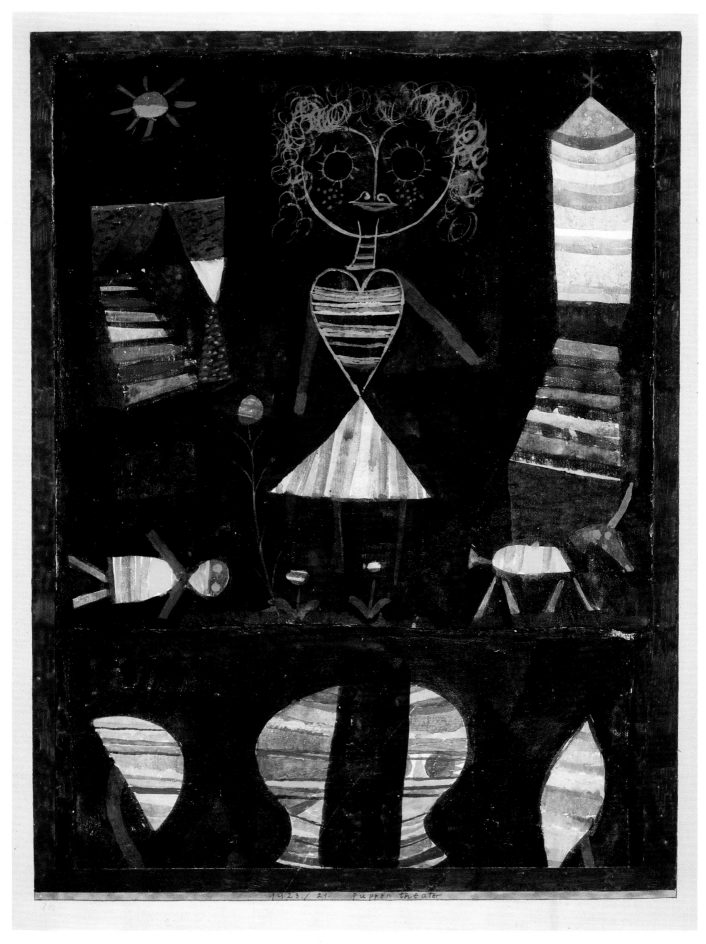

145. PUPPET SHOW
(PUPPENTHEATER)
1923/21 – Watercolor on wrapping paper glued on cardboard, 52 × 37.6 cm
Paul Klee Foundation, Kunstmuseum, Bern.

146. CHILD
(KIND)
1918/70 – Ink drawing, 22.6 × 10.5 cm
Paul Klee Foundation, Kunstmuseum, Bern.

147. HEAD BEARER
(KOPFTRÄGER)
1922/168 – Pencil on paper, 28.6 × 21.6 cm
Paul Klee Foundation, Kunstmuseum, Bern.

148. PHYSIOGNOMY (IN THE STYLE OF A LITTLE PORTRAIT)
(PHYSIOGNOMISCH [IN DER ART EINES KLEINEN BILDNISSES])
1924/26 – Pen and purple ink on paper, 12.1 × 12.4 cm
Paul Klee Foundation, Kunstmuseum, Bern.

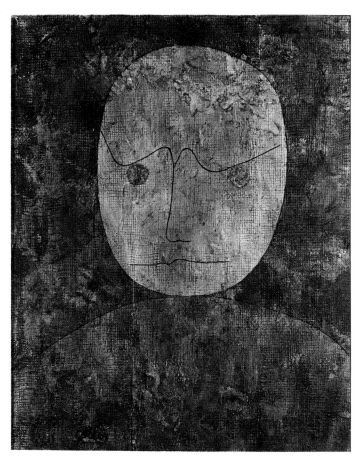

149. SCHOLAR
(GELEHRTER)
1933/286 – Oil and gouache on gauze covered with plaster, 35 × 26.5 cm
Private collection, Bern.

Senecio, 1922

As can be seen from the *Magic Squares* series, Klee often departed from the formal theme of the rectangle or square that he used as a sober and subtle element of rhythm, as well as a vehicle for a melody of color. Sometimes Klee leaves form and color on this level without differentiating from the figurative theme. Other times he divides the rectangles into triangles and opposes a circle with a rectangle and an almond shape with a triangle — the circle, for example, being associated with the "head" and the almond with the "eye." The image of a head with an all-knowing and surprised look, linked to a rhythm of pure form and a melody of pure color, is constituted in this way (like a poem that becomes a rhythmic melody of words). The head is perched on a loose neck resting on narrow shoulders —*Senecio*.

Its organization is so strictly geometric that we wonder if Klee, the botany afficionado, was making a portrait of a flower? *Senecio* is the Latin name for groundsel, cruciform, herbaceous with yellow flowers, a wild plant of which cineraria is the cultivated form.

This mysterious, sparkling, and purposely naïve picture is perhaps a joke (the face being more infantile than senile), as well as a game of analogies between humankind and nature that Klee so much liked to play: sun-head (like in the *Scholar* of 1933 with the moon face) and leaf-eyes (like in *Witches Glance* of 1923).

At the same time Klee brings out all the piquancy of the geometric picture puzzle he uses for the anatomical domain. The mouth is formed at the junction of four quadrilaterals from two little purple squares united by an angle. The play between the brow ridges is also subtly comical; the twin sand peaks underlined with a green line respond humorously to the white triangle of the left eye.

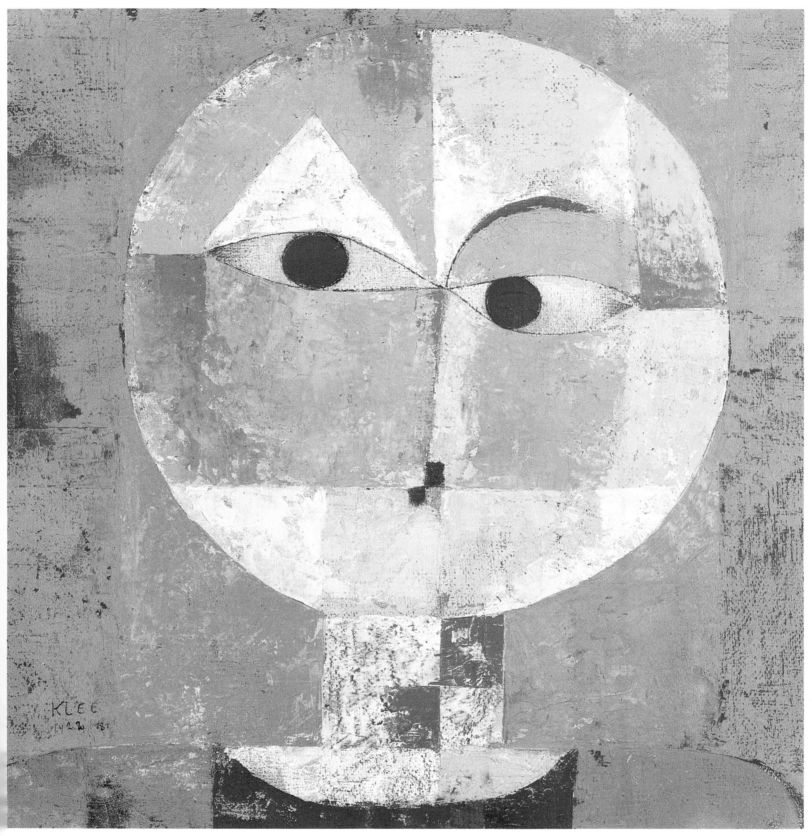

150. SENECIO
1922/181 – Oil on canvas remounted on wood, 40.5 × 38 cm
Kunstmuseum, Basel.

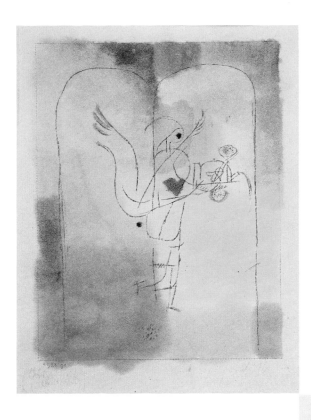

151. GENIUS SERVING BREAKFAST
(EIN GENIUS SERVIERT EIN KLEINES FRÜHSTÜCK)
1920/91 – Lithograph, 19.8 × 14.6 cm
Sprengel Museum, Hanover.

152. THE GOD OF THE NORDIC FOREST
(DER GOTT DES NÖRDLICHEN WALDES)
1922/32 – Oil on canvas glued onto cardboard, 53.5 × 41.4 cm
Paul Klee Foundation, Kunstmuseum, Bern.

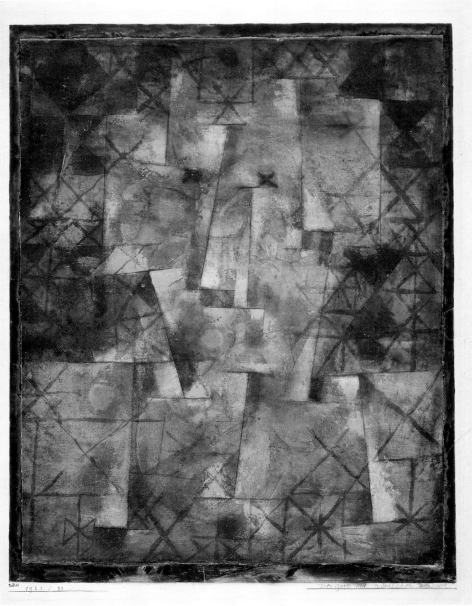

153. STORM SPIRIT
(STURMGEIST)
1925/244 (Y 4) – Pen and India ink on paper, 28.8 × 22.8 cm
Paul Klee Foundation, Kunstmuseum, Bern.

154. THE WILD MAN
(DER WILDE MANN)
1922/43 – Watercolor and oil on a chalk base, 47.6 × 29 cm
Städtische Gallery in Lenbachhaus, Munich.

155. THUNDERBOLT
(BLITZSCHLAG)
1924 – Oil on paper covered with plaster
mounted on canvas, 43 × 29.5 cm
Sprengel Museum, Hanover.

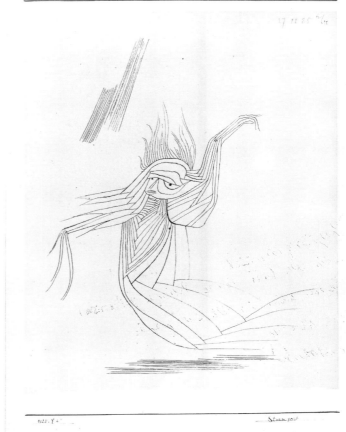

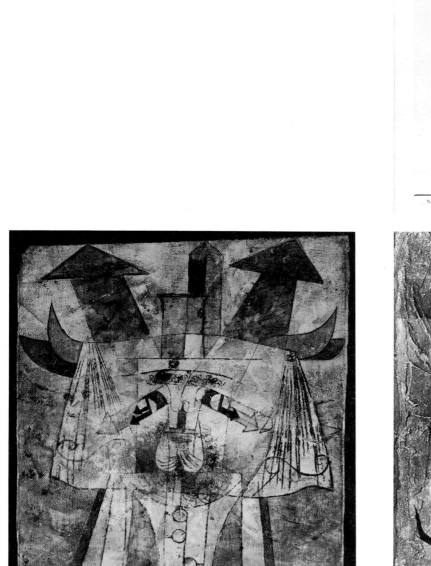

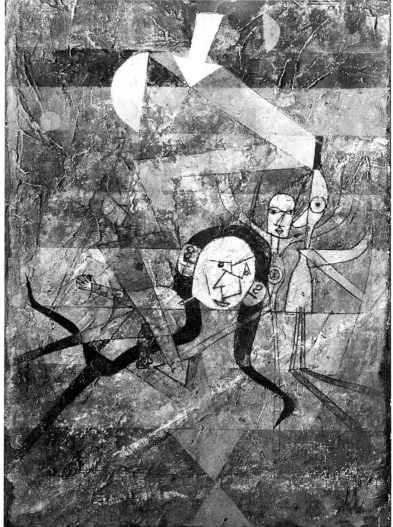

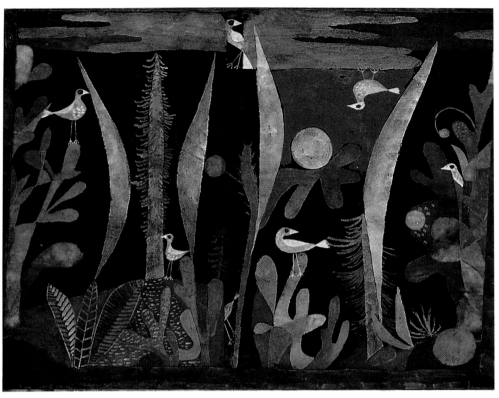

156. LANDSCAPE WITH YELLOW BIRDS
(LANDSCHAFT MIT GELBEN VÖGELN)
1923/32 -- Watercolor on blackened ground on drawing paper mounted on cardboard, 35.5 × 44 cm
Private collection, Switzerland.

156 Landscape with Yellow Birds, 1923

Seven chrome-yellow birds, like stylized Sassanid motifs, inhabit a dark forest with strange vegetation. One of them hangs upside down on a milky blue cloud conversing with a full moon dozing indolently on a beige madrepore. "What is the meaning of the whitish lianas that give such firm scansion to the picture?" asks Will Grohmann. They are not lianas, but the four, stretched, bluish-white quarters of the moon, sharing the other birds' interest. According to Klee, space is nothing but crystallized time, and here, several phases of the moon coexist peacefully together.

Moreover, as the birds show, this strange forest is terrestrial as well as underwater. There are three fir trees, but two metamorphose into Veretillum with cylindrical polypide. A whole colony of madrepore rise from the ground, sponges, sea anemones, coral, starfish . . . evoking Matisse, as Grohmann points out, but Arp's 1917 reliefs entitled *Forests* (Marguerite Arp Collection and the Cleveland Museum) are what immediately come to mind. "In Ascona," Arp tells us, "I dipped a brush in India ink and drew the broken branches, roots, grass, and stones that the lake had thrown up onto the banks. Ultimately, I simplified these forms and depicted their essence in moving ovals, symbols of the metamorphosis of matter into the human body."

For both Arp and Klee it was vital to acknowledge, or rather to make visible, the essential. "Art does not reproduce the visible, it renders visible," said Klee at the beginning of "Creative Confession." They also both believed that the role of art was basically to act as an intermediary between disorientated man and authentic reality. In order to fulfill its role, art had to liberate itself from the "exteriorities," that is its narrative content, and confine itself to pure forms and abstract colors. The *Landscape with Yellow Birds* evokes a poem of Klee's dated December 24, 1912:

On seeing a tree
The little birds excite envy.
They avoid
Thinking about trunk and roots,
And are satisfied to have fun all day,
 nimbly swinging
On the newest twigs and singing.

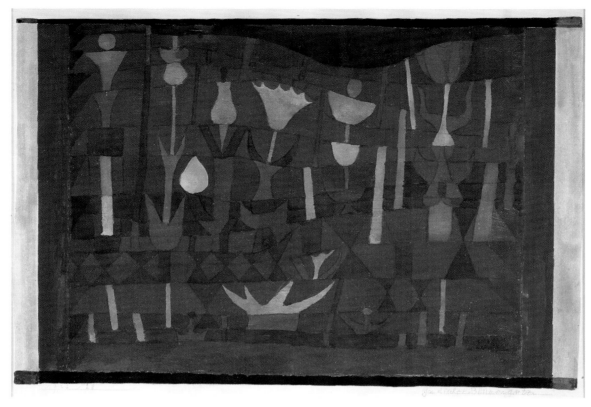

157. GARDEN OF INDIAN FLOWERS
(INDISCHER BLUMENGARTEN)
1922/28 – Gouache on paper mounted on cardboard, 24 × 25.8 cm
Saarland Museum, Sarrebrücken.

158. GARDEN PLAN
(GARTEN-PLAN)
1922/150 – Watercolor on Ingres paper glued onto cardboard, 26.6 × 33.5 cm
Paul Klee Foundation, Kunstmuseum, Bern.

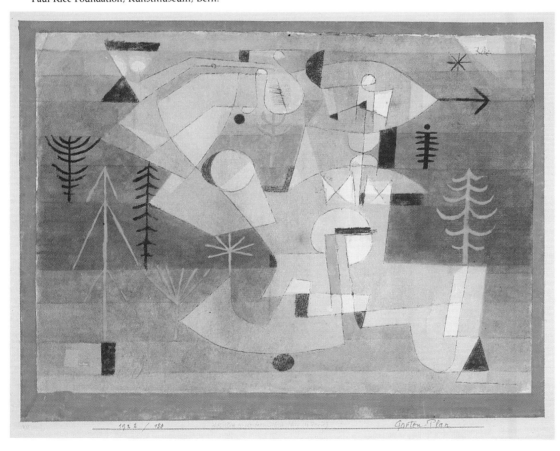

159. THE LOVER
(DER VERLIEBTE)
1923/91 – Lithograph in color, 27.4 × 19 cm
Hamburger Kunsthalle, Hamburg.

160. VENTRILOQUIST
(DER BAUCHREDNER)
1921/190 – Pencil on paper, 28.3 × 23.3 cm
Paul Klee Foundation, Kunstmuseum, Bern.

161 Ventriloquist (Crier on the Moor), 1923

This watercolor was done during the same period that "Ways of Studying Nature (An Internal Exploration of Nature: Reality and Appearance)" was published by the Bauhaus. In it Klee combined two radically contradictory styles of working. The background, like a Scottish kilt, is composed of intercrossing yellow and green bands, which are darkest in the upper part. The technique used in this painting culminated from many other paintings; formulated in certain of the Tunisian watercolors and pursued in the painting-poems, it was further developed in the magic squares. It would be erroneous to claim that this painting belongs exclusively to the structural paintings done at the Bauhaus in Weimar. Besides having been progressively constituted since 1914, this painting with its ruled score of quadrilaterals and its polyphonic placement of tones and values (green, yellow and purple) involves a musical concept.

On the checkered background, a personage has been inked in and filled with a transparent screen of squares in the lightest of tones (pale pink and blue); it is reminiscent of a child's drawing, though the line is very precise and has been put down with great authority. The head is in the form of a bell or helmet. The stomach is an enormous protuberance where, through the checks, five fantastic animals can be seen gathered around the umbilical. The animals float in an undifferentiated space, which goes back to a series of "organic" works. A strange fish is suspended from the stomach by a thread. The general feel is that of an Ubu drawing by Jarry.

The animal forms seen through the squares are very similar to compositions in the X-rayed paintings on bark from Arnhem in Australia, as well as to oceanic art and some works of the Tlingit Indians of Canada. But while the intestines and vertebral column in the foetus of the paintings on bark are painted according to intellectual realism, here they are monstrous imaginative beings who presumably can only speak through the ventriloquist. Klee had already used this technique in a 1922 lithograph, *The Lover*, in which the body of the loved one is in the head, legs spread and erotically penetrated. To materialize these phantoms, he used the same method as that used in the X-rayed bark paintings; therefore they have the same function (to reveal what is not usually visible to the human eye), but what is revealed shows anatomical knowledge in the one case, and in the other, imagination or obsession. The status of eventual borrowings must, therefore, be evaluated on a double register: that is, first as an elementary sign that no longer has its original meaning, and secondly as a sign whose significance is related to the work in which it is placed.

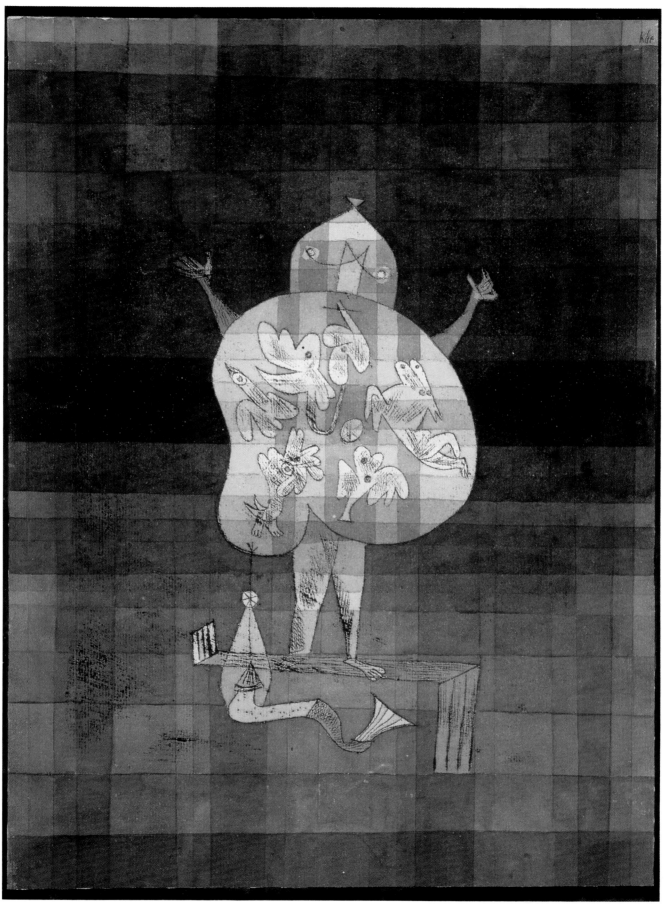

161. VENTRILOQUIST (CRIER IN THE MOOR)
(DER BAUCHREDNER RUFER IM MOOR)
1923/103 – Watercolor and pen, 41 × 29 cm
Berggruen Collection, Metropolitan Museum of Art, New York.

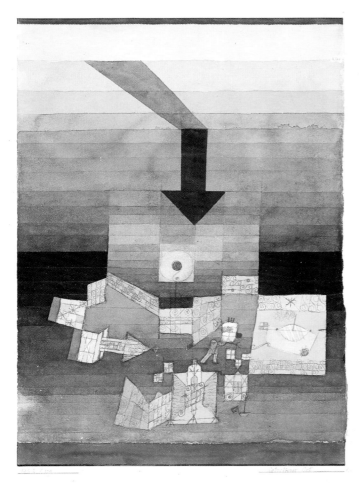

162. STRICKEN PLACE
(BETROFFENER ORT)
1922/109 – Watercolor on Ingres paper
glued onto cardboard, 32.8 × 23.1 cm
Paul Klee Foundation, Kunstmuseum, Bern.

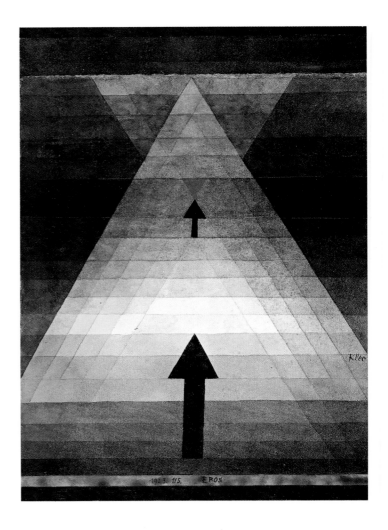

163. EROS
1923/115 – Watercolor on Ingres paper, 33.3 × 25.5 cm
Rosengart Collection, Lucerne.

The antagonism between the dividual and individual elements can be seen most clearly in the strip images in which Klee introduced narrative motifs, instead of abstract crossbars, into the structure of the horizontal bands. In the case in this painting, as well as in two other compositions of 1922, *Garden Plan* and *The House with the Arrow*, a collection of decorative forms and figurative signs is threatened by a powerful arrow coming, like a fatal catastrophe, from the top of the painting. "The longer the journey between here and the world beyond is," remarked Klee, "the more perceptible the tragic tension becomes." He further accentuated this impression by the break in the horizontal layers at the arrow's point of impact. He borrowed his plastic means from an observation of nature: "The active part (the line) can attack in two ways: It either divides the form achieved into two parts or goes further and causes a displacement, which in geological terms is called a fault . . ."

With regard to the static movement, he noted: "The arrow's target is the center of the earth; its trajectory ends on the most favorable terrestrial layer and becomes position. (. . .) The straight lines going horizontally are abstract notions of the static rules of the second degree (layers and accumulation resulting from the force of gravity)."

With or without the help of the arrow, Klee represents the movement of forms by a progressive series, notably through the elements of horizontal bands. In this work the tension of the event condenses as the bands gather together around the target. According to Klee's definition, rows that shrink while regressing towards the center are mortal. The chromatism is there to reinforce this impression, and the progressive darkening acts as a threatening charge. The luminous yellow of the upper part is engulfed in the black and has its counterpart in the bottom part. The two currents are rushing toward the target. One has the impression that at the junction point of the colored currents, underneath the forms that constitute the decorative bands, and the mysterious and grotesque figures and ships, lies chaos. These forms are "thrown into relief" by the displacement of colored layers.

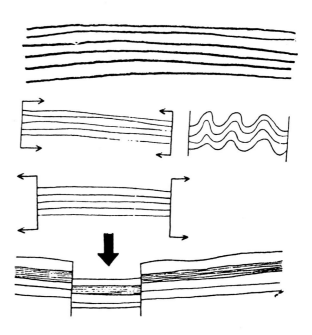

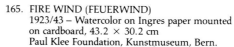

Pressure and counterpressure lead to mountainous pleating

Or the opposite:
Slackening off the pressure produces a fault.

165. FIRE WIND (FEUERWIND)
1923/43 – Watercolor on Ingres paper mounted on cardboard, 43.2 × 30.2 cm
Paul Klee Foundation, Kunstmuseum, Bern.

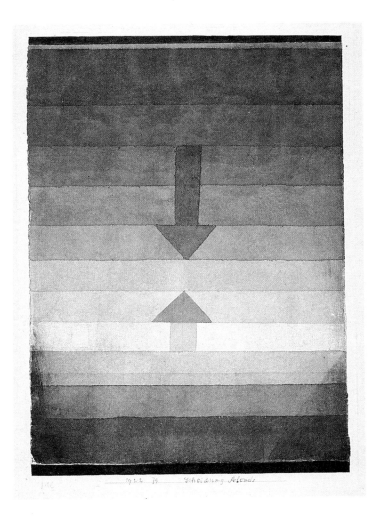

166. EVENING SEPARATION
(SCHEIDUNG ABENDS)
1922/79 – Watercolor on paper mounted on cardboard, 33.5 × 23.5 cm
Private collection, Switzerland.

Double Tent, 1923

167

166

Like a 1922 watercolor, *Evening Separation*, this one could be subtitled "Diametrical gradation in blue-purple and yellow orange." Movement and countermovement (rise and fall) are face to face, and the opposites run into each other. The degrees ranged in tiers between dark and light result in the fusion of the binary vibration staggered between the colors of the spectrum.

In "Fundamental Elements of the Theory of Form," Klee compares cosmos and chaos: "From a cosmogenetic point of view (relative to a cosmic vision of things), the ordered cosmos is formed from the myth of the original state of the world either suddenly, or progressively, or in an independent fashion, or by the intermediary of a creator.

The natural state of movement between the white and the black (or between the red and the green, according to the chosen example) is not without order; it is without structure. (. . .)

"*Artificial Order*. It is, of course, a weakened state, but it still can be described so that it can be perceived: decomposition of light/dark movement, aided by measurable transitions, from one pole to the other. We immediately see the infinite number of tonalities in the ladder of light and dark tones between the two poles.

"By climbing up the degrees that separate the dark depths from the source of light, we feel the grandeur and fullness of the gradation of tones between the two poles, but it must not be given too much importance. At the bottom, dark, subterranean underwater rumbling; at the top, a precise quivering dazzle.

"On the tonal value ladder the intermediate gradations, in so far as they are distinct dimensions, can be measured, weighed, and perceived by the critical senses.

"The practical problem is the following: to mix or fix these gradations and explain them by integrating them into the chiaroscuro ladder."

This watercolor was done at the same time as Klee gave these lectures at the Bauhaus. For Klee there was hardly any distance at all between theory and the work itself. He had, of course, made a minute study of the problems of form before discussing them with his students. His work is one of systematic experimentation, and his development in part ran parallel to his teaching.

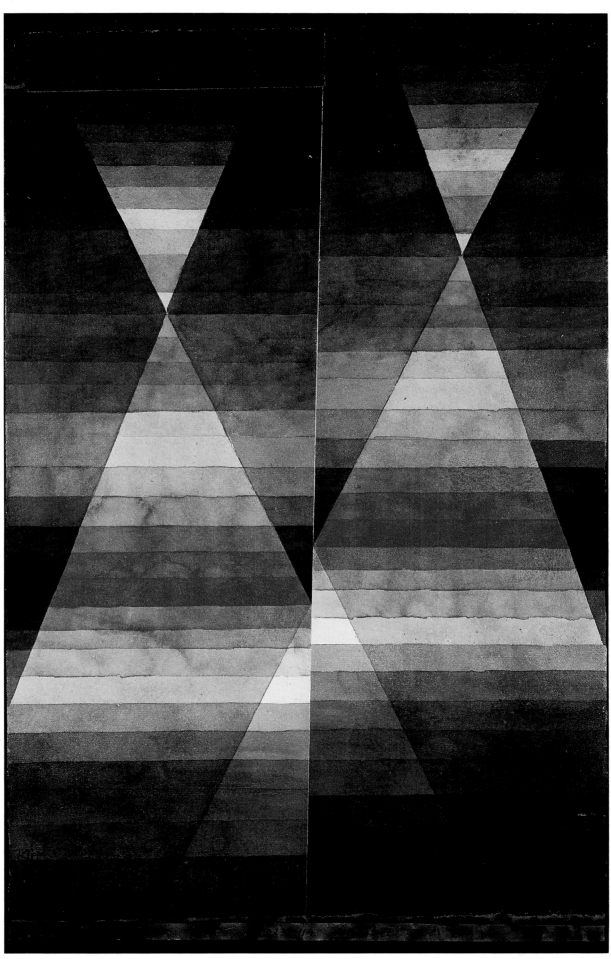

167. DOUBLE TENT
(DOPPELZELT)
1923/114 – Watercolor on Ingres paper mounted on cardboard, 50 × 31.8 cm
Rosengart Collection, Lucerne.

121

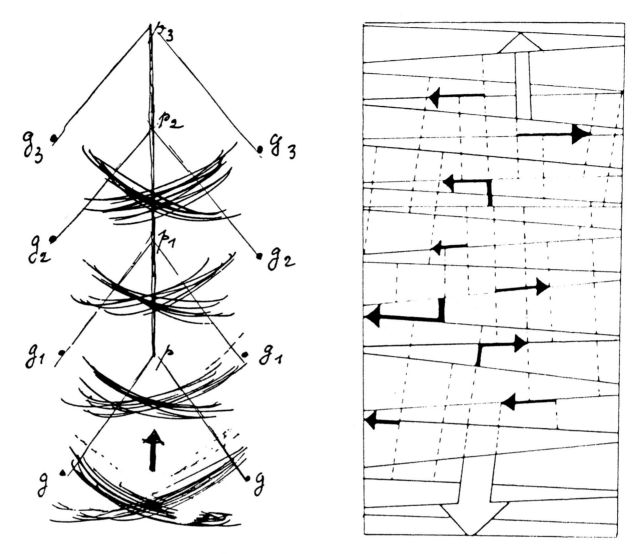

168–169. SKETCH EXTRACTED FROM "THE THOUGHT OF THE PLASTIC ARTIST"

Unstable Equilibrium, 1922

This series of studies of equilibrium and vectors, which was closely linked to his course at the Bauhaus, is purely about a battle for space; it is not a necessary combat from an exterior point of view but one that has an internal necessity. It is about symbols for forms in movement that had led Klee to study over a long period different types of dynamic equilibrium.

His lecture on April 3, 1922, defined the subject matter: "Cause, the effect and formation of animated forces. The organization of movement and the synthesis of the details destined to create a calm-animated and animated-calm whole. The solution emerging from the infinite movement."

The movement, conditioned by the pendular oscillation and indicated by the arrows, determines not only the construction of the whole and its equilibrium, but also the progression of the static construction of the underlying quadrilaterals. The balance always corresponds to a movement that goes in a contrary direction to that of the vertical. Therefore, a counter-movement in an opposite direction always corresponds with this vertical. The composition moves according to the movement of the whole construction. The vertical (indicated by the two thickest arrows) and the equilibrium movement are inverted. The whole, which appears as a meshing of forms, is not without ambiguity. In principal, the relationship between the surfaces derives from the play of forces.

Klee also titled this watercolor *Balancing Activity* and described it like this: "Little horizontal drama, the scaffolding is wavering . . . We can imagine that the force capable of causing the fall is expressed by the arrow, and its range, by its weight."

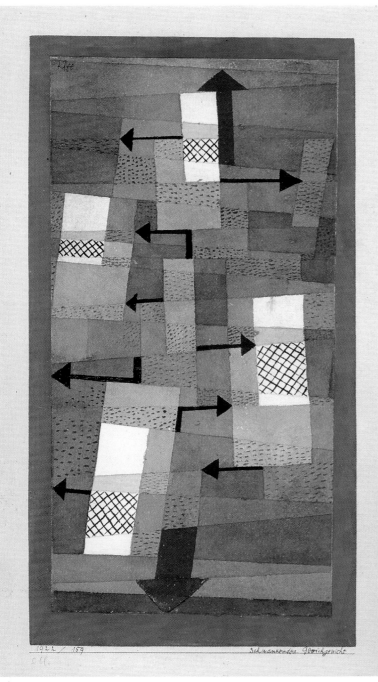

170. UNSTABLE EQUILIBRIUM
(SCHWANKENDES GLEICHGEWICHT)
1922/159 – Watercolor on Ingres paper glued
onto cardboard, 34.5 × 17.9 cm
Paul Klee Foundation, Kunstmuseum, Bern.

171. ARROW IN THE GARDEN
(PFEIL IM GARTEN)
1929/27 (S 7) – Oil and tempera on canvas, 70 × 50.2 cm
National Museum of Modern Art, Georges-Pompidou Center, Paris.
Gift of Louise and Michel Leiris who retain usufruct.

STRUCTURE DENSIMETRIQUE DANS LES
DEUX DIMENSIONS (l'Echiquier)

première
dimension :
sommes
verticales
(poids des
bandes)

seconde dimension :
sommes horizontales
(poids des bandes)

Fig. 17

Fig. 17 : les deux dimensions combinées (croisement)

PAGE EXTRACTED FROM *LA THÉORIE DE L'ART MODERNE*
Édition Denoël, 1985, P.82

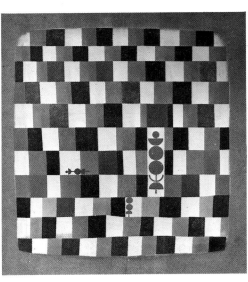

172. SUPERCHECK
(ÜBERSCHACH)
1937 – Oil on jute canvas, 120 × 110
Kunsthaus, Zurich.

173 **Architecture, 1923**

This work is part of the *Magic Squares* series where Klee, using color and chiaroscuro, studies the effects of the rhythmic repetition of identical elements, grouped "in such a pure and logical way that each one is in its correct place, and not one disturbs the order," according to the *Pedagogical Sketchbook*. No other artist has explored the domain of elementary geometrical forms as much as Klee did. He uses geometry, not only in order to create pure pictorial facts like in this painting, but also to explain organic life, as in the 1934 work *Blossoming*.

As René Crevel wrote in 1930, "the most simple materials, words or colors, serve as the intermediary between the world beyond and the seer. The poetry is contained in the discovery of unsuspected relationships of one element to another. The painter who found poetry in the dryest geometry will also know how to ascend after his dives."

Will Grohmann compares the series of Magic Squares with contemporary musical research, in particular the system of twelve tones invented by Schonberg in 1923, the same year as Klee painted *Architec-

ture.* "I found a slip of paper among Klee's papers on which was a plan for one of his pictures; numbers were written in the squares, a series of numbers ran first in one direction then in the other, crossing each other. When the numbers are added along the horizontals and verticals, the totals are equal, as in the well-known 'magic square.' In a psychic investigation of the most elementary geometrical figures and the internal structure of the material, its matrix and rhythmic forms, Klee finds an active principal of organization based on the same pulsation from which comes the creative being as well as the created universe. But the abstract forms used by Klee to translate this pulsation are only abstract in the way in which he puts them down. He works hard at discovering and then putting down the rhythm of 'great nature' as instinctive movements or urban centers."

This action has been thought about, in that all putting down of the work is of necessity an ordering process. By a controlled organization of form, color, and rhythm, Klee imposes an intelligible logic on the signs he invents and the meanings he discovers.

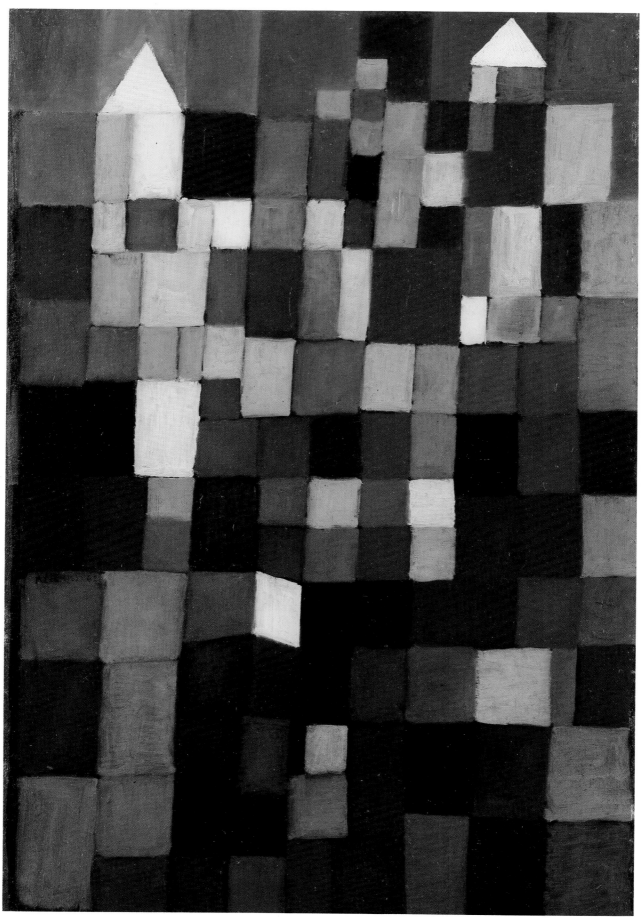

173. ARCHITECTURE
(ARCHITEKTUR)
1923/62 – Oil on cardboard, 57 × 37.5 cm
National Gallery, Berlin.

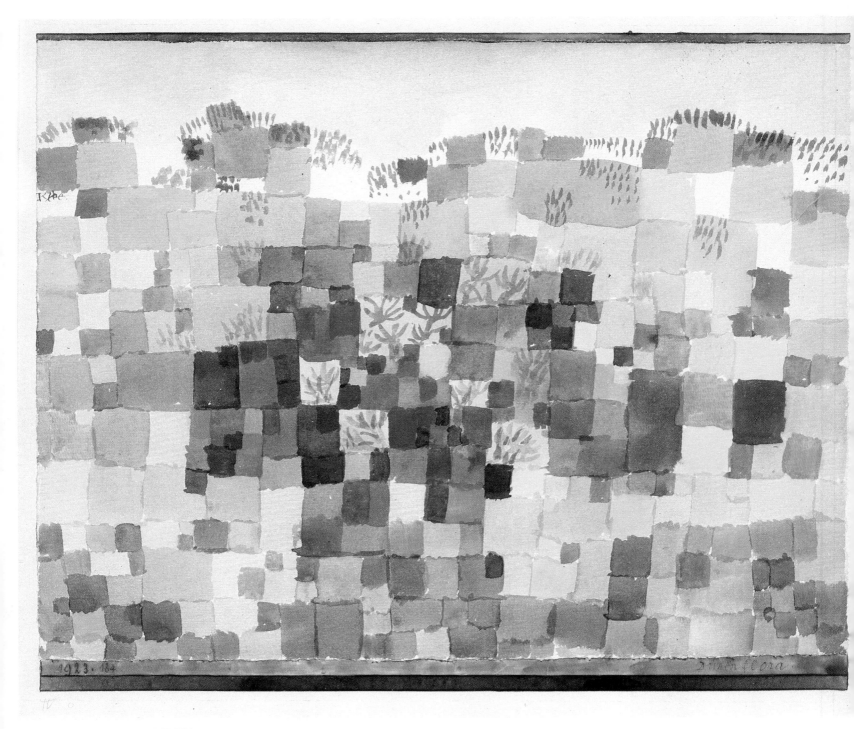

174. DUNE FLORA
(DÜNENFLORA)
1923/184 – Watercolor on Ingres paper mounted on cardboard, 25.4 × 30.2 cm
Private collection, New York.

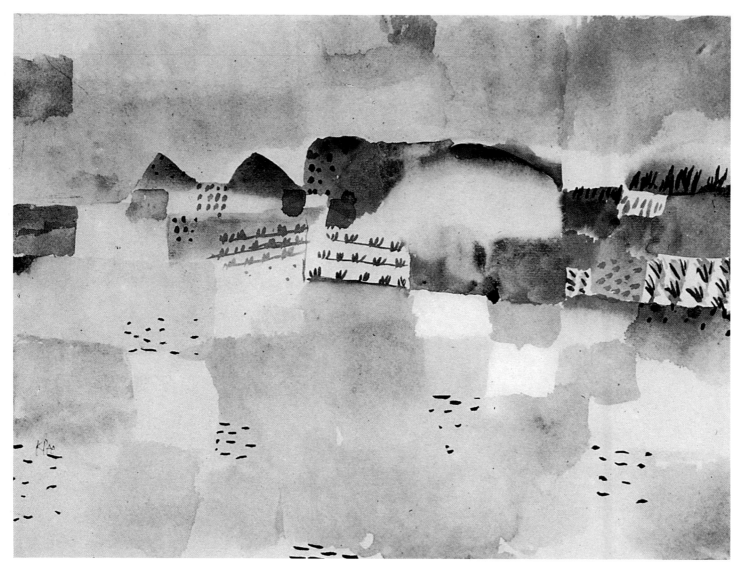

175. FORTIFIED DUNES
(BEFESTIGTE DÜNEN)
1923 – Watercolor
Private collection, United States.

74 Dune Flora, 1923

This watercolor done in 1923, is a continuation of the Tunisian watercolors of 1914. The schemata is the same, a carpet of colored squares and rectangles that end at the top of the dunes, which block our view of the sea. A horizontal mauve strip lies above the beige sky giving it an unexpected dazzle; another mauve strip, with a green strip on top of it bearing the title and date, supports the geometrical vegetation. Pink coral-like vegetation has been placed in several places near the center, and ochres and greens, toward the summit of the dunes. Sparse flora battle for survival against the wind and sand.

Nothing could be more elementary or more simplistic than this juxtaposition of different colored quadrilaterals that start dividing in the center. And yet the simple factor of this division seems to make them rise up and bump against each other, as if they were being pushed by a force that can no longer contain itself. The colors get lighter and clearer; whites, pinks, yellows, greens, and mauves appear, and this effect is sufficient to give us the feeling that we are looking at flowers blossoming. The interior of the picture vibrates in this to-and-fro movement of a thousand reciprocal influences, floating without a single immobile point. The whole is nothing more than an affair of color play, each color centering and firmly placing itself opposite another and thereby finding its resolution. One has the impression, as Cezanne said, that colors come up from the roots of the world . . .

"The countryside here looks like bushy ruins," said Francis Ponge, on December 25, 1947, at Sidi-Madani, "and on the ground, in the wadi beds, fragments of mosaic like cracked paving stone."

1935 3

Spiel auf dem Wasser

176. GAME ON THE WATER
(SPIEL AUF DEM WASSER)
1935/3 – Pencil on paper on cardboard, 17.9 × 27 cm
Paul Klee Foundation, Kunstmuseum, Bern.

177 North Sea (at Baltrum), 1923
178

In 1923 Klee spent his summer vacation at Baltrum, an island in the North Sea. As had happened on his trip to Tunisia and the later ones to Sicily and Egypt, the direct contact with nature filled his work with sensitive impressions that were more spontaneous than usual. Like Caspar David Friedrich, he was deeply moved by the desolate dune landscape and the encounter with the sea. But Klee no longer felt the need to put one or several personages in front of the marine horizon, even though the atmospheric impression is so close to that of Friedrich's *Monk in Front of the Sea* (1808–1810, Berlin, National Gallery). As in Tunisia, the watercolors were executed directly from nature and formed the counterbalance to the abstract squares of the same year. Klee reduced the format and chromatism to such an extent that one can hardly distinguish these works from certain abstract works.

One consists of a series of colored horizontal stratum that, despite the small format, immediately evoke the sea. Klee put his colors down in thin layers on moist paper with the edges of the stratum slightly overlapping. A line left in the original white of the paper denotes the horizon. Earth, sky and water appear as atmospheric layers behind a bank of mist. This watercolor corresponds without doubt to a natural impression that Klee related to the apparition of a rainbow. In his November 28, 1922, lecture "Color Classification," he said: "Nature offers us an image of colored incentives: the vegetable kingdom, the animal kingdom, mineralogy, the composition that we call landscape — all of it unceasing matter to reflect upon and be grateful for.

"It is, however, a phenomenon that goes beyond all these colored things, like an abstraction of all application, transformation, or modification of color, an abstraction in the sense that the purity of color is the phenomenon of the rainbow.

"It is revealing that this particular case of a gradation of pure colors does not totally belong in this world but is situated rather in the intermediate domain of the atmosphere, which is both earthly and cosmic. It follows that the rainbow offers a certain degree of perfection, but not of the highest degree, for it actually only half brings into relief the world beyond."

177.

178.

177. NORTH SEA (AT BALTRUM)
(NORDSEEBILD [AUS BALTRUM])
1923/246 – Watercolor and brush drawing on Ingres paper
glued onto cardboard, 30.7 × 47.1 cm
Paul Klee Foundation, Kunstmuseum, Bern.

178. NORTH SEA (AT BALTRUM)
(NORDSEEBILD [AUS BALTRUM])
1923/242 – Watercolor on Ingres paper glued
onto cardboard, 24.7 × 31.3 cm
Paul Klee Foundation, Kunstmuseum, Bern.

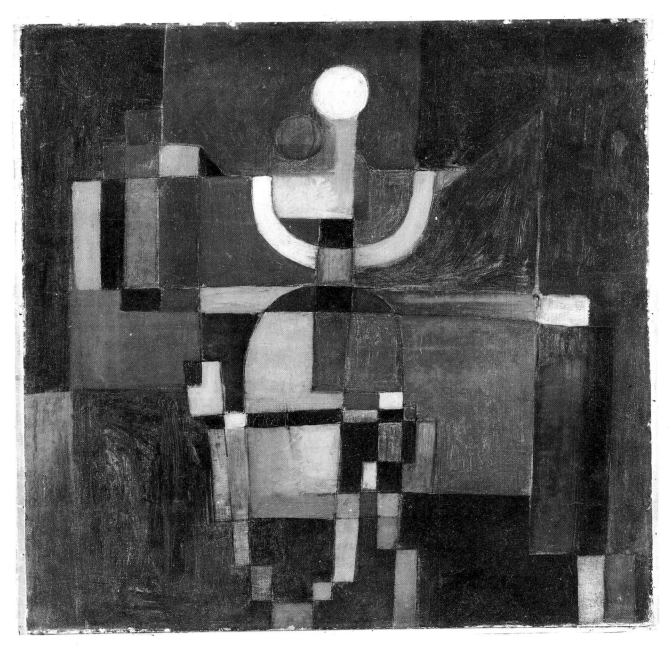

179. ORACLE
(ORAKEL)
1922 – Oil on cardboard, 53 × 51.5 cm
Staatsgalerie, Stuttgart.

180 **Garden in PH, 1925**

Put down in an unrestrained manner, this horizontal and diagonal mosaic of superimposed or juxtaposed layers on a dark ground tries rather awkwardly to create an alive structural rhythm. It is a color abstraction in which a quite disjointed dynamic of light and dark can be seen. If we include this work in the *Magic Squares* series, we see that it is one of the least successful.

This sketch on black paper lets us see so much of the base that the quadrilaterals resemble the freestone of a Cyclopean construction. The differentia-

tion of color is effected on a very dark scale; only the reds and mixed yellows come into relief. However, we must not ignore the sketchlike feel of this work or the loose character of the marks that have been put down so summarily. Furthermore, the colors are much more imaginative on this black base than they would be on a white base. We try to follow the overlapping quadrilaterals going in different directions, but in the end the picture is still a map of incongruous colors.

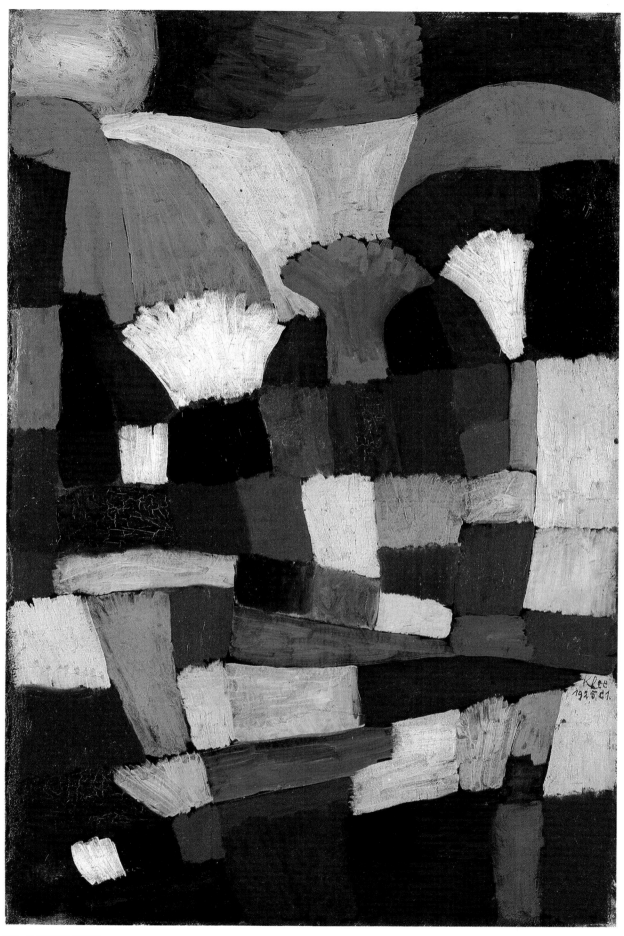

180. GARDEN IN PH
(GARTEN IN PH)
1925 – Oil on canvas, 51 × 33 cm
Staatsgalerie Moderne Kunst, Munich.

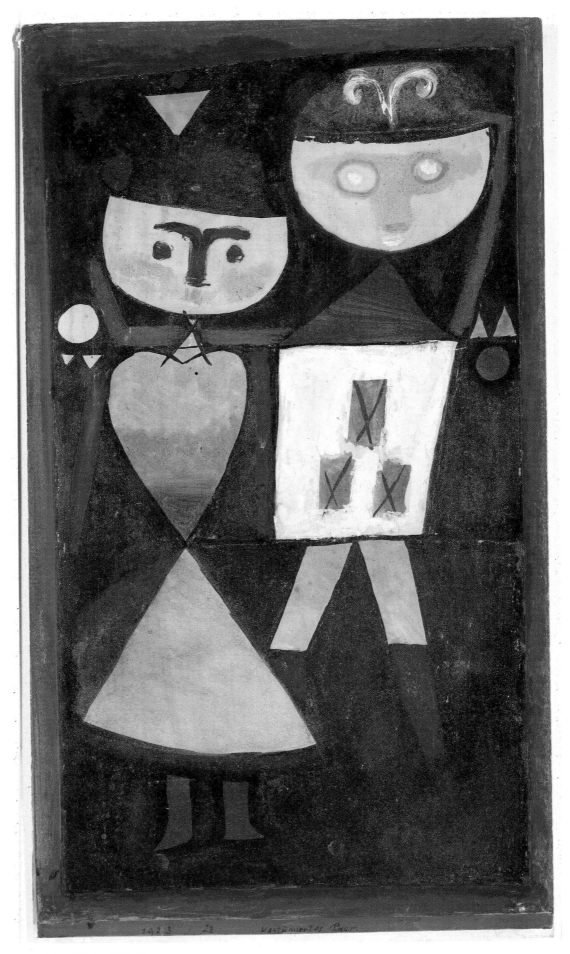

181. COUPLE IN COSTUME
(KOSTÜMIERTES PAAR)
1923/28 – Oil and gouache on paper pasted on cardboard, 51 × 27.8 cm
Jan Krugier Gallery, Geneva.

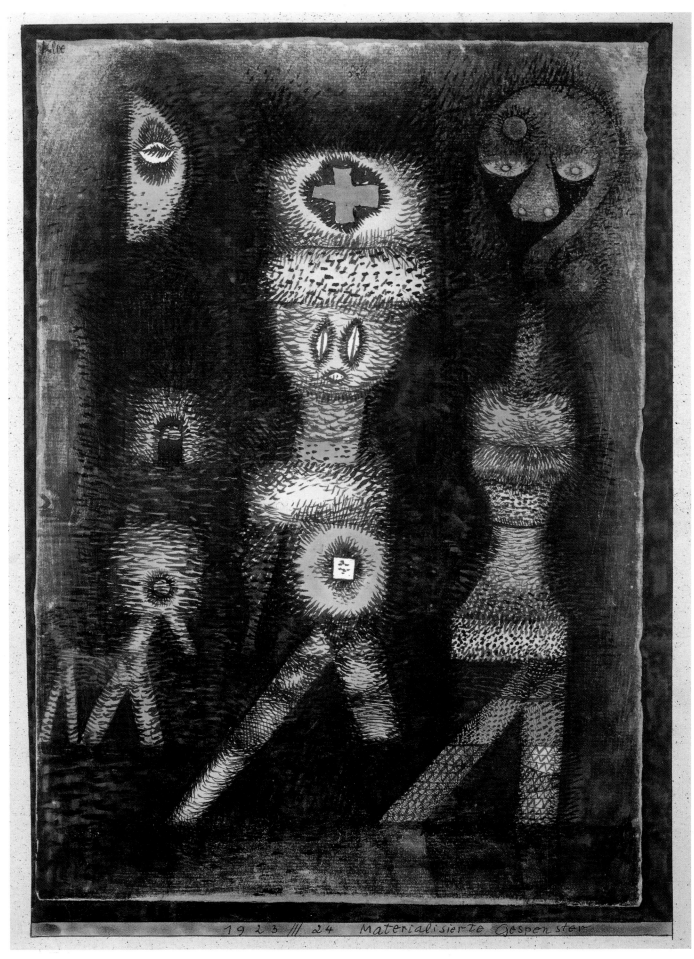

182. MATERIALIZED GHOSTS
(MATERIALISIERTE GESPENSTER)
1923/24 – Pen and watercolor on paper mounted on cardboard, 37 × 25.2 cm
Jan Krugier Gallery, Geneva.

183. PYRAMID
1934/41 (L 1) – Watercolor on cotton glued on cardboard, 26.7 × 44.8 cm
Paul Klee Foundation, Kunstmuseum, Bern.

184 **Mountains in Winter, 1925**

Teaching at the Bauhaus took Klee from his solitude and led him to experiment with various techniques that some of the teachers, such as Moholy-Nagy, had introduced. Except for some places that have been masked off, the colors in this work on a chalk base have been powdered, a method that he used again in *Plan for a Fortified Castle*. In this patch of twilight with its floating yellow sun, projector beams diffuse a radiant peace. The basic theme is of an achieved form of space and time, a visual system of coordinates with all the fields of possible interference that this comprises. We are led into a padded harmony hanging over a transparent variation that slips into the imaginary space of the work; the mountains metamorphose into esoteric pyramids that dematerialize into projector beams. The volumes are given a new dimension by the presence of the light that plays around the tree stripped by winter.

A work like this evokes Schwerdtfeger's play of colored light, which Hirschfeld-Mack took up and developed by adding reflective effects. In 1922, Schwerdtfeger began a detailed study of the illumination effects of kerosene lamps, and this paved the way for a new field of investigation at the Bauhaus, that of the play of colored light (Reflektorischen Farbenlichtspiele). This picture could be illustrating this passage of André Breton's in *Surrealism and Painting*: "For a long time, I think, humankind will feel the need to go up again to the real mouth of the magic river flowing out from under their eyes, which bathes in the same light, in the same hallucinatory shadow, things that are and those that are not. Without always being sure to what they owe the troubling discovery, they will set one of these sources very high above the summit of all mountains. This region, where fascinating vapors condense from what they still don't know and what they are going to love, appears to them in a flash of lightning."

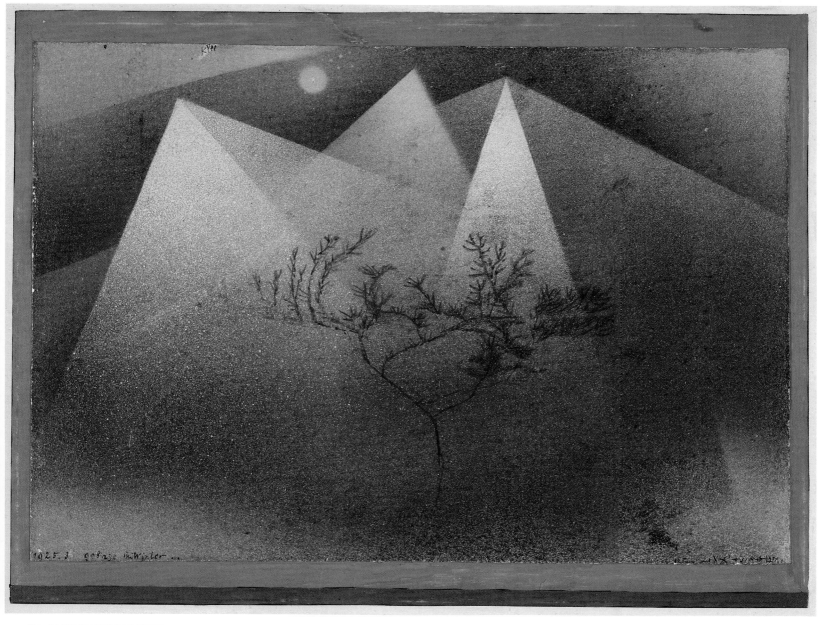

184. MOUNTAINS IN WINTER
(GEBIRGE IM WINTER)
1925/3 – Watercolor, brush drawing on a chalk base on paper, 28.7 × 37 cm
Hermann and Margrit Rupf Collection, Kunstmuseum, Bern.

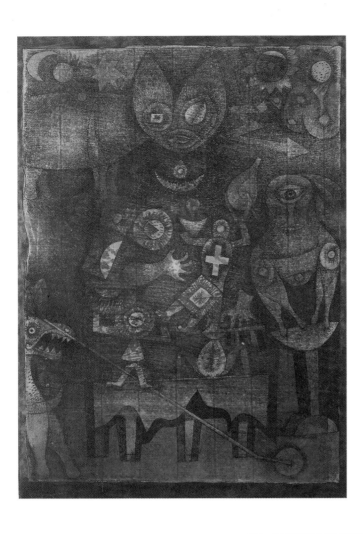

185. MAGIC THEATER
(ZAUBERTHEATER)
1923/25 – India ink and watercolor on paper mounted on cardboard, 33.6 × 22.8 cm
Paul Klee Foundation, Kunstmuseum, Bern.

186. CARNIVAL IN THE MOUNTAINS
(KARNEVAL IM GEBIRGE)
1924/114 – Brush drawing, watercolor on a chalk base, 26.5 × 33.1 cm
Paul Klee Foundation, Kunstmuseum, Bern.

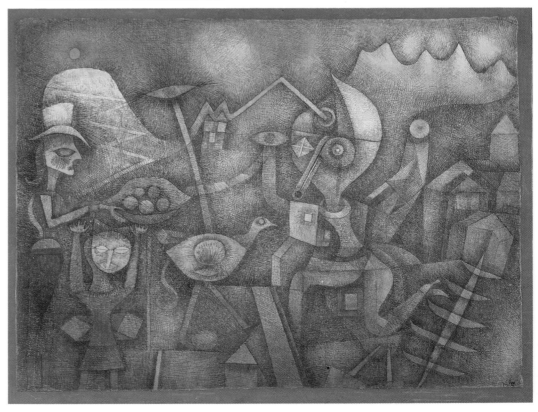

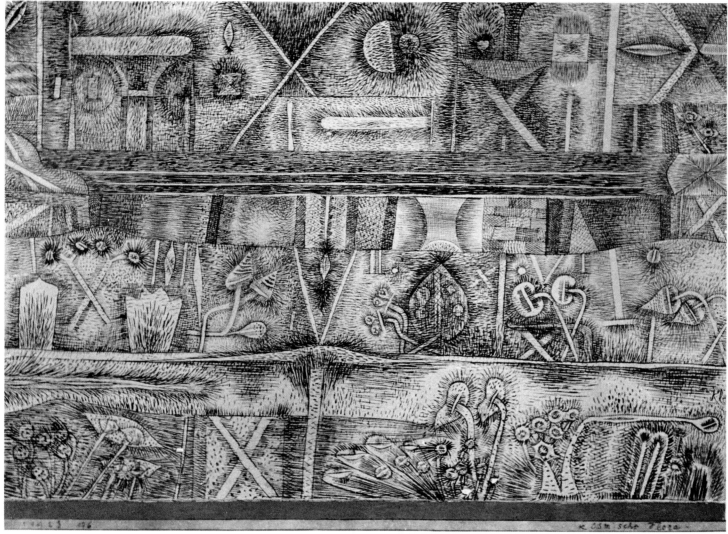

187. COSMIC FLORA
(KOSMISCHE FLORA)
1923/176 – Brush drawing, watercolor on a chalk base on paper glued on cardboard, 27.2 × 36.6 cm
Paul Klee Foundation, Kunstmuseum, Bern.

36 Carnival in the Mountains, 1924

The meticulous brush drawing of this watercolor recalls Klee's carefulness that he pushed to the extreme in his first etchings. He stated in his catalogue that the work had taken a week to complete. However, no one up till now has attempted to decipher the enigmatically appealing *Carnival*. To the right of the scene, the clear outline of a mountain hangs over a remote sun near a Cubist village. To the left, the moon weakly illuminates the snowy crest of a hill that is mounted by a zig-zag path; a masked woman with a silver hat holds out a basket of oranges, and a little girl, also masked, lifts her arms to the sky. These two personages have the same mysterious aura that we find in Balthus' works. In the center, an ostrich, inhabited by a heavenly body

and an eye, goose steps toward the oddest and most surreal personage. "The slash of nails that scratch, according to their Cyclopean whim, graffiti from the world beyond upon rocks and stones; these creatures and their ectoplasmic flowers from the realms of hypnosis were drawn and photographed without any lighting tricks, or false romanticism, or grandiloquent lying," wrote René Crevel.

This grotesque *Carnival* comes close to evoking the human comedy. "There are two mountains on which the weather is bright and clear, the mountain of the animals and the mountain of the gods. But between them stretches the twilight valley of humankind," Klee wrote in his Diary in 1903.

188. PEOPLE WITH FISH
(FISCH-LEUTE)
1927/11 (K 1)) – Oil and distemper on canvas, 32.1 × 55 cm
Paul Klee Foundation, Kunstmuseum, Bern.

188 **People with Fish, 1927**

We see these three accomplices with caricaturized bloated faces through an aquarium very like the one Klee saw in Naples during Holy Week in 1902. They seem to be fascinated by a fish "sitting in sand up to its ears, like humanity sunk in its prejudice." An echo of Klee's satirical verve is present in these three hallucinatory faces, which represent three states of "a convulsed me with big ears" caught in the trap of being the observed observer.

189 & **Monsieur Pearlswine —**
190 **Mask with Flag, 1925**

These two humorous masks were done according to the technique introduced by Laszlo Moholy-Nagy to the Bauhaus, whereby watercolor was powdered onto places that had previously been covered by a stencil. *Physiognomical Lightning* and *Black Prince* were executed in the same style in 1927. These pictures are a long way from the "essentially resigned physiognomy" of *Menacing Head* of April 1905, or the desperate ugliness of the 1919, lithographic self-portrait entitled *Meditation — Self-Portrait*. A humorous distancing is at play here, conferring on these two masks the anonymous sovereignty of playing cards. Set in a mist of fine particles and radiating with a luminescence due to the powdering of the watercolor, *Monsieur Pearlswine* and *Mask with Flag* stand in the undecided zone between phantasmagoria and reality. Enclosed in a magnetic field, they attain, through the "absence of self," the transparency that allows them to enter the nonmanifest world and appears something like objective chance. Two colors, gray and pink, exuberantly fill the pure shapes left open by the stencil, making them look as if they have been filled with an exquisite powder stolen from butterflies' wings.

189. MONSIEUR PEARLSWINE
(MONSIEUR PERLENSCHWEIN)
1925/223 – Stencil and watercolor on paper mounted
on cardboard, 51.6 × 35.5 cm
Kunstsammlung Nordrhein Westfalen, Düsseldorf.

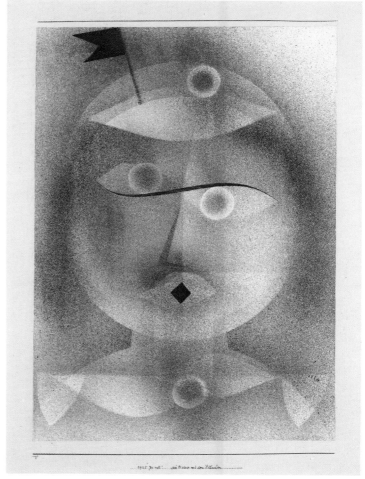

190. MASK WITH FLAG
(DIE MASKE MIT DEM FÄHNCHEN)
1925/220 (W 0) – Watercolor on chalk base on paper mounted
on cardboard, 65 × 49 cm
Bayerische Staatsgemäldesammlungen, Munich.

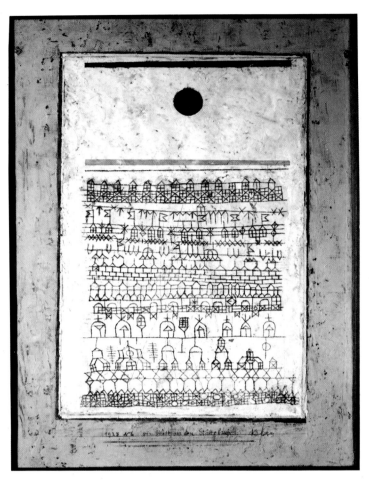

191. A LEAF FROM THE BOOK OF CITIES
(EIN BLATT AUS DEM STÄDTEBUCH)
1928 (N 6) – Chalk base on paper mounted on wood, 42.5 × 31.5 cm
Kunstmuseum, Basel.

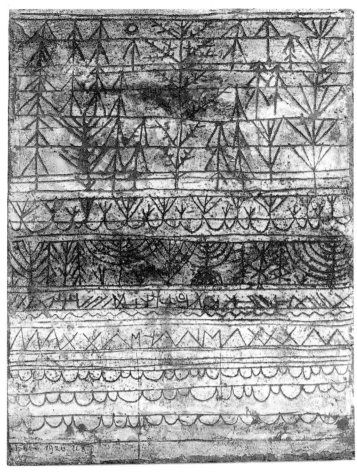

192. YOUNG FOREST TABLEAU
(JUNGWALDTAFEL)
1926/208 (U 8) – Oil on gauze covered with plaster and mounted
on cardboard and wood, 36 × 25.5 cm
Staatsgalerie, Stuttgart.

193 Neighborhood of Florentine Villas, 1926

These pages of writing (Schriftbildern) took root early in Klee's work and reappeared in a more matured form in 1924, in *Egypt Destroyed*. Most of them are composed of different signs either placed in transverse strips or freely all over the surface. They are usually made up of fine watercolor or, as in this work, of streaks of oil on a prepared surface. The writing can consist of simple signs, such as crosses, or decorative motifs, or "characters," such as houses, plants, or trees. The title sparks off an association with the images.

In 1941, in "Artistic Genesis and Perspectives of Surrealism," André Breton said: "The painter's hand truly flies by itself alongside him. It is no longer the same one that copies the shape of an object but rather one that, enamored of its own movement and only it, draws involuntary shapes in which experience shows

that these forms have been called up to re-embody themselves. Surrealism's most important discovery is, in fact, that without any preconception, the pen that races to write, or the pencil that races to draw, *spins* an infinitely precious substance that is perhaps not all exchanged content but that, at the least, appears charged with everything that the poet or painter receive from their emotions."

It is a delirious world that resembles Michaux's, a world of false images, pseudo-likenesses, a world of optical illusion and simulacrum that frees the "joyous news" announcing itself by a "simulated doctrine" in fragmented writing; a world of intermittent intensity lived by the subject who both borders on the void and is in the void. "Up until now we have never allowed a line to dream . . ." noted Henri Michaux in 1954.

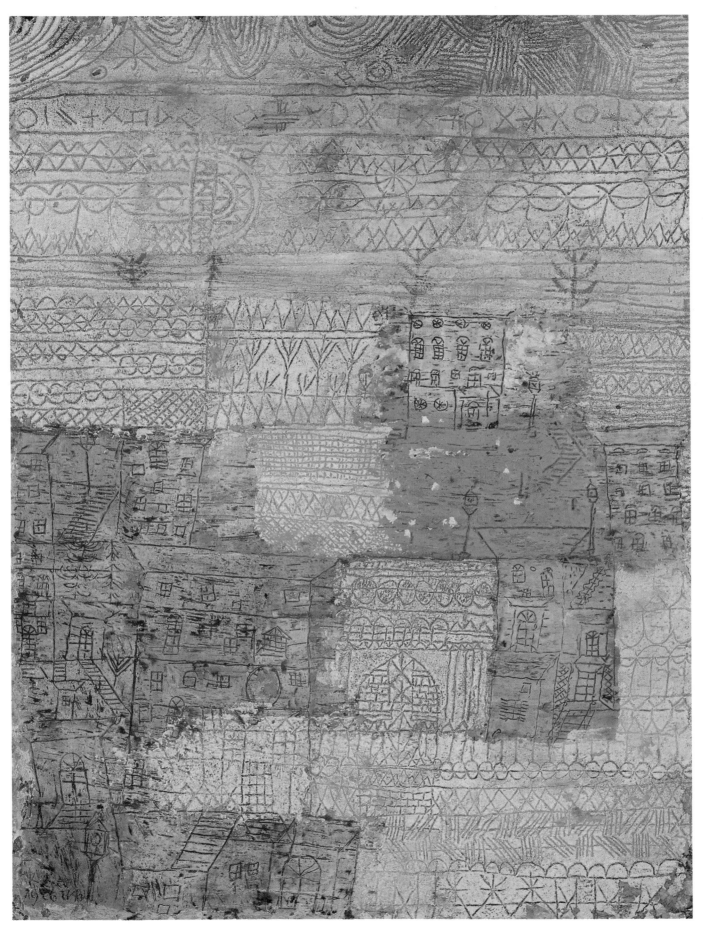

193. NEIGHBORHOOD OF FLORENTINE VILLAS
("FLORENTINISCHES" VILLEN VIERTEL)
1926/223 (W 3) – Oil on cardboard, 49.5 × 36.5 cm
National Museum of Modern Art, Georges-Pompidou Center, Paris.

1926. 2.

Schloss im Wald zu bauen

1927 VI

Neu-Wasserstadt

194. CASTLE TO BE BUILT IN A FOREST
(SCHLOSS IM WALD ZU BAUEN)
1926 – Watercolor and ink on paper
mounted on cardboard, 28 × 40.8 cm
Staatsgalerie, Stuttgart.

195. NEW WATER TOWN
(NEU WASSERSTADT)
1927/246 – Watercolor and gouache on
primed paper mounted on cardboard,
27.5 × 30.5 cm
Jan Krugier Gallery, Geneva.

142

196. A GARDEN FOR ORPHEUS
(EIN GARTEN FÜR ORPHEUS)
1926/3 – Pen and India ink on Ingres paper, 47 × 32 cm
Paul Klee Foundation, Kunstmuseum, Bern.

197. DRAWING FOR THE BATTLE SCENE IN "THE SEAFARER"
(ZEICHNUNG ZUR KAMPFSZENE DES SEEFAHRERS)
1923/208 – Pencil on paper mounted on cardboard, 23.4 × 34.4 cm
Paul Klee Foundation, Kunstmuseum, Bern.

198 **Picture of Fish, 1925**

The effort Paul Klee took to understand "Nature's spirit," is particularly apparent in his paintings of fish, which appear throughout the body of his work. They are the marks of his untiring quest to deepen universal vision. In the iconography of Indo-European peoples, the fish, the water emblem, is a symbol of fertility and wisdom. Hidden deep in the sea, it is penetrated by the sacred force of the ocean depths.

In 1902, when he was in Naples, Klee had been smitten by the aquarium. "Especially expressive are such sedentary creatures as octopi, starfish, and mussels. And snakelike monstrosities with poisonous eyes, huge mouths, and pocketlike gullets," he had written in his Diary.

199 During 1925, Klee also painted *The Goldfish* (Hamburg, Kunsthalle), and *Fish Magic* (Philadelphia Mu-

seum). In *Picture of Fish*, 20 fish move slowly in an oceanic space done in deep blues. Some are parallel while some prefer perpendicular contacts with other fish. And some have gone by so quickly that only a trace of them, like a greenish whirlwind, remains. The picture leaves us with a feeling of how fundamentally indeterminable everything really is, very much like Calder's mobiles; *Lobster Trap and Fish Tail* were made by Calder in 1939.

"Paul Klee, we can only call miraculous your journey into the most secret seas from which you returned with a treasure of mica, comets, and crystals in the palm of your hand, a harvest of haunting seaweed and the reflection of engulfed towns. As transparent as serrated fish, everything you brought back from the depths is worthy of attention," wrote René Crevel in 1929.

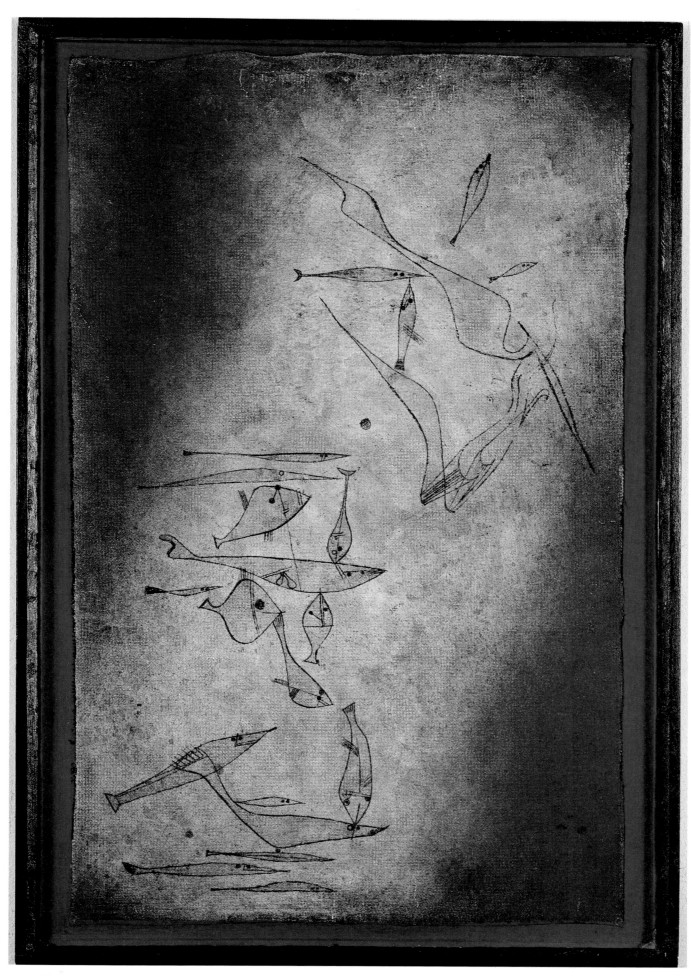

198. PICTURE OF FISH
 (FISCH BILD)
 1925/5 – Oil, watercolor and pen drawing on a gypsum base mounted on cardboard, 62 × 41 cm
 Rosengart Collection, Lucerne.

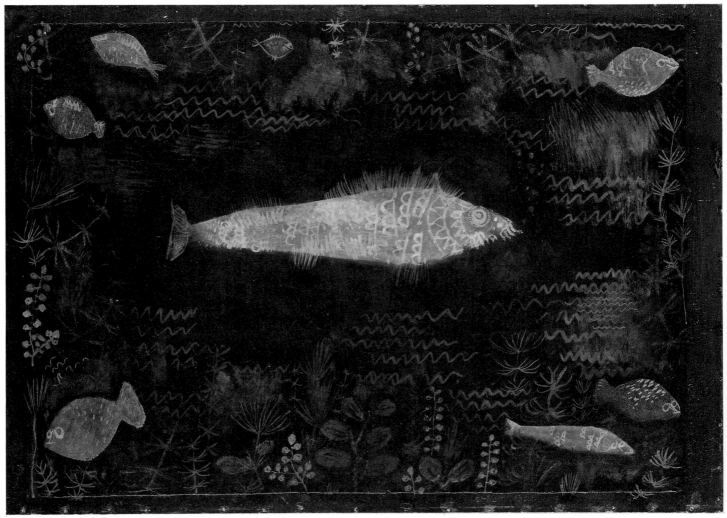

199. THE GOLDFISH
(DER GOLDFISCH)
1925/R6 – Oil and watercolor on paper mounted on cardboard, 49.6 × 69.2 cm
Hamburger Kunsthalle, Hamburg.

200 Around the Fish, 1926

This painting has sometimes been seen as an evangelical allegory: the fish of the first Christians, the cross, and guilt symbolized by the arrow that leads from the fish and targets a human mask . . . Siegfried Gohr goes so far as to see the deliverance of the human soul from the curse of individual existence as being its theme. The fish would symbolize the cycle of the always renewed flow from fertilization to the production of a new plant or new life, which leads irrevocably to the death of the organism. "Klee presents an allegory of the ego states in a language conveyed by the image."

It has been felt for a long time that this work is an enigma that it would be valuable to resolve. Many have tried, but no one has succeeded; a dream loses its charm by being interpreted. This mysterious and elusive fish evokes Surrealist procedure and tactics.

The fish is surrounded by other symbolic elements. The proximity of the moon and sun symbolize original unity. And from this original couple emanates the turning movement around the fish, which symbolizes the lost soul, that is in psychological terms, the "self" dominated by me. At all events, it is without doubt a metaphysical still life with a tinge of humor, in which the lowly everyday things (a vase and flower, the fish with fennel) and the marvelous cosmic objects (the moon-sun couple) are placed in the same nocturnal timelessness.

146

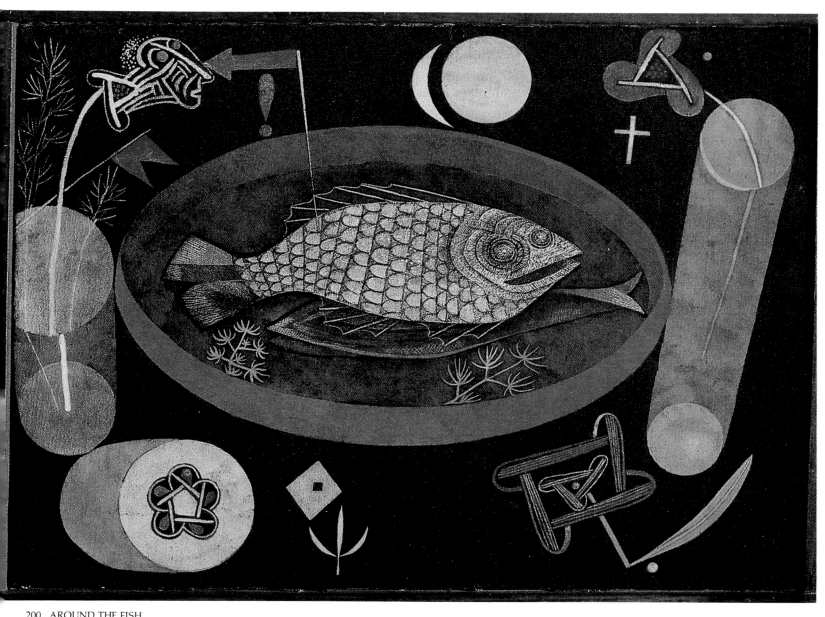

200. AROUND THE FISH
(UM DEN FISCH)
1926 – Oil and gouache on cardboard, 46.7 × 63.8 cm.
Abby Aldrich Rockefeller Fund, Museum of Modern Art, New York.

The Ships Depart, 1927

Although from a formal point of view the multidimensional accord is only an outline, it is also an expansion of the event (the departure of the ships) that is situated in a specific place and moment, indicated by both the ships, which have gone some distance and point to the immobile sleeping port, and the purple moon, which amplifies the space and suggests the presence of an invisible horizon. Thus the orange arrow emphasizing the direction of the movement is an epic accent in this landscape belonging to a cosmic fable. The boats and their sails have been reduced to stereotyped signs that have their plastic counterpart in the moon and its crescent.

"The space we introduce onto the surface is imaginary," Klee reminds us, and only comes about as a result of the absence of a perspective orientation of the space; the "relationships created in the picture" need order. This is a necessary condition if one wants to clearly depict the unfolding of the direction of movement. A three-dimensional space is conceived if the composition involves, in addition to the line and surface, the chiaroscuro or color values. On this point Klee's theory on the third dimension is fundamentally different from the traditional notions of space and dimension. The depth effect produced by the colors inside the image creates a movement toward the right. In a space without any perspective, Klee is able to fix the depth dimension due to the direction of the "fore-and-aft" movement.

The multidimensionality rests on the *hic et nunc* —the here and now — that, because there are no details in the nocturnal emptiness, becomes the "always and everywhere." The iconographic exactitude of the different stereotyped elements (the ship, moon, and the simultaneous presence of different movements) does not detract at all from the emblematic value of the scene that has the dramatic flavor of a stage set; this multidimensional accord is also present in a theatrical scene. "An agglomeration of movements in the universe with myself as its center," according to his "Creative Confession" of 1920, can signify the recognized unity of the place, time and action of the tragedy. Klee loved the theater passionately, and it is not by chance that the nocturnal emptiness of this landscape and the charm of the event are filled with the atmosphere of a fable with an epic overtone.

201. SHIPS IN THE LOCK
(SCHIFFE IN DER SCHLEUSE)
1928/40 (M 10) – Pen and India ink on Ingres paper mounted on cardboard, 29.6 × 45.5 cm
Paul Klee Foundation, Kunstmuseum, Bern.

202. ACTIVITY IN THE SEA TOWN
(AKTIVITÄT DER SEESTADT)
1927/216 (V 6) – Pen and India ink mounted on cardboard, 30 × 46.5 cm
Paul Klee Foundation, Kunstmuseum, Bern.

203. SHIPS AFTER THE STORM
(SCHIFFE NACH DEM STURM)
1927/211 (V 1) – Drawing in black and colored chalk on paper, 21 × 33 cm
Private collection, Switzerland.

204. HARD FORMS IN MOVEMENT
(HÄRTEN IN BEWEGUNG)
1927/214 (V 5) – Drawing in black chalk on paper, 20.9 × 33 cm
Private collection, Switzerland.

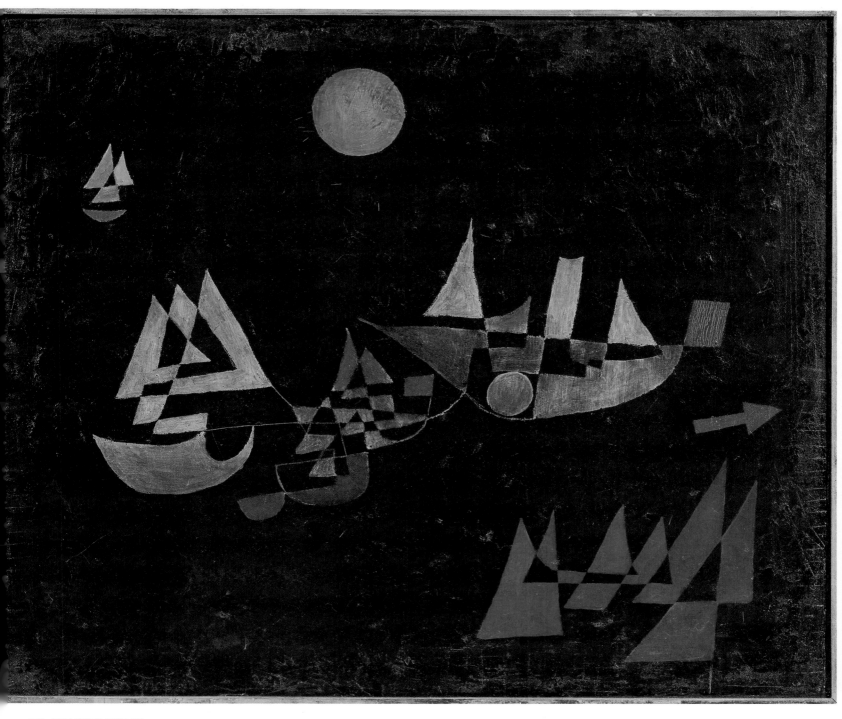

205. THE SHIPS DEPART
(ABFAHRT DER SCHIFFE)
1927/140 (D 10) – Oil on canvas, 50 × 60 cm
Private collection, Switzerland. On loan to the Kunstmuseum, Basel.

206. TOWN WITH WATCHTOWERS
(STADT MIT WACHTÜRMEN)
1929/181 (I 1) – Pen and brown ink on Ingres paper mounted
on cardboard, 45 × 30 cm
Paul Klee Foundation, Kunstmuseum, Bern.

207. UNCOMPOSED OBJECTS IN SPACE
(NICHTKOMPONIERTES IM RAUM)
1929/124 (C 4) – India ink and watercolor on Ingres paper
mounted on cardboard, 32 × 25 cm
Private collection, Switzerland.

208 **Italian Town, 1928**
207 **Uncomposed Objects in Space, 1929**

In *Uncomposed Objects in Space*, as in *Italian Town*, which appears to be organized around a center, Paul Klee was not content to introduce a simple optical perspective, that is a symmetrical axis and horizon; instead, he moves the optical point of vision, and "the eye changes places." The straight lines have different vanishing points, and some of them are found outside of the pictorial space. On this subject Klee had this to say: "Myself, very far away. Myself, still not very near. Myself, very near." The eye is drawn to different points, and the space is thus observed according to variable distances.

In *Uncomposed Objects in Space*, the perspective description of the plunging and counterplunging bodies and volumes is not organized around a precise center but is founded on an optical displacement animated by a movement from bottom to top. And at

the same time, we are able to observe the vertical axis swinging from left to right. The equilibrium arising from movement and countermovement likewise creates an equilibrium in the composition, and reestablishes an impression of symmetry. If we take the central optical perspective as a norm of reference, the movement causes a deformation that in its turn is corrected by a countermovement. Klee explained this in his 1922, Bauhaus lecture on the "Receptive Process."

With regard to the image in relief, he added: "The more distant the imaginary lines of projection are and the more elevated a dimension they attain, the better the result." The vanishing points have to be placed outside of the picture. The gradation of the depths likewise takes place on the chromatic level because of the horizontal parallel strips that he had used before in *Double Tent* (1923) and *Stricken Place* (1922).

208. ITALIAN TOWN
(ITALIENISCHE STADT)
1928/66 (P 6) – Watercolor on paper, 34 × 23.5 cm
Private collection, Switzerland.

209. STRANGE PLANTS
(SELTSAME PFLANZEN)
1921/203 – Pencil drawing, 19 × 28 cm
Kunstsammlung Nordrhein Westfalen, Düsseldorf.

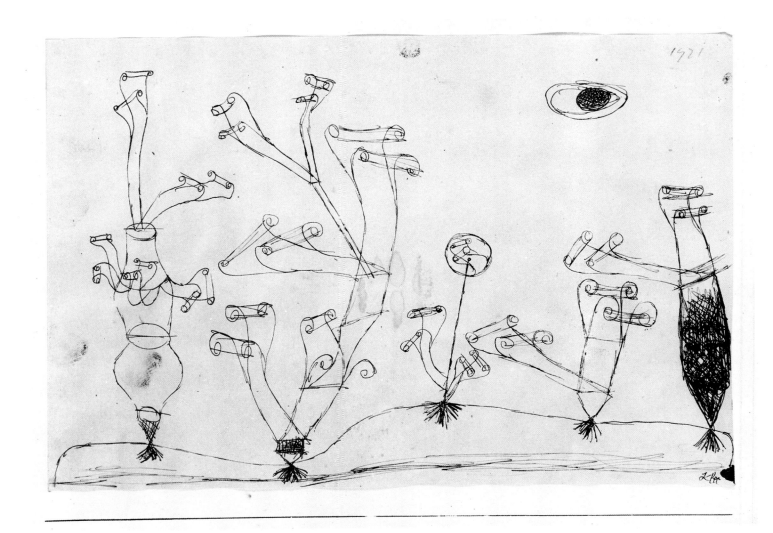

210. PLANTS IN THE FIELD
(PFLANZEN AUF DEM ACKER)
1921/160 – Pencil drawing, 23 × 28 cm
Kunstsammlung Nordrhein Westfalen, Düsseldorf.

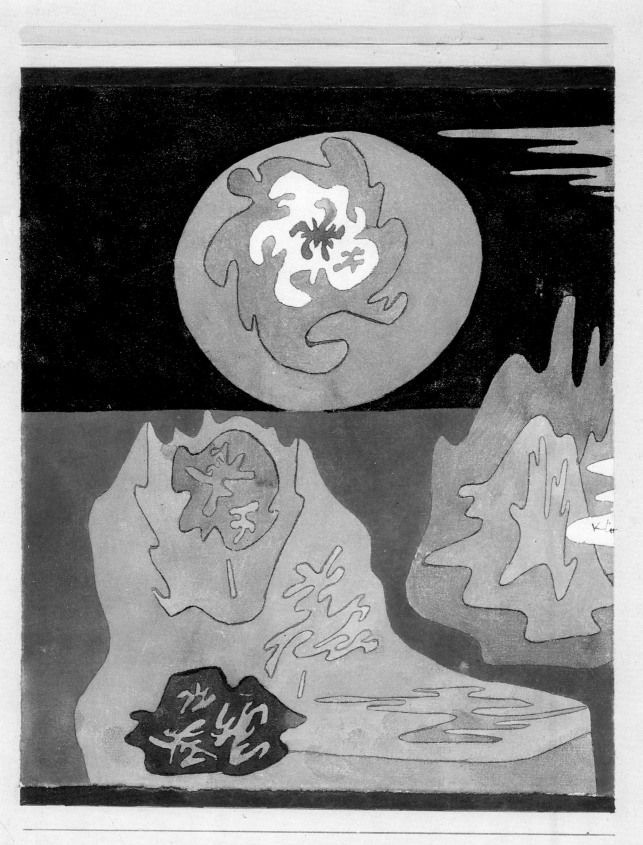

1929. 3H·18 im Lande Edelstein

211. FROM EDELSTEIN'S COUNTRY
 (IM LANDE EDELSTEIN)
 1929/318 (3 H 18) – Watercolor, 27 × 22 cm
 Kupferstichkabinett, Kunstmuseum, Basel.

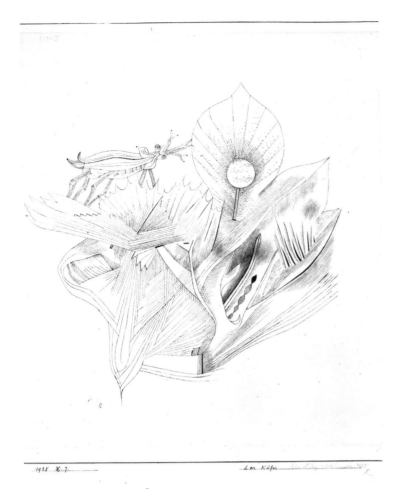

1925 ℋ.7 — Der Käfer 1925

212. THE BEETLE (DER KÄFER)
1925/237 (X 7) – Pen and India ink on Ingres paper, 29.5 × 24.6 cm
Paul Klee Foundation, Kunstmuseum, Bern.

213. SKETCH EXTRACT FROM "CREATIVE THOUGHT" (p. 64).

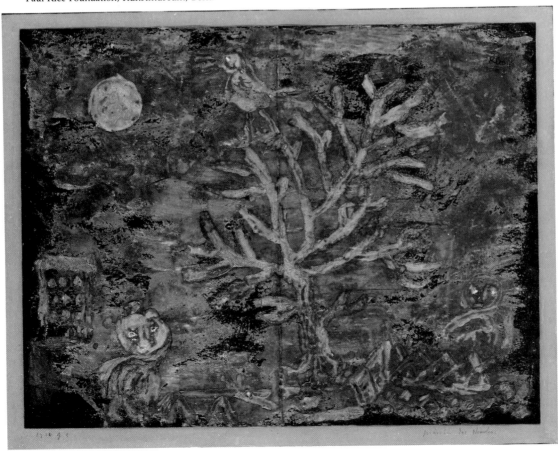

**214. STORY FROM THE NORTH
(MÄRCHEN DES NORDENS)**
1930 – Tempera on paper, 33 × 42 cm
Kunstmuseum, Basel.

215. ILLUMINATED LEAF
(BELICHTETES BLATT)
1929/274 (Oe 4) – Watercolor and India ink on Ingres paper
mounted on cardboard, 30.9 × 23 cm
Paul Klee Foundation, Kunstmuseum, Bern.

216. STRANGE VEGETABLE
(PFLANZLICH SELTSAM)
1929/317 (3 H 17) – Watercolor on paper prepared with
black watercolor on cardboard, 33.1 × 25.6 cm
Paul Klee Foundation, Kunstmuseum, Bern.

Strange Vegetable, 1929

In 1929, in an attempt to master meteorological phenomena, Klee painted *Unsettled Weather, Hunting Scene,* and *Wandering Soul.* This little group of atmospheric pictures were painted shortly before *Surfaces in Tension* and *Floating Town* and also referred to spatial problems. *Strange Vegetable* is about the translucent and irregular surfaces of leaves rather than construction. "The true essential form," said Klee, "is a synthesis of form (Gestaltung) and semblance." The study of an organism from the inside is achieved by emphasizing its dynamic character. A transversal incision thus allows us to see both interior and exterior. Destructive forces on the exterior attempt to penetrate the interior. This is accentuated by the color and transparency.

A play of tonal modulation arises from the harmony of the colored layers in which the hues themselves can be perceived. This polyphonic concept is borrowed from music and characterizes a composition with several voices in which each one evolves independently according to a melodic design found inside the composition. In his Jena lecture, Klee stated: "The coexistence of multiple dimensions in the same complex, as in music, the art of time, where the dazzlingly sovereign polyphony carries the drama to the summits, has also been recently attained in the art of space — unfortunately, this phenomenon of simultaneity is not present in the area of teaching or discourse."

1929 3.H.20. Flüchtiges auf dem Wasser

217. FUGITIVE FORMS ON THE WATER
(FLÜCHTIGES AUF DEM WASSER)
1929/320 – Watercolor, 26 × 31 cm
Beyeler Gallery, Basel

218. THE TWINS PLACE
(DIE STELLE DER ZWILLINGE)
1929/321 (3 H 21) – Watercolor on Ingres paper mounted on cardboard, 27.6 × 30.6 cm
Paul Klee Foundation, Kunstmuseum, Bern.

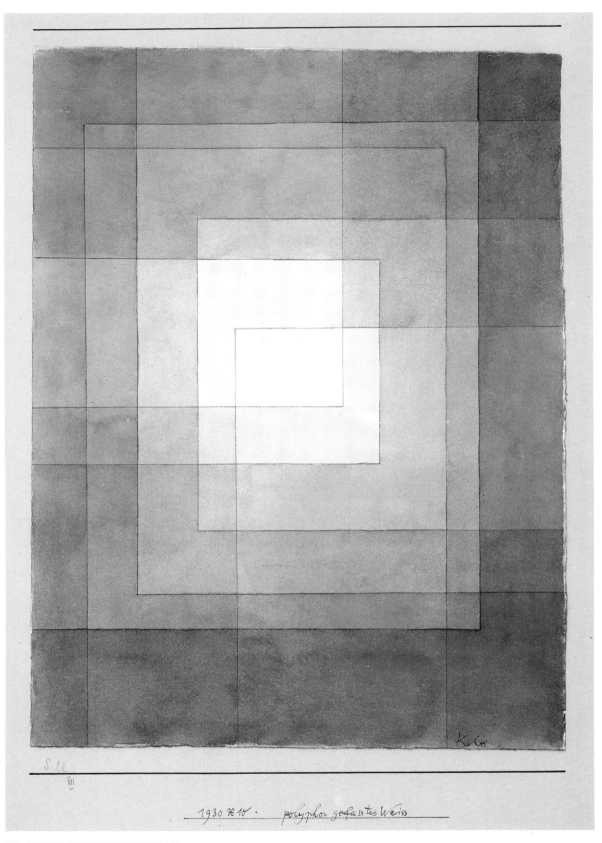

219. WHITE SET POLYPHONICALLY
(POLYPHON GEFASSTES WEISS)
1930/140 (X 10) – Watercolor and India ink on Ingres paper, 32.2 × 24.5 cm
Paul Klee Foundation, Kunstmuseum, Bern.

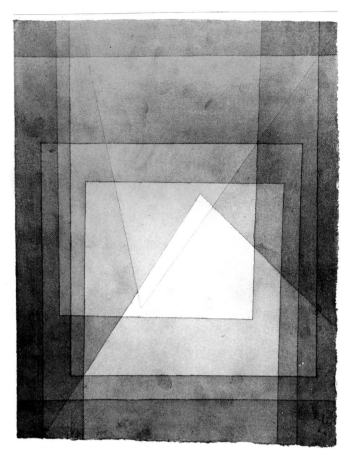

220. PYRAMID
1930/138 (X 8) – Watercolor on Ingres paper mounted
on cardboard, 31.2 × 23.2 cm
Paul Klee Foundation, Kunstmuseum, Bern.

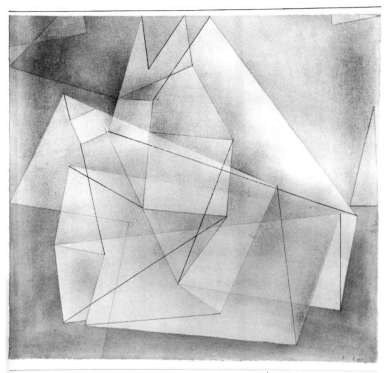

221. CRYSTALLIZATION
(KRISTALLISATION)
1930/215 (S 5) – Watercolor on Ingres paper, 31.1 × 32.1 cm
Paul Klee Foundation, Kunstmuseum, Bern.

219 White Set Polyphonically, 1930

Similar in style to the watercolor titled *House, Exterior and Interior* (Lucerne, Rosengart Gallery) done in the same year, this painting belongs to the "Forms and Format" series through which Klee had been studying the structural order of chiaroscuro at the Bauhaus since 1924. In his lecture on January 15, 1924, he said: "The natural state of a movement from black to white, in order to come back again to this point is not without order, it is without structure. It is arranged in opposition to chaos where light and dark have not yet been separated. It is arranged in the natural way of a subtle flow from one pole to the other. This distribution of the tension (this movement) is infinitely subtle."

Here Klee arranges the flow of white to the darker values through a quadrangular screen intelligently placed to avoid any monotony in the chromatic passage. We see here a deployment of energy that augments as it moves from the white at the center, the present, toward a dark future where something will be activated. Why could it not work the other way round? Because the emphasis lies on the rela-

tionship between the minor specific and the major generality. The latter acts on the state of the usual, which is passive, and the former, on the state of the unusual, which is active.

Klee added for his pupils: "All intense conflict in the chiaroscuro domain is linked in one way or the other to the two black and white poles. They provide the tension in the play of strengths in the different degrees of black and white, even if they are not direct participants and only impart energy from their distant reserves to the domains closest to them." But he added: "From this level I would not always be able to gambol so happily between the black and the white on all the degrees of the scale without infringing on the interior necessity. On the contrary, in this perspective I would have to differentiate from time to time between the arrangement and the alternation of the tonal scale." This is what he is doing here where subtle gradations from pink to red and from pale blue to dark blue, join at the corners to form two purple areas.

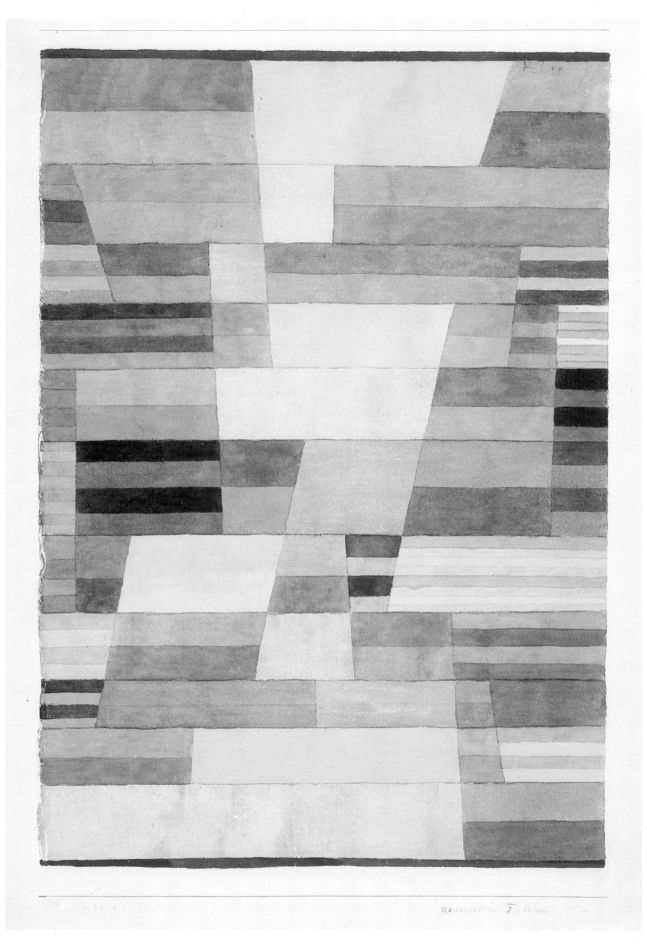

222. MONUMENT IN FERTILE LAND
(MONUMENT IM FRUCHTLAND)
1929/41 (N 1) – Watercolor on Ingres paper mounted on cardboard, 45.7 × 30.8 cm
Paul Klee Foundation, Kunstmuseum, Bern.

22 Monument in Fertile Land, 1929

Bordered by two red strips, eleven horizontal stratum divided into strips of unequal thickness are disrupted by three short verticals and eleven obliques. The extensive and subtle chromatism indicates the fertility of the land: From yellow to purple it passes through all the hues of pink, ochre, mauve, purplish-blue, and the softness of some almond greens.

We attempt in vain to locate the monument in question on the various levels, carved up into different degrees, that are strongly and precisely defined in the space. These differences between altogether too subtle values and colors lead us astray, in the way that all natural phenomena that we understand intellectually lead us astray until we succeed one day in understanding them differently.

Things in Klee's work often have this fascinating and elusive aspect. We identify them, they become familiar, and an instant later we can hardly recognize them. Are they objects or are they allusions to objects? Are they not more than pure form? In this we can really see Klee's originality as he straddles the line between the Figurative and the Abstract and continuously invites us to cross the border in both directions. The element of surprise that we find in his work derives from this. And part of their mystery as well.

223. CLEAR TERRAIN WITH HIGHWAY
(FREIGELEGTES GELÄNDE MIT DEM HAUPTWEG)
1929/43 (N 3) – Pen and India ink on Ingres paper mounted on cardboard, 31.4 × 24.3 cm
Ludwig Museum, Cologne.

Movement and countermovement

Structure of antithetical movement and the equilibrium process between two opposite terms

161

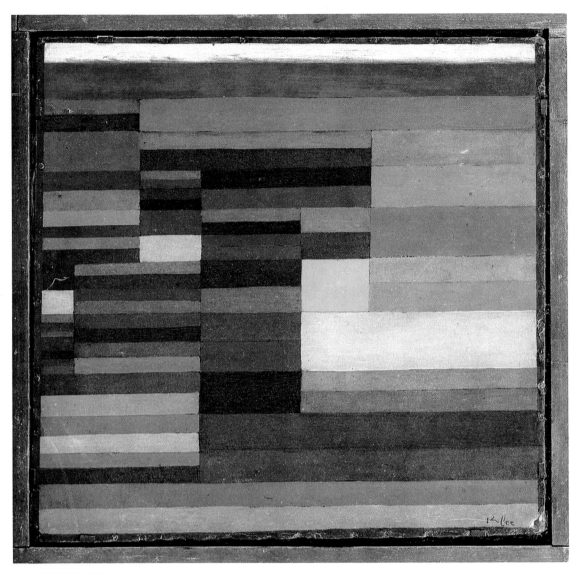

224. EVENING FIRE
(FEUER ABENDS)
1929/95 (S 5) – Oil on cardboard, 34 × 35 cm
Museum of Modern Art, New York. Mr. and Mrs. Joachim Jean Aberbach Endowment.

225 **Individualized Movement of Levels, 1930**
224 **Evening Fire, 1929**

The composition of this work recalls Klee's lecture at the Bauhaus on December 12, 1921, "A Sense of Equilibrium, an element of artistic creation." Klee stated that: "When the base widens, the horizontal widens with it at the expense of the vertical. A very considerable relaxation occurs then, an epic moment in relationship to the dramatic character of the vertical. Which obviously does not exclude an evaluation of the thrusts from each side of the axis. The vertical is always present!

"The weight of the forces is only excluded at the moment the diagonal disappears and the balance is immobilized, as, for example, in the case of the most primitive rhythm of the structure in which only horizontals or verticals are present."

This rupture of the tension in a horizontal way constitutes what Klee called the "epic tempo." In this structure the atmosphere that is sought is characterized by the chromatism. In the whole, which is dominated by pinks, browns, and greens, a vermilion bursts from the off center square on the right. Referring to this in "The Spiritual in Art," Kandinsky, Klee's friend and colleague at the Bauhaus said, "it resounds dully and flatly on the white, which makes its vibrant and brilliant dazzle on the black so surprising." Which is why Klee juxtaposed it with a black and dark brown.

162

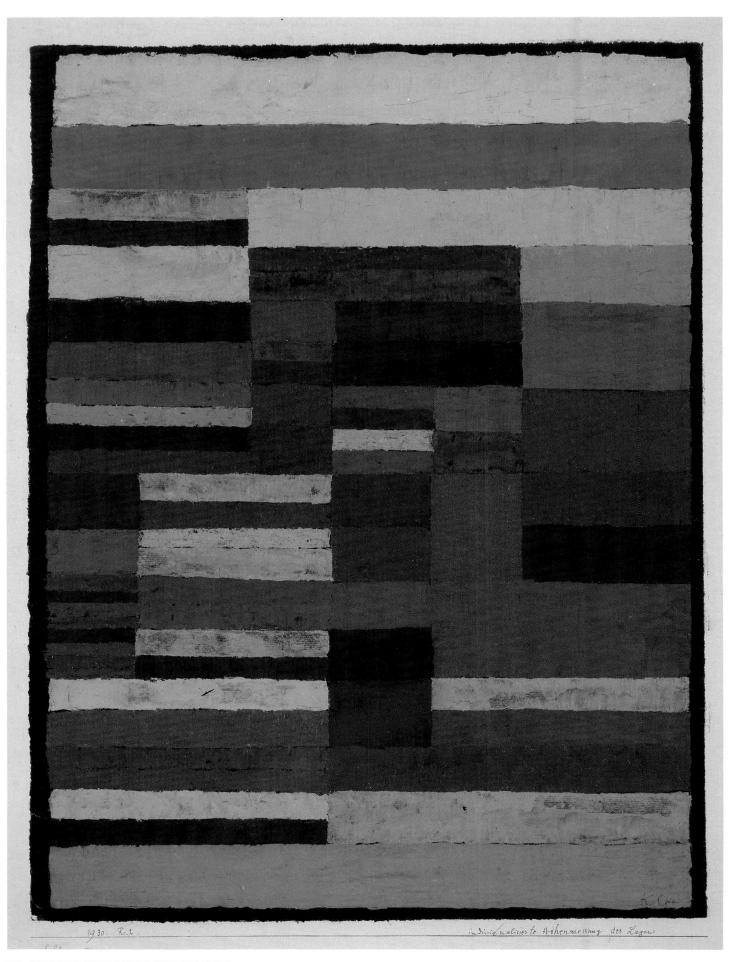

225. INDIVIDUALIZED MOVEMENT OF LEVELS
(INDIVIDUALISIERTE HÖHENMESSUNG DER LAGEN)
1930/82 (R 2) – Pastel on black Ingres paper, 46.8 × 34.8 cm
Paul Klee Foundation, Kunstmuseum, Bern.

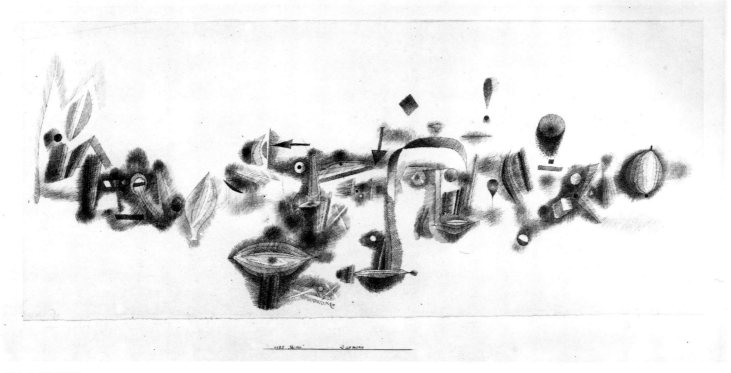

226. DAEMONS
(DÄMONIE)
1925/204 (U 4) – Pen and India ink on Ingres paper mounted on cardboard, 24.7 × 55.4 cm
Paul Klee Foundation, Kunstmuseum, Bern.

227 **Ad Marginem, 1930**

Like fishing nets, Klee's formal themes dive into the sea of the unconscious in order to bring past experiences to the surface of the work. His work, which is extremely thoughtful, is wholly concerned with the development of formal themes, so much so that all figurative form remains at the primary expressive level of a sign bordering on a pictograph. Whether it is a question of forms or themes, Klee's work is filled with a richness that no other painter of this century has attained. No one else but Klee has scrutinized artistic means more closely: line, surface, body, space, value and tone, chromatic value and structure — or better adapted them to suit his purpose. No one else but he has welcomed and brought forth from the unconscious into the visible world such variety: plants, creatures, humans, houses, tools, vehicles, gardens, mountains, stars . . .

Ad Marginem (On the Edge) has its point of departure in a purely formal idea of pushing plants and crystals from the four edges of the frame toward a meeting with the dark sun, which from the inner part of the picture draws forth their afflicted growth.

A fabulous world from far away, engulfed, covered with rust and lichen, and flecked with stains, seems to be rising up. "The sun warmed by mist, which then does battle with it," wrote Klee in an 1899 poem. This painting was done in 1930, during the Bauhaus period. Klee went back to Bern in December of 1933, and during 1935–1936 he worked again on this watercolor. The veil of melancholy that stretches over it accords with the change in his feelings as well as his environment.

"I have met the animals of the soul, the birds of intelligence, fish from the heart, and the plants of dreams," wrote René Crevel in 1929, "tiny creatures with boundless eyes, sea-weed free of any rock, hello-to-you and thank-you beings, vegetation, and things who cannot live in the world we know, but who nevertheless seem more stable and real in your surreal intangibility than our houses, gasburners, cafés and banal loves."

This painting takes us to the edge of things, where we are haunted by these marginal figures on the borders of reality itself.

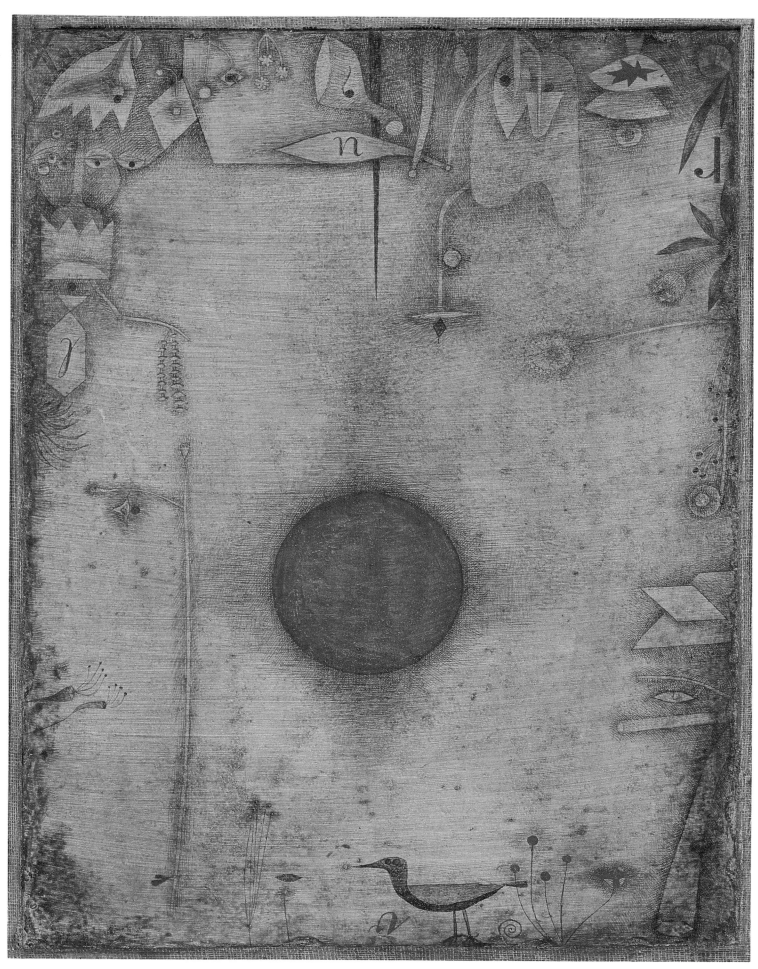

227. AD MARGINEM
 1930 and 1935-36/210 (E 10) – Watercolor and ink on cardboard, 45 × 33 cm
 Kunstmuseum, Basel.

228. CALMLY DARING
(GEWAGT WÄGEND)
1930/144 (Y 4) – Watercolor and India ink on Ingres paper
glued on cardboard, 31 × 24.6 cm
Paul Klee Foundation, Kunstmuseum, Bern.

229. MODEL 41d (WITH POT OF FLOWERS)
(MODELL 41d (MIT DEM BLUMENTOPF)
1931/5 (5) – Drawing pen and India ink on Ingres paper
on cardboard, 40.4 × 59.2 cm
Paul Klee Foundation, Kunstmuseum, Bern.

230 Hovering (About to Take Off), 1930

From the middle of the 1920s, Klee had started exploring the different possible relationships between geometrical forms, from point to line and from surface to volume. He eventually based his research on a "metalogical" plan. One of his goals was to make the geometric elements move in a weightless environment. He linked, from one corner to the other, the quadrangular forms that he had freely placed in opposition to each other according to the rules of his "free geometrical aesthetic," without any seemingly logical principle. "Forms," he declared in his Jena lecture, "as we have often called these creations evoking whatever kind of figure, have likewise a special 'attitude' — an 'attitude' that results from the way in which the various groups of elements have been set in motion. (. . .) This 'attitude' can sometimes be less rigid and be transported into an intermediary world, such as water or the atmosphere, where there are no longer any dominating verticals (as in swimming or gliding)."

Thus works like *Crystallization* or *Hovering*, which present unstable cubic forms, came into being in 1930. The spatiality no longer submits to a logical principle of construction but is informed by a dynamic fluctuating movement. "The whole concern moves according to the progression of the construction in its totality. The vertical and the movements of equilibrium are inverted."

Hidden in these irrational geometric bodies was both solution and dissolution. These suspended constructions did not permit any solid spatial determination. The extreme degree of the dynamic expression of movement also represented for Klee the limit to the possibilities of three-dimensional form. From then on spatial constructions did not seem to interest him anymore, and only some two-dimensional compositions like *Little Rocky Town* (1932) are found in his work.

166

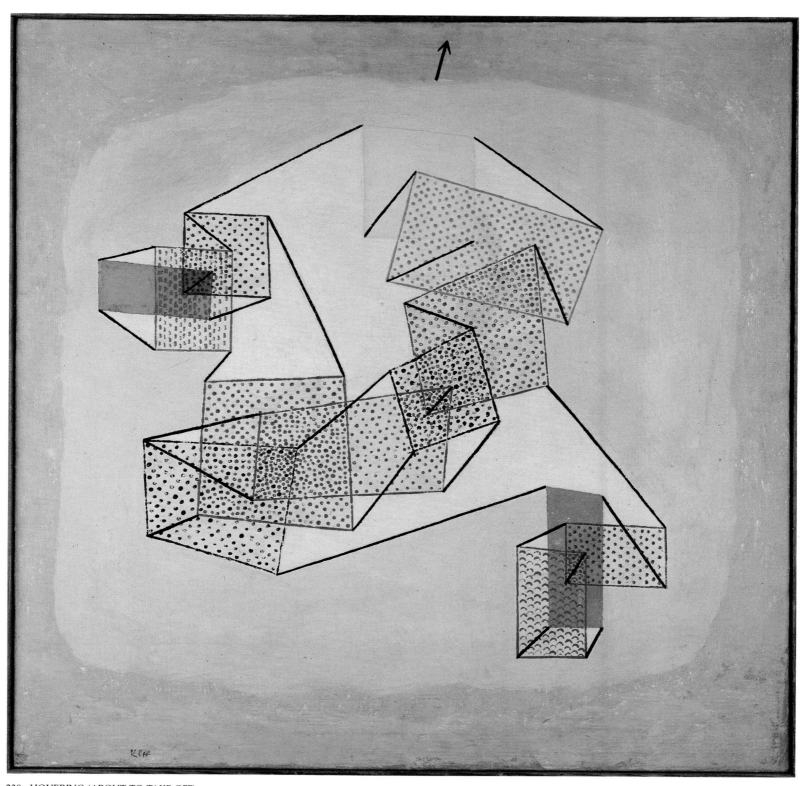

230. HOVERING (ABOUT TO TAKE OFF)
(SCHWEBENDES [VOR DEM ANSTIEG])
1930/220 (S 10) – Oil on canvas, 84 × 84 cm
Paul Klee Foundation, Kunstmuseum, Bern.

231. PORTRAIT OF BRIGITTE
(BILDNIS BRIGITTE)
1928/64 – Watercolor and gouache on Ingres paper, 30.5 × 22.7 cm
Beyeler Gallery, Basel.

232. GHOST'S OATH
(GESPENSTER SCHWUR)
1930/113 (V 3) – Pen and ink drawing on paper mounted on cardboard
47.1 × 37.8 cm
Paul Klee Foundation, Kunstmuseum, Bern.

233. DISCUSSION
(DISPUT)
1929/232 (X 2) – Tempera on canvas, 67 × 67 cm
Paul Klee Foundation, Kunstmuseum, Bern.

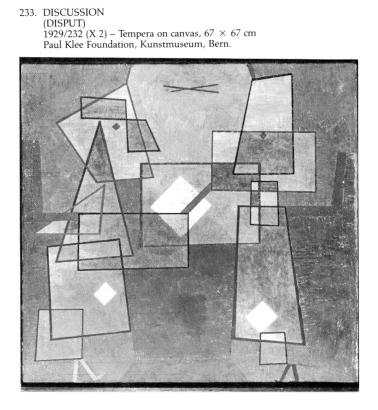

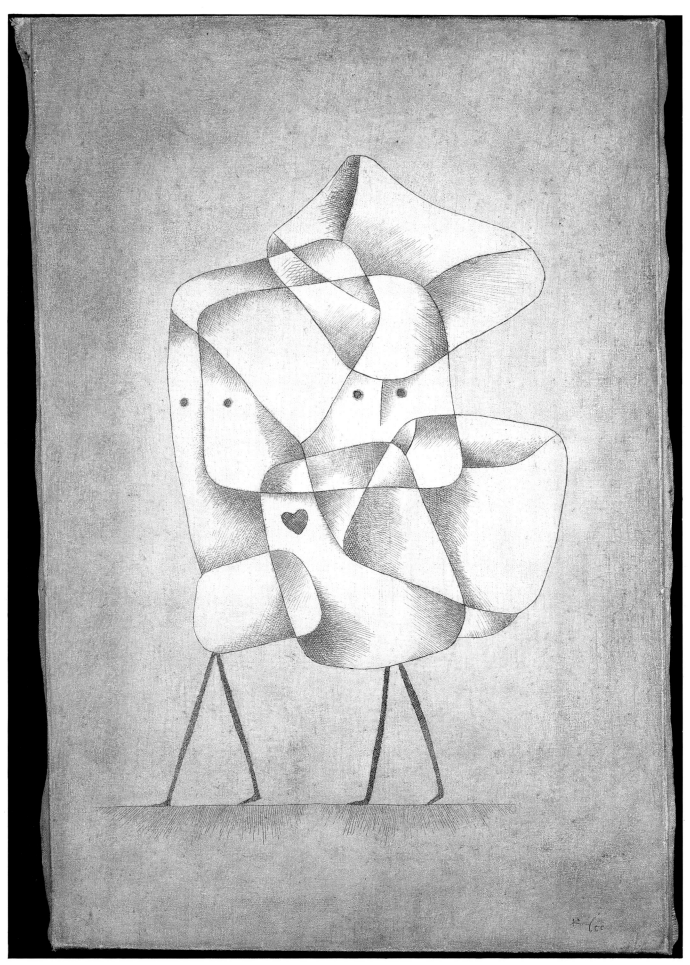

234. BROTHER AND SISTER
(GESCHWISTER)
1930 – Oil on canvas, 70.7 × 44.2 cm
Private collection, New York.

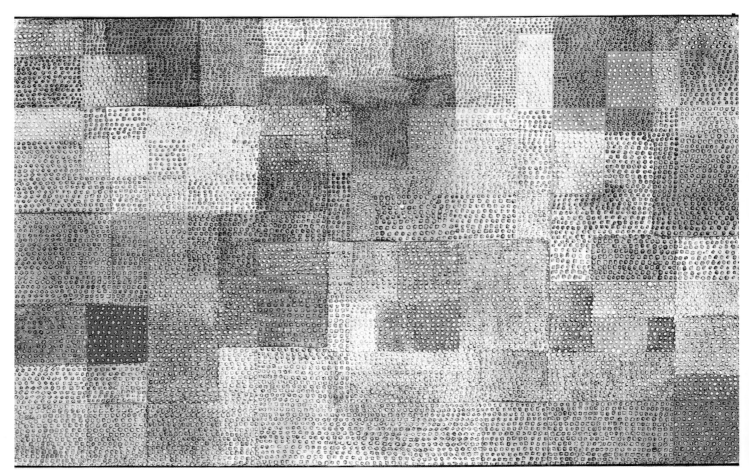

235. POLYPHONY
1932/273 (X 13) – Oil on canvas, 66.5 × 106 cm
Kunstmuseum, Basel, Emanuel Hoffman Bequest.

236 **Ad Parnassum, 1932**

Some 1932 works, such as *Light and So Much Else* and *Ad Parnassum*, which can be called "divisionist," reveal Klee's admiration for Seurat's work, which gave Klee a shock akin to the one he had when he first saw the Byzantine mosaics in Venice, Ravenna, and Palermo.

Ad Parnassum was the largest painting Klee had done up until then. The title indicates the level of development he knew he had attained; it comes from Josef Fux's famous book of counterpoint *Gradus ad Parnassum* (1725), which represented for generations of musicians the ideal of polyphonic composition. This painting is the affirmation of the "great work" that Klee talked about at the end of his Jena lecture: "I sometimes dream of a work on a vast scale that would cover the whole field of the element of art, subject matter, content, and style." Klee was trying to realize in the plastic domain, "that which has been a part of music since the beginning of the 18th century."

Ad Parnassum reveals itself to the observer from two points of view. Seen from close up, the chromatic polyphony is a rich spectrum of tones of different hues, which despite the large stretch of surface appear to have been painted with minute attention to detail. Seen from a distance, the monumental marks take on weight. None of these enigmatic signs circumscribe a closed form. Even the colors do not give the lines any internal or external structure; a scintillating atmosphere plays around them and only the orange circle emerges boldly. Lines and colors mingle intimately, and the tones only occasionally react with a pale gleam when they come into contact with the lines. It is the opposite of a reciprocal game of form and color. In an imperceptible way, this outlay of richly hued colors augments the significance of the lines, which without the color would appear empty in their simplicity. Besides the shock of the linear and pointillist elements, the composition itself establishes an essential tension. The work awakens contradictory feelings in the spectator. The big plastic signs linked to the chromatic pointillist fabric remain ambiguous. They could as easily be the signals for a dynamic crescendo as the symbols of a mountain, a door, or a constellation, even though the title pushes us toward ancient Parnassus, the dwelling place of Apollo and the muses.

On April 17, 1932, Klee wrote to Lily: "Today is the first Sunday I can work without shivers going up my back. The calm of the palace is sinister, sotto voce. I am painting a landscape something like the view of the desolate mountains of the valley of Kings in the land of milk and honey. The polyphony is maintained as tightly as possible."

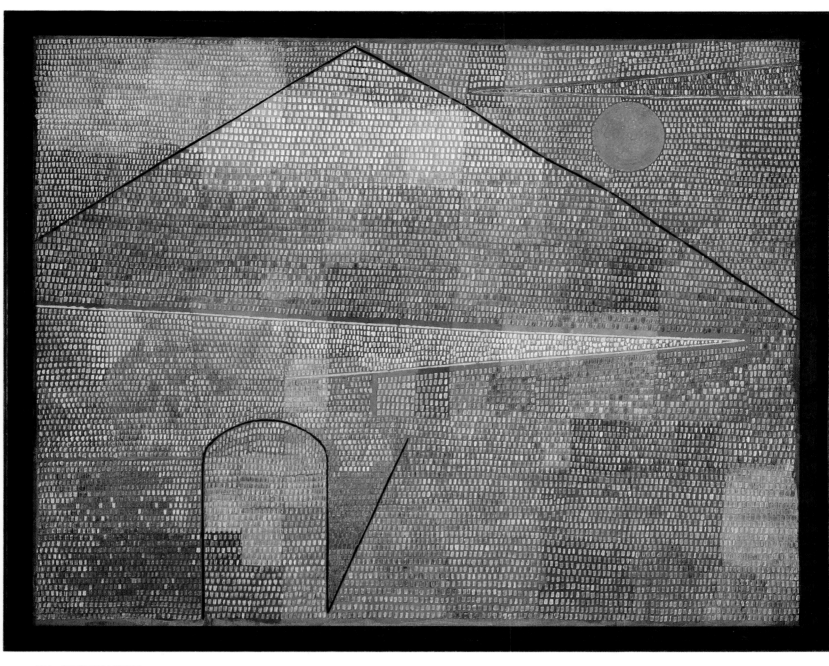

236. AD PARNASSUM
1932/274 (X 14) – Oil on canvas, 109 × 126 cm
Society of the Friends of the Kunstmuseum, Bern.

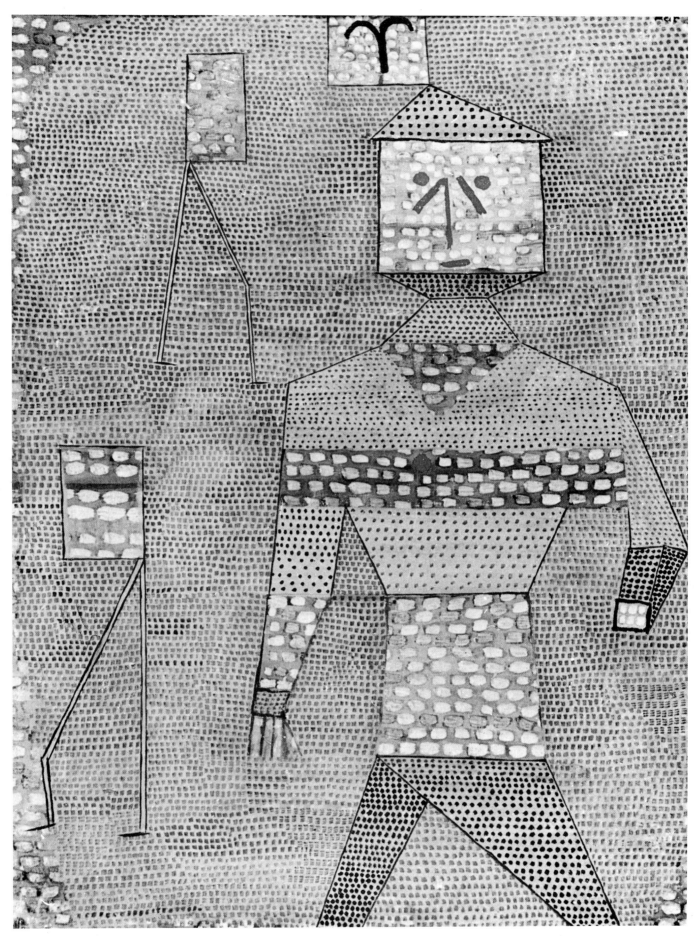

237. BARBARIAN CAPTAIN
(BARBAREN FELDHERR)
1932/1 – Oil and tempera on cardboard, 56 × 41.5 cm
Private collection, Switzerland.

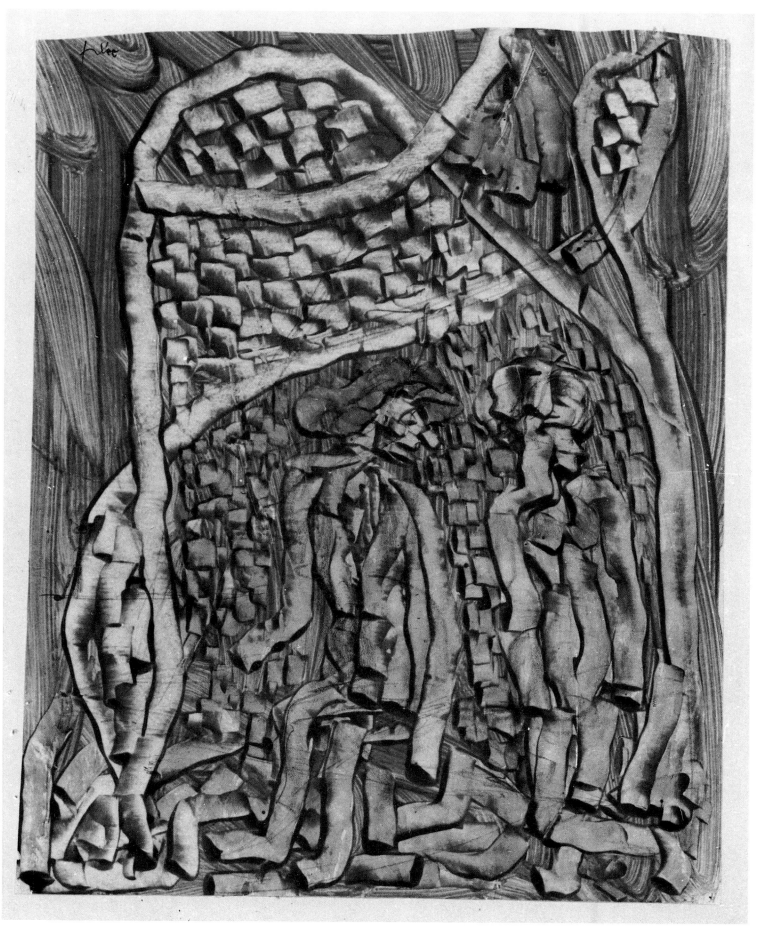

238. TWO WOMEN IN THE FOREST
(ZWEI FRAUEN IM WALD)
1933/259 (X 19) – Watercolor on paper, 39.8 × 30.8 cm
Private collection, Switzerland.

239. TENDRIL
 (RANKE)
 1932/29 (K 9) – Oil on oval wood, 39.5 × 34.5 cm
 Private collection, Switzerland.

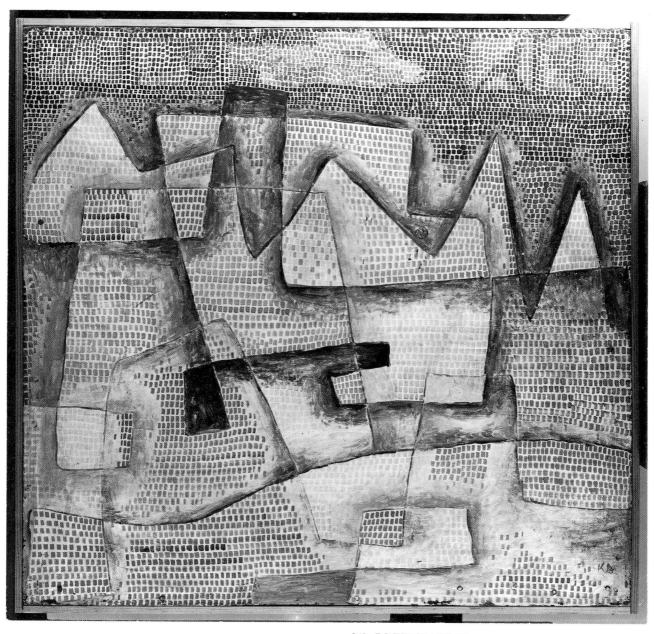

240. ROCKY COASTLINE
(FELSIGE KÜSTE)
1931 – Oil on wood, 53 × 51 cm
Hamburger Kunsthalle, Hamburg.

Tendril, 1932

At the start of 1910, in Paris, Ceret and Sorgues, Braque and Picasso again took up the oval form traditionally reserved for portraits, and using collage, which had appeared in *Still Life with Cane Chair*, they started redefining pictorial illusionism. It was a case of representing a part of something, and this oval format was particularly suited to the materialization of this new space that painters were exploring.

With the exception of *Hommage to Picasso* in 1914, in which he awkwardly tried to fit the quadrilaterals into this format, *Tendril* is Klee's only oval picture. It is connected to his divisionist period, which took place between 1930 and 1933 and in which we find *The Light and Other* and *Ad Parnassum*. Even more than Seurat, it was the Ravenna

mosaics, which he had rediscovered in the summer of 1926, that gave rise to these alluring fields of colored dots. The impression of chromatic chaos is tempered by the fact that the marks are grouped in areas of different hues which do not mingle with each other. These singular junctures of scattered color seem to be animated by the fluid and ephemeral light. On this moving ground that evokes the "enchanting harmonies that change accordingly," which rocked young Hyacinth in the *Disciples at Sais*, Klee establishes the horizon with a line of sand around which a spiral coils itself, "the most pure form of movement we can imagine." Another active line freely disports itself around some islands of sand, and a sun, also made from sand, with a blue accent above it hangs calmly over the horizon, radiating the red dots around it.

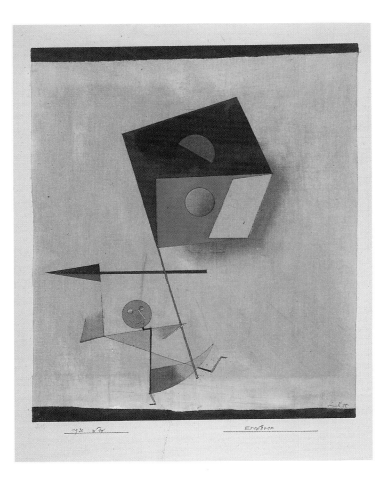

241. CONQUEROR
(EROBERER)
1930/129 (W 10) – Watercolor on fine cotton
glued on cardboard, 40.5 × 34.2 cm
Paul Klee Foundation, Kunstmuseum, Bern.

241. CONQUEROR
(EROBERER)
1930/129 (W 10) – Watercolor on fine cotton
glued on cardboard, 40.5 × 34.2 cm
Paul Klee Foundation, Kunstmuseum, Bern.

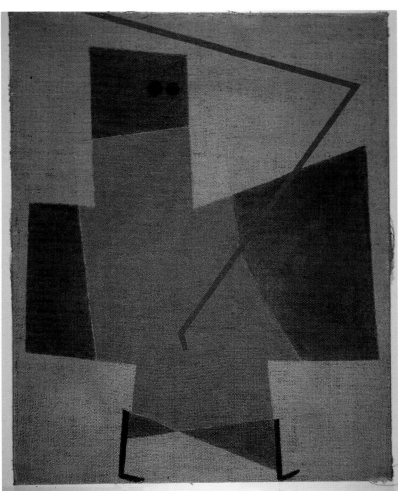

242. THE STEP
(DER SCHRITT)
1932/319 (L 19) – Oil on jute canvas, 71 × 55.5 cm
Private collection, Switzerland.

243. DIRIGIBLE GRANDFATHER
(LENKBARER GROSSVATER)
1930/252 (J 2) – Pen and India ink on Ingres paper, 59.6 × 46.5 cm
Paul Klee Foundation, Kunstmuseum, Bern.

244. FLIGHT FROM ONESELF (FIRST STATE)
(FLUCHT VOR SICH (ERSTES STADIUM)
1931/25 (K 5) – Drawing pen and blue-black ink, 41.8 × 58 cm
Paul Klee Foundation, Kunstmuseum, Bern.

245. STONE DESERT
(STEINWÜSTE)
1933/289 – Water colors on Ingres paper, 48 × 34.3 cm
Beyeler Gallery, Basel.

246. ALERT BEARING
(BESCHWINGT-SCHREITENDE)
1931/242 (W 2) – Pencil on Ingres paper, 59.6 × 45.2 cm
Paul Klee Foundation, Kunstmuseum, Bern.

247. LIANA
(SCHLING-GEWÄCHSE)
1932 – Watercolor on paper, 49.5 × 33 cm
Beyeler Gallery, Basel.

248. DIANA IN THE AUTUMN WIND
(DIANA IM HERBSTWIND)
1934/142 (R 2) – Watercolor on Ingres paper
glued on cardboard, 62.6 × 47.8 cm
Paul Klee Foundation, Kunstmuseum, Bern.

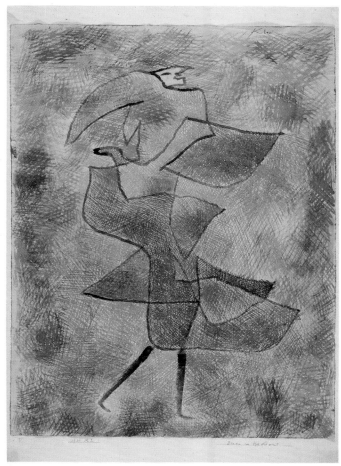

249. MODEL 7a CHANGING OF POSITION AND FORMAT
(MODELL 7a IN POSITIONS UND FORMATWECHSEL)
1931/6 (6) – Drawing pen and India ink on Ingres paper
on cardboard, 61 × 37.2 cm

252 Blossoming, 1934

Pursuing his psychic inquiry into the most elementary geometrical figures in the internal structure of matter, in its matrix and rhythmical forms, Paul Klee found an active principle of organization based on the same pulsation of the creative being and the created universe. The forms translated by Klee are only abstract in the way in which he puts down the pulsations. He applied himself to first discovering and then transmitting the rhythm of "great nature" as organic or inorganic.

The vegetable and sensorial geometry enclosed in this square composed of squares, and titled *Blossoming*, evokes, more than any image taken from nature could, in its elementary squaring of a composition that appears to be abstract, the image of young flowers springing up and bursting with buds; it is the actual liberation of the vital energy. With regard to *Individual Rhythms*, Klee said: "If we take the notion of harmony into account right from the beginning, we have to arrive at the following conclusion: A progressive deformation has taken place, and it has gradually stretched the dimensions of the squares that were originally equal. If the whole, piece by piece, is composed of a quantity of uniform color, this decreases as the dimensions get bigger and augments if they shrink. In the biggest elements the color is quite diffuse, and in the littlest it is compact."

What could be more elementary or more simplistic than this juxtaposition of differently colored squares and rectangles that start dividing towards the center? Yet the mere fact of division is enough to make them appear to be hurtling upward as if thrust by an incompressible force, and it is also sufficient for the colors to get lighter and clearer, for whites, pinks, and yellows to appear, for it to feel as if we are witnessing an opening, a springing forth of flowers; and this sensation is even more vital than the delirious sweetness of the blossoming surrounded by the obscure energy and dark sap from which it was produced.

On the edges of the great thrusting movement, where the blossoming force is most vitally compressed, the whites burst open into their own luminous energy. The organization of the particularly compressed values, graduated according to extent and intensity between the surrounding dark nutritive values and the bursting blossoming values in the center, contributes greatly to this exalted theme.

250. VERTICAL AND HORIZONTAL PLANES IN THE STUDIO
(VERTIKAL UND HORIZONTALFLÄCHEN IM ATELIER)
1931/41 (L 1) – Drawing pen and red, brown and blue-black ink
on cardboard, 39.3 × 61.4 cm

251. CANON OF MIRRORS (ON FOUR LEVELS)
(SPIEGELKANON [AUF VIER EBENEN])
1931/213 (U 13) – Drawing pen and blue, red, green, brown and black ink
on Ingres paper on cardboard, 31.4 × 47.7 cm

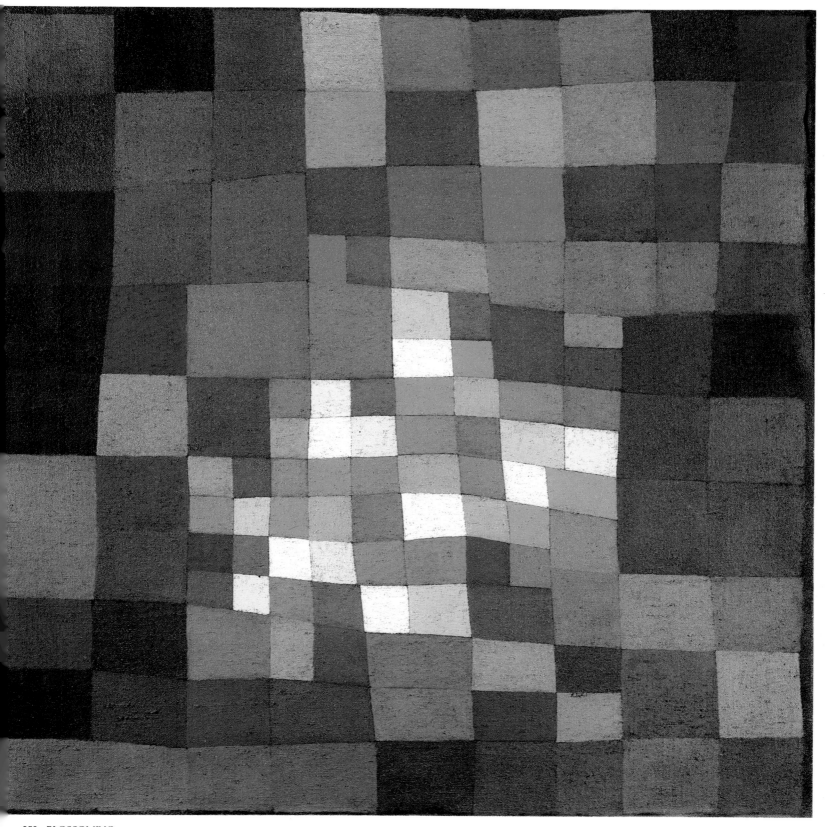

252. BLOSSOMING
(BLÜHENDES)
1934/199 (T 19) – Oil on a black ground on canvas, 81 × 80 cm
Kunstmuseum, Winterthur.

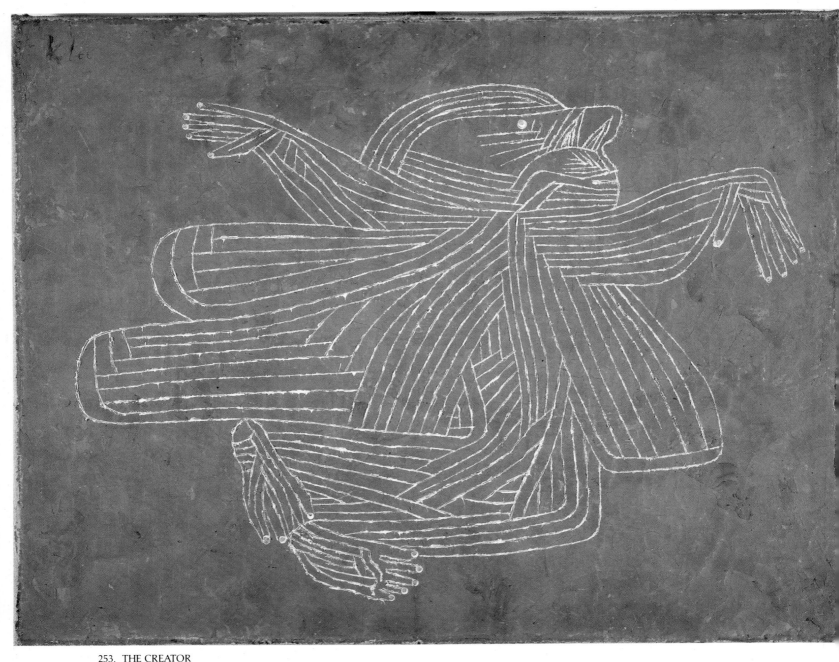

253. THE CREATOR
(DER SCHÖPFER)
1934/213 (U 13) – Oil on canvas, 42 × 53.5 cm
Paul Klee Foundation, Kunstmuseum, Bern.

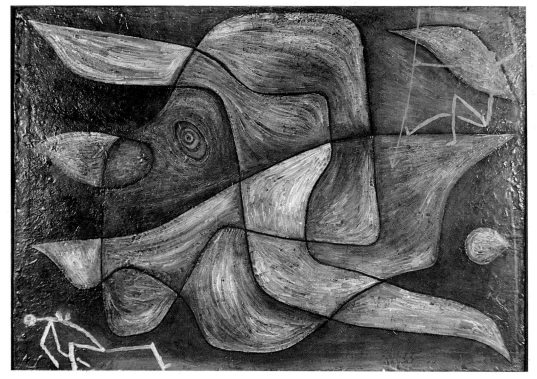

254. SAINT GEORGE
(ST. GEORG)
1936/21 (K 1) – Oil, gouache and watercolor on cardboard, 31.8 × 42.7 cm
Paul Klee Foundation, Kunstmuseum, Bern.

253 The Creator, 1934

In the catalogue of his works, Klee indicated that this painting, "took several years to formulate." We can in fact see the relationship between it, an ink drawing done in the same format, and a version drawn in oil, which was done in 1930. In this work, instead of simply painting with a brush, he used a complicated procedure of engraved/impressed white lines. As he had in the oil drawn version (*Der Schopfer II*), he wanted to impart a feeling of spontaneity to the lines. The white drawing on a pink background is provocatively simple. The divinity with spread arms and flowing robes soars in the cosmos. The space is entirely taken up by the figure of the Creator, for which the masterfully drawn parallel white lines evoke Michaelangelo's vision in the Sistine Chapel. According to Genesis, God's spirit soars above the waters. The fresh pink, a tinge of a new rose, emanates from Him to cover the world.

But there is also an irresistible element of clowning in his treatment of the subject matter. If we remember how close Klee felt as an artist to the origin of things, and to the Creator, we are able to see the touch of self-irony in the figure's jovial expression. This half-serious, half-amused vision of the Creator has nothing blasphemous in it. Klee maintained the same confidently trusting relationship with the Creator as he did with his angels, a kind of unembarrassed celebration that was devoid of any false sentimentality.

Klee said in "Ways of Studying Nature," published by the Bauhaus in 1923: "We are led to the upper paths by our desire to liberate ourselves by swimming or flight, from the earth's fetters and so to attain full liberty, liberty through movement. All these paths meet in the eye and from that point, being translated into form, lead to a synthesis of external vision and inner contemplation."

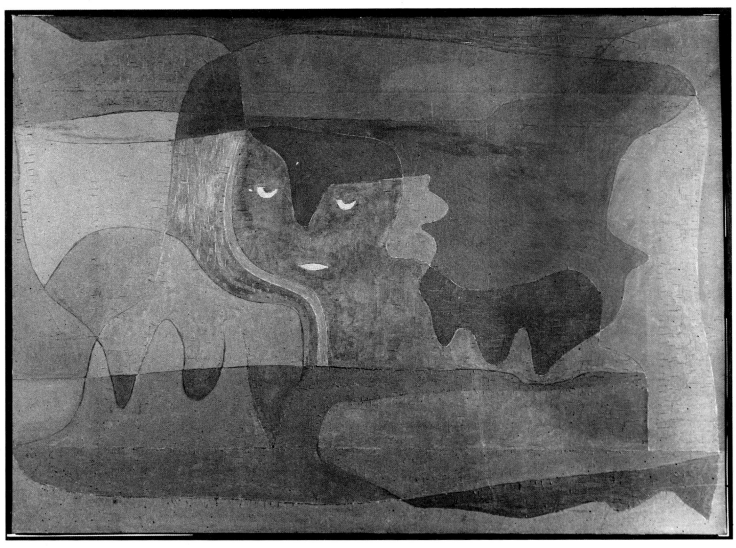

255. RESTING SPHINX
(RUHENDE SPHINX)
1934/210 (U 10) – Oil on canvas, 90 × 120 cm
Paul Klee Foundation, Kunstmuseum, Bern.

256. BERTA
1924/82 – Pencil on paper mounted on cardboard, 28.3 × 22.7 cm
Paul Klee Foundation, Kunstmuseum, Bern.

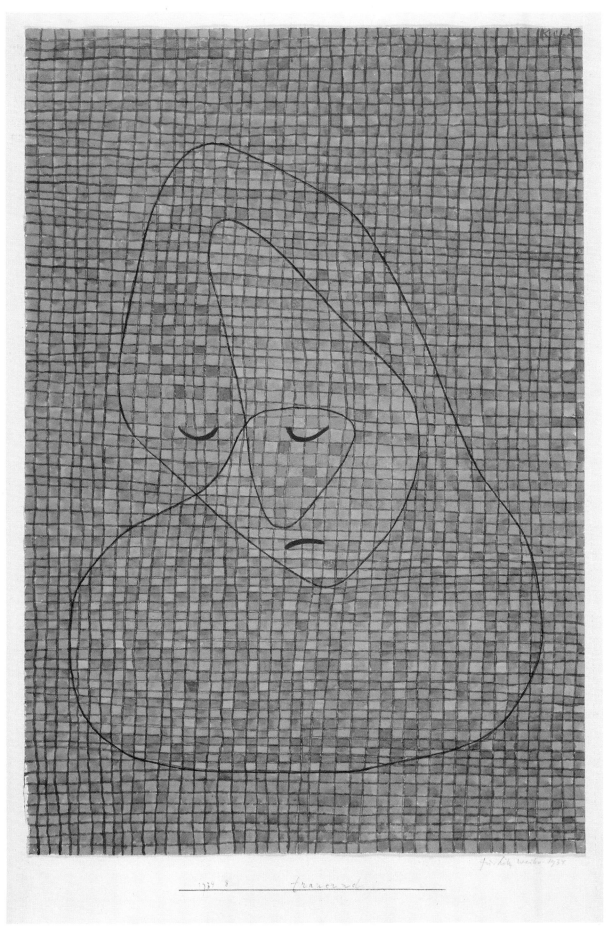

257. MOURNING
(TRAUERND)
1934/8 – Brush drawing, watercolor on paper mounted on cardboard, 48.7 × 32.1 cm
Paul Klee Foundation, Kunstmuseum, Bern.

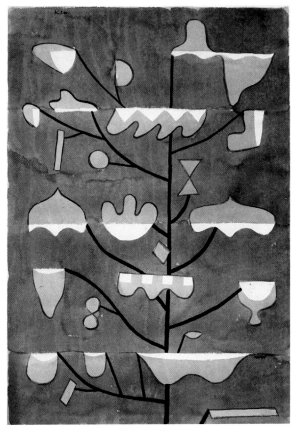

258. EVERYTHING THAT GROWS
(WAS ALLES WÄCHST)
1932/233 (V 13) – Watercolor on Ingres paper
mounted on cardboard, 47.9 × 31.5 cm
Paul Klee Foundation, Kunstmuseum, Bern.

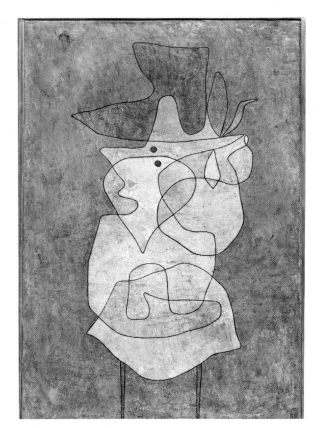

259. DAME DEMON
(DAME DÄMON)
1935/115 (P 15) – Oil and watercolor on a gypsum base
on canvas, 150 × 100 cm
Paul Klee Foundation, Kunstmuseum, Bern.

258 **Everything that Grows, 1932**

Klee's parable of the tree in his Jena lecture on Modern Art, is very well known. Here Klee sets himself the task of working plastically with this fundamental motif. He first unites the important bipartition of the central trunk by using four superimposed registers which either cut into the suspended elements or modify their tonality. The ramifications do not cut transversally through the main vein but are arranged alternately. In his lecture on October 23, 1923, "Structuring Energies," Klee explained to his Bauhaus pupils that: "The interdependence between the leaf, the branch, and the whole tree through the intermediary of the twig means that there can never be complete parity; even if the adjacent vein becomes as important as the central vein, their function is only to enhance the symmetry. Therefore, the supreme importance of the means remains intact.

"If we think of the vein as structuring and constructive energies, we will henceforth see a leaf's evolution as a conflict between the linear specific energy and the massive multiplicity of the surface.

"The massiveness is the level on which the eye can no longer take in the singular notion of line so that it

appears, because of its interlaced lines, to be a specific element. In conjunction with the linear precision this element produces an impression of diffusion.

"The insertion of this line's system into another element is done by a branch or verticil, and the link upon which both are dependent will be of equal strength.

"The form that results from this is now dependent on the insertion of radiance. And the outline of the form appears at the point at which the linear force exhausts itself."

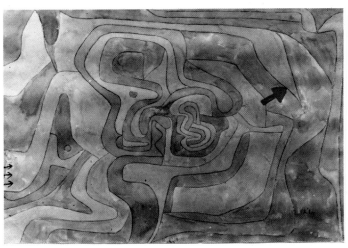

260. FLIGHT
(ENTFLIEGEN)
1934/10 – Watercolor, 33.1 × 48.1 cm
Old Masters Collection, Saidenberg Gallery, New York.

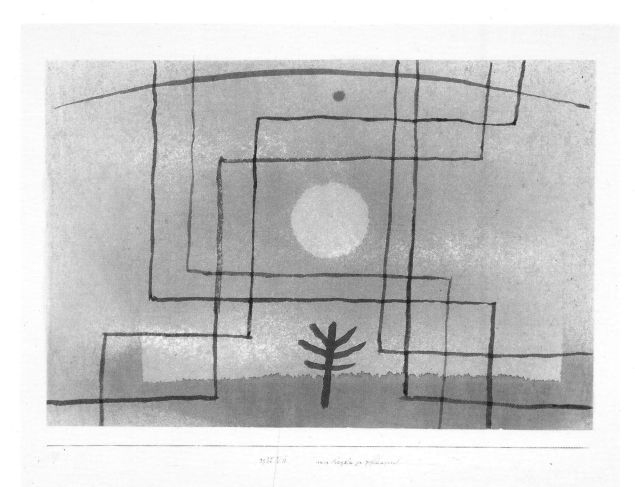

261. PLANT ACCORDING TO THE RULES
(NACH REGELN ZU PFLANZEN)
1935/91 (N 11) – Watercolor on paper mounted
on cardboard, 25.8 × 36.9 cm
Paul Klee Foundation, Kunstmuseum, Bern.

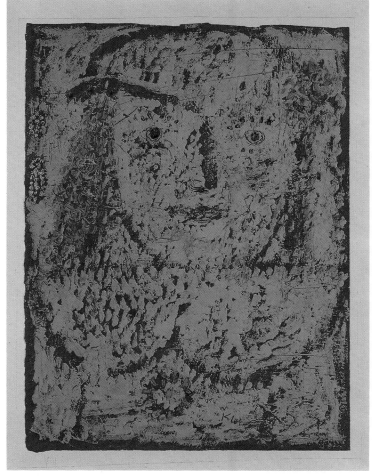

262. FLORA
1937/28 (K 8) – Oil on paper mounted on cardboard, 39.4 × 28.9 cm
Paul Klee Foundation, Kunstmuseum, Bern.

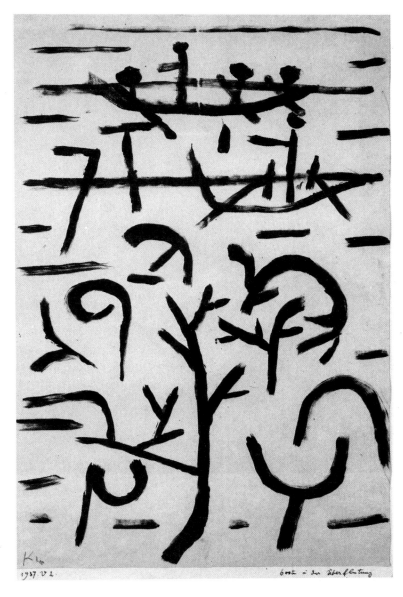

263. BOATS IN THE FLOOD
(BOOTE IN DER ÜBERFLUTUNG)
1937/222 (V 2) – Brush, blue paste medium on wrapping paper
mounted on cardboard, 49.5 × 32.5 cm
Beyeler Gallery, Basel.

264 **Legend of the Nile, 1937**

The compartmentalizing of the surface into irregular quadrilaterals, which first appeared in Klee's work towards the middle of his Tunisian trip, and which was later formally developed in "architectures" and the "magic squares" series, appears here in connection with an Orientally inspired iconography. The signs are more alive and heterogeneous than usual and contain a residue of the Egyptian hieroglyphics that he saw during his trip to Egypt in the winter of 1928–1929. This swarming mass of forms, which are linked to the river teeming with barques, marks Klee's debut into a more figurative universe. The fish, the eye warding off evil, and even the characters from the Greek alphabet, such as pi and upsilon, have been loosely derived from hieroglyphics. Next to the classical moon and sun are the elementary geometric forms that he had so often drawn on the blackboard for his Bauhaus students.

In his "Contribution to a Creative Theory of Form" he said: "One gathers together and adds some objects that one then arranges in an acceptable order from a fragmented point of view. This order is often brutally broken up, and it then becomes impossible to find again the notion of the concrete (or objective). The faculty of memory — the event having taken place in the past — then gives rise to the principle of the association of images. The new element in this situation is the following: the meeting point of the real and the abstract or rather their simultaneous appearance. An organic cohesion and the presence of decipherable elements in the abstract are components that often act together."

This pastel is part of the first big compositions that were strongly structured by ideograms. He used a compelling dark ochre for these instead of black and then surrounded the image with a lighter tone, which complemented the dark blues of the ground.

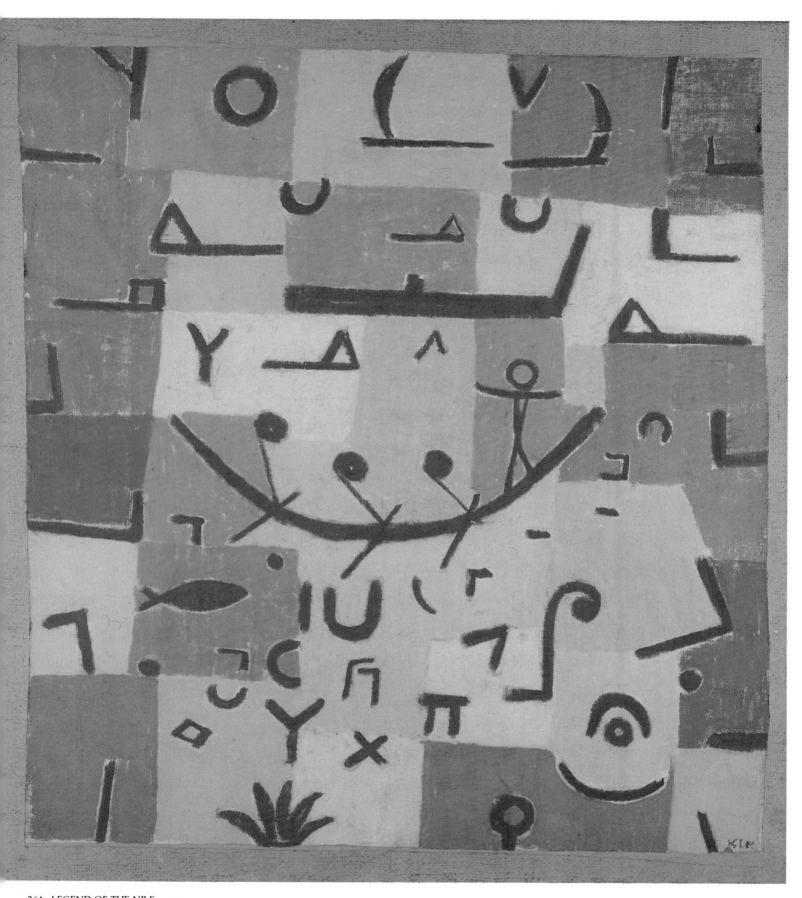

264. LEGEND OF THE NILE
(LEGENDE VOM NIL)
1937/215 (U 15) – Pastel on cardboard, 69 × 61 cm
Kunstmuseum, Bern. Gift of Hermann and Margrit Rupf.

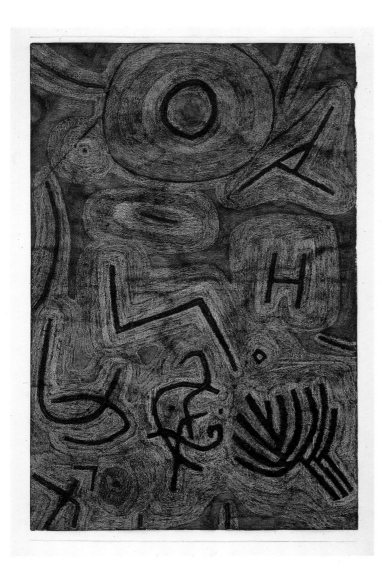

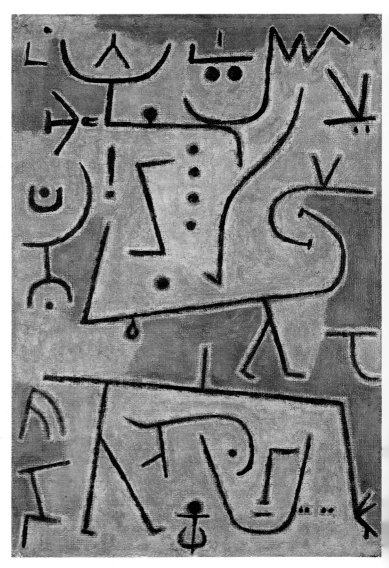

265. CATHARSIS
(KATHARSIS)
1937/40 (K 20) – Colored pencil on Ingres paper
on cardboard, 48.8 × 32.3 cm
Paul Klee Foundation, Kunstmuseum, Bern.

266. THE RED WAISTCOAT
(DIE ROTE WESTE)
1938 – Color in paste medium on jute and cotton
canvas mounted on wood, 65 × 43 cm
Kunstsammlung, Nordrhein Westfalen, Düsseldorf.

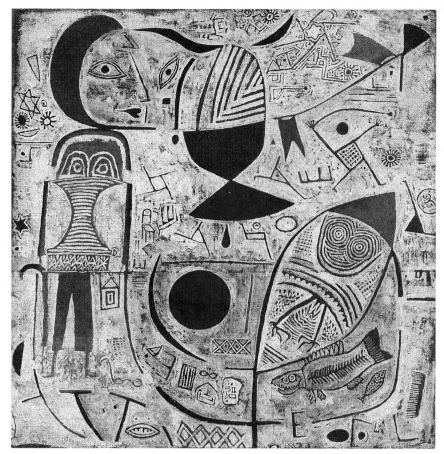

267. PICTURE PAGE
(BILDERBOGEN)
1937/133 (Qu 13) – Gouache on panel, 60 × 56 cm
The Phillips Collection, Washington.

5 **Catharsis, 1937**

7 **Picture Page, 1937**

From the beginning of his career, Klee experimented with various ways of representing the human figure, looking for both aliveness of form and new meanings. Using a simple childlike approach, he sometimes used stick figures. In the 1920s, he became very interested in the art produced by schizophrenics as well as in the symbolic figures of tribal art. He had been familiar from his youth with the ethnographic collection in the Bern Museum of History and the collection of folk art in Munich.

"For these are primitive beginnings in art," Klee noted in his Diary in 1912, "such as one usually finds in ethnographic collections or at home in the nursery." In 1923 at the Bauhaus he confided in Lothar Schreier: "Children and madmen, and primitive people have retained — or rediscovered — the art of seeing. And what they see and draw from it are for me the most precious of forms. For we all see the same thing, even though we all see it in different ways. The same thing in both the whole and the details in everything on this planet is not the product of a frenzied imagination but a real fact."

Picture Page has its inspiration in the concentric linear models of Melanesian art and Australian Aboriginal art. Klee uses a kind of X-ray image that reveals the spine of one of his fish. The whole is presided over by a moon-woman whose head is formed from a moon crescent and whose body is decorated with ceremonial stripes painted in the earthy ochre used in tribal decoration. The base and pigments have been carefully chosen, and the gouache used on unprepared canvas gives a chalklike impression.

Klee adapted the hieroglyphic form so that it was not focused on a large central image but was distributed in different laddered models. As the title indicates, it is a leaf or page of an album rather than a singular unified composition. Spread about this page are signs representing the sun and moon, furnishings, and fish of which the biggest is wedded to a watery moon sign. This painting does not provide any explanations; the elements are all separate, which gives it a quality of mystery and evasion. But the big moon-woman ladder and the red and black mask decorated with floating horns in the center make it a painting of chalky images from which a primitive magic emanates.

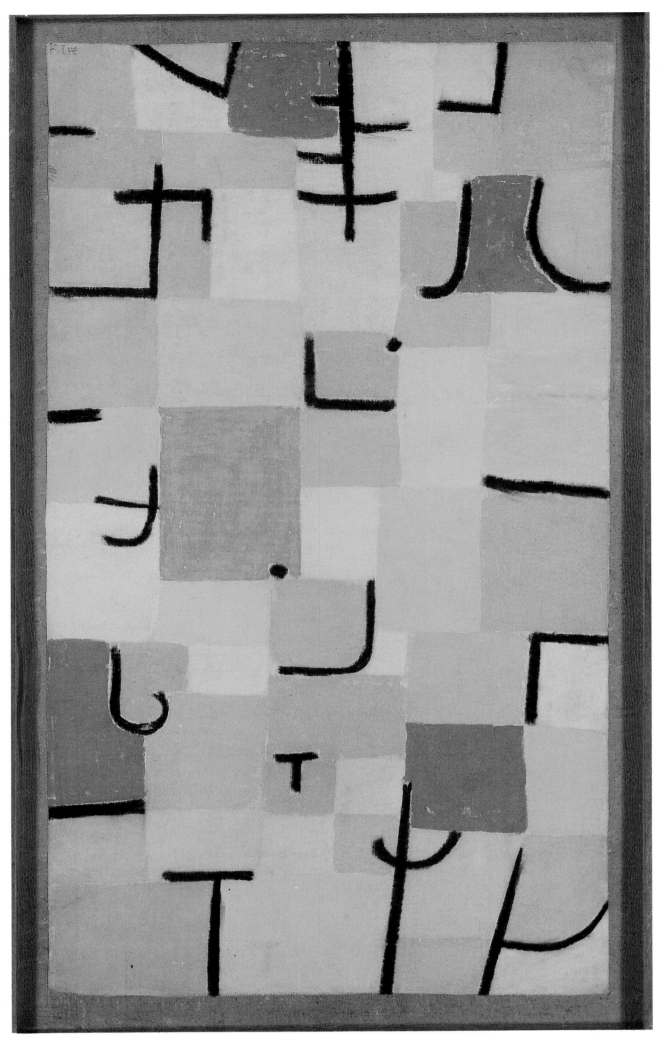

268. SIGNS ON A YELLOW BACKGROUND
(ZEICHEN IN GELB)
1937/210 (U 10) – Pastel on canvas, 83.5 × 50.5 cm
Beyeler Gallery, Basel.

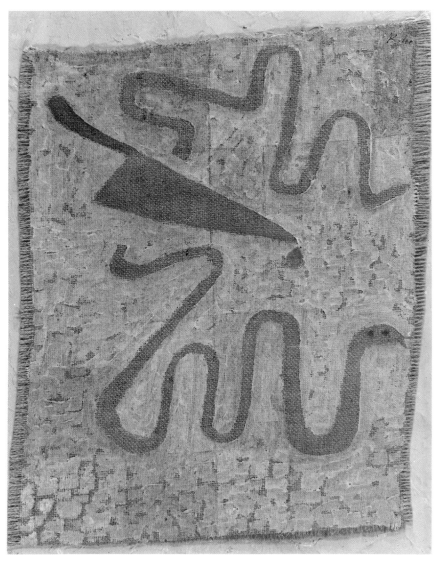

269. THE SNAKE CUTOUT
1938 – Tempera on jute canvas, 50.6 × 38.1 cm
Solomon R. Guggenheim Museum, New York.

Signs on a Yellow Background, 1937

This pastel, in which a series of black signs offset an underlying yellow checkerboard, could be the illustration for an exercise Klee gave to his Bauhaus students on January 23, 1922 — a composition based on:

I. individual rhythms,
II. structural rhythms,
III. the reciprocal utilization of the first two elements.

"The path leading to this type of composition is the path that successively uses the elements to form the whole," Klee explained. "It is not always enough to link unit to unit, to juxtapose and join line to line and surface to surface. On the contrary, the double formation can be expressed by the fact that line and surface, usually considered as independent elements, act in unison.

"Organic and contradictory polyphony.

"In the space the open forms make up the frame for the linking movements."

This abundant growth of the line, complete with thrusts and pauses, evokes Michaux. This graphic system of thick black signs was one of the systems that Klee used for the rest of his life. Oscillating between image and writing, they can be considered pseudo-graphemic, and Pierce has remarked on similarities between these signs and Coptic writing. In this respect, Klee's trip to Egypt (1928–1929) was as revelatory as his Tunisian journey had been fifteen years earlier.

270. BLUE NIGHT
(BLAUE NACHT)
1937/208 (U 8) – Tempera and pastel on canvas, 50.5 × 76.5 cm
Kunstmuseum, Basel.

271 **Picturesque Landscape, 1937**

1937 was Klee's year for pastels, on cotton or jute and more rarely on paper; the pigments were applied to a damp base that absorbed them. The linear marks are both thick and fine and appear for the first time in some brightly colored paintings and some more nocturnal ones, like this; these paintings with their sparingly used hieroglyphic signs are highly meditative works.

This work, trying to integrate time and memory in a pictorial language, consists of signs and ideograms and hieroglyphics or cursive writing. Klee transmits an intimate reality to us, a "reality that does not exist" without an inner necessity. The "communion with nature" — understood in the sense of "natura naturans," genesis and growth in time and space —was always for him the sine qua non condition of creation; at this time Klee was watching nature from within himself in order to transcribe its innermost movement. The concepts of movement, fluidity, development, and growth were translated in the form of lines, thick downstrokes, and cursive signs that, proceeding metonymically, orient how one looks at and reads the picture: Toward the bottom, a slanting profile; above in the green zone, an oar; a plant, which could be a sex organ; and a breast attached to a staircase with an appogiatura question mark next to it. The surfaces cross into each other creating multiple nested spaces. From two red planes to the green in the center, the yellows are extinguished in a chaos of browns of different tones. In this nested scene, the rhythm knocks about the heavy earth-colored enamel forms crowding the surface. The black marks are like the lead in a stained-glass window. The spaces where the black lines come to an end lend an element of risk to the work.

271. PICTURESQUE LANDSCAPE
(BÜHNEN-LANDSCHAFT)
1937/212 (U 12) – Pastel on cotton, 58.5 × 86 cm
Paul Klee Foundation, Kunstmuseum, Bern.

272. FRIENDSHIP
(FREUNDSCHAFT)
1938/54 (E 14) – Drawing in paste medium on paper mounted on cardboard, 17.9 × 28 cm
Paul Klee Foundation, Kunstmuseum, Bern.

273 Three Exotic Young People, 1938

There was a striking relationship between drawing and writing in Klee's work of the last years, the one, it could be said, substituted for the other. The forms were developed from transversal lines of varying thicknesses without any hatching or superfluous marks. According to Grohmann, Klee "wrote" his drawing in a "state of ecstasy stimulated by rhythmic movements."

In this work, the lines no longer grope to find the surface as in the earlier drawings but, instead, extend in vigorous and well constructed-strokes. The features of his personages have become concise stenographic marks similar to the ones seen in the Tsogho masks of Gabon and the Tshokwe of Zaire. More-over, these marks operate as substitutions rather than abstractions taken from an exterior reality, as in the primitive cultures that inspired Klee. The chromatism is limited to four clearly set out colors: a blue, a faded pink, a beige, and a purplish-blue brown.

There is a mixture at play here of the rawest savagery and the most refined intellectualism. Klee's vision, which is both universal and primitive, surmounts the erroneous distinctions between barbaric and civilized and proceeds equally well from Chinese or Arabic calligraphy or Irish or gothic illuminations, as from the tradition to which he is irrevocably bound by his precise observation and humorous fantasy.

1938 19 drei junge Exoten

273. THREE EXOTIC YOUNG PEOPLE
(DREI JUNGE EXOTEN)
1938/19 – Color in paste medium on wrapping paper glued on cardboard, 46.6 × 39.8 cm
Paul Klee Foundation, Kunstmuseum, Bern.

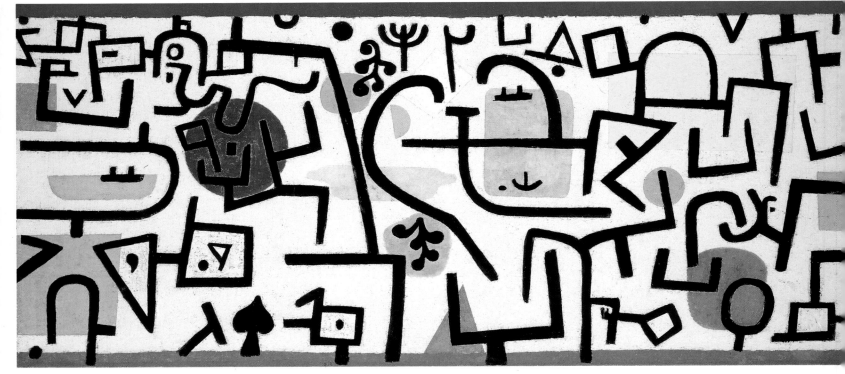

274. RICH HARBOR
(REICHER HAFEN)
1938/147 (K 7) – Tempera on primed paper on canvas, 75 × 165 cm
Kunstmuseum, Basel.

275. FRUITS ON BLUE
(FRÜCHTE AUF BLAU)
1938/130 (J 10) – Colors mixed with gum on newspaper glued on jute, 55.5 × 136 cm
Paul Klee Foundation, Kunstmuseum, Bern.

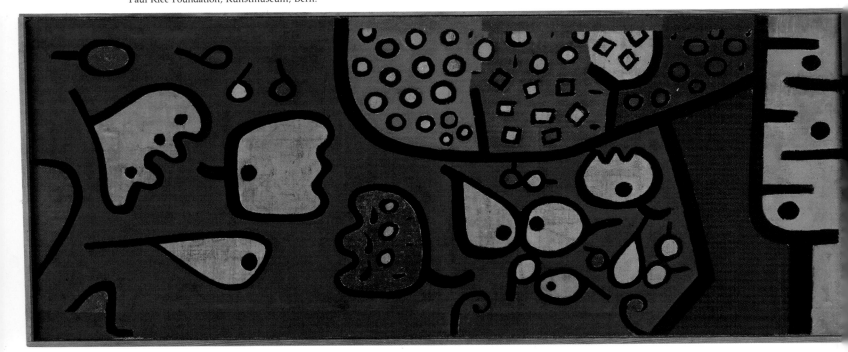

276. ALPHABET I
1938/187 (M 7) – Wash on newspaper mounted
on cardboard, 53.9 × 34.4 cm
Paul Klee Foundation, Kunstmuseum, Bern.

277. FRONTIER
(GRENZE)
1938/37 (D 17) – Colors mixed with black and brown gum on Japanese
paper mounted on cardboard, 59 × 35.4 cm
Paul Klee Foundation, Kunstmuseum, Bern.

Rich Harbor, 1938

Multiple signs are deployed here: triangles, rectangles, circles, points, open and closed forms, and fragmented forms that are not easily circumscribed. All these elements have to be read as imagery. If we allow our imagination to play with this mass of black marks, they suddenly come alive, and a different world is offered to our eyes. We have reached the point at which the iconography has become decipherable.

Let us imagine we are a gull wheeling above the scene and looking down on it. We see a large port area. Leaves, branches, tins, planks, and buoys float amidst patches of speckled oil in the moving water. The small outline of some distant ships can also be discerned. On the quays there are cranes and constructions and we note that there is a lot going on in this port.

Like children's drawings, Klee's work has something fabulous about it. But there is nothing childish about them in that they have been precisely constructed according to very specific laws. The brown strip on the bottom of the quay, the stretch of water

in the center, the strip of blue horizon above, and the big uneven black line that joins these two strips, all have their purpose.

We can interpret the marks as we wish. Some people have seen a "great weeping willow on top of a hill," others, a pyramid and chapels! However, Klee kept to what he intended, and the spatial play emerges from this. The genesis of the picture can be seen. He painted a form and then looked for something to which it could relate. He looked again at what he had painted and allowed himself to be guided by it until there was an almost unconscious creation of new elements; it was absolutely essential here for him to not look for any contextual content. Klee spent a lot of time on this process of creation, and eventually a unique pile of forms, colors and surfaces emerged. This painting is very balanced; there is not one rectangle too much or one circle too little, and there is a perfect interdependence between all the different parts. The relationships that are at play between the isolated elements come into the foreground. The painting comes alive.

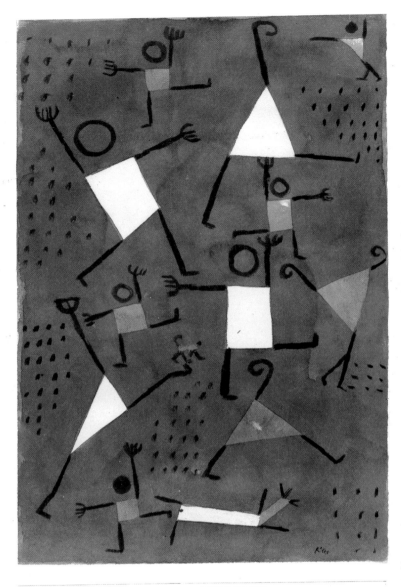

1938.y 10. Tänze vor Angst

278. DANCING FOR FEAR
(TÄNZE VOR ANGST)
1938/90 (G 10) – Wash on Ingres paper glued on cardboard, 43 × 31 cm
Paul Klee Foundation, Kunstmuseum, Bern.

279 Intention, 1938

This important picture is typical of the separation between interior and exterior and the past and the present that Klee sought.

The cryptic writing in *Intention* can be deciphered in part. The outline of a body to the waist formed by a continuous line separates the surface into two unequal parts. On the left, on an olive gray ground, are a cluster of precise signs: a little masked man, a dog, a tree, and four pink flags, which bring to mind the dynamic figures in *Dancing for Fear* (1938). The almost colorless tonality is stifling, a symbol of the exterior life that the silhouette with the blue eye has left behind her. However, on the right, inside the figure, the creative and ludic field of *Intention* is deployed on a yellow ground covered with pink. In

this part of the picture the signs hover between abstract and figurative. Only the eye is identifiable; it characterizes the figure and is the symbol of a spiritual perception that transcends the past as well as the present. The use of two superimposed colors in combination with the black signs, makes the whole picture vibrate.

Considered as a self-portrait, *Intention* seems to be Klee's vital rendering of his personal feeling about the potential space between the world here and the world beyond. From a psychological point of view, it is a hieroglyphical composition, the dark part representing the unconscious, and the light part, the conscious.

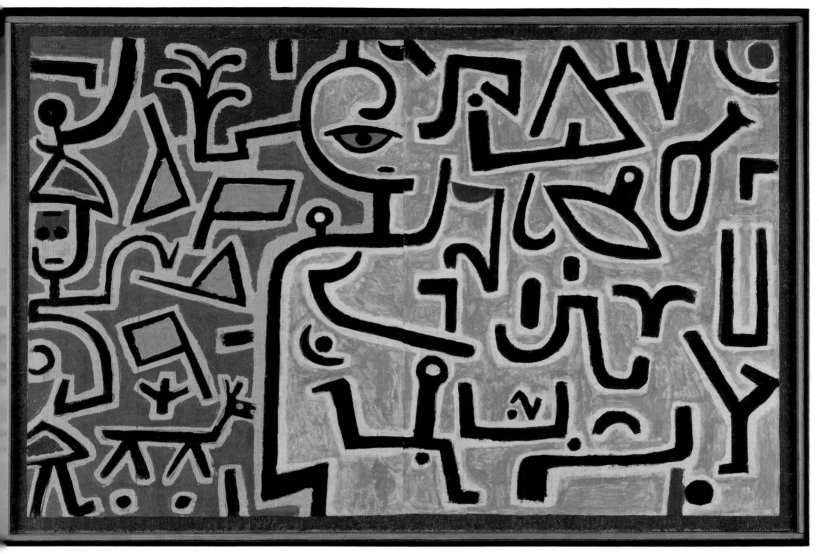

279. INTENTION
(VORHABEN)
1938/126 (J 6) – Colors mixed with gum on newspaper on jute, 75 × 112 cm
Paul Klee Foundation, Kunstmuseum, Bern.

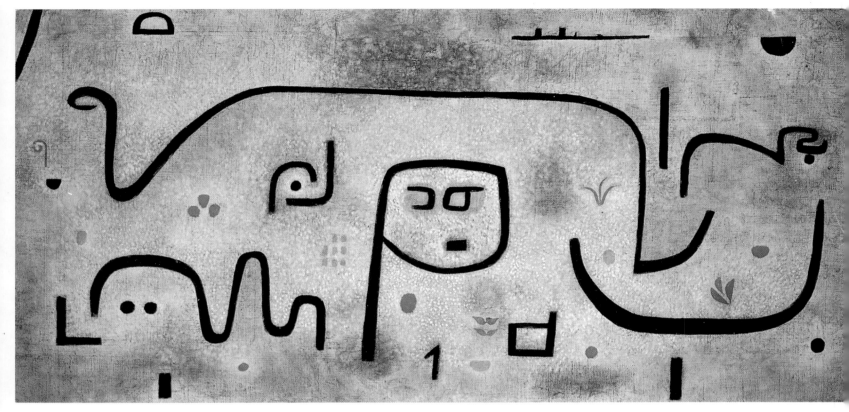

280. INSULA DULCAMARA
1938/481 (C 1) – Oil and gum on primed newspaper on jute, 88 × 176 cm
Paul Klee Foundation, Kunstmuseum, Bern.

280 **Insula Dulcamara, 1938**

Paul Klee painted seven rectangular panels in 1938, all first sketched in charcoal on newspaper and then glued onto jute or canvas so as to get a ground that was both even and uneven. Sometimes, the newspaper printing appears through the colors, and we are able to read parts of advertisements and articles. Klee enjoyed shocking us by inserting these kind of unusual elements.

Artist's Bequest (from the same series of seven) with its sparse accessories on a dark ground is quite 275 different from *Insula Dulcamara* and *Fruits on Blue Ground*, which are very serene works. These two pictures speak of the South and warmth, and *Insula Dulcamara* also depicts the Homeric myth. Someone suggested *Calypso Island* for this painting, which Klee thought too literal a title, but the sketch was

certainly done with this idea in mind. The black contours indicate the coast; the upright head, an idol, and the other curved lines are enmeshed in a tragic way. A mist, not part of the myth, passes over the horizon. The moon rises and sets, for "space is also a temporal concept." The colors are spring colors: a willow-green, a soft pink, and a sky blue. It is spring on one of the Cyclades that Ulysses passed through on his way to Ithaca. His age has not yet been completed, and ours has been here for a long time already. Transparent time, transparent space . . . Where does it begin? Where does it end? What difference between sea and land? Klee now unconsciously moves in a world with several dimensions, which in his youth he considered the supreme goal.

202

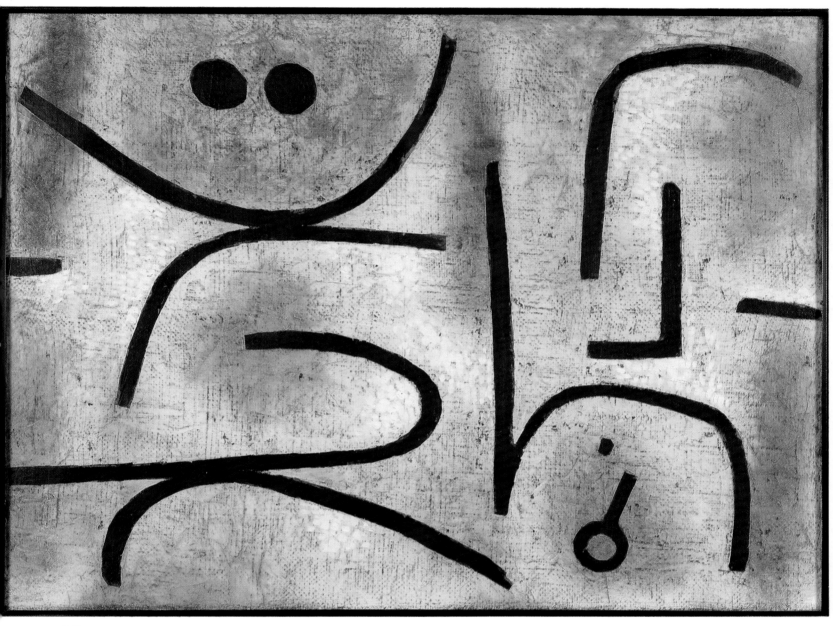

281. BROKEN KEY
(ZERBROCHENER SCHLÜSSEL)
1938/136 (J 16) – Oil on canvas, 50 × 64.4 cm
Sprengel Museum, Hanover. Bernhard Sprengel Collection.

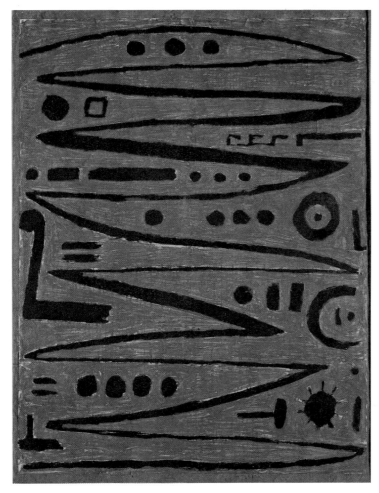

282. HEROIC FIDDLING
(HEROISCHE BOGENSTRICHE)
1938/1 (1) – Painting in a gum mixture on newspaper, 73 × 52.7 cm
Museum of Modern Art, New York. Gift of Nelson A. Rockefeller.

283 **The Gray One and the Coastline, 1938**
282 **Heroic Fiddling, 1938**

Heroic Fiddling is a hommage to the great violinist Adolf Busch with whom Klee was friendly. It was conceived as a rhythmic structure analogous to Busch's energetic, supple and heroic playing. The form Klee composes consists of a series of strange beaks strewn with hieroglyphics. The thick jambs, which first appeared in 1937, correspond to his desire to directly transmit the phenomenon of music into a plastic form. The work is rhythmical in space and has a continuity in time like a musical stave. The blue resounds profoundly like Bach's music; it could represent a fugue.

The same rhythmic structure is found in a work that was done a month later, *The Gray One and the Coastline*, which was supposed to be called *Fiddling II*. In this one the strokes of the bow become the tongues of land going into the dark blue sea. Some musical notations are still there, but a gray personage now appears in the upper right hand corner. The human theme and the rhythmic structural theme overlap. Klee has utilized the same schema for two completely different themes: The first version belongs exclusively to the musical and spiritual domain, and the second, to the human domain and destiny.

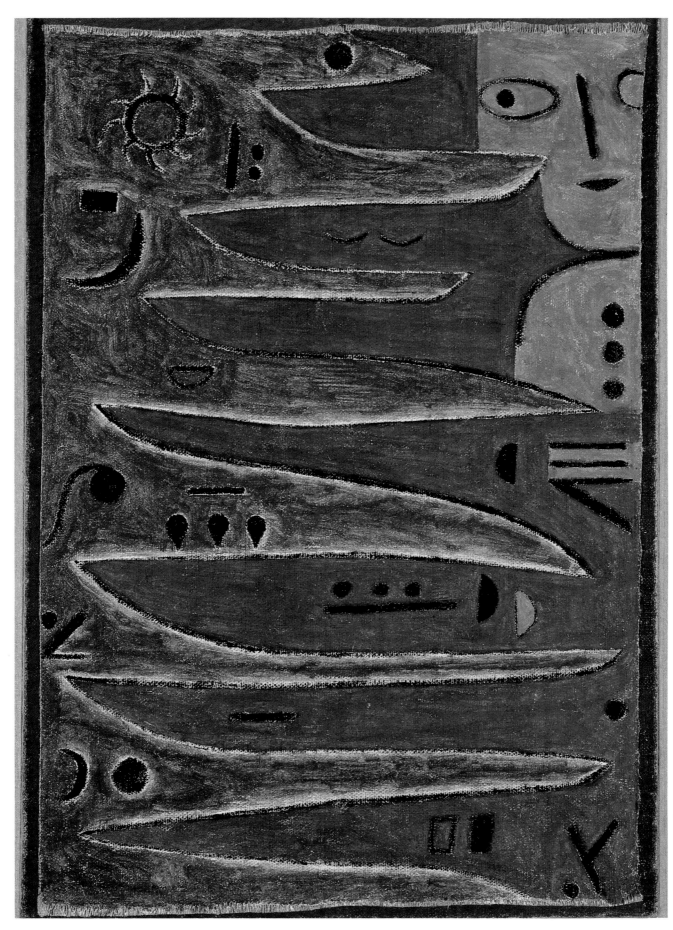

283. THE GRAY ONE AND THE COASTLINE
(DER GRAUE UND DIE KÜSTE)
1938/125 (J 5) – Colored paste on canvas, 105 × 71 cm
Private collection.

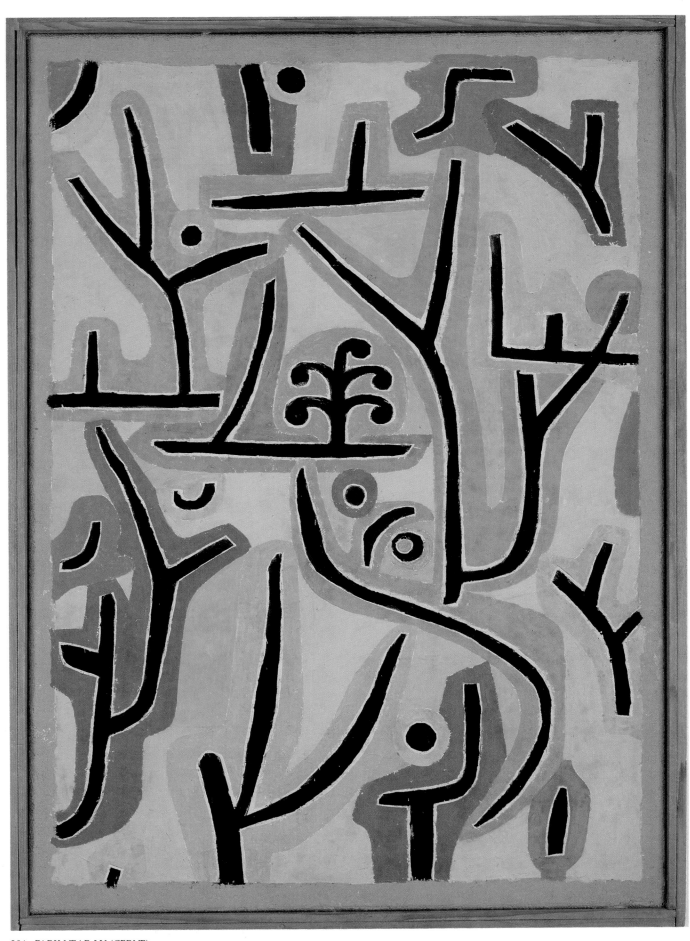

284. PARK NEAR LU (CERNE)
(PARK BEI LU [ZERN])
1938/129 (J 9) – Oil on newspaper glued on canvas, 100 × 70 cm
Paul Klee Foundation, Kunstmuseum, Bern.

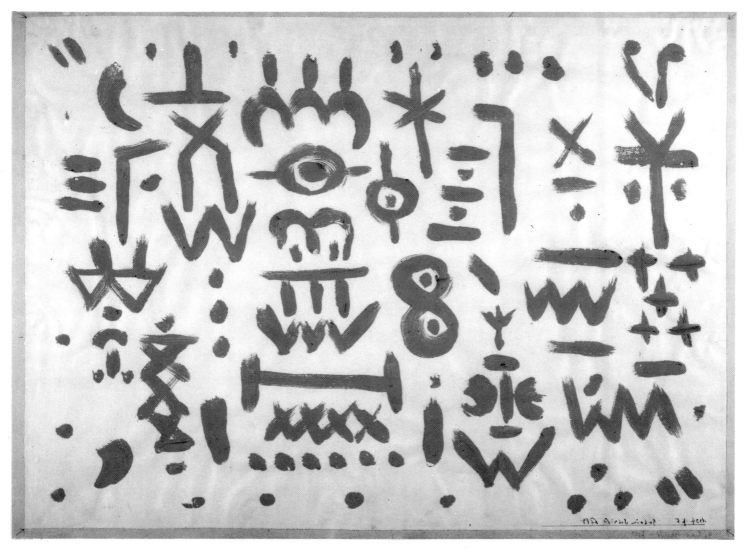

285. SECRET WRITING
(GEHEIMSCHRIFTBILD)
1934/105 (P 5) – Brush and colors mixed with gum on Ingres paper mounted on cardboard, 48 × 63.5 cm
Paul Klee Foundation, Kunstmuseum, Bern.

Park Near Lu (cerne), 1938

Among the morbid and dramatic works of the last period, this one appears as an oasis of joyous serenity. The emphasis is on the long areas of color — yellows, beiges, pinks, purples, almond greens, and magentas —which have branches thinly encircled in white running through them. Here and there, this puzzle of areas animated by branches is cut into by patches of Verona green and by other patches that do not contain branches. Klee's dialogue with nature succeeds fully here, a dialogue that he considered the sine qua non of art.

On November 27, 1923, at the Bauhaus, after giving back his pupils' efforts, some of which were more successful than others, he explained: "Do not try to align dead shells, rather begin by giving form and volume to the littlest of life's functions and then build a skin or shell around this, as it is with an apple or snail. That is quite enough to bring forth an alive painting from a painter. As for the creative energy, it remains unnameable and always mysterious. But there is no mystery without a fundamental shock. (. . .) Creative energy is probably an aspect of matter that is as imperceptible as its usual modes of operation. But it is in these recognized ways and means of matter that energy must affirm itself. It has to unite with it so that it can fulfill its function of giving to a work an alive and real form. Thus, matter is animated and arranged from its smallest particles to its secondary rhythms and extends finally as far as its most important articulation. The particles of which it is composed resound with an original vibration, and their oscillation goes from the most simple to the most complex. Necessity has to break through and reveal itself; the bow cannot have any pity; in order to fulfill its function, energy has always to have a convincing motive. Thus initially, medially, and ultimately the elements will be closely linked. Nothing problematic can infiltrate anywhere because everything infallibly fits in."

286. BUST OF GAIA
(BÜSTBILD DER GAIA)
1939/343 (Y 3) – Oil on canvas, 97 × 69 cm
Private collection, Switzerland.

287. LOVE SONG BY THE NEW MOON
(LIEBESLIED BEI NEUMOND)
1939/342 (Y 2) – Gouache on jute canvas, 100 × 70 cm
Paul Klee Foundation, Kunstmuseum, Bern.

288. THE TORSO AND HIS OWN IN FULL MOONLIGHT
(DER TORSO UND DIE SEINE [BEI VOLLMOND])
1939/256 (T 16) – Varnished watercolor on jute canvas, 65.5 × 50.5 cm
Paul Klee Foundation, Kunstmuseum, Bern.

289. MEPHISTOPHELES AS PALLAS
(MEPHISTO ALS PALLAS)
1939/855 (UU 15) – Watercolor and tempera on black Ingres paper
mounted on cardboard, 48.4 × 30.9 cm
Museum der Stadt, Ulm.

290. MOTHER AND CHILD
(MUTTER UND KIND)
1938/140 (J 20) – Watercolor on jute canvas, 56 × 52 cm
Private collection, Switzerland.

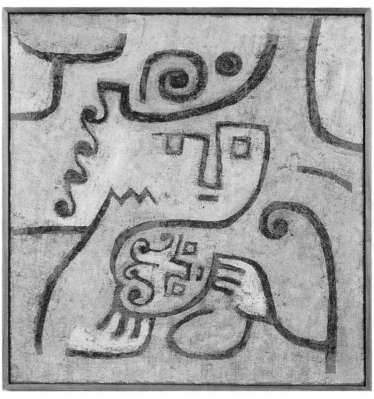

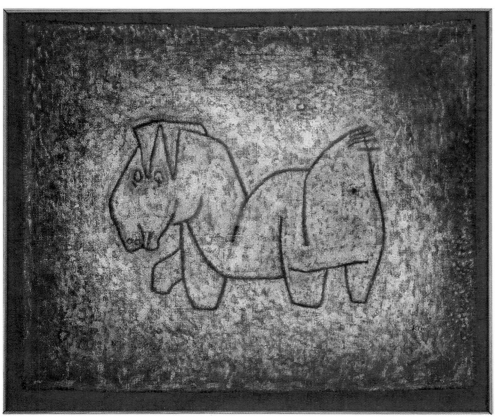

291. BASTARD
(BASTARD)
1939 – Paint and gum mixture, tempera, and oil on jute, 60 × 70 cm
Private collection, Switzerland.

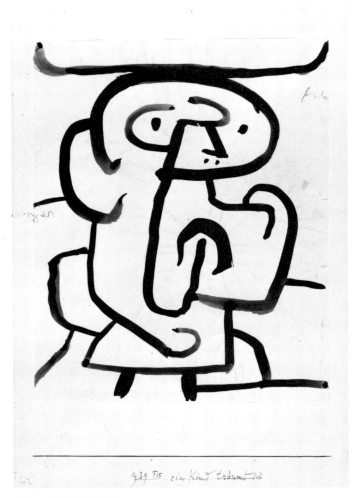

292. A CHILD DREAMS
(EIN KIND TRÄUMT SICH)
1939/495 (F 15) – Brush and watercolor on paper
on cardboard, 27 × 21.5 cm
Paul Klee Foundation, Kunstmuseum, Bern.

293. CHILD AT BREAKFAST
(KIND BEIM FRÜHSTÜCK)
1939/275 (U 15) – Colors mixed with gum on
writing paper, 29.5 × 20,9 cm
Paul Klee Foundation, Kunstmuseum, Bern.

294 Rock Flora, 1940

On an orange and purplish-blue ground sprinkled with pink, a confusion of branches, flowers, fruits, and green buds cross one another unrestrainedly. This is quite different to the restraint shown in *Park Near to Lu (cerne)*. In this picture, growth is depicted by the rambling scriptural characters. The more Klee's work leans towards pure graphism (putting the emphasis on the formal and constituent elements of graphic expressionism), the less reliant he is on a realistic interpretation of the visible — a rhetoric that depends entirely on surprise and spontaneity, but that is nonetheless as demanding and disciplined as the other. It is a matter for Klee of opposing the obedience of the two dimensional surface to be painted with the magical charm of the trompe-l'oeil; he hopes to make this come about by juxtaposing straight and circular in the same way as the Japanese do. This results in arabesques and simple spots and points that the art lover can see in any combination he or she wishes.

Klee managed to put all the knowledge he had gained about growth over the years into the simple colors and the whimsical ideograms. The pale tones are an accumulation of his experience in depicting serenity; the warm ones, joy. His old way of using perspective on an impressionist grid, the remains of which were still evident even after he had gone back to Switzerland, slowly disappeared from his last works. Reality was henceforth based on a series of emotional shocks and vague feelings constantly in flux. As if the pictures were as out of Klee's reach as they are ours. His grip on them is precarious; it is as if we do not know where they came from or what caused them. So much so, that finally we have to understand this painting not by what is clear, but by what is not; not by what is proposed, but by what is; and not by what he wanted, but by what he suffered. The subtle drawing, the unusual tones, the mysterious surface, and the many fabulously elegant details all work together to determine how we look at the painting. This kind of painting is different from classical painting and demands that we view it differently. It calls up new feelings, among them sensuousness and sometimes an unexpected disgust; we cannot differentiate between the stupor and mystery of this rather desperate love.

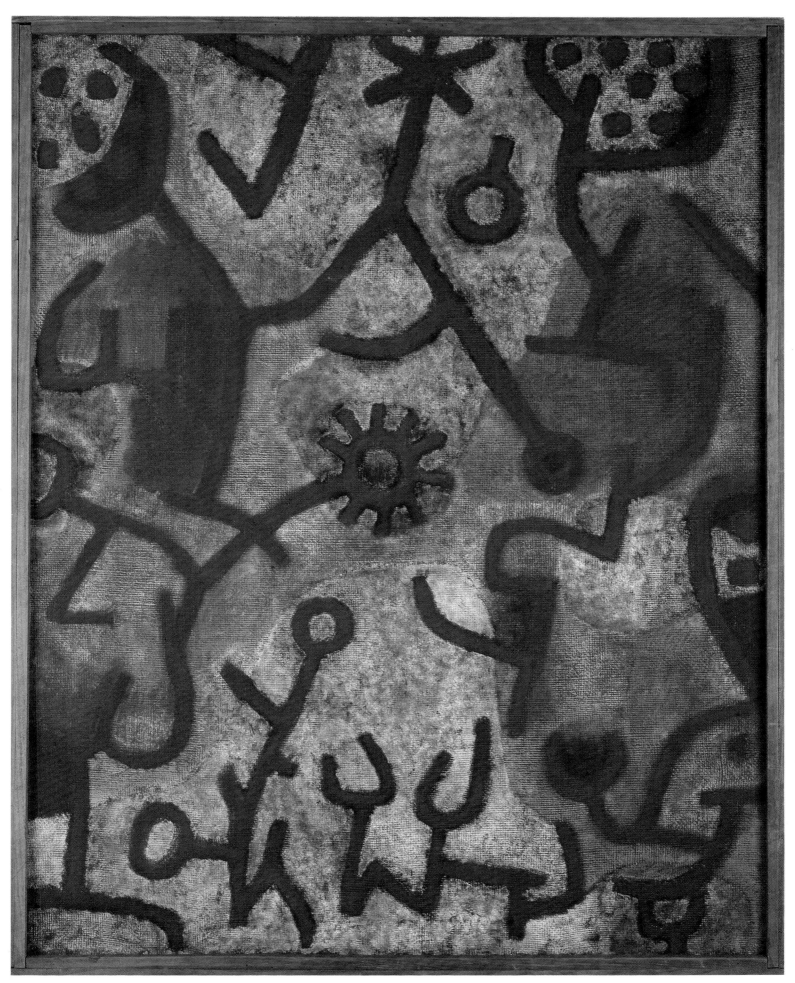

294. ROCK FLORA
(FLORA AM FELSEN)
1940/343 (F 3) – Oil on jute, 90 × 70 cm
Paul Klee Foundation, Kunstmuseum, Bern.

211

295. FORGETFUL ANGEL (VERGESSLICHER ENGEL)
1939/880 (VV 20) – Pencil on paper, 29.5 × 21 cm
Paul Klee Foundation, Kunstmuseum, Bern.

296. THE APPROACH OF LUCIFER (NÄHERUNG LUZIFER)
1939/443 (D 3) – Pencil on Japanese simili, 29.7 × 20.9 cm
Paul Klee Foundation, Kunstmuseum, Bern.

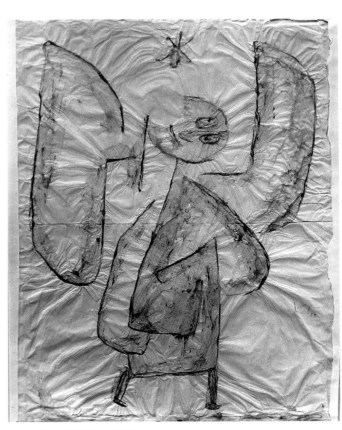

299. OTHER ANGEL OF THE CROSS
(ANDERER ENGEL VOM KREUZ)
1939/1026 (DE 6) – Black chalk on wrapping paper
on cardboard, 45.6 × 30.3 cm
Paul Klee Foundation, Kunstmuseum, Bern.

300. ANGEL FROM A STAR
(ENGEL VOM STERN)
1939/1050 (EF 10) – Colors mixed with gum on paper
glued on cardboard, 61.8 × 46.2 cm
Paul Klee Foundation, Kunstmuseum, Bern.

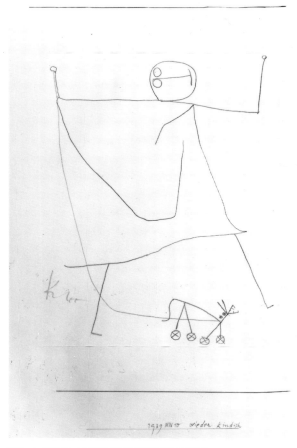

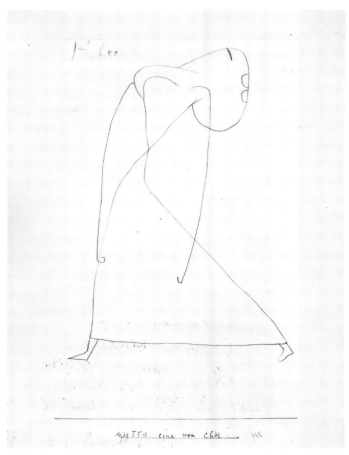

297. A CHILD AGAIN (WIEDER KINDISCH)
1939/750 (NN 10) – Pencil on paper mounted on cardboard, 27 × 21.5 cm
Paul Klee Foundation, Kunstmuseum, Bern.

298. ONE FROM THE CHOIR (EINE VOM CHOR)
1939/833 (TT 13) – Pencil on paper mounted on cardboard, 29.5 × 21 cm
Paul Klee Foundation, Kunstmuseum, Bern.

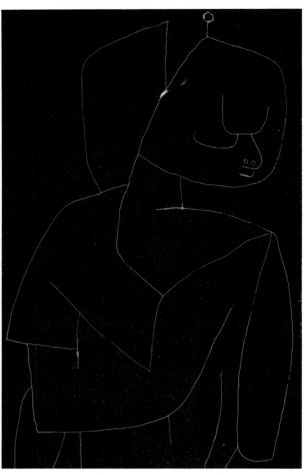

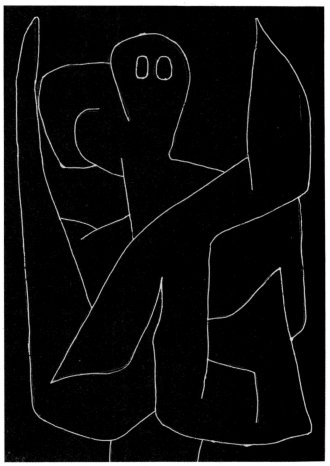

301. EXOTIC TEMPLE GIRL
(EXOTISCHES MÄDCHEN VOM TEMPEL)
1939/865 (VV 5) – Pencil and drawing pen on black paper
mounted on cardboard, 32.8 × 20.9 cm
Paul Klee Foundation, Kunstmuseum, Bern.

302. GUARDIAN ANGEL
(WACHSAMER ENGEL)
1939/850 (UU 19) – Pencil and tempera on black
newspaper, 48.5 × 33 cm
Private collection, Switzerland.

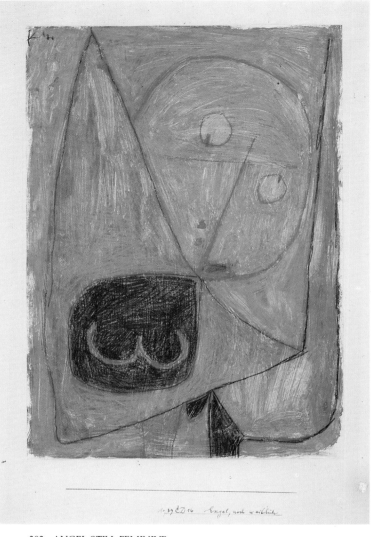

303. ANGEL STILL FEMININE
(ENGEL NOCH WEIBLICH)
1939/1016 (CD 16) – Oil crayon on paper glued
on cardboard, 41.7 × 29.4 cm
Paul Klee Foundation, Kunstmuseum, Bern.

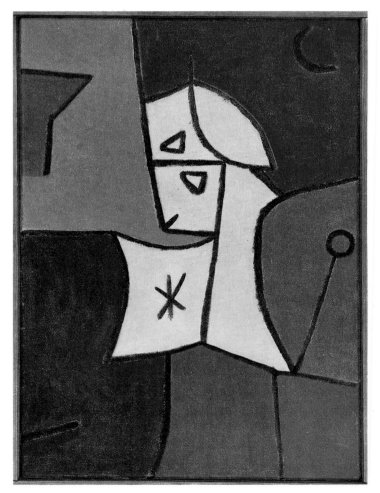

304. HIGH WATCHMAN
(HOHER WÄCHTER)
1940/257 (M 17) – Painting with wax on canvas, 70 × 50 cm
Paul Klee Foundation, Kunstmuseum, Bern.

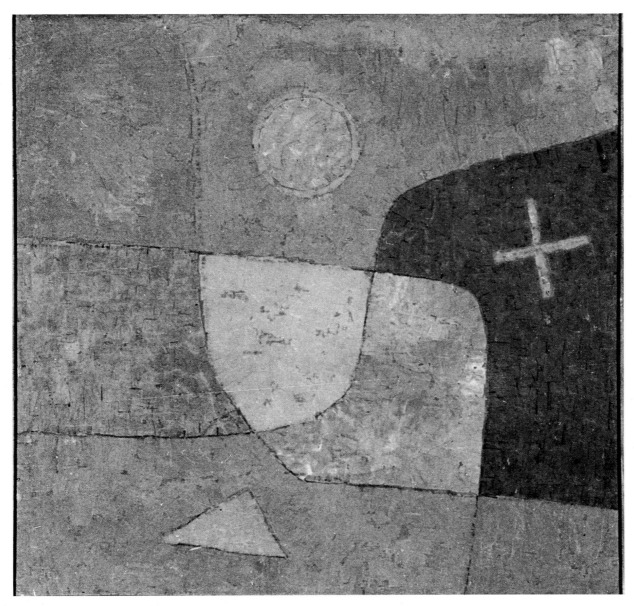

305. ANGEL IN THE MAKING
(ENGEL IM WERDEN)
1934/204 (U 4) – Oil on wood, 51 × 51 cm
Private collection, Switzerland.

No other artist of the 20th century other than Klee has used the angel in their work as frequently or in as many changing forms and meanings. For him it symbolizes the dawning of creation, which, of course, heralds the advent of death as well as birth. In Klee's drawings the angel is not the ideal perfect essential being, far out of the reach of mankind. His angels have human features and frailties. They are in a state of becoming, and during their progression they often fall, start drinking, are unhappy or anxious, and retain a feminine form. For Klee, who was so interested in the intermediary zones, the angels belong to the secret place between this world and the world beyond.

"I philosophize on death, not out of resignation but in a search for perfection," he said. In 1939, thirty or so angels came up in his work. This is the plastic concept of *Glass Façade* from which came *High Watchman*. The figure is formed from a network of intersecting black lines. A watercolor, *Sailor* (48/31), done along similar lines, appeared in the same year; a sailor's cap is perched aslant on a forehead from which a mutinous chin juts. As the *High Watchman* is also wearing the cap but without the pompom, *Sailor* belongs as he does to the Angel series. The blue, beige, and purple chromatism reinforces the sublime and angelic atmosphere.

In a poem of his youth, Paul Klee had announced: "One day I will not be anywhere, lying next to some angel or other.

306. GLASS FAÇADE
(GLAS FASSADE)
1940/288 (K 8) – Color on jute, 71 × 95 cm.
Paul Klee Foundation, Kunstmuseum, Bern.

307. STILL LIFE ON LEAP DAY
(STILLEBEN AM SCHALTTAG)
1940/233 (N 13) – Colors mixed with gum on paper glued on jute, 74 × 109.5 cm
Paul Klee Foundation, Kunstmuseum, Bern.

308. WOMAN IN NATIONAL COSTUME
(FRAU IN TRACHT)
1940/254 (M 14) – Color mixed with gum on Ingres paper glued on cardboard, 48 × 31.3 cm
Paul Klee Foundation, Kunstmuseum, Bern.

309. SPORTIVE YOUNG LADY
(DAS FRÄULEIN VON SPORT)
1938/29 (D 9) – Colors mixed with gum on paper, 54 × 34.5 cm
Private collection, Switzerland.

310. WITH FLOWERS
(MIT BLUMEN)
1939/766 (PP 6) – Pencil, 27 × 21.4 cm
Paul Klee Foundation, Kunstmuseum, Bern.

311 The Beautiful Gardener (Biedermeier Ghost), 1939

The simplicity of the plastic means used in these last works was an expression of a creative process that had become tremendously concentrated. There were so many things he wanted to put down that he had to work very rapidly and intensely. "I don't even have enough time for my principal occupation," Klee wrote to Felix Klee on December 29, 1939. "Production assumes an increased ratio in an accelerated tempo, and I can no longer follow these children very well." Despite his speed, he managed to push colors and forms to their most intense and effective extremes.

The subtitle (*Biedermeier Ghost*) needs some kind of explanation. Klee is alluding here to the bourgeois style, composed of a strange mixture of moral outbursts, romantic idyll, and family intimacy, that reigned in Germany and Austria between 1815 and 1848. In this society there was a liking for simple unaffected gardens strewn with multicolored flowers like the "Biedermeier bouquet." In Vienna for example, the Rosenbaum garden had forty thousand roses in it growing alongside the fruit trees, vines, and vegetables. Grohmann's use of the word "prudhommesque," describes this gaudy fantasy very well.

From the extremely colorful ground of the *The Beautiful Gardener*, a phosphorescent and magic ghost rises. Significantly, the lines from which it is made up are not black rods but fluorescent reds and blues. An aura of the same colors radiates on the brown ground, animating it. Here and there a cold green casts a pastoral feel. If we compare this painting with the rapid sketch of the same year entitled *With Flowers*, we can see to what extent Klee could use a lyrical chromatism to animate and reinforce a simple linear tracing. While the drawing shows us a simple figure in a crinoline holding a bouquet, *The Beautiful Gardener* is both a fantastic and humorous vision.

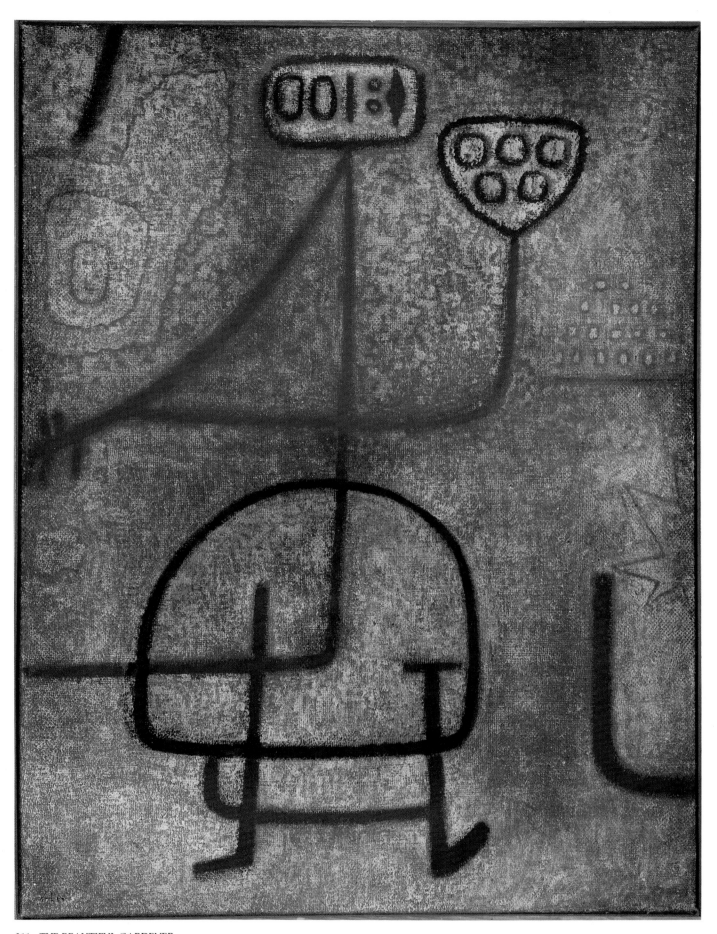

311. THE BEAUTIFUL GARDENER
 (A BIEDERMEIER GHOST)
 (EIN BIEDERMEIERGESPENST)
 1939/1237 (QP 17) – Oil and tempera on jute, 95 × 70 cm
 Paul Klee Foundation, Kunstmuseum, Bern.

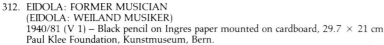

312. EIDOLA: FORMER MUSICIAN
(EIDOLA: WEILAND MUSIKER)
1940/81 (V 1) – Black pencil on Ingres paper mounted on cardboard, 29.7 × 21 cm
Paul Klee Foundation, Kunstmuseum, Bern.

313. EIDOLA: KNAUEROS, FORMER KETTLEDRUMMER
(EIDOLA: KNAUEROS, WEILAND PAUKER)
1940/102 (V 2) – Black pencil on paper mounted on cardboard, 29.7 × 21 cm
Paul Klee Foundation, Kunstmuseum, Bern.

314. EIDOLA: FORMER HARPIST
(EIDOLA: WEILAND HARFNER)
1940/100 (V 20) – Black pencil on paper mounted on cardboard, 29.7 × 21 cm
Paul Klee Foundation, Kunstmuseum, Bern.

315. EIDOLA: FORMER PIANIST
(EIDOLA: WEILAND PIANIST)
1940/104 (U 4) – Black pencil on paper mounted on cardboard. 29.7 × 21 cm
Paul Klee Foundation, Kunstmuseum, Bern.

316 **Kettledrummer, 1940**

With *Kettledrummer*, Klee attained an extremely expressive degree of symbolism, even though he used plastic and chromatic means so sparingly. The figure consists only of two arms, one of which is linked to an encircled eye while the other is isolated in space like an exclamation mark. Two red patches (magenta and vermillion) add a dramatic emphasis. They give an optical expression to the drum rolls. The mysterious eye fixes the spectator with a searching look. This *Kettledrummer* from the apocalypse seems to be saying: "It is time!"

On July 8, 1937, when Klee was very ill, Lily Klee wrote to Grohmann: "He stays up until eleven at night, and the drawings fall to the ground one after the other." And in connection with the making of this work, Grohmann remembers Klee remarking that he had, "felt so excited it was as if I was beating a drum." This expresses, whether it be in a realistic or a metaphorical way, one of the fundamental problems of Klee's theoretical work — the relationship to time. Should the heartbeat be compared to drumbeats? Is it a chronometer? Klee questions the relationship of at least three different ideas of time: mechanical time, expressive time, and physiological time.

Andrew Kagan compares the *Kettledrummer* with one of the drawings from the *Eidola* series entitled, *Knaueros, Former Kettledrummer* (1940, Bern Museum). In contrast to the usual commentaries on this series, which bring the term eidola back to eidos, meaning an archetype in a more Jungian than Platonic sense, for Klee the title of the series maintains its original Greek meaning: images, simulacrum, portraits, idols, and even ghosts. In *Kettledrummer*, all the references come together and crystallize: the memory (according to Grohmann) of a dead kettledrummer from the Dresden Opera company by the name of Knauer whom Klee had admired, the use of Greek letters that belong to the epic as well as the "birth of tragedy", and the imminence of the final catastrophe. It is impossible to not compare this work and *Knaueros*, with the drummer of the *Dance of the Dead*, engraved on wood by Holbein in 1538, whose drumsticks resemble bones. The allegorical figure of the *Kettledrummer*, worthy of being some modern *Memento Mori*, indirectly evokes the strange figure that came to order Mozart's Requiem.

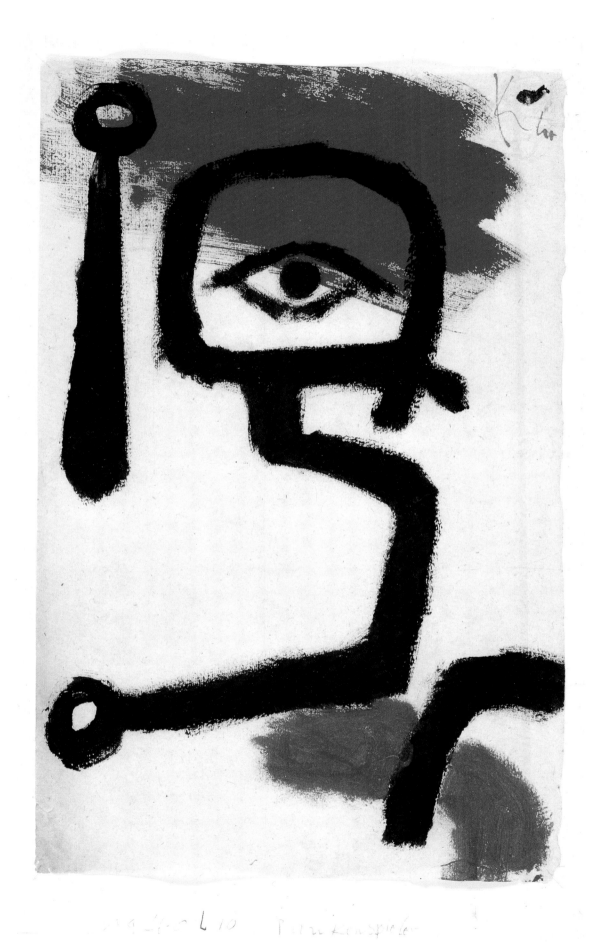

316. KETTLEDRUMMER
(PAUKENSPIELER)
1940/270 (L 10) – Colors mixed with gum on cardboard, 34.6 × 21.2 cm
Paul Klee Foundation, Kunstmuseum, Bern.

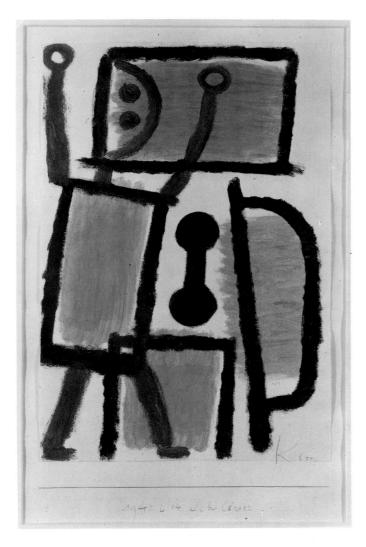

317. LOCKSMITH
(SCHLOSSER)
1940/274 (L 14) – Brush and tempera, 48 × 50 cm
Kupferstichkabinett, Kunstmuseum, Basel.

318 **Death and Fire, 1940**

Knowing that the end was near, Klee painted his own grimacing death mask without compassion. A silhouette moves forward from the background on the right, and in the foreground, dominating the work, a death's head on top of a skeleton comes out of the earth, brandishing a golden ring with which it tries to catch the attention of the silhouette, which is going to go across the fire of life. But this is merely an interpretation; whereas the shock of the image hits one immediately. Using well-tried plastic means, Klee managed to transpose the ultimate human challenge into artistic form. Death's face recalls the tormented features of a pastel self-portrait of the same year subtitled *durchalten*! (*Hold Fast*!).

His conception of death is teleological and is thus experienced as the continuous approach of an inaccessi-

ble totality. At the same time it is a conception of the world here and the world beyond, a gnostic tension that is very obvious here, but that could already be seen in a 1923 work called *Angelus Novus*, which Walter Benjamin made into his personal mandala. It is also about the recognition of the historical breaking points that take place in human development, that is the dissociation of humankind and nature. The image in its totality is a symbol of funerary rites where the ferryman takes the dead to another empire.

"While I was in the cold of the approach of death," wrote Henri Michaux in *Alphabet*, "I looked deeply at humankind for the last time. As this icy stare came into contact with mortals, everything not essential disappeared."

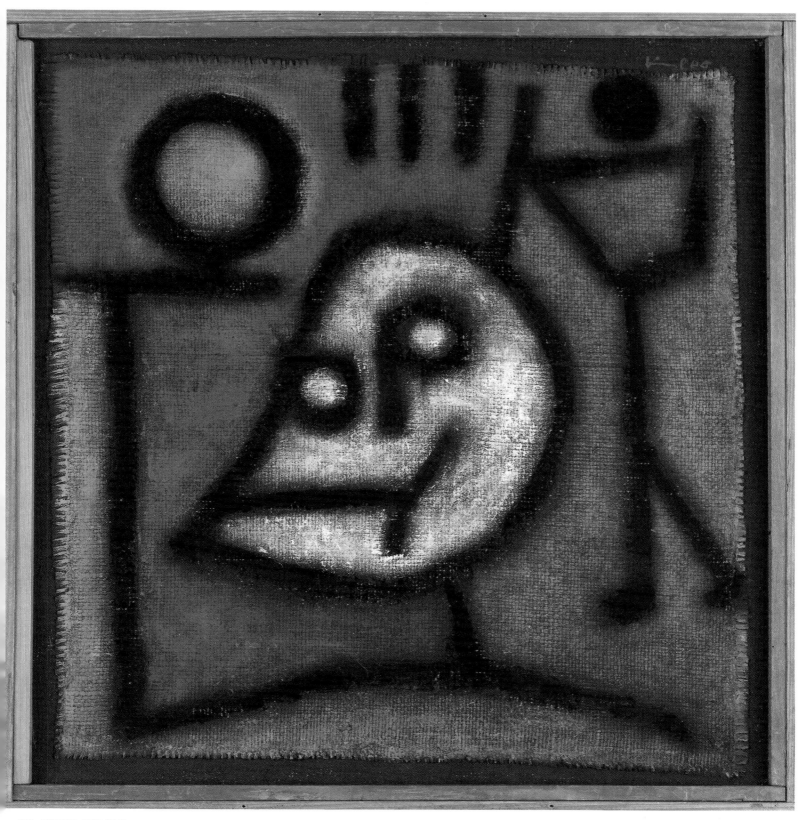

318. DEATH AND FIRE
(TOT UND FEUER)
1940/322 (G 12) – Oil on jute, 46 × 44 cm
Paul Klee Foundation, Kunstmuseum, Bern.

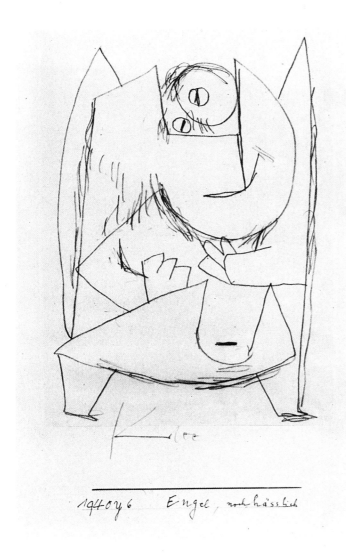

1940 y 6 Engel, noch hässlich

319. ANGEL STILL UGLY
(ENGEL NOCH HÄSSLICH)
1940/26 (46) – Pencil on paper, 29.6 × 20.9 cm
Paul Klee Foundation, Kunstmuseum, Bern.

320 **Untitled (Still Life), 1940**

This still life, the painter's last work, certainly evokes Matisse, but it also sums up some of Klee's principal themes. Therefore, it has both the value of a manifesto and a testament. The method used to create space is the same that Klee used in a large number of the works done before 1933: an epiphany of objects and colors on a neutral ground. The ground here is uniformly light brown, and the sculptural objects float in matter that is both mineral and luminous. Besides the yellow moon, which has punctuated all of his work, the motifs come from the last years of his life in Bern: encased forms (at the top and to the left), the Angel (drawn on a white sheet), and the flowered ideograms (on the tray). But the statue, coffee pot, and vases no longer seem to have the same meaning, and a luminous dimension suffuses them. Magical and disturbing, these everyday objects come alive. In the encompassing night, each

one is lit by its own light. Floating and immobile, there is something hieratic about these presences, it is almost as if they are the protagonists in a strange vigil.

Whether for a happy death or birth, the angel's hands are squeezed together. The light of the yellow moon is like the last ray of hope! The flowers strewn over the orange tray, on which the coffee pot and the statue rest, have just been cut and are curling in the light and life that they have left. The flowers are tears that have fallen from the objects and are the characters of a strange alphabet waiting to be formed into a language, characters in search of meaning. However, at the top of the painting, as if planted in the blue vase, two flowers have conquered eternity and live with their strange roots in a unique and definitive red light.

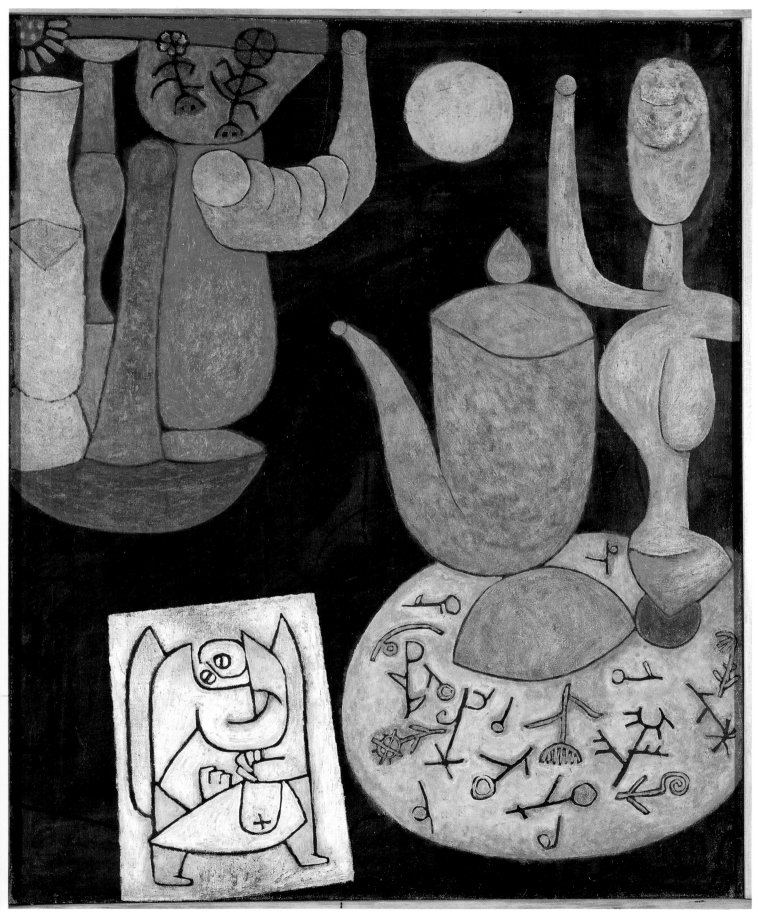

320. UNTITLED (STILL LIFE)
Posthumous work
(OHNE TITEL [STILLEBEN])
1940 N – Oil on canvas, 100 × 80.5 cm
Private collection, Switzerland.

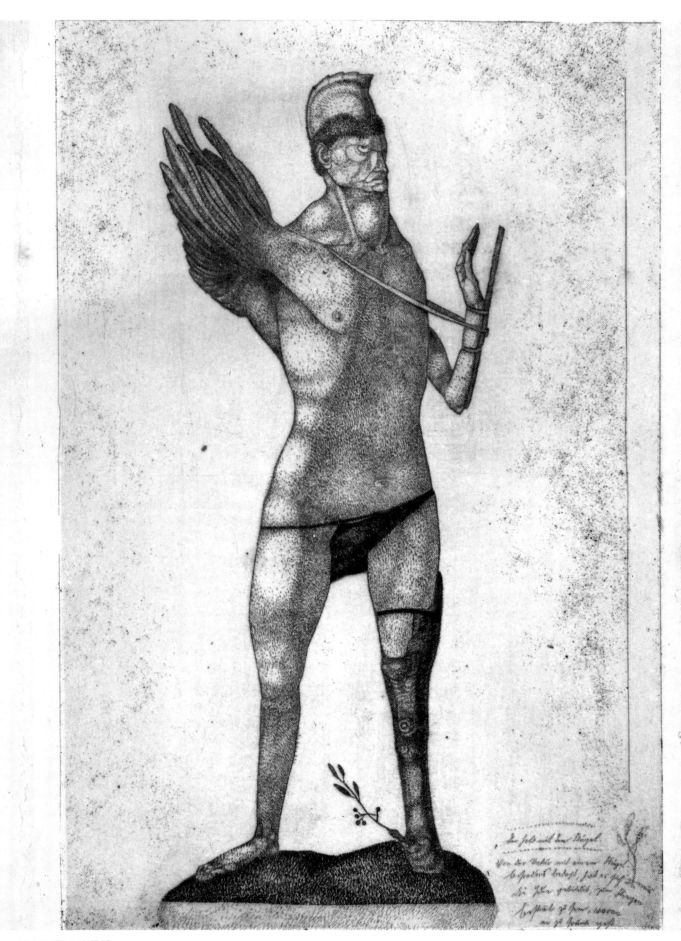

321. HERO WITH A WING
(HELD MIT DEM FLÜGEL)
1905/38 – Etching, 25.4 × 15.9 cm
Paul Klee Foundation, Kunstmuseum, Bern.

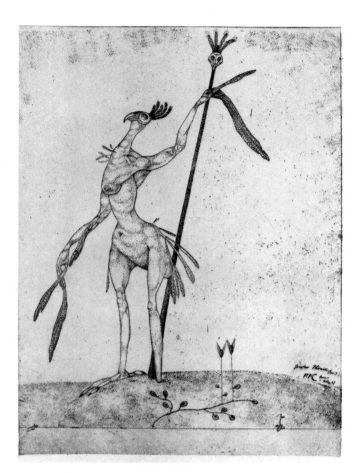

322. SENILE PHOENIX
(GREISER PHOENIX)
1905/36 – Etching, 27 × 19.8 cm
Paul Klee Foundation, Kunstmuseum, Bern.

323. REFLECTING WINDOW
(SPIEGELENDES FENSTER)
1915/211 – Aqua fortis, 16.3 × 11.8 cm
Paul Klee Foundation, Kunstmuseum, Bern.

The Etchings

During his trip to Italy in 1901, Paul Klee wrote in his Diary: "I am again entirely on the side of satire. Am I to be completely absorbed by it again? For the time being it is my only faith." In fact, between the period of the first etchings (1903–1905) and the *Candide* illustrations (1911–1912), his art was essentially satirical and graphic, influenced particularly by Ensor whose work he had been introduced to by his friend Sonderegger in 1907. He was also perfectly aware of the limitations of satire and confessed in April 1905: "I have to strive further; otherwise, I shall grow poor in this clean and comfortable orderliness, or it will turn into an idyll. (. . .) One day I must sink to my knees in a place where there is nothing and be deeply moved by doing so. Enough of this bitter laughter on the subject of what is and what is not as it should be."

While waiting, Klee regularly commented on his etching attempts. "January 1905, *The Hero With a Wing*, a tragicomic hero, perhaps a Don Quixote of ancient times. This formula and poetic idea, which murkily came up in November 1904, has now defini-

tively been clarified and developed. . . . The contrast between his monumental and solemn attitude and his already ruined state needed particularly to be captured, to remain as an emblem of the tragicomic."

"March 20th. The *Senile Phoenix* does not represent an ideal figure; he is really nearly five hundred years old, and as can be seen, all kinds of things happened to him during this time. This cross between realism and fable is what gives the comic effect. The bird's expression has a tragic side, and the thought that it will soon pass into parthenogenesis hardly opens any cheering perspectives. The rhythm of failure, belonging to a five-hundred-year period, is an extremely comic notion.

"Although the reference to Ovid is not correct here, we can read a number of interesting things about this bird in his work (*Metamorphoses* XV, 395). I agree with Ovid in that I would not like to see him fatally burned. The *Senile Phoenix* has something Homeric about it in so far as it is a parable; it parabolizes on one point, but for the rest, it is formulated — in a sense — for itself."

322

227

324. SPECIES OF GREYHOUND
(WINDSPIERLARTIGES TIER)
Rome 1902/1 (A) – Pen, watercolor and pencil on paper, 11.5 × 13.4 cm

WOMAN-DOLL
(PUPPENARTIGE DAME)
Rome 1902/2 (A) – Pen, watercolor and chalk on paper, 14.3 × 7.2 cm
Paul Klee Foundation, Kunstmuseum, Bern.

The Drawings

"Writing and drawing are basically identical," said Klee, stating what is profoundly true in the Far East, since the same brush is used there to write as well as to paint. The humor and spontaneity of these Roman sketches show with what a mocking and facetious eye the young Klee observed and grasped the strangeness of the daily street life. We can see this in the 324 greyhound coming to a halt, looking round inquisitively, its tail under its raised haunch, two legs as stiff as a stilt-bird's, and the two others suspended acrostically; or in the *Woman-Doll*, with her ornamental 324 hat and protruding petticoat, who curves in the serpentine style so beloved of the mannerists, and whose breasts, navel, and sex are visible through her muslin dress.

Twenty years later, during the Weimar period, Klee drew a series of studies of imaginary architectural perspectives. In the *Paddleboat Passes Alongside the Botanical Garden*, a marvelous cartography unfolds in front of our eyes: In a drawing resembling a child's, Klee seems to have been overtaken by a passion for graphs, which he puts on musical staves on both sides of the ship whose paddle wheels joyously spit smoke. In a first attempt the paddleboat was at the top of the composition above the two staves full of exotic trees, but then Klee decided to put the bottom part at the top, which explains why the title of the drawing is near the center of the image. The two sections of *Botanical Garden* were used again in a 1923 watercolor entitled *Tropical Horticulture*.

Starting from the first years of his teaching at the Bauhaus, Klee made a real imaginary theater for himself, for which he conceived costumed figurines, personages from the opera or Schubertian Lieder, and

acrobats. *The Dance of the Mourning Child* belongs to this series of grotesque as well as moving physiognomies. A somewhat languid grace comes from this figurine with a heart-shaped mouth in her thrown back head and a peacock feather in her hands. Supple marks close together form the forehead and the one eyebrow arch; the other is formed from an umbrella handle of which the umbrella is humorously intended as a receptacle for her tears.

The *Armour-Plated Virgin and Animals*, with its incisive and electrical graphism, irresistibly brings to mind the robotic puppets of the *Ballet of the Triod*, which Oskar Schlemmer was producing at the Bauhaus at the same time. If we take into account Klee's rather reserved attitude toward the glorification of the machine and Moholy-Nagy's "calibrated spirituality" (Feininger's term), we can see that there is certainly an element of satire concerning his colleagues' views in this work.

325. PADDLE-BOAT PASSES ALONGSIDE THE BOTANICAL GARDEN
(DER DAMPFER FÄHRT AM BOTANISCHEN GARTEN VORBEI)
1921/199 – Pen and India ink on paper mounted on cardboard, 11.9 × 28.9 cm
Paul Klee Foundation, Kunstmuseum, Bern.

326. DRAWING FOR DANCE OF THE MOURNING CHILD
(ZEICHNUNG ZUM "TANZ DES TRAUERNDEN KINDES")
1921/186 – Pen and India ink on cardboard, 19.2 × 22 cm
Paul Klee Foundation, Kunstmuseum, Bern.

327. COHESION AND FRUIT
(ZUSAMMENHANG UND FRÜCHTE)
1927/276 (OE 6) – Pen and India ink on Ingres paper mounted on cardboard, 30.2 × 45.5 cm
Paul Klee Foundation, Kunstmuseum, Bern.

328. THE ARMOR-PLATED VIRGIN AND ANIMALS
(DIE GEPANZERTE JUNGFRAU UND DIE TIERE)
1922/207 – Pencil on paper mounted on cardboard, 22.2 × 28 cm
Paul Klee Foundation, Kunstmuseum, Bern.

329. FINDS
(FUNDE)
1935/123 (QU 3) – Pencil on paper mounted on cardboard, 21 × 33 cm
Paul Klee Foundation, Kunstmuseum, Bern.

330. DOUBLE PORTRAIT
(DOPPELBILDNIS)
1920/64 – Pencil on paper, 22.6 × 28.1 cm
Paul Klee Foundation, Kunstmuseum, Bern.

In his last drawings, it was less a question for Klee of getting a perfectly finished work than of rendering his continual inner dialogue. Working on these drawings took the place of keeping his Diary. Klee, moreover emphasized in his letters that drawing had taken the place of writing for him. "I myself am completely astonished," he wrote on November 29, 1938, to his son Felix for his birthday, "to watch my pen dip itself in the ink, although it is a fountain pen, and then run across the fine paper, writing unintelligibly and not making the mysterious signs it usually does."

These last drawings are no longer motivated by the sole intention of giving a purely linear form to the images. "I am no longer completely master of these children," he wrote again to Felix on November 29, 1939. "They escape me." He described his work on

these last drawings to Grohmann as an ecstasy stimulated by rhythmic gestures. There is no more wavering of the lines in search of surface; instead, they spontaneously fill the page with energetic and supple marks.

What Klee learned from using his hesitant lines as a linear means of expression in his early works, he later tried to theorize during his teaching period at the Bauhaus. The numerous geometrical drawings from the *Pedagogical Sketchbook*, which he worked on until the beginning of the thirties, were used mainly to try out the various possibilities of expression inherent in the proportional laws of lines, and in their interdependence as well as their relationship to the overall design. It was only after having taken these theoretical reflections on the essence and expression of linear forms to their conclusion that,

331. DRAWING FOR BARBARIC VENUS
(ZEICHNUNG ZUR BARBAREN-VENUS)
1920/212 – Pencil on paper mounted on cardboard, 27.7 × 21.7 cm
Paul Klee Foundation, Kunstmuseum, Bern.

332. SILENT RANCOR
(STILLER GROLL)
1939/211 (R 11) – Pencil on paper mounted on
cardboard, 24.1 × 20.9 cm
Paul Klee Foundation, Kunstmuseum, Bern.

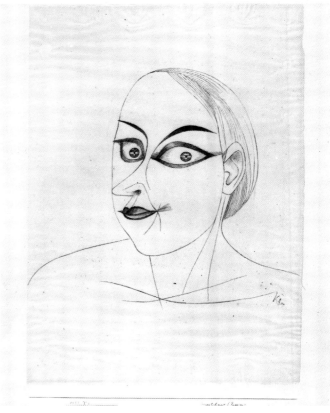

333. SEMITIC BEAUTY (PRECISION)
(SEMITISCHE SCHÖNHEIT [PRÄZION])
1927/191 (T 1) – Pen and India ink on Ingres paper
mounted on cardboard, 43.7 × 40.4 cm
Paul Klee Foundation, Kunstmuseum, Bern.

334. UGLINESS (PRECISION)
(HÄSSLICHKEIT (PRÄZION)
1927/194 (T 4) – Pen and India ink on Ingres paper
mounted on cardboard, 46.4 × 32.4 cm
Paul Klee Foundation, Kunstmuseum, Bern.

1925.X.7° d. Scene mit der Laufenden

1926 9# 1 *Christus*

335. STAGE WITH RUNNING WOMAN
(DIE SZENE MIT DER LAUFENDEN)
1925/247 (Y 7) – Pen and India ink on Ingres paper, 21 × 28.8 cm
Paul Klee Foundation, Kunstmuseum, Bern.

336. CHRIST
(CHRISTUS)
1926/71 (QU 1) – Pen and India ink on Ingres paper, 16.1 × 15.6 cm
Paul Klee Foundation, Kunstmuseum, Bern.

toward 1933, a new style of drawing emerged that differed from the preceding in its greater spontaneity. The *Eidola*, in particular, are the most intimate and spontaneous representations of his serenity in the face of approaching death.

"Drawing," Monsieur Ingres, repeated to his students, "is art's probity." An opinion that Klee, who had declared to Braque, when he came to visit him in 1937 in Bern, "Truth is; what we invent are lies," surely did not share. During the years 1925 to 1926, in a series of pen and ink drawings, Klee developed his "interlaced style." The lines, placed in parallel spindles, combined and became vegetative forms, which made up figures like the 1926 *Christ*, or the shapes in the 1925 *Stage with Running Woman*.

337. THE GREAT DOME
(DIE GROSSE KUPPEL)
1927/43 (N 3) – Pen and India ink on Ingres paper
mounted on cardboard, 26.3 × 30.3 cm
Paul Klee Foundation, Kunstmuseum, Bern.

338. SKETCH FOR "HOME OF THE OPERA-BOUFFE"
SKIZZE ZUM "HAUS DER OPERA BUFFA"
1924/272 – Pen and blue-black ink on paper mounted
on cardboard, 17.2 × 21.8 cm
Paul Klee Foundation, Kunstmuseum, Bern.

1927 O1 Beride (Wasser Tadt)

339. BERIDE (WATER TOWN)
 (BERIDE [WASSERSTADT])
 1927/51 (O 1) – Pen and India ink on Ingres paper mounted on cardboard, 16.3 × 22.1 cm
 Paul Klee Foundation, Kunstmuseum, Bern.

The rhythmic and dynamic placement of the lines created an optical effect of ascending or descending movement. This graphic process can also look like the stria of muscular fibers, to the point that the woman becomes an anatomical figure. This "interlaced style" is found again in two 1929 watercolors, *Evening in Egypt* and *Light Touches the Planes*.

The following remark, dated July 24, 1924, comes from the *Pedagogical Sketchbook*: "In the Classical domain, the forces of weight are dominant. In the Romantic, the centrifugal forces dominate." This is rather like the feeling we get when comparing *The Great Dome* of 1927 with the sketch for *Home of the Opera-Bouffe* of 1924. Finely drawn with a pen, *The Great Dome* (which is more likely to be that of the Santa Maria del Fiore cathedral in Florence than in

337
338

Pisa or Venice as Glaesmer thinks) lies with all its weight on a kind of milfoil surmounted by a campanile, while the little *Home of the Opera-Bouffe*, made from different sources, appears with its crazy staircases to want to explode.

We have tried to situate *The Great Dome*, but *Beride* is pure invention, an imaginary water town that Grohmann places in Egypt, "not in the sense of a recognized antiquity but rather of a vision or hallucination." On a sheet striated with horizontal lines that evoke the fluidity of water, vessels from operettas sail; bell-tower minarets rise up; checkerboard edifices stand out in profile, and labyrinths meander through the whole. The general impression it gives is of a fantastic embroidery drawn by a utopian urbanist.

340. "HARPIA HARPIANA" FOR TENOR AND SOPRANOBIMBO
("HARPIA HARPIANA" FUR TENOR UND SOPRANOBIMBO [UNISONO] IN GES)
1938/446 (A 7) – Pen on paper mounted on cardboard, 27 × 11.4 cm and 27 × 10.3 cm
Paul Klee Foundation, Kunstmuseum, Bern.

1938 Z 16 Kinder-Spiele

341. CHILDREN'S GAMES
(KINDER-SPIELE)
1938/436 (Z 16) – Pencil on paper mounted on
cardboard, 20.9 × 29.8 cm
Paul Klee Foundation, Kunstmuseum, Bern.

In the catalogue of his works, after the number 1938/365, Klee wrote down a phrase from Pliny: "Nulla dies sine linea." What is, in fact, striking in these last years of his life, when he was literally encircled by disease, is the abundance and supreme freedom of his graphic production. While some of his prior drawings often appear constrained, embarrassed, and even tortured, in his last phase there is ease, funambulatory joy, and sometimes a tinge of melancholy. The unbridled imagination of children's drawings inform the musicians and singers of *Harpia Harpiana for Tenor and Sopranobimbo*. *Children's Games* and *Architecture in Ruins* were fantasies composed in the style of puzzles. *The Little Prussian* executes his rhythmic march in a constellation of marks liberally spattering the paper. And caricature even resurfaces in the hilarious *Clowns* drawn in a few strokes, which immediately convey the humor.

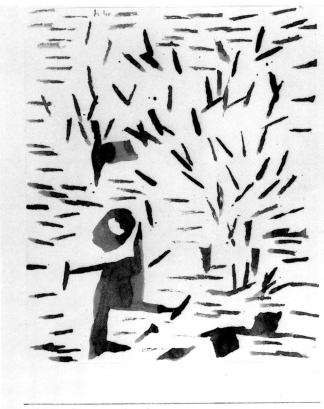

1938 R 7 der kleine Preusse

342. THE LITTLE PRUSSIAN
(DER KLEINE PREUSSE)
1938/267 (R 7) – Black watercolor on paper mounted
on cardboard, 27 × 21.5 cm
Paul Klee Foundation, Kunstmuseum, Bern.

343. ARCHITECTURE IN RUINS
(VERFALL EINER ARCHITEKTUR)
1939/483 (C 3) – Pen and ink on paper mounted on cardboard, 29.7 × 20.9 cm
Paul Klee Foundation, Kunstmuseum, Bern.

344. CLOWN DOUBLE
(CLOWN DOPPEL)
1939/529 (BB 9) – Pencil on Japanese simili, 29.7 × 20.9 cm
Paul Klee Foundation, Kunstmuseum, Bern.

345. OFFENDED CLOWN
(BELEIDIGTER CLOWN)
1940/202 (P 2) – Black chalk on paper, 29.6 × 21 cm
Paul Klee Foundation, Kunstmuseum, Bern.

346. ON HORSEBACK
(RÖSSLI-SPIEL)
1938/249 (QU 9) – Pencil on paper mounted on
cardboard, 27.1 × 21 cm
Paul Klee Foundation, Kunstmuseum, Bern.

347. DIGRESSIONS
(UMSCHWEIFE)
1938/416 (Y 16) – Pencil on paper mounted on
cardboard, 29.8 × 20.8 cm
Paul Klee Foundation, Kunstmuseum, Bern.

348. MIMUS THE MONKEY
(DER AFFE MIMUS)
1939/288 (V 8) – Pencil on Japanese simili, 20.9 × 29.7 cm
Paul Klee Foundation, Kunstmuseum, Bern.

349. WOOD LOUSE IN ENCLOSURE
(ASSEL IM GEHEGE)
1940/353 – Pastel on cotton mounted on cardboard, 31.3 × 41.5 cm
Paul Klee Foundation, Kunstmuseum, Bern.

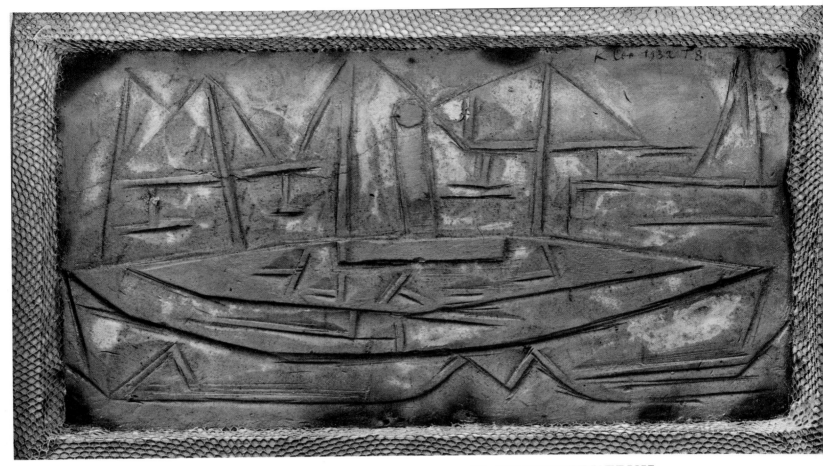

350. LITTLE STEAMSHIP IN THE PORT
(KLEINER DAMPFER IM HAFEN)
1932 – Bas-relief in colored gypsum, 11.8 × 22 cm
Paul Klee Foundation, Kunstmuseum, Bern.

354–360 **Puppets**

Felix Klee tells us about this period: "At the beginning of 1916, Klee began to make me puppets. Up until 1925, he created in all for my 'theater' some fifty figures of which thirty are still in existence. I received the first eight for my ninth birthday in 1916. The costumes had been sewn by Sasha von Sinner, one of our friends who subsequently married the painter Morgenthaler. Klee first made the heads out of plaster, but he later also used other materials, boxes of matches, electrical wires, wood, cattle bones, and papier-mâché. As to the choice of figure, he always made whom I wanted. Among them were 'Kasperl,' his friend Sepperl, Sir and Lady Death, the Devil and his Grandmother, and the Policeman and the Crocodile. The theater was set up in the little apartment in Schwabing in Munich: A large picture frame was hung from the doorpost between the bedroom and the dining room, and Klee would cover it, like a collage, with bits of fabric taken from a drawer full of mending — which Lily usually guarded jealously. (. . .)"

351. DOLL HANGING FROM PURPLE RIBBONS
(PUPPE AN VIOLETTEN BÄNDERN)
1906/14 (A) – Sous-verre, 24.3 × 16 cm
Paul Klee Foundation, Kunstmuseum, Bern.

352. SAINT BEYOND LAUGHTER AND TEARS
(HEILIGER JENSEITS VON LACHEN UND WEINEN)
1915/227 – Colored gypsum, height 25 cm
Paul Klee Foundation, Kunstmuseum, Bern.

353. HEAD SCULPTURE IN A PIECE OF TILE
(KOPF AUS EINEM IM LECH GESCHLIFFENEN ZIEGELSTÜCK,
GRÖSSER BÜSTE AUSGEARBEITETER)
1919/34 – Colored gypsum blended with stone, 30 × 13.5 × 6.5 cm
Paul Klee Foundation, Kunstmuseum, Bern.

354

355

358

356

357

359

360

354. GERMAN NATIONALIST
(DEUTSCH NATIONALER)
1921 – Puppet, 11 × 4.5 × 5 cm
Private collection, Switzerland.

355. THE BARBER FROM BAGHDAD
(DER BARBIER VON BAGDAD)
1920 – Plaster puppet, 14 × 9 × 9.5 cm
Private collection, Switzerland.

356. PEASANT IN BLACK OVERGARMENT
(BAUER MIT SCHWARTZER KAPPE)
1920 – Puppet, 10 × 5.5 × 6 cm
Private collection, Switzerland.

357. BANDIT
1923 – Puppet, 11 × 7 × 7 cm
Private collection, Switzerland.

358. SCARECROW GHOST
(VOGELSCHEUCHEN GESPENST)
1923 – Puppet in plaster, wood and cloth, 14 × 8 × 7.5 cm
Private collection, Switzerland.

359. MADAM DEATH
(FRAU TOD)
1921 – Plaster puppet, 10 × 5.5 × 3.5 cm
Private collection, Switzerland.

360. SELF-PORTRAIT
(SELBSTBILDNIS)
1922 – Plaster puppet, 9 × 5.5 × 6.5 cm
Private collection, Switzerland.

BIOGRAPHY

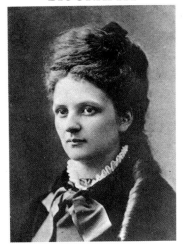

361. IDA KLEE-FRICK, PAUL'S MOTHER, 1879.

364. HANS KLEE, PAUL'S FATHER, 1916.

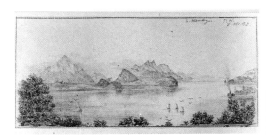

367. LAKE THUN IN MERLINGEN
1893 – Drawing.

1898
Graduation examination. In October, Klee goes to Munich and enters Heinrich Knirr's school of art.

1879
Born December 18 at Munchenbuchsee near Bern, to a German father, Hans Klee (1849–1940), music master at the Hofwil training school for teachers, and Ida Frick (1855–1921), a Swiss born at Besancon.

1886
Attends primary school at Bern; studies the violin with Karl Jahn. At age eleven, he becomes a member of the Bern muncipal orchestra.

365. CHRIST CHILD WITH YELLOW WINGS
1885 – Drawing by Paul Klee.

1889
Klee sees his first opera, *Il Trovatore*.

362. PAUL KLEE, BABY, 1881.

368. LILY STUMPF IN 1898.

1899
In the autumn, he meets Lily Stumpf (born in 1876), the daughter of a Munich doctor.

1880
The Klee family moves to Bern (6 Ostbergweg).

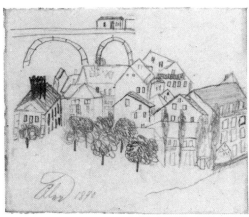

363. MEADOW IN BERN SEEN FROM KIRCHENFELD, 1890

366. PAUL KLEE IN 1892.

1890
Enters the Progymnasium in Bern.

369. GROUP OF TREES
1899 – Oil.

1900
In October, Klee enrolls at the Munich Academy. He joines Franz Stuck's studio where Kandinksy is also studying, but the two men do not meet until 1911. Klee takes courses on the history of art and anatomy, and makes his first attempt at sculpture.

370. PAUL KLEE AND HALLER IN ROME, 1902.

1901

Goes on his first journey to Italy (Milan, Genoa, Livorno, Pisa, and Rome) with the sculptor Hermann Haller, whom he has known since 1886.

371. KLEE: PORTRAIT OF HIS MOTHER
1893 – Drawing.

1902

He returns to Bern and stays with his parents until 1906.

372. PAUL KLEE AND THE KNIRR SCHOOL ORCHESTRA, IN 1900 (he is on the far right).

1903

Klee does his first etchings. He is a violinist in the Bern muncipal orchestra.

373. COMEDIAN
1904 – Etching on zinc.

1904

During a trip to Munich, he discovers the work of Beardsley, Blake, and Goya in the Kupferstichkabinet.

374. MATHILDE KLEE, PAUL'S SISTER
1903 – Oil.

1905

Goes to Paris (May 31–June 13) with Hans Bloesch and Louis Moilliet. Visits the Louvre and the Musée du Luxembourg and is particularly impressed by Leonardo da Vinci, Goya, Velazquez, Tintoretto, Watteau, Chardin, Puvis, Manet, Monet, and Renoir. Produces his first sous-verres.

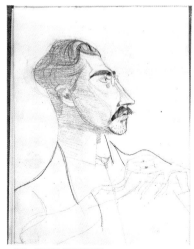

375. HANS BLOESCH
1902-1903 – Drawing.

376. PORTRAIT OF A RUSSIAN
1905 – Sous-verre.

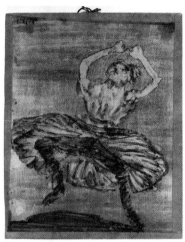

377. DANCER FROM THE SOUTH
1908 – Sous-verre.

1906

Klee exhibits ten etchings at the Sezession in Munich. Travels to Berlin in April with Bloesch; sees the Emperor Fredrich's Centenary Exhibition. He is particularly interested in Feuerbach, Leibl, Trübner, Menzel, and Liebermann. Sees Grunewald's *Crucifixion* at Karlsruhe. He marries Lily Stumpf on September 16, after a six-year engagement. They make their home in Munich in the artist's quarter of Schwabing (36 Ainmillerstrasse). Lily supports them by giving piano lessons.

The review *Simplicissimus* rejects the drawings he submitted to them.

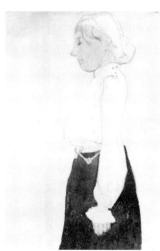

378. LILY KLEE
1905 – Drawing.

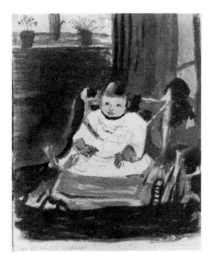

379. FELIX KLEE IN HIS FOLDING CHAIR
1908 – Watercolor.

381. SELF-PORTRAIT
1908 – Drawing

383. LILY ASLEEP
1908 – Drawing.

1907

Klee submits etchings and sous-verres to Kunst & Kunstler; they are rejected, as are the three sous-verres submitted to the jury of the Munich Sezession. Ernst Sonderegger introduces him to the work of Ensor and Daumier.

Felix Klee born November 30.

1908

Klee sees two Van Gogh exhibitions at the Zimmermann and Brakl galleries. The Union of Drawing Artists refuses to make him a member. He works for some months as a supervisor at the Debschitz School of Art. The Munich Sezession exhibits three of his sous-verres. He offers *Hero with a Wing* to Franz Blei for publication in the review *Hyperion*; Blei rejects it. The Berlin Sezession exhibits six of his drawings.

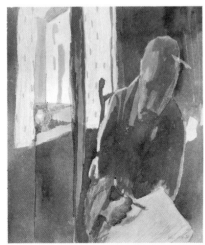

380. DRAWER, SELF-PORTRAIT
1909 – Watercolor.

1909

He is very impressed by the Marées exhibition. The Sezession rejects his six drawings. He sees Cézanne's work and discovers Matisse at Thannhauser's gallery. Meier-Graefe rejects his drawings for publication.

1910

Klee exhibits fifty-six of his works (1907–1910) at the Bern museum, at the Zurich Kunsthaus, and in a gallery at Winterthur. Kubin buys one of his drawings.

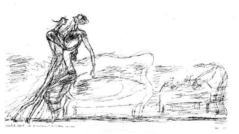

382. ILLUSTRATION FOR *CANDIDE*,
"They sit down again on this beautiful sofa,"
1911 – Drawing.

1911

The Klee exhibition is transferred to Basel. Kubin goes to see it. The first illustrations for Voltaire's *Candide* appear. Tannhauser exhibits thirty of his drawings. Klee meets August Macke at the house of Louis Moilliet. In December Marc and Kandinsky organize the Blaue Reiter exhibition, which has in it forty-three pictures. Klee is particularly interested in Henri Rousseau and Robert Delaunay. He begins to draw up a catalogue of his works since 1884.

1912

Klee participates in the second exhibition of the Blaue Reiter group, which is held in the Goltz gallery and is composed entirely of drawings and etchings. He is at the heart of the current discussion on modern art. Leaving his isolation of the first years in Munich, he meets Karl Wolfskehl, Reinhard Piper, Herwarth Walden, Rilke, Hans von Carossa, Eliasberg, Meier-Graefe, Thannhauser . . .

Makes second journey to Paris (April 2–8), where he meets Delaunay and Le Fauconnier. At Wilhelm Uhde's house he sees the works of Henri Rousseau, Braque and Picasso; at Kahnweiler's house, Derain, Vlaminck, and Picasso; at Bernheim's, Matisse. He translates and publishes Delaunay's article entitled "On Light" in *Der Sturm*. He exhibits four drawings at the Cologne Sonderbund and some pictures at the second exhibition of the Union of the Moderns in Zurich. His friend Hans Bloesch publishes his articles in his review *Die Alpen*.

1913

Hans Arp puts him into contact with Otto Flake, with a view to publishing his illustrations for *Candide*. He participates in two exhibitions at the Sturm Gallery and in the first German Autumn Salon.

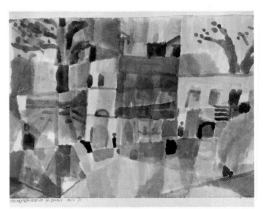

384. YELLOW AND RED HOUSES IN TUNIS
1914 – Watercolor.

1914

Klee is one of the founders of the New Munich Sezession at the instigation of Wilhelm Hausenstein. Klee, Macke and Moilliet leave for Tunis and arrive on April 7; they visit Carthage, Hamammet, and Kairouan. Their return journey starts on April 17, by way of Palermo, Naples, Rome, and Milan. During this journey, Klee starts using watercolor.

385. CLOCK IN THE TOWN
1914 – Drawing.

1915

Klee receives a visit from Rilke. Begins to produce small polychromatic sculptures.

386. CAMEL HEAD
1915 – Plaster sculpture.

1916

March 11, Klee mobilized in the Landsturm. During the summer, he paints airplane fuselages at the Schleissheim depot. He accompanies various convoys to Cologne and Saint-Quentin.

387. KLEE AS A SOLDIER AT LANDSHUT
1916 (on the right in the first row).

1917

January 16, he is transferred to the Bavarian School of Flying at Gersthofen near Ausburg and promoted to corporal. Several works from his exhibition at the Sturm Gallery are sold. An article on him by Theodor Dobler appears in the *Berliner Borsencourier*.

1918

After the armistice, Klee returns to Munich. Volume no. 3 of *Der Sturm* is published by Walden with fifteen of Klee's drawings.

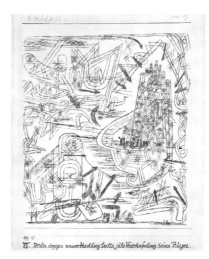

388. "BERLIN DAGEGEN UNSERE HOCHBURG,"
1919 – Drawing.

1919

He rents a large studio in the Suresnes Palace at Werneck. Baumeister and Schlemmer try in vain to have him taken on as professor at the Stuttgart Academy. He signs a contract with the dealer Goltz, which will be renewed until 1925. Kahnweiler buys some of his watercolors.

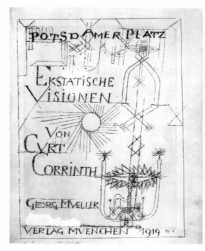

389. TITLE PAGE FOR *POTSDAMER PLATZ*
1919 – Drawing.

1920

Klee has a big exhibition of 362 of his works at Goltz's gallery in Munich. Caisimir Edschmid publishes "Creative Confession" in his Berlin review. His illustrations to *Candide*, which date from 1911, are published by Kurt Wolff in Munich. Another work with his illustrations, *Potsdamer Platz* by Curt Corrinth, is also published in Munich. Hans von Wedderkop and Leopold Zahn each devote a monograph to him.

On November 25, by unanimous vote, he is invited by Gropius to Weimar.

390. PAUL KLEE'S MOTHER
1909 – Drawing

1921

Klee starts drafting notes for his teaching at the Bauhaus. "Contributions to the Teaching of the Plastic Arts" is developed from these. Wilhelm Hausenstein publishes a third monograph on Klee. Summers at Possenhofen on the banks of Starngergersee. Death of his mother. Moves to Weimar.

1922

Takes part in exhibitions at Wiesbaden and Berlin. Because of him, Kandinsky is also invited to teach at the Bauhaus.

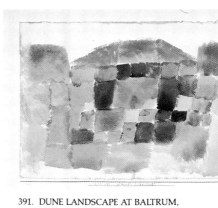

391. DUNE LANDSCAPE AT BALTRUM,
1923.

1923

His essay "Ways of Studying Nature" appears in the first Bauhaus publication. He passes the summer on the island of Baltrum in the North Sea. Exhbits in the Kronprinzenpalast in Berlin.

1924

First Klee exhibition in America, at the Anonymous Society of New York. Emmy Galka Scheyer founds the "Blauen Vier" with Kandinsky, Klee, Feininger, and Jawlensky. Leon Paul Fargue visits him. Voyage to Scicily.

Klee gives a lecture at the Artist's Union in Jena, where his exhibition is taking place.

392. PAUL KLEE'S STUDIO AT WEIMAR, 1925.

1925

In April, the Bauhaus settles in Dessau. Klee and Kandinsky move into two houses joined to each other. The Bauhaus publishes his *Pedagogical Sketchbook*. He has his second big exhibition, 214 works, at Goltz's gallery in Munich. He takes part in the first exhibition of Surrealist painters, which is held in the Galerie Pierre in Paris, along with Arp, Chirico, Ernst, Miró and Picasso. He also has his first one-person exhibition in Paris in the Galerie Vavin-Raspail. Eluard and Aragon are very enthusiastic about his work.

393. MOUNTAIN VIEW NEAR TAORMINA, 1924 – Drawing.

1926

Spends the summer in Italy (Elba, Pisa, Florence, and Ravenna).

1927

Spends the summer on Poquerolles and Corsica.

1928

Spends the summer in Brittany. The K. K. Society (Otto Ralfs) offers him a trip to Egypt, which lasts from December 17, 1928, to January 17, 1929.

394. WASSILY AND NINA KANDINSKY, GEORGE MUCHE, PAUL KLEE AND WALTER GROPIUS AT THE BAUHAUS, DESSAU, 1926.

395. PAUL KLEE'S STUDIO AT DESSAU, 1926.

1929

For his fiftieth birthday the Flechtheim Gallery in Berlin organizes a retrospective of his work. He has another exhibition in Paris, at the younger Bernheim's gallery. Will Grohmann publishes a monograph on him in the *Cahiers d'Art*. Spends the summer at Carcassonne and Hendaye.

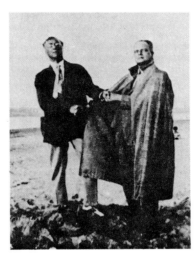

396. KANDINSKY AND KLEE MIMICKING SCHILLER AND GOETHE, 1929.

1930

The Museum of Modern Art of New York organizes an exhibition of his at the Flechtheim Gallery. In April he spends some time with Will Grohmann at Dessau.

1931

Klee terminates his contract with the Bauhaus and accepts a chair from Walter Kaesbach of the Düsseldorf Academy, where he will remain until 1933. An exhibition of 252 of his works is held at the Düsseldorf Union of Artists. He visits Sicily for the second time. Kubin comes to visit him in December.

1932

Klee sees a Picasso exhibition at the Zurich Kunsthaus. He spends the summer in Venice and Switzerland. The Bauhaus is transferred to Berlin, and the S. S. start an investigation of him.

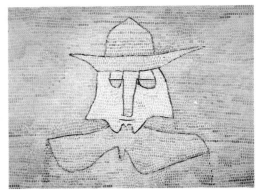

397. PASTOR KOL, 1932 – Oil.

1933

Violently attacked by the Nazis, he is dismissed in April from the Academy. His house is searched, and he has to prove he is not a Jew. He spends the summer in the South of France. The Bauhaus is dissolved. Klee leaves Germany in December and returns to Bern to live.

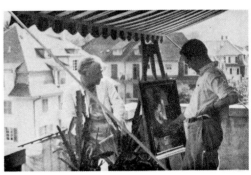

398. PAUL AND FELIX KLEE IN BERN, 1934.

1934

Has his first exhibition in England, at the Mayor Gallery in London. Kahnweiler becomes his dealer. Will Grohmann publishes a book on his drawings (1921–1930); the book is confiscated by the Gestapo.

399. PAUL AND LILY KLEE, 1935.

1935

Large retrospective exhibition in Bern. First symptoms of scleroderma.

1936

He goes for treatment to Tarasp and Montana. Has an exhibition at the Lucerne Kunsthaus. Works very little.

1937

Picasso, Braque, and Kirchner come to visit him in Bern. He spends the summer at Ascona. Seventeen of his works are included in the exhibition of "degenerate art" in Munich. The Germans confiscate 102 of his works from public collections.

1938

He exhibits in New York at the Bucholtz and Nierendorf Galleries and in Paris at the Simon and Carre Galleries. He spends the summer in Beatenberg.

1939

He visits the exhibition from the Prado at Geneva. He spends a week in the autumn at Faoug on Murtensee.

400. PAUL KLEE IN 1939.

1940

Large Klee exhibition in February at the Zurich Kunsthaus of 213 works dating from 1935–1940. In May he enters the sanatorium at Orsolina. On June 8, he is moved to the Sant' Agnese Clinic at Locarno where he dies from paralysis of the heart on June 28.

Commemorative exhibitions are held in November at the Bern Kunsthalle (233 works) and in New York, and in February 1941, at the Basel Kunstmuseum (358 works).

401. PAUL KLEE IN 1940.

402. FELIX KLEE AND HIS WIFE, 1982.

KLEE'S WRITINGS

"Die Austellung des Modernen Bundes im Kunsthaus Zurich", in *Die Alpen*, Bern, Zurich, August 1912. French translation, Paris, 1963.

"Schopferische Konfession" in *Tribune der Kust und Zeit*, Berlin, 1920. French translation, "Creative Confession," published in *Dans l'Entremonde*, Delpire, Paris, 1957.

"Uben der Wert der Kritik," in *Der Ararat*, Goltz, Munich, 1921.

"Wege des Naturstudiums," in *Staatliches Bauhaus, Weimar, 1919–1923*, Weimar and Munich, 1923.

Pedagogisches Skizzenbuch, Bauhausbucher 2, Albert Langen, Munich, 1925. French translation, "Theorie de l'Art moderne," Gonthier, Paris, 1963.

"Kandinsky," in *Katalog Jubilaumsaustellung zum 60 Geburtstag*, Arnold Gallery, Dresden, 1926.

"Emil Nolde," in *Festshrift fur Emil Nolde anlasslich seines 60 Geburtstages*, in *Neue Kunst Fides*, Dresden, 1927.

"Exakte Versuche im Bereich der Kunst," in *Bauhaus, Zeitschrift fur Gestaltung*, Dessau, 1928.

Uber die moderne Kunst, Benteli, Bern, 1945. French translation, *De l'Art moderne*, Connaissance, Brussels, 1948.

"Eight Poems," in Carola Giedion Walcker, *Poems from the Outer Edge*, Benteli, Berne-Bumpliz, 1946.

Dokumente und Bilder aus den Jahren 1896–1930, Volume I, texts and extracts from letters and Diary, Klee-Gesellschaft and Benteli, Bern, 1949.

Das Bildnerische Denken, Bauhaus lectures, 1921–1922, Schwabe, Bern and Stuttgart, 1956. French translation, *la Pensee Creatrice*, by Sylvie Gerard, Dessain and Tolra, Paris, 1973.

Tagebucher von Paul Klee 1898–1918, DuMont, Cologne, 1957. French translation, *Journal de Paul Klee*, by Pierre Klossowski, Grasset, Paris, 1959.

Unendliche Naturgeschichte, Schwabe, Basel, 1970. French translation *Histoire naturelle infinie* by Sylvia Gerard, Dessain and Tolra, Paris, 1977.

Schriften, A collection of writings organized by Christian Geelhaar, DuMont, Cologne, 1976.

Brief an die Familie, I, 1893–1906; II, 1917–1940, edited by Felix Klee, DuMont, Cologne, 1979.

RECENT EXHIBITIONS

Paul Klee, Maeght Foundation, Saint-Paul-de-Vence, 1977.

Paul Klee, Das Werk der Jahre 1919–1933, Gemalde, Handzeichnungen, Druckgraphik, Kunsthalle, Cologne, 1979.

Paul Klee, Das Fruhwerk, 1893–1922, Städtische Gallery in Lenbachlaus, Munich, 1980.

Paul Klee, Works from 1933 to 1940, Beaux-Arts Museum, Nimes, 1984.

Klee, Pierre Gianadda Foundation, Martigny, 1985.

Klee and Music, National Museum of Modern Art, Georges-Pompidou Center, Paris, 1985.

Paul Klee als Zeichner, 1921–1933, Städtische Gallery in Lenbachlaus, Munich; Kunsthalle, Bremen, 1985–1986.

Paul Klee Spatwerke, Bünder Kunstmuseum, Chur, 1986.

Paul Klee, The Museum of Modern Art, New York, and Museum of Art, Cleveland, 1987.

Paul Klee, Kunstmuseum, Bern, 1987.

Paul Klee, Museum of Modern Art, Saint-Etienne, 1988.

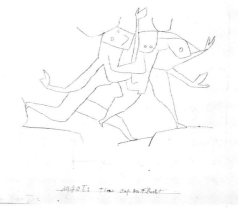

403. FLEEING ANIMALS
1940 – Drawing.

BIBLIOGRAPHY

Daniel ABADIE, *Paul Klee*, Maeght, Paris, 1977.

K. C. ADAM, *Platonic and Neoplatonic Aesthetic Tradition in Art Theory and Form: Relationship of sense object to idea in selected works of Hindemith & Klee*, University of Ohio, Columbus, OH, 1975.

Bruno ALFIERI, *Paul Klee*, Venice, 1948.

Merle ARMITAGE, *5 Essays on Klee*, New York, 1950.

Heinz BERGGRUEN, *Paul Klee*, Paris, 1964.

Rudolf BERNOUILLI, *Mein Weg zu Klee*, Bern-Bumpliz, 1940.

Hans BLOESCH and Georg SCHMIDT, *Paul Klee*, Bern-Bumpliz, 1940.

Marcel BRION, *Paul Klee*, Aimery Somogy, Paris, 1971.

Denys CHEVALIER, *Klee*, Flammarion, Paris, 1971.

Douglas COOPER, *Paul Klee*, Penguin Books, Harmondsworth, 1949.

Pierre COURTHION, *Klee*, Fernand Hanzan, Paris, 1953.

René CREVEL, *Paul Klee*, Gallimard, Paris, 1930.

Hugo DEBRUNNER, *Paul Klee*, Zurich, 1949.

Gillo DORFLES, *Paul Klee*, London, 1954.

Jean DUVIGNAUD, *Klee en Tunisie*, Bibliotheque des Arts, Lausanne-Paris, 1980.

Alfred EICHHORN, *Paul Klee*, Stuttgart, 1948.

Robert FISCHER, *Klee*, Tudor Publishing Co., New York, 1966.

Andrew FORGE, *Paul Klee*, London, 1954.

Christian GEELHAAR, *Paul Klee und das Bauhaus*, DuMont, Cologne, 1972. French translation, *Ides et Calendes*, Neuchatel; Bibliotheque des Arts, Paris, 1972.

Christian GEELHAAR, *Paul Klee, Leben und Werk*, DuMont, Cologne, 1974.

Hans GEIST, *Paul Klee*, Hamburg, 1948.

Carola GIEDION-WELCKER, *Paul Klee*, New York, 1952.

Jürgen GLAESEMER, *Paul Klee, Handzeichnungen I : Kindheit bis 1920*, Bern Kunstmuseum, 1973; II : *1921–1936*, Bern Kunstmuseum, 1974; III : *1937–1940*, Bern Kunstmuseum, 1979. Catalogue Raisonne of drawings at the Bern Kunstmuseum.

Jürgen GLAESEMER, *Paul Klee, Die farbigen Werke im Kunstmuseum Bern*, Kornfeld, Bern, 1976. Catalogue Raisonne of works in color at the Bern Kunstmuseum.

Jürgen GLAESEMER, *Paul Klee, Beitrage zur bildernischen Formlehre*, Schwabe, Basel, 1979.

Jürgen GLAESEMER, *Paul Klee, Leben und Werk*, Hatje, Stuttgart, 1987.

Will GROHMANN, *Paul Klee, Trois Collines, Geneva, 1954*; Kohlhammer, Stuttgart; Flinker, Paris, 1957.

Will GROHMANN, *Paul Klee, Handzeichnungen*, DuMont, Cologne, 1959.

Will GROHMANN, *Der Maler Paul Klee*, DuMont, Cologne, 1966.

Will GROHMANN, *Paul Klee*, Nouvelles Editions Francaises, Paris, 1977.

Ludwig GROTE, *Erinnerungen an Paul Klee*, Prestel, Munich, 1959.

Werner HAFTMANN, *Paul Klee: Wege bildnerischen Denkens*, Prestel, Munich, 1950.

Charles W. HAXTHAUSEN, *Paul Klee: The Formative Years*, Gartland, New York, 1981.

Sara Lynn HENRY, *Paul Klee, Nature and Modern Science*, University of California Berkley, 1976.

L'HERTIG, *Paul Klee*, Lucerne, 1959.

Max HUGGLER, *Paul Klee*, Bern-Bümpliz, 1960.

Max HUGGLER, *Paul Klee, Die Malerei als Blick in den Kosmos*, Huber, Frauenfeld, Stuttgart, 1969.

Nika HULTON, *An approach to Paul Klee*, London, 1956.

David IRWIN, *Paul Klee*, Bristol, 1967.

Hans JAFFE, *Paul Klee*, London, New York, 1971.

Gotthard JEDLICKA, *Paul Klee*, Munich, 1960.

Jim JORDAN, *Paul Klee and Cubism*, Princeton University Press, Princeton, NJ, 1984.

Andrew KAGAN, *Paul Klee, Art and Music*, Cornell University Press, Ithaca, NY, 1983.

Daniel-Henri KAHNWEILER, *Klee*, Braun, Paris, 1950.

Wolfgang KERSTEN, *Paul Klee, "Zerstörung, der Konstruktion Zuliebe,"* Jonas Verlag, Marburg, 1987.

Felix KLEE, *Paul Klee, Leben und Werke in Dokumenten*, Diogenes, Zurich, 1960.

Felix KLEE, *Paul Klee: Paul Klee par lui-même et son fils*, Les Libraires associes, Paris, 1963.

Eberhard KORNFELD, *Verzeichnis des graphischen Werkes von Paul Klee*, Kornfeld and Klipstein, Bern, 1963. (Catalogue Raisonne of the etchings.)

Miroslav LAMAC, Paul Klee, Prague, 1965.

Bo LINDWALL, *Paul Klee*, Stockholm, 1953.

Norbert LYNTON, Klee, New York, 1975.

Maria MARCUS, *Paul Klee*, Copenhagen, 1956.

Marcel MARNAT, *Klee*, Fernand Hazan, Paris, 1974.

André MASSON, *Éloge de Paul Klee*, 1946.

Walter MEHRING, *Klee*, Bern, 1956.

Michael and Erica METZGER, *Klee*, Boston, 1967.

Ake MEYERSON, *Paul Klee*, Stockholm, 1956.

Margaret MILLER, *Paul Klee*, New York, 1946.

Andeheinz MOSSER, *Das Problem der Bewegugn bei Paul Klee*, Heidelberg University, 1973.

Joseph-Emile MÜLLER, *Klee, Carrés magiques*, Fernand Hazan, Paris, 1956. *Figures et masques*, 1961.

Christa MURKEN, *Paul Klee*, Düsseldorf, 1971.

Constance NAUBERT-RISER, *Klee, Les Chefs-d'oeuvre*, Fernand Hazan, Paris, 1988.

Karl NIERENDORF, *Paul Klee, Paintings, Watercolors, 1883 to 1939*. Oxford University Press, New York, 1941.

Toshio NISHIMURA, *Klee*, Tokyo, 1973.

Tilman OSTERWOLD, *Paul Klee, Ein Kind traumt sich*, Gerde Hajte, Stuttgart, 1979.

Geza PERNECSKY, *Klee*, Budapest, 1967.

Petra PETITPIERRE, *Aus der Malklasse von Paul Klee*, Bern, 1957.

Erich PFEIFFER-BELLI, *Klee*, Munich, 1964.

James PIERCE, *Paul Klee and Primitive Art*, New York University, New York, 1976.

Margaret PLANT, *Paul Klee, Figures and Faces*, Thames and Hudson, London, 1978.

Margaret POLSON, *Paul Klee*, University of North Carolina, Chapel Hill, NC, 1974.

Nello PONENTE, *Klee*, Skira, Geneva, 1960.

Ernest RABOFF, *Paul Klee*, New York, 1968.

Herbert READ, *Klee, (1879–1940)*, Faber & Faber, London, 1948.

Sabine REWALD, *Paul Klee, The Berggruen Collection in the Metropolitan Museum, and in the Musée national d'Art moderne*, Paris, New York, 1988.

Mark ROSENTHAL, *The Arrow. A Microcosm in the Art of Paul Klee*, University of Iowa, Iowa City, IA, 1975.

Hans ROETHEL, *Paul Klee in Munchen*, Kornfeld and Klipstein, Bern, 1971.

Claude ROY, *Paul Klee, Aux sources de la peinture*, Le Club francais du Livre, Paris, 1963.

Gualtieri DI SAN LAZZARO, *La Vie et l'Oeuvre*, Fernand Hazan, Paris, 1958.

Werner SCHMALENBACH, *Paul Klee*, Wiesbaden, 1955.

Werner SCHMALENBACH, *Paul Klee*, Nordrhein Westfalen Kunstsammlung, Düsseldorf, 1977.

Georg SCHMIDT, *Paul Klee*, Baden-Baden, 1957.

Hans SCHWEIZER, *Paul Klee*, University of Tübingen, 1976.

James Thrall SOBY, *The Prints of Paul Klee*, Kurt Valentin, New York, 1945.

Jürg SPILLER, *Paul Klee: Das bildnerische Denken*, Stuttgart, 1971

Eva STAHN, *Paul Klee*, Bern, 1973.

James Johnson SWEENEY, *Paul Klee*, New York, 1941.

Felix THURLEMANN, *Paul Klee, Analyse sémiotique de trois peintures*, L'Age d'or, Lausanne, 1982.

Richard VERDI, *Klee and Nature*, Rizzoli, New York, 1985.

Katalin von WALTERSKIRCHEN, *Paul Klee*, Filipacchi, 1975.

Hans von WEDDERKOP, *Paul Klee*, Klikhardt and Biermann, Leipzig, 1920.

Otto K. WERCKMEISER, *Versuche über Paul Klee*, Syndikat, Frankfurt, 1981.

Leopold ZAHN, *Paul Klee: Leben, Werk, Geist*, Kiepenheuer, Potsdam, 1920.

257

ETCHINGS — LITHOGRAPHS

PROVENANCE OF PHOTOGRAPHS

The author and publisher wish to thank
and express their gratitude to

FELIX KLEE

and the

PAUL KLEE FOUNDATION

For allowing us access to their precious archives

This book was conceived by

ELIANE ALLEGRET

The text was set in Aldus and Goudy by

STUDIO 31

404. TAKING LEAVE
(ABSCHIED NEHMEND) 1938